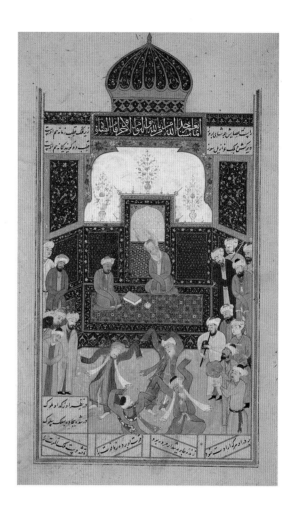

ISLAM

FAITH · ART · CULTURE

ISLAM
FAITH · ART · CULTURE

Manuscripts of the Chester Beatty Library

ELAINE WRIGHT

SCALA

This edition © 2009 Scala Publishers Ltd
Photographs © 2009 The Chester Beatty Library, Dublin
Text © 2009 Elaine Wright and the Chester Beatty Library, Dublin

First published in 2009 by
Scala Publishers Ltd
Northburgh House
10 Northburgh Street
London EC1V 0AT, UK
www.scalapublishers.com

In association with the Chester Beatty Library, Dublin

ISBN 978-1-85759-512-3

Photography by Denis Mortell, Roy Hewson and Louis Pieterse
Expert reading by Daoud Rosser-Owen
Copy edited by Helena Bacon
Project managed by Oliver Craske
Designed by Nigel Soper

Printed in Singapore

10 9 8 7 6 5 4 3 2 1

Front cover: CBL T 413, f. 119a (see fig. 106)
Back cover: CBL Ar 4180, f. 40a (see fig. 136)
Page 1: CBL Per 163.6 (see fig. 173)
Page 2: CBL Is 1431, f. 7b (detail of fig. 88)

CONTENTS

INTRODUCTION

IN RECENT YEARS a flood of books has appeared on the market, all designed to provide the 'Western', non-Muslim reader with a much-needed, basic understanding of the Islamic religion. Most of these books deal with aspects of both orthodox faith and popular piety, as does this book. However, a somewhat different approach has been taken here in that the reader is introduced to aspects of the faith through the rich heritage of the Islamic book, a heritage of which few people in the West other than specialists are aware. The books, or more specifically manuscripts (i.e. handwritten books), and single folios that are reproduced here are all part of the collection of Islamic manuscripts that Sir Alfred Chester Beatty, the American mining magnate and philanthropist, left in trust for the public benefit upon his death in 1968. It is one of the most important and finest collections of Islamic manuscripts in existence, and included in the collection are more than 260 complete and fragmentary copies of the Qur'an, the holy scripture of the Islamic faith.

Although the Holy Qur'an alone can be considered a sacred text, a vast number of other texts in the collection, even many that are purely secular, touch upon various aspects of both the orthodox tenets and popular beliefs of Islam. Many include figural imagery – notably images of Muhammad and other prophets – anathema to many orthodox believers, but nevertheless, as explained in the first chapter, very much a part of Islamic history and, in particular, the tradition of the Islamic book. To ignore this material would be to give a false impression of the culture and history of Islam. The choice of topics discussed has been largely dictated by the material included in the collection (and specifically by that which is visually appealing and hence suitable for reproduction). The manuscripts and folios reproduced span the period from the ninth century to the early twentieth, though most were produced between about the thirteenth and sixteenth centuries. This does not mean, however, that what is presented is an image of a bygone world, because in almost all cases the texts (or at least the types of texts) and the concepts they deal with are as relevant today as they were when the manuscripts were produced.

The first two chapters of this book aim to establish the historical context of the divine revelation, the first chapter dealing specifically with the early history of Islam, until the death, in AD 661, of Ali, the fourth caliph; the second chapter focuses on the Prophet Muhammad and his family. The Qur'an itself is the focus of the third and fourth chapters: the third chapter examines the contents of the holy text (with there being a deliberate attempt, in particular in this chapter, to include a considerable number of translated verses of the Qur'an), and the fourth chapter deals with aspects (mainly the calligraphy) of actual manuscript copies of the Qur'an. Matters concerning the practice of the faith – the five pillars of Islam, Islamic law and the study of the faith – are explored in the fifth chapter. The sixth chapter consists of brief accounts of a sampling of the many prophets and other figures revered by Muslims, some of whom are common to the biblical and Islamic traditions, some purely Islamic. Discussed in the seventh and final chapter is Islamic mysticism, including the work of various mystical poets.

NOTES TO THE READER

BIBLIOGRAPHICAL REFERENCES

In an attempt to make the text more readable for a general audience, footnotes have not been included. However, inclusion in the bibliography should be taken as an acknowledgement of a volume's use and of a debt owed to the authors listed therein; any particular use made of a volume, such as the inclusion in the text of a direct quote from it, is indicated in parentheses at the end of the bibliographic entry for that volume.

QUR'AN

The English translation of the Qur'an used is that of Yusuf Ali, though a great deal of liberty has been taken in altering the English wording to make the text more readable. References to chapters and verses quoted are given, as, for example, 9:102. The more correct, though perhaps less common, spelling, 'Qur'an', rather than 'Koran', is used throughout.

THE TRANSLATION AND TRANSLITERATION OF ARABIC WORDS

Foreign words included in the text are always Arabic unless indicated otherwise, and their English equivalent is always given upon first mention, but whether the English or Arabic form of a name or any other word is used subsequently varies depending on which version seems more appropriate.

An Arabic transliteration system has been used, with minor exceptions, though diacriticals, vowel markings and most other orthographic marks have been omitted from the transliterations for ease of reading on the part of the non-specialist, the intended audience of this book. The following points of transliteration should be noted.

The Arabic letter *dal*, transliterated as 'd', corresponds, more or less, to an English 'd'. The letter *dhal*, transliterated as 'dh', is pronounced basically as an English 'th' as in 'that', but in Persian

is pronounced and transliterated as a 'z'; thus the name for the individual who makes the call to prayer is *mu'adhdhin* in Arabic transliteration but *muezzin* in Persian (and the latter is the pronunciation generally used by English speakers). Somewhat confusingly, the letter *dad* is also transliterated here as 'd' (though usually it is transliterated as a 'd' with dot beneath it) and is pronounced by Arabic speakers as a heavy 'd' as in 'duh' but by Persian speakers as a 'z'; thus the word *rawdat* – usually translated as 'garden' or 'tomb' – is pronounced *rawzat* in Persian.

Similarly, the letter *waw* when used as a consonant is pronounced as an English 'w' in Arabic, but as a 'v' in Persian; thus a government minister is a *wazir* to the Arabs but a *vazir* (or *vizir* or *vizier*) to Persian-speakers (and it is the Arabic form that is used here).

The Arabic consonants *ayn* (a strong guttural which in its transliterated form usually resembles a sort of backwards apostrophe) and *hamza* (a glottal stop rendered in transliteration as an apostrophe), neither of which has a Roman alphabet equivalent, have been omitted when they occur at the beginning or end of a word but retained when in a medial position; the latter is to indicate to the reader that there should be a clear distinction between the letters on either side of the marks used to represent these consonants.

As Arabic does not use capital letters, they have been omitted in Arabic transliterations (with the exception of Qur'an chapter titles and, usually, for the first word of all other titles), but are used for English translations.

NAMES

Muslim names can be confusing to those unfamiliar with them, but the most basic fact to remember is that in names the word *ibn* is read as 'son of'; thus Muhammad ibn Abd Allah means Muhammad the son of Abd Allah – not all that different from, say, an

English name such as Johnson, which of course originally simply indicated that the individual was the son of John. *Abu* and *umm*, which are also frequently used in names, are read as, respectively, 'father of' and 'mother of'. Also of note are the terms *bani* and *banu*, used for the names of various tribes and which translate as 'sons of', as in the Bani Nadir or Banu Qurayza. It should also be noted that the form Abd Allah is generally used, not Abdallah or Abdullah, this being merely a personal preference. There is some altering of the spelling of certain names depending on context; this specifically concerns the name Solomon, which is given in either its Arabic form of Sulayman or its Turkish form of Suleyman, depending on which is more appropriate.

DATES

Dates in manuscripts are given according to the Islamic calendar, year one of which is equivalent to AD 622. Islamic dates are here generally included only in captions to illustrations of dated manuscripts where they are placed in parentheses and designated as AH, meaning *anno hegirae* ('after the migration' from Mecca to Medina). All dates in the body of the text are therefore AD dates, unless indicated otherwise, though the AD designation is generally not included, even for dates prior to the year 1000. (The supposedly politically incorrect AD is used, not CE, because it simply makes sense to do so considering the necessary parallel reference to an equally religious-based, non-Western calendar.) Because the Islamic calendar is lunar while the Western, or Gregorian, calendar is solar, an exact equivalence of years between the two systems rarely exists, and so the Gregorian year must often be stated as spanning two years.

ISLAMIC MANUSCRIPTS

All books reproduced here are manuscripts, namely handwritten books, and the reader should bear in mind that Arabic is read right to left and thus the beginning of an Islamic book or manuscript is what would be the end of a 'Western' book. 'Folio' refers to both sides of a single sheet of paper, the obverse and reverse being referred to as the 'a' and 'b' sides, respectively. When 'page' is used, it of course refers to a single side of a folio.

ILLUSTRATIONS AND CAPTIONS TO THE ILLUSTRATIONS

All illustrations are of material that is part of the Islamic Collections of the Chester Beatty Library, Dublin. In illustration captions: Qur'ans, whether complete manuscripts, bound fragments of a manuscript, or even single folios, are always identified simply as 'Qur'an'; the text on any folio reproduced is identified only when it is pertinent to the information being discussed; measurements given are always those of the whole page, even when only a detail of a page is reproduced; and the inventory numbers of the manuscripts are listed as, for example, CBL Is 1472, ff. 142b–143a. Also, in all manuscripts the text is in Arabic and written on paper, unless indicated otherwise.

ACKNOWLEDGEMENTS

I would like to express my gratitude to the Director of the Chester Beatty Library, Dr Michael Ryan, and the Library's Board of Trustees, for their kind support of this project. Thanks are also due to Jill Unkel for her assistance in the final stages of the preparation of the text for publication (including the compiling of the glossary and the concordances) and, especially, to Sinead Ward, who oversaw all matters concerning the photography of the manuscripts. I would also like to make particular note of my appreciation of Daoud Rosser-Owen's very careful and sensitive reading of and comments on the text.

1 THE EARLY HISTORY OF ISLAM

The Lifetime of the Prophet

Islam IS AN ARABIC word that means 'submitting'. It is a derivation of the tri-literal, consonantal root s-l-m, and altering the vowelling of this root and the addition of prefixes, suffixes and in-fixes produces a number of different words, all related in meaning. Thus, *salam* means 'peace' and *muslim* means 'one who submits' (to the will of God) and specifically one who is an adherent of Islam. This system of tri-literal consonantal roots is a characteristic feature of all Semitic languages, including both Arabic and Hebrew.

The Qur'an is the holy book of the Islamic faith, and for the more than one billion Muslims around the world, living in both Arabic- and non-Arabic-speaking countries, it is a record of the words that God spoke to the Prophet Muhammad some fourteen centuries ago. God did not speak directly to Muhammad, rather his words were transmitted to him by Jibril (the Archangel Gabriel), and it is important to stress that the Qur'an is not an account of Muhammad's life, nor is it Muhammad's interpretation of God's words: it is regarded as the written record, with no alterations, additions or deletions, of the *exact* words uttered by God (fig. 1).

Muhammad was born in about the year 570, in the highly mercantile city of Mecca, in the southeast of present-day Saudi Arabia. He was orphaned at a young age, his father, Abd Allah, having died before his birth and his mother, Amina, when he was just six years old, leaving him to be raised first by his grandfather, Abd al-Muttalib, and then, after his death, by his uncle, Abu Talib, who was then head of the Hashim, one of the clans that made up the tribe known as Quraysh. Despite the support of family and friends, as an orphan Muhammad was at a disadvantage, but his fortunes changed when, as a young man, a local Meccan businesswoman named Khadija gave him a position as a merchant (the trade of both his father and uncle), travelling with other merchants by caravan to Syria; eventually he rose to the position of caravan commander. Khadija was a twice-widowed mother of several children who is said to have been one of the most highly respected and wealthiest women of Muhammad's tribe. Although several years older than Muhammad, she eventually married him and they had several children together.

It was the practice of Muhammad (and apparently of many individuals of the time) to go off on a religious retreat each year, and it was in the course of one such month-long retreat, in a cave in the side of Mount Hira, some five kilometres (three miles) north of Mecca, that Muhammad first heard the word of God. This was in 610, when Muhammad was about forty years old. Gabriel appeared to him in the cave and instructed him to 'Recite!', namely that he should repeat aloud the words that came to him and thereby commit them to memory. (Some accounts say that Gabriel embraced him with a coverlet on which were written the words he commanded Muhammad to recite.) Confused, Muhammad protested until he was so overwhelmed by Gabriel that he had no choice but to do as the angel commanded. This first revelation is what is now verses 96:1–5 of the Qur'an, which state (fig. 2):

> Recite! In the name of your Lord,
> Who created man from a clot of blood;
> Recite! and your Lord is most generous,
> He who taught with the Pen,
> Taught man that which he did not know.

The word *qur'an* translates as 'recitation', and the night during which Muhammad received this first revelation was that between the 26th and 27th of the Muslim month of Ramadan, now celebrated annually by Muslims around the world as *laylat al-qadr*, meaning 'the Night of Power' (or 'the Night of Destiny'). Many Muslims spend this entire night in the mosque praying and reading the Qur'an, and it is believed that this night is better than a thousand months and that any request made of God at this time will be granted.

Fig. 1

Qur'an, with headings for Chapters 108–113

Naskh script (with heading inscriptions in gold *kufic*)

Late 12th–early 13th century,
Iran or Iraq
39 x 33cm, CBL Is 1439, ff. 365a–366b

The illuminating of the Qur'an is seen as a glorification of the words of God, and this especially beautiful manuscript is a work of art that fulfils this function magnificently. The 114 headings – one to introduce each chapter of the holy text – are all different and comprise a myriad of lush, scrolling palmette forms. One curious feature of the headings of this particular manuscript is that in some cases the final words of the preceding chapter, written in black *naskh* script, are included within the rectangular space of the heading.

Muhammad is said to have at first been understandably confused and refused to believe that it truly was God's words that Gabriel had delivered to him. Initially, he confided only in Khadija, who never doubted that her husband had indeed been chosen as God's prophet. In fact, according to tradition, several signs of Muhammad's impending prophethood had appeared before his birth and throughout his early life. For example, just prior to his parents' wedding, a brilliant light is said to have shone from between the eyes of his father, indicating that he was about to beget a prophet. Also, the breasts of his wet-nurse, Halima, overflowed with milk immediately upon putting the baby Muhammad to her breast for the first time, even though she had previously been dry and unable to feed even her own child; likewise her family's sheep and camels immediately began to produce copious amounts of milk, despite it being a time of famine during which the flocks of other members of their clan produced nothing. And one day when he was still a boy, Muhammad accompanied his merchant uncle Abu Talib on a caravan journey to Syria and as always the caravan passed the cell of a monk known as Bahira, but this time the monk noticed a cloud hovering above the caravan

and so he rushed out to invite the travellers into his cell for a small feast. Afterwards, he pulled Muhammad aside and saw between his shoulders the seal or mark of prophethood, and thus recognised him as the prophet that had been foretold him. Moreover, some years later, before Khadija's marriage to Muhammad, one of her employees reported a similar event to her, claiming that during a caravan trip to Syria a monk had told him that Muhammad had been chosen as God's prophet and that during the same trip he witnessed two angels sheltering Muhammad from the heat of the sun.

That a new prophet was to arise in Arabia seems to have been believed by many people of the time, Christians, Jews and pagans alike. Of the many stories indicating this is one recorded by the historian Ibn Ishaq (*b. c.*704 in Medina) in his biography of the Prophet; it tells of a Jew who moved from his home in Syria to Medina in order to be close to the prophet whose imminent arrival had been foretold. Another tells of one Zayd ibn Amr, a member of the Quraysh who renounced the religion of his people and travelled north to Mesopotamia (present-day Iraq) and Syria seeking the true religion of Abraham; but once there he too was told that a prophet

Fig. 2
Qur'an

Black *thulth* script between upper and lower lines of a large gold *muhaqqaq* script, and a middle line of large gold *thulth* script

Late 15th century, Iran
34.7 x 24.8cm, CBL Is 1499, f. 215b

The illuminated heading in the middle of this folio marks the beginning of Chapter 96, *al-Alaq* (The Clot), the first revelation to be received by the Prophet Muhammad, in the year 610, in a cave in the side of Mount Hira, just outside Mecca. The gold *thulth* script of the heading has been placed on a bed of orange arabesque against a black ground. At the lower edge of the folio, another, larger heading, but in a more subdued palette, similarly marks the beginning of Chapter 97.

would soon come forth in Arabia, so he turned around and headed for home. And when Khadija was told by her employee of the events that had taken place during the caravan trip to Syria, she confided in her cousin Waraqa, a Christian, who responded by saying that the coming of a prophet was indeed anticipated. Furthermore, according to the Gospel of John (14:16, 15:26 and 16:7), Jesus said that he would send a 'Comforter' after him to remind his disciples of his teachings. Through various misreadings and mistranslations of the original text, 'Comforter' (or 'Paracletos' in Greek) came to be interpreted as 'the praised one', the precise meaning of the names Muhammad and Ahmad; this foretelling by Jesus of a prophet named 'the praised one' is also recorded in the Qur'an (61:6):

And remember, Jesus,
The son of Mary, said:
'O Children of Israel!
I am the messenger of Allah
(Sent) to you, confirming
The Law (which came)
Before me, and giving
Glad Tidings of a Messenger
To come after me,
Whose name shall be Ahmad.' (fig. 3)

Muhammad did not immediately begin to preach God's words, and, in fact, after receiving the first few revelations, there was a period of some two years during which time he received no further revelations. This hiatus caused him to question what he

Fig. 3
Qur'an

Black *naskh*, gold *thulth* and blue *muhaqqaq* scripts

Mid 16th century, Iran
42.4 x 30cm, CBL Is 1545, ff. 225b–226a

The illuminated heading in the lower section of the right-hand page proclaims the start of Chapter 61 of the Qur'an, known as *al-Saff* (The Battle Array). The upper half of the left-hand page includes verse 6 of this chapter, which records Jesus' foretelling of a prophet named Ahmad.

had experienced, and, despite the unfailing support of Khadija, he wondered if he had perhaps been mistaken or mislead. When the revelations suddenly recommenced, Muhammad began to preach openly, though cautiously, his number of converts gradually increasing and drawn, at first, mainly from his family (first his cousins) and from the young and those with less secure and less powerful positions within the tribe. Arabia in the seventh century was a tribal society and the Quraysh, Muhammad's tribe and the tribe responsible for transforming Mecca into a thriving commercial centre, consisted of numerous clans, each wielding varying degrees of power and influence within the tribe, and it was from the weakest of the Quraysh clans that many of Muhammad's

first converts were drawn. Family divisions within the clans arose as some members of a clan converted and others did not: the tribal system was based on blood bonds, but by becoming Muslims alliances were being formed based not on blood but on religion and this in itself was seen as a serious threat to traditional Arab society.

Much of the power and influence of the Quraysh among the other Arabian tribes derived from their custodianship of the Ka'ba, the ancient stone sanctuary in the centre of Mecca. According to Muslim tradition, Adam built a temple on this site after his and Eve's expulsion from the Garden of Eden. The temple was destroyed in the Flood, but another one was then built on the same spot by

Ibrahim and his son Isma'il (the Biblical Abraham and Ishmael). Over time, this initially monotheistic shrine was transformed into a predominantly pagan sanctuary, and it is said that in Muhammad's day it was surrounded by 360 idols with representations of earlier prophets on the walls inside. Many such shrines once existed throughout Arabia, devoted to individual gods, but the shrine in Mecca was the most important and Arabs from throughout the land made the annual pilgrimage to worship there. This annual mass gathering of the tribes not surprisingly functioned as a time of major trading and the fair that took place each year was a prime source of income for the Quraysh.

Despite the widespread belief in a range of gods, monotheism was not unknown at the time. The Jews and Judaised Arabs, who resided mainly in the agricultural settlement of Yathrib to the north of Mecca, were of course monotheists, as were the Christians, most of whom (both Arab and non-Arab) lived just beyond the distant, northern borders of Arabia in the lands ruled by the Byzantine emperors, and a small number of Arabs, known as *hanifs* (true believers), claimed to have returned to the pure religion of Abraham and to the worship of one god. Even the pagan Arabs, despite worshipping any number of deities, generally accepted the existence of one god as supreme over all others and who was known to them as al-Ilah (meaning simply, 'the god') or Allah (Allah being the name by which Muslims refer to God). Amongst the other gods worshipped, the so-called *banat* (daughters) of al-Ilah (al-Lat, al-Uzza and Manat) were particular favourites. Muhammad was, however, asking his fellow Arabs to forego them and all other lesser gods and to believe in one god and one god only, and for most Arabs this was a radical concept that was difficult to accept. Furthermore, like the Quraysh who benefited commercially from the annual pilgrimage to Mecca, many other tribes served as custodians of smaller shrines, situated in other communities and devoted

to other, lesser gods, and their livelihood too was eventually threatened by the new religion.

As time passed, and as more and more families were divided by conversions to Islam, hatred for Muhammad grew amongst the non-converts. Within the tribal and clan system, however, to harm a member of another clan meant incurring the wrath of all members of that clan. The Hashim, Muhammad's clan, was one of the weaker clans in Mecca, but Abu Talib, Muhammad's uncle and head of the clan, was a well-respected individual. He had raised Muhammad after his grandfather's death and, though he himself was never fully convinced of Muhammad's mission and therefore never became a Muslim, he loved and supported his nephew. As long as he was protected by Abu Talib and hence by his clan, no one would have dared harm Muhammad. Nevertheless, the situation for the Muslims continually worsened until finally Muhammad was driven to search for a new home for at least some of his followers. Thus, in 616, just over eighty Muslim converts and their families left Mecca and emigrated to the Monophysite Christian (i.e. those who believe that Christ has just one, divine, not two natures) kingdom of Abyssinia (Ethiopia). Included amongst the emigrants were Muhammad's and Khadija's daughter Ruqayya and her husband. They and about a third of the families returned to Mecca some three years later, but it was almost ten years more before the remainder of the Abyssinian emigrants were reunited with Muhammad and the rest of the Muslim community, by then firmly established in Medina.

By the time of the emigration to Abyssinia, the number of converts was increasing ever more rapidly and had come to include a number of highly influential Meccans, such as the Prophet's uncle, Hamza, and Umar, who was to become the second caliph, or head of the Muslim community, after the death of the Prophet. Fearful of Muhammad's growing power and despite the protection of his uncle

Abu Talib, the Quraysh devised a plan to inflict harm upon Muhammad and his converts, and some time after the emigrants left for Abyssinia the clans all signed a treaty against the Hashim and the Muttalib, the latter being the clan of Muhammad's great-grandfather's brother, prohibiting all trade with them in an attempt to starve the Muslims into submission (or presumably even extinction) and confining them all to an area known as Shi'b Abi Talib, a small valley or ravine on the outskirts of Mecca. As the clans were, however, all related to one another through marriage, it was difficult for people to stand by and watch their loved ones suffer, especially those who had not converted and were being punished simply because they were related to Muhammad. Food and other supplies were smuggled to them, yet the two (or three) long years that the boycott lasted were difficult in the extreme and a true test of the Muslims' commitment to their new faith and of the non-Muslim clansmen's support of Muhammad. When the ban finally ended, the jubilation that followed was short-lived, for Abu Talib died soon after, in 619, marking the end of Muhammad's protection in Mecca. Khadija, his beloved wife and close confidante, also died that same year, causing this especially sorrowful year to be known as *am al-huzn* (the year of grief). Although the new head of the Hashim was in theory obliged to extend his protection to all clan members, he was actually strongly opposed to Muhammad, and, so, placed in this new and precarious situation, Muhammad had no option but to look for a protector beyond Mecca. He first approached the leaders of Ta'if, a town to the southeast of Mecca and home of the shrine to al-Lat, one of the 'daughters of God', but no one there was willing to help. However, a new home for the Muslims was eventually found, and this was the city of Yathrib, to the north of Mecca.

In 620, Muhammad met with a group of six pilgrims from the agricultural settlement of Yathrib, an oasis that included numerous small communities living together in what by then was a state of almost constant, open hostility. Although the tribes and clans that made up the population consisted of both Jews and Arabs, there was in fact little difference between the two groups other than their religion (which seems not to have been a matter of contention). Impressed by Muhammad's words and eager to find someone who could ease the social unrest that was devastating their home, the pilgrims (who had in fact heard much about Muhammad before actually meeting him) quickly converted and returned to Yathrib to muster support for Muhammad and his followers. A meeting took place again the next year when twelve men returned to Mecca for the pilgrimage. At this meeting, known as First Aqaba (after the location, al-Aqaba, just outside Mecca where it took place), the men pledged their allegiance to Muhammad. After this meeting, one of Muhammad's followers went ahead to Yathrib to preach to the inhabitants of the oasis. By 622, a considerable number of conversions had taken place, and that year the group of pilgrims travelling from Yathrib to Mecca included just over seventy Muslims. Again they met with the Prophet at Aqaba and once more the pilgrims swore their allegiance to him, agreeing to offer help and protection to the Muslims of Mecca who would eventually migrate north. To accept the protection of, and to offer it to, people who were not of your tribe or clan and thus not bound to you by blood was a major break with the centuries-old tribal system. As noted previously, such a transferring of one's allegiance from the tribe and clan, and thus from the family, to those bound to you by religious persuasion meant the introduction a new social order. The Muslims from Yathrib who offered their help came to be known as the Helpers (or *ansar*, from the root n-s-r meaning 'to help', 'aid' or 'assist') and were mainly converts from two tribes, the Aws and Khazraj.

Hostility towards the Muslim community at Mecca had by then peaked and, though understand-

ably reluctant to leave their homes and non-Muslim relatives, during the months immediately following the second meeting at Aqaba, the majority of the Meccan Muslims emigrated north to Yathrib. Muhammad and one of his close companions, Abu Bakr, did not leave Mecca with the rest of the Emigrants (or *muhajirun*), but instead waited until they were sure everyone had safely departed. Angered by the departure of so many of their kinsmen and fearful of Muhammad's increasing influence (which now extended beyond the confines of the Quraysh), the leaders of the Quraysh hatched a plot to kill Muhammad before his departure for Yathrib. However, it is said that Gabriel warned the Prophet of the plot and, therefore, on the night of his departure from Mecca, the would-be assassins waiting outside his house were deceived: Ali covered himself in Muhammad's cloak and lay in his bed, while Muhammad, reciting God's words – 'We have covered them up, so that they cannot see' (36:9) – left his house unseen by the men outside, whom God had temporarily blinded. Muhammad and Abu Bakr thus managed to escape from the city unharmed. Suspecting that search parties would be sent after them – as they were – Muhammad and Abu Bakr initially headed south, not north, to confuse those tracking them. They spent three days hiding in a cave in Mount Thawr (fig. 4), and, according to tradition, one day they heard voices outside the cave, but the men passed by, believing that no one could possibly be inside because the entrance to the cave was obstructed by a large acacia tree and a giant spider web, both of which had miraculously appeared to deceive the men and thereby protect the Prophet. In late September, Muhammad and Abu Bakr finally reached Yathrib. This major event in the early history of Islam is known as the *hijra*, or migration, and it marks the beginning of the Muslim era. Thus the year AD 622 is the equivalent of AH (*anno hegirae*) 1 in the Islamic calendar, which is lunar. At this time, Yathrib took

on a somewhat new name: the oasis was known to the Jews as *medinta*, an Aramaic word that means simply 'the city', but it soon became known to its new Muslim community as *madinat al-nabi* (the city of the Prophet). Now, in their new home of Medina, as the city is today known to the wider world, the Muslim community was for the first time able to worship openly, without fear of harassment or harm.

The *hijra* is referred to several times in the Qur'an, as in verse 9:100, wherein it is noted that Paradise (described as 'gardens under which rivers flow') awaits the faithful Emigrants and Helpers:

> The vanguard of Islam –
> The first of those who forsook
> Their homes and of those
> Who gave them aid, and also
> Those who follow them
> In all good deeds –
> Well-pleased is Allah with them,
> As they are with Him;
> For them has He prepared
> Gardens under which rivers flow,
> To dwell therein forever:
> That is the supreme felicity.

Upon their arrival in Medina, the Helpers housed and cared for the Emigrants until they could build their own dwellings. When Muhammad arrived, his first task was to purchase land to build a mosque, which would serve as both a place of prayer and a meeting place for the *umma*, the community of Muslims. It also served as a dwelling for the Prophet and his family.

Muhammad eventually functioned as both the religious and political leader of Medina, but initially his political role was superseded by that of several of the established Medinan leaders. Moreover, despite the apparently large numbers who converted after the arrival of Muhammad, not all were fully committed to the new faith and its Prophet. In the view

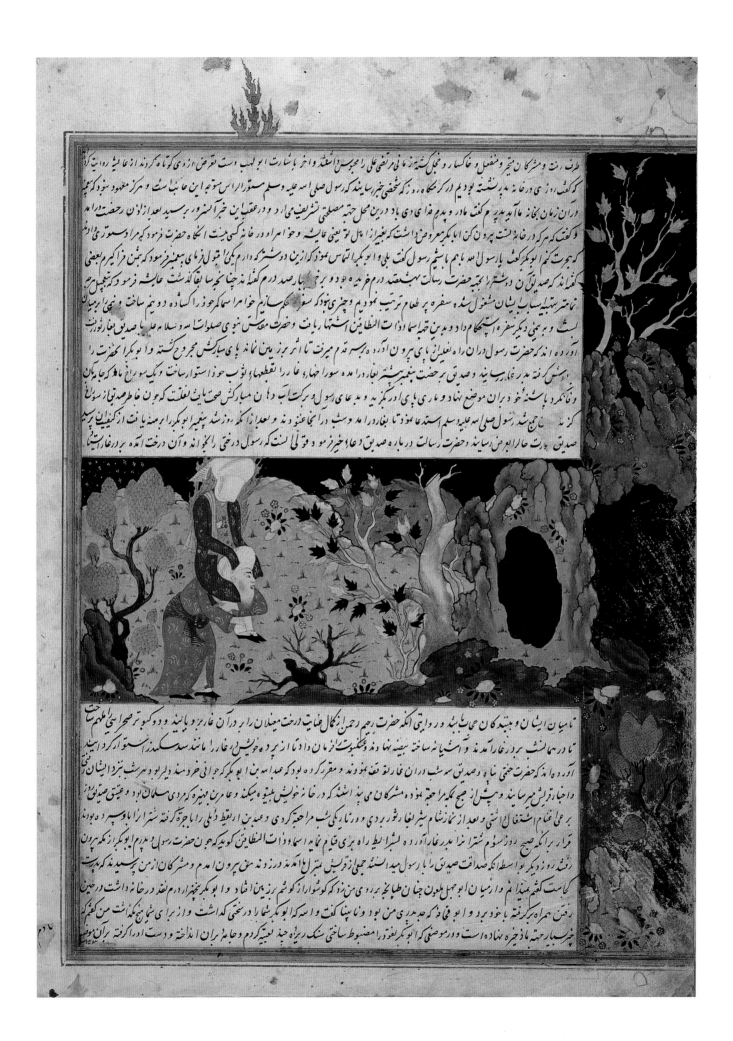

Fig. 4

Abu Bakr Carrying Muhammad on his Shoulders as They Approach the Cave in Mount Thawr, from a copy of *Rawdat al-safa* (The Garden of Purity)

Persian text in *nasta'liq* script

1595 (AH 1003), Shiraz, Iran
35.5 x 25.4cm, CBL Per 254.32

During the course of their *hijra* to Yathrib (Medina) in 622, Muhammad and Abu Bakr spent several days hiding in a cave in Mount Thawr. It is said that once they were safely inside the cave, God used a large acacia tree and a giant spider web to obstruct the entrance to it. Therefore, when the men of the Quraysh came in search of the Prophet, they passed by the cave, not bothering to enter it because it seemed that with its entrance so blocked, no one could possibly be inside.

of some Western scholars, even before the *hijra*, Muhammad appears to have made concessions to Judaism in an apparent attempt to encourage the Jews of Medina to convert. Two of these supposed concessions are Muhammad's instruction to Muslims to pray facing Jerusalem, as did both Jews and Christians, and his designation of the Jewish Day of Atonement (Yom Kippur), which took place on the tenth of the Jewish month of Tishri, as a Muslim day of fasting, known as *ashura* (tenth). However, Muslims regard the Qur'an not as a new revelation but instead as a continuation of the earlier revelations made to the Jews and Christians and thus it should not be surprising that certain features of these earlier religions were initially also features of the new Islamic faith. Whatever the case, by about a year and half after the *hijra*, it was clear that the Jews of Medina were not going to accept Islam, and it was then that a revelation (2:144) was received which commanded a change in the *qibla* (the direction of prayer), from Jerusalem to the Sacred Mosque (namely the site of the Ka'ba in Mecca):

> We see the turning
> Of your face (for guidance)
> To the heavens:
> Now shall We turn you
> To a qibla that shall please you.
> Turn then your face in the direction
> Of the Sacred Mosque;
> Wherever you are, turn
> Your faces in that direction.

Despite the importance of Jerusalem, this change in the direction of prayer was surely welcomed by the Muslims, for whom the Ka'ba, both before and after their conversion, featured so greatly in the practice of their faith. Moreover, it immediately became a defining feature of Islam, clearly distinguishing it from Judaism and Christianity. Shortly after the change in the *qibla* took place, a revelation was received commanding Muslims to fast for all of the month of Ramadan, and from that time the fast of Ashura was no longer an obligatory duty of Muslims, though many continue to observe it, as did the Prophet until his death. As noted in the Qur'an (2:185), it was in the month of Ramadan that the first revelation had been received:

> Ramadan is the month
> In which the Qur'an was sent down
> As a guide to mankind,
> And also clear Signs
> For guidance and judgement
> (Between right and wrong).
> So every one of you
> Who is present (at his home)
> During that month
> Should spend it in fasting.

In the year prior to this, Muhammad had initiated a series of raids on caravans. Raiding was a part of Arab life: for the nomadic Bedouin tribes it was seen as a means of assuring an even distribution of wealth and for the settled tribes it was a more or less accepted means of supplementing a group's income in times of need, and the Emigrants, not wanting to be a burden on the Helpers, soon found themselves in need. Medina was primarily an agricultural settlement, but the Emigrants' skills were all related to commerce. Medina, however, was conveniently situated on the main north–south merchant caravan route, thereby presenting a perfect means of support for the Emigrants, if only for the short term. However, the Emigrants' decision to turn to raiding was a major one, for they would be attacking their fellow Quraysh and even their fellow clansmen. Throughout the year 623, the Muslims carried out a series of raids, which, though mostly unsuccessful in terms of booty, resulted in the Muslims confirming treaties with many of the tribes along the Red Sea Coast – treaties that were to prove beneficial for future raids.

A small raid, though one of considerable significance, then took place in January 624, south of Mecca, in the valley of Nakhlah, where the Muslims successfully attacked a Quraysh caravan coming from the Yemen. One of the men guiding the caravan was killed and the caravan was seized and taken, along with the captured Meccans, back to Medina. The people of Medina were shocked when they learned what had happened, for the raid had occurred on the last day of Rajab, one of the four holy months when bloodshed was prohibited throughout Arabia. Muhammad himself had remained in Medina and so was not part of the raiding party and he appears to have given no explicit order to the men involved to attack the caravan. It is thought that as the holy months were part of the old pagan religion, the men involved in the raid felt no need to respect them. Whatever the case, the situation was ameliorated when Muhammad received a revelation (2:217) pointing out that, although fighting in the holy months or indeed at any time is a grave offence, it is certainly much less so than preventing one from practising the religion of Allah and prohibiting access to the Ka'ba. In other words, the raid was justified by the much worse deeds of the Quraysh.

A few months after the raid at Nakhlah, in March 624, one of the most decisive events in the early history of Islam took place at the Well of Badr near the Red Sea, site of a large annual fair. The Muslims set out with a contingent of Helpers to attack a large caravan on its homeward journey from Gaza to Mecca. It was the largest caravan of the year, one in which almost every Meccan family had an interest and so it was accompanied by representatives of every Meccan clan. Therefore, when they were warned of the approach of the Medinans, the caravan leaders immediately sent word to Mecca for help. An army of almost a thousand men, close to three times the number of Medinans, heeded the call and set off to face their kinsmen in battle, determined to finish Muhammad off, once and for all. Thus, even when they heard that the caravan had managed to avoid the Medinans and was out of danger, they did not turn back. Muhammad's men, however, were encamped at the Wells of Badr, preventing the Meccans access to this valuable water source, and this sealed their fate. Under Muhammad's command, the Medinans soundly defeated the much larger Meccan force (fig. 5). Moreover, the leader of the Meccans, Abu Jahl, who was at the time the most important figure in Meccan politics and Muhammad's most vehement rival, was killed in the battle. That the Quraysh were the most important tribe in all of Arabia yet Muhammad and his much smaller army had managed to defeat them – and kill Abu Jahl – was seen as a sign of salvation, a sign that God was indeed on their side. It boosted the morale and confidence of the Muslims, but it also transformed them in the eyes of their opponents from a ragtag group of outcasts to a force to be feared and even respected. The Battle of Badr took place in the month of Ramadan, and it was following this great success that Muhammad, having received the revelation that is now verse 2:185 of the Qur'an (quoted above), decreed Ramadan a month of fasting, thus commemorating both the battle and the receiving of the first revelation.

The usual Arab practice was to kill all prisoners of war, but instead the Meccans captured at the Battle of Badr were taken to Medina where they were treated kindly and with respect (fig. 6); in fact, many were so impressed by what they saw and heard in Medina that instead of being ransomed and returned home they chose to remain and convert to Islam. Nevertheless, besides Abu Jahl, some fifty other Meccans had been killed in the battle, and the Meccans were bound by the laws of tribal society to avenge the deaths of their kinsmen. Also important for the Meccans was their need to prove that they could still ensure safe passage of caravans, trade being the source of their livelihood. Therefore it was not

Fig. 5
Muhammad and His Followers (right) and the Quraysh in Battle Array (left), from *Siyar-i nabi* (The Life of the Prophet)
Turkish text in *naskh* script

1594–95 (AH 1003), Istanbul, Turkey
37.4 x 27cm, CBL T 419,
ff. 216b–217a

These two facing compositions depict the Muslims and the Meccans, in March 624, shortly before the Battle of Badr. On the right is Muhammad, his face veiled and a flaming halo engulfing most of his body, sitting under a canopy as he prays to God for victory. On the left is the Meccan camp, with the members of the Quraysh portrayed wearing sixteenth-century European armour, a device surely intended to denote more forcefully the status of the Meccans as the enemy. (In fig. 29, Muhammad's supporters wear typical sixteenth-century Ottoman armour; note especially the difference between the helmets worn by the figures in the two illustrations.) Several of the warriors hold a finger up to their lips, a common artistic convention in Islamic art for indicating surprise or puzzlement and used here to indicate the Meccans' shock and dismay at the distant sight of Muhammad and his supporters.

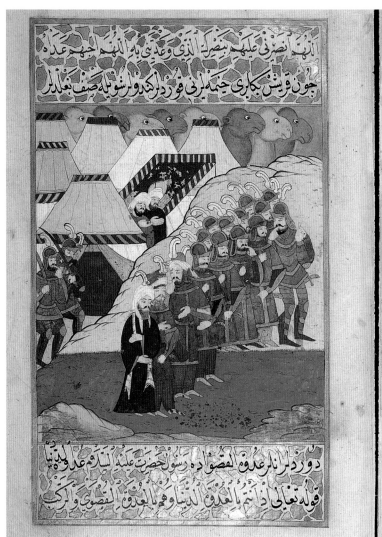

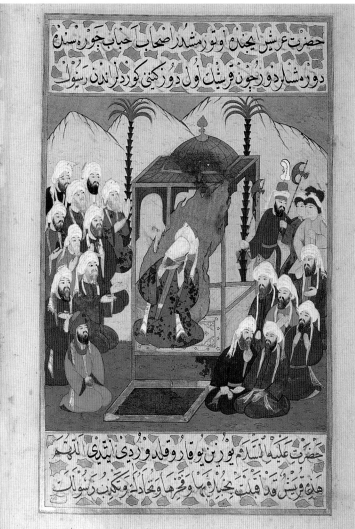

surprising when, in March 625, almost exactly a year after the Battle of Badr, word was received that a Meccan army of more than 3,000 under the leadership of Abu Sufyan, who had succeeded Abu Jahl as the most influential figure in Mecca, was advancing towards Medina. The two armies met on the plain before Mount Uhud, to the north-west of Medina. Again Muhammad was seriously outnumbered, having fewer than a thousand men, but if God had saved the Muslims the previous year, this time he seemed to have deserted them, for the battle went badly and most of the Muslims were eventually forced to take refuge in the rocky lava-flows that surround most of the city. Muhammad himself was injured, though not seriously, and his uncle Hamza was killed. Luckily, the Meccans decided not to pursue the battle further and simply returned to Mecca, leaving the Muslims to reflect upon their demoralising defeat.

It was two years before the Meccans and Muslims faced one another again in a major battle. During that time, Muhammad's first task was to

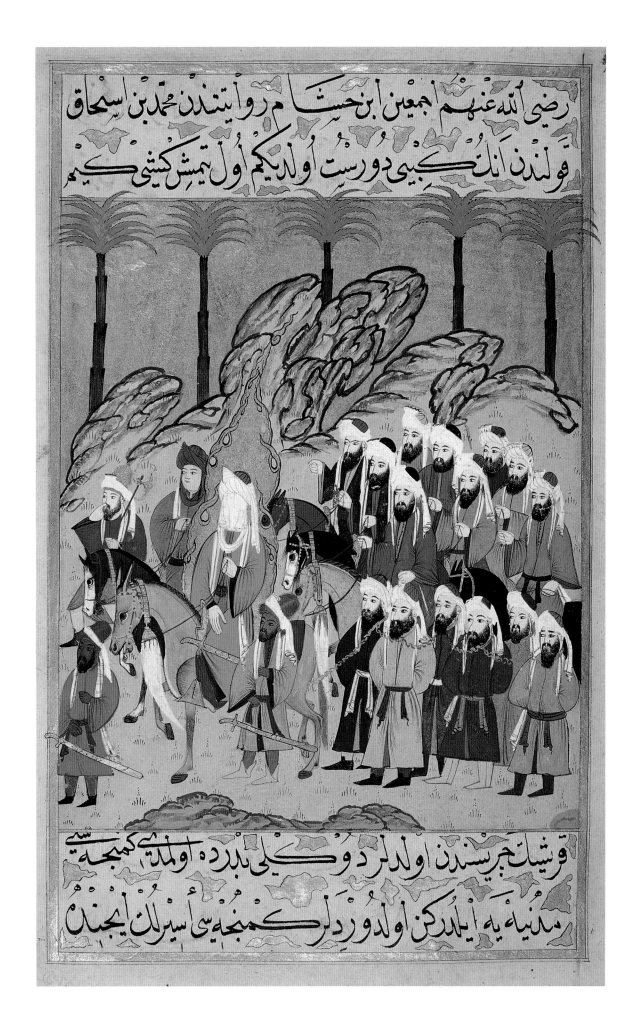

Fig. 6
The Quraysh (Meccan) Prisoners Being Led in Fetters to Medina, from *Siyar-i nabi* (The Life of the Prophet)
Turkish text in *naskh* script

1594–95 (AH 1003), Istanbul, Turkey
37.4 x 27cm, CBL T 419, f. 253a

Following the Battle of Badr, the Meccan prisoners were not killed but instead were taken to Medina where they were treated kindly by their Muslim hosts. Here Muhammad rides at the head of a group of prisoners.

secure his position in Medina. His failure to repeat at Uhud his success of the previous year had placed him in a somewhat precarious position, especially because the main Jewish clans, who had yet to recognise fully his political authority, had refused to participate at Uhud. Therefore, in an effort to counter the disaster of Uhud and to secure his position of authority over the oasis through a show of strength, Muhammad moved against the Bani Nadir, the most wealthy and prominent Jewish clan, whose leaders were said to be plotting against him. The end result was that the clan was forced to leave the city, moving to Khaybar, an oasis to the north of Medina where a large community of Jews resided. With one problem dealt with, Muhammad's next move was to increase his influence and authority amongst the nomadic tribes of the surrounding region – a move matched by the actions of Abu Sufyan and the Meccans. The conflict between Muslim and non-Muslim was by now not simply one of Meccans versus Medinans, but one that had expanded to involve most of the non-urban, nomadic population of western Arabia, and so the final, major battle of Muhammad's life was one with much wider implications for the region as a whole than any earlier Muslim–Meccan confrontation. This was the Battle of the Trench, which took place in March 627, when the Muslims avoided attack by a 10,000-strong Meccan-led army by digging a deep trench around the northern and most vulnerable area of Medina – one of the few areas of the city not bordered by rocky lava-flows or otherwise protected from potential intruders. In describing this tactic, the sources use the Persian term *khandaq*, meaning 'ditch' or 'trench', which suggests that this was a foreign and not typically Arab method of warfare, and, indeed, the building of the trench is recorded as having been suggested to the Prophet by Salman, a Persian-born Zoroastrian who converted to Christianity and moved to Syria; there he was told of the coming of a prophet in Arabia and so he moved to Medina

where he lived as the slave of a Jew, converted to Islam, and eventually, with the help of Muhammad, bought his freedom.

Salman's suggestion proved a success: the Meccans were unable to breach the trench and so were forced into a siege that they were not prepared for and could not maintain. At the instigation of the exiled Jewish Bani Nadir, some of whom had joined with the Meccan forces, the Meccans attempted to redress the situation by urging the Jewish tribe of Banu Qurayza, residing in the southern section of Medina, to join forces with them. But fearful of what would (and did) befall them if the Quraysh were defeated or deserted them and they were left to the mercy of Muhammad, they refused to attack the Muslims or physically assist the Quraysh, though they did abandon their pact with Muhammad and sided with the Quraysh. In the end, the Quraysh were forced to withdraw and return home to Mecca, and the Banu Qurayza eventually surrendered to the Muslims. Sa'd ibn Mu'adh, who converted to Islam shortly after the *hijra*, was a prominent member of the Aws, one of the (non-Jewish) tribes of Medina who were allies with the Banu Qurayza. When the time came to pass judgement on the Banu Qurayza, the Prophet agreed to allow a member of the Aws to determine their fate and Sa'd was chosen as judge, and it was he who decreed that as punishment for their unfaithfulness to the Prophet, all men of the Ban Qurayza should be put to death, while the women and children should be enslaved. The refusal of the Jews to convert or at least to recognise Muhammad as the undisputed leader of Medina had been a continuing source of annoyance, but now, with only a few exceptions, almost all the Jews of Medina had been either killed or exiled, finally securing the Prophet's position as both religious and political head of Medina. Moreover, Medina was now regarded by all as Mecca's equal in terms of power and influence within the region.

A year later, in the spring of 628, a group of some 1,500 Muslims set out from Medina, intent on making the pilgrimage to the Ka'ba. They encamped just outside Mecca on the edge of the sacred precinct, but while there their request to make the pilgrimage was refused by the Meccans, who probably felt that to agree immediately would make them appear weak. Instead, it was decided that they could return the next year, at which time the Meccans would vacate the city for three days to enable the Muslims to complete the pilgrimage in their absence. Moreover, a ten-year truce between the two communities was agreed.

Muhammad's influence had by then begun to spread farther afield. Following the Battle of the Trench, he had embarked upon a policy of expansion northwards to Syria, although it is probable that initially, at least, the intention was only to secure the trade route. Nevertheless, by allying themselves with Muhammad, the tribes along the route (many of which were Christian) were expected to accept him as the messenger of God, and thus it was no mere commercial alliance they were joining, even for those who did not actually convert to Islam. Muhammad's position in the region was further entrenched when, following the truce with Mecca, he decided to move against the rich oasis of Khaybar, the Jewish settlement to which the Bani Nadir had been exiled shortly after the Battle of Uhud. The hostility of the people of the oasis towards the Muslims and their behind-the-scenes involvement in the Battle of the Trench (they had encouraged the Quraysh to attack Medina and had then in turn encouraged their allies, the Bedouin Ghatafan, to ally themselves with the Quraysh against the Medinans) meant that they would eventually have to be dealt with and the truce with Mecca provided an opportunity to do so. The oasis consisted of a number of forts, each of which the Muslims managed to capture despite being greatly outnumbered. Especially rewarding for the Muslims, in every sense, was

the surrender of the fortress of Qamus, which belonged to one of the wealthiest and most powerful clans of the Bani Nadir, many of whose members were amongst those recently exiled from Medina (figs. 7–8). Upon hearing of the defeat of Khaybar, the small but wealthy oasis of Fadak, north of Khaybar and likewise a Jewish settlement, quickly surrendered and offered allegiance to the Prophet.

The pilgrimage took place as planned in the spring of 629 (though it was only the *umra*, or lesser pilgrimage, meaning it consisted of visiting the Ka'ba only and not the other holy sites surrounding Mecca), and then that autumn the Prophet's adopted son Zayd led a force of 3,000 men north towards the Syrian border. The expedition was dispatched in response to the killing by the Christian Ghassanids of a Muslim envoy to Bostra (Busra) in Syria, the main market centre for goods coming by caravan from Arabia. The conflict that ensued proved a resounding defeat for the Muslims because the Byzantine Emperor Heraclius had sent troops to assist the northern tribes who met the Muslims near the southern tip of the Dead Sea. Zayd and Ja'far, the latter the Prophet's cousin and brother of Ali (a future successor to the Prophet) and second in command of the expedition, were both killed. A second expedition was more successful, largely because this time the emperor sent no reinforcements and as a result only one small confrontation took place, enabling the Muslims to re-establish their influence along the Syrian border.

At about this time, the truce with Mecca was broken when allies of the Quraysh made a raid on a Bedouin tribe allied with the Muslims, many of whom had converted to Islam. As a result, in January 630, Muhammad departed from Medina at the head of a 10,000-strong army composed of both Medinans and local tribesmen. Entering Mecca from four directions, they encountered minor resistance on one front only. Undoubtedly to the disappointment of some, the order was given that the city was not to

Fig. 7
Ali Fighting to Take the Fortress of Qamus, from a copy of *Athar al-muzaffar* (The Exploits of the Victorious)
Persian text in *nasta'liq* script

1567 (AH 974), Iran
26.0 x 17.8cm, CBL Per 235, f. 132a

During the taking of the fortress of Qamus, Ali, the Prophet's cousin and son-in-law, especially distinguished himself. It is said that he single-handedly ripped off the door of the fortress, using it first as a shield to fend off attackers and then as a bridge to allow his fellow Muslims to cross the moat that surrounded the fortress. (Popular tradition relates that the door was so heavy that it later took seven men to replace it.) In this painting, illustrating a historical text, Ali is shown holding the door while standing in front of the moat (painted silver, but now tarnished black). Muhammad, behind him, oversees his attack and in the lower right is Ali's long-eared mule.

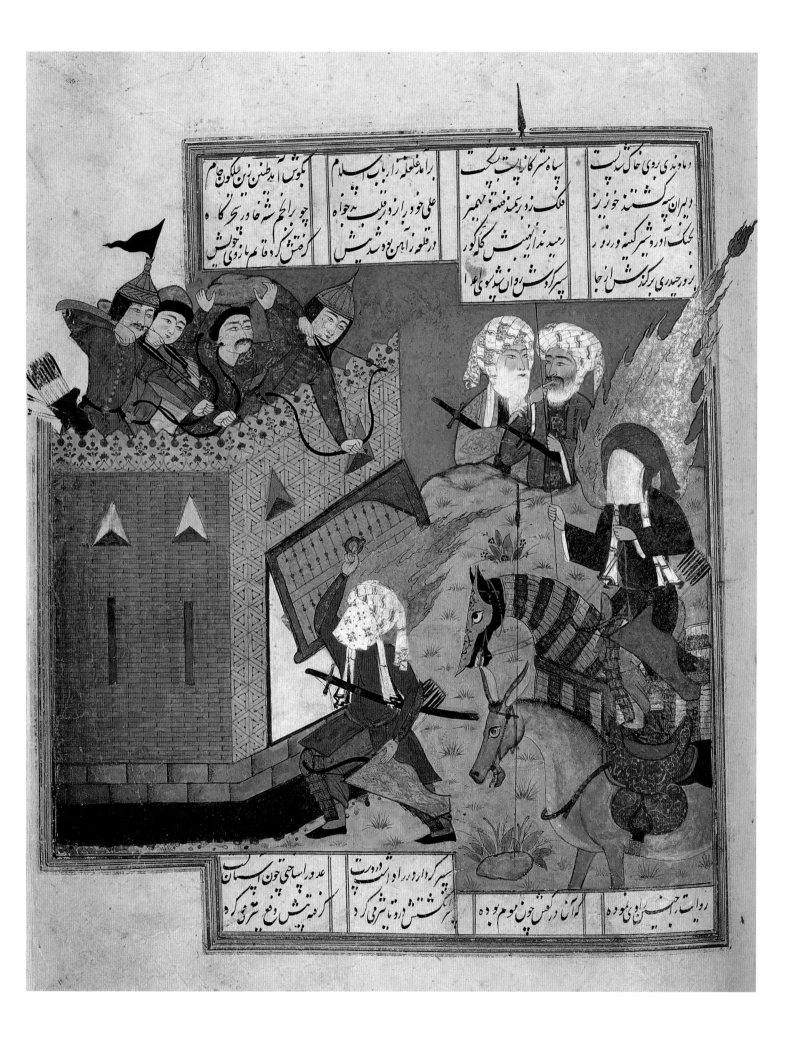

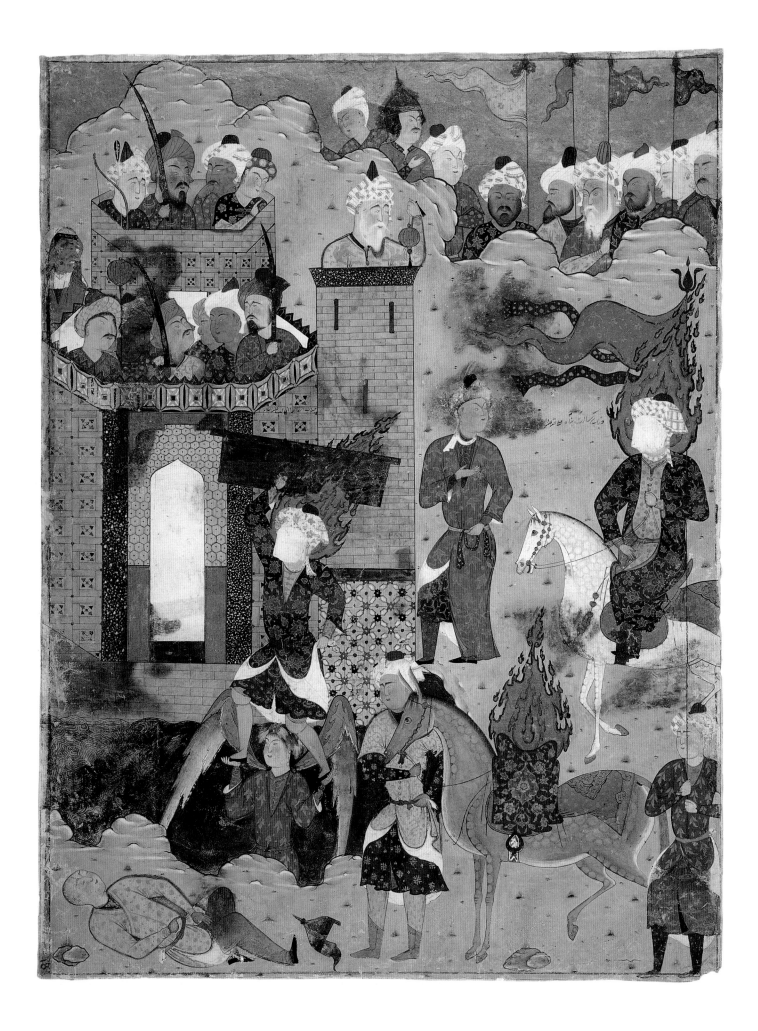

Fig. 8
Ali Fighting to Take the Fortress of Qamus, from a *Falnama* (Book of Divinations)

1550–60, Iran
59.7 x 45.4cm, CBL Per 395.2

The same event as in fig. 7 is pictured here, but this contemporary painting is from a Book of Divinations made for Tahmasp, ruler of Iran (*r.* 1524–76). In comparison with fig. 7, this painting is much larger, the composition much more intricate with more figures and more 'pockets' of activity depicted, and there is a more lavish use of gold. Note also that here Ali stands on the shoulders of an angel and a flaming halo emerges from the saddle of his mule.

be sacked and no one was to be killed, save a few specific individuals who had converted to and then forsaken Islam and apparently also some singers who had sung satirical songs about Muhammad. When he arrived at the Ka'ba, it is said that the Prophet rode around it on his camel seven times, touching the Black Stone with his staff each time he passed it. He then pointed his staff at the 360 idols that surrounded the Ka'ba, proclaiming (17:81):

Truth has now arrived
And Falsehood has perished;
For Falsehood is (by its nature)
Bound to perish.

The idols are said to have instantly crashed to the ground and broken, one after the other (fig. 9). The Ka'ba was then unlocked and, upon entering, the Prophet immediately ordered the destruction of the representations of the pagan gods and prophets within – only the images of Abraham, Mary and Jesus were preserved. By these actions, Muhammad laid claim to the holy shrine for the Islamic faith, returning it to its original function as a monotheistic shrine. The order was then given that the city's inhabitants destroy all idols within their homes, and once having done so many quickly presented themselves before the Prophet to pledge their allegiance to him and embrace Islam. Mecca had been successfully taken with little bloodshed, the majority of its inhabitants having realised the ineffectiveness of their many minor gods against Allah, the one true God; probably, they as well recognised the benefits of an alliance with Muhammad. The latter was proven only two weeks later in the valley of Hunayn where Muhammad defeated the Hawazin, a confederacy of some 20,000 Bedouins, traditional and previously undefeated enemies of the Meccans. Not only did this defeat bring Muhammad the respect of the Bedouin, but also that of the Meccan elite.

During the following two years – the last years

of Muhammad's life – Islamic influence in the region continued to expand. An important event in this respect occurred when the town of Ta'if surrendered to Muhammad and the town's ruling clans were integrated into the Muslim community. Ta'if had been home of the shrine to al-Lat and the town had, following Abu Talib's death in 619, refused to offer protection to the Prophet. Further efforts were made – with considerable success – in both securing the trade route and winning over other inhabitants of the Arabian Peninsula, and usually the latter at least was achieved through peaceful means. In other cases, local tribes sent delegations to Muhammad wishing to form alliances with him now that the Quraysh, formerly a dominant force in the region, had been absorbed into the Muslim community. Sometimes, Muhammad sought out tribal leaders through letters and his own delegations. Besides the fall of Mecca and Ta'if, the decline of Persian influence in the region (Yemen, for example, was a Persian satrapy) contributed to the willingness of some tribes to form alliances with the Muslims. Just how many of these new alliances involved actual conversion to Islam on the part of those concerned is unclear, though it does seem that near the end the Prophet's life the situation became somewhat less tolerant, with Christians obliged to pay a poll tax and paganism rigorously opposed. Nevertheless, by the time of his death in 632, Muhammad's influence had spread throughout much – but certainly not all – of the Arabian peninsula, even if those who recognised his political leadership, or who at least had formed alliances with him, did not actually acknowledge him as the messenger of God.

In 632, the Prophet announced that he would lead the annual pilgrimage to Mecca himself, and when he set out for what has come to be called his Farewell Pilgrimage he was accompanied by some 30,000 pilgrims, including all his wives. During the course of the pilgrimage, at Arafat, the Prophet

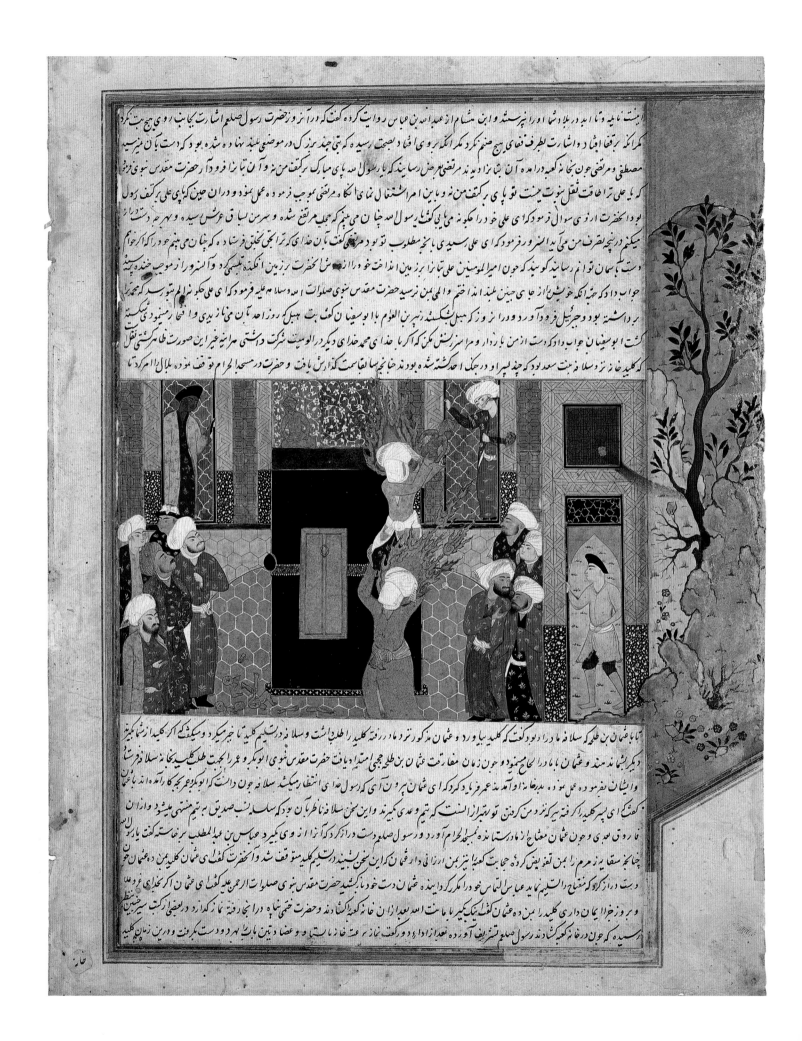

Fig. 9
**Muhammad and Ali Destroying
the Idols of the Ka'ba, from
a copy of *Rawdat al-safa*
(The Garden of Purity)**
Persian text in *nasta'liq* script

1595 (AH 1003), Shiraz, Iran
35.5 x 25.4cm, CBL Per 254.83

It is said that the Ka'ba in Mecca was surrounded by 360 pagan idols with yet more images inside the sacred shrine, but, in 630, when Muhammad at last gained control of Mecca and the Ka'ba the idols immediately crashed to the ground and broke. However, here (and in fig. 135) Ali is shown on the roof of the Ka'ba helping to destroy them. It is said that only the images of Jesus and Mary, housed within the Ka'ba, were saved.

preached a short sermon, and then, having just received a revelation, recited it for the assembled pilgrims. This, the final revelation, ends by stating (5:3):

> This day the disbelievers despair
> Of prevailing against your religion;
> So fear them not,
> But fear Me!
> This day I have perfected
> Your religion for you,
> And fulfilled My favour unto you,
> And it has been my good pleasure
> To choose Islam for you as your religion.

When his pilgrimage was completed, Muhammad returned to Medina where he had continued to reside despite his conquest of Mecca two years earlier. Once home, he became ill, eventually being able to lead the daily prayers only while seated, and, finally, when unable to lead the prayers at all, he assigned this task to Abu Bakr. The Prophet is said to have insisted that God and the believers would accept no one but his close companion to lead the prayers, and this is interpreted by Sunnis as a sign that he intended Abu Bakr to take his place after his death. Then, on the thirteenth day of the Islamic month of Rabi I, in year 11 AH (8 June 632), the Prophet died. His companions soon pledged their allegiance to Abu Bakr, who then took up the role as head of the *umma*, the community of Muslims.

THE EXPANSION OF THE ISLAMIC STATE UNDER THE RASHIDUN

In Arabic, the tri-literal root *kh-l-f* means 'to succeed', 'to follow', or 'to be the successor', and it is from this root that the word *khalifa* derives. Thus a *khalifa* – or caliph in English – is 'one who succeeds', but more specifically it refers to the individuals who succeeded the Prophet Muhammad as head of the Muslim community after his death. The first caliphs were drawn from amongst the so-called Compan-

ions of the Prophet, or *sahaba*, those outstanding individuals who were closest to the Prophet (though sometimes the term is used more broadly to refer to those who made up the original community of Muslims in Medina, or even all those who saw him during his lifetime). As the Prophet did not clearly designate anyone as his successor, the caliphs were initially chosen by the community. The first so chosen, Abu Bakr, was a close friend of Muhammad and the father of his wife Aisha. Abu Bakr (d. 634) was then succeeded in turn by Umar (d. 644), Uthman (d. 656) and Ali (d. 661). Each was not only a close companion of the Prophet, but also a member of his tribe, the Quraysh. Uthman was also the Prophet's son-in-law (he was married, successively, to two of the Prophet's daughters, Ruqayya and Umm Kulthum), and Ali was a close relative – not only was he the Prophet's cousin and son-in-law (the husband of his daughter Fatima) but he was also the Prophet's foster-son, having entered his household at the age of five in order to help to alleviate the constrained financial situation in which his father (in whose household the Prophet had been raised) found himself. The majority of Muslims are Sunni, namely those who follow the *sunna*, or customary practice, of the Prophet, and for them, Abu Bakr, Umar, Uthman and Ali are known as the Rightly Guided Ones, or *rashidun*, to distinguish them from the caliphs who followed. The years of their reign saw the establishment and then expansion of a truly Islamic empire (fig. 10).

Many of the Arabian tribes who had formed alliances with the Prophet regarded these as alliances with him personally and saw no obligation to transfer their allegiance to Abu Bakr. In many cases, the alliances had involved the tribe's conversion to Islam, and so with the Prophet's death many of the tribes abandoned their new faith. The numerous battles that took place during the two years following the Prophet's death to re-establish these alliances with the Arabian tribes are known as the Ridda Wars, *ridda*

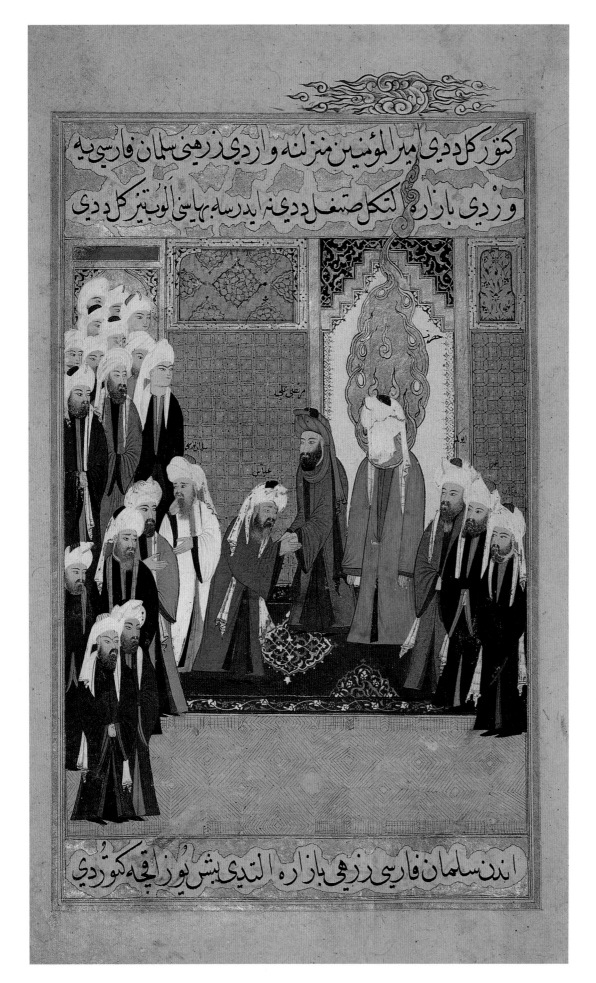

Fig. 10

Muhammad's Companions Congratulate Ali on His Prospective Marriage to Fatima, from *Siyar-i nabi* (The Life of the Prophet)

Turkish text in *naskh* script

1594–95 (AH 1003), Istanbul, Turkey
37.4 x 27cm, CBL T 419, f. 14a

The *rashidun*, the first four orthodox caliphs, are all pictured in this painting, in which a number of figures are gathered to congratulate Ali, the future fourth caliph, on his engagement to the Prophet's daughter Fatima. To the right of Muhammad (who is dressed in green with his head engulfed by a flaming halo) are the first three caliphs: Abu Bakr (closest to Muhammad), then Umar and Uthman. On his other side is Ali (also dressed in green), his hands grasped by those of Abbas, Muhammad's uncle (Muhammad later married the sister of Abbas's wife). Behind Abbas (dressed in white) is Salman the Persian, who suggested the tactic of digging a trench around a section of Medina to protect the city during what became known as the Battle of the Trench. The name of each of these figures is written above his head, although Muhammad is identified not by name but as *hadrat* (Pers. *hazrat*), a title used for great men, both religious and secular.

meaning 'apostasy from Islam'. It was the population of the Hijaz (the western section of the peninsula along the Red Sea coast) – specifically the urban peoples and their Bedouin allies who had remained faithful to the *umma* – who carried out this conquest of Arabia. During these years Abu Bakr also began the conquest of Syria, the aim of which, like the conquest of Arabia, was that all Arabs, no matter whether residing in Arabia itself or beyond its borders, must accept Islam as both their faith and their political authority. However, historians have also noted that the conquest of new lands was in fact essential because the booty that raiding and warfare provided was a fundamental and traditional factor in the economic survival of the Bedouin tribes. With Arabia itself now predominantly Muslim, new, non-Muslim sources of booty had to be found and this meant expansion, in the first instance, into Syria and Iraq. Abu Bakr died in 634 and it was during the ten-year reign as caliph of his successor, Umar, that the full conquest of these regions, and of Palestine and Egypt, took place. The precise chronology of events is unclear, but by 637 Damascus had fallen and the Byzantine forces, under the leadership of the Emperor Heraclius, had retreated from Syria, northwards to the safety of Anatolia (the Asian portion of present-day Turkey). The city of Jerusalem, revered by Muslims, fell the following year, in 638, and about this same time the Persian-held province of Iraq came under Muslim control. In the immediately following years, the Jazira (the 'island' between the upper reaches of the Tigris and Euphrates Rivers) also fell under Muslim control. Contemporary with these events was the Muslim invasion of Egypt and the final defeat of its Byzantine rulers, with full Muslim control of the then mainly Monophysite Christian country being achieved in the autumn of 642. Two years later, in 644, Umar was assassinated. Under his successor, Uthman, expansion of the Islamic state continued, with Muslim armies moving westwards from Egypt, further into North Africa, and eastwards as far as Khurasan, the north-west province of Iran; by the time of Uthman's assassination in 656, all of Iran was in Muslim hands.

From the time of the conquest of Mecca in 630, there had been conflict over the status within the community of the three groups of Muslims who now made up the community: the first Meccan converts to Islam; the Helpers (or *ansar*), who had provided refuge for the Prophet when his own fellow Meccans drove him from the city; and the members of the traditional Quraysh elite, those very individuals who had forced the Prophet to flee and who only converted to Islam once Mecca had fallen to the Muslims. It was the latter group who more often than not were granted positions of privilege and power in the years following the Prophet's death (and even before) and the resentment felt towards them by those who had first championed the cause of Islam, namely the early Meccan converts and especially the Helpers, is not surprising. Uthman was determined not only to place control of the Islamic state in the hands of the traditional Meccan elite, but more specifically in the hands of his own clan, the Umayya, and it was this that led to his assassination while sitting quietly in his home reading the Qur'an. Ali, the Prophet's cousin and son-in-law, was elected caliph after Umar's death and though he fought to reverse this policy (a prime feature of his caliphate was the striving for a truly Islamic community in which all believers would be equal), his own death, in 661, marked the establishment, in Damascus, of the Umayyad caliphal dynasty, in whose hands power would remain until the year 750.

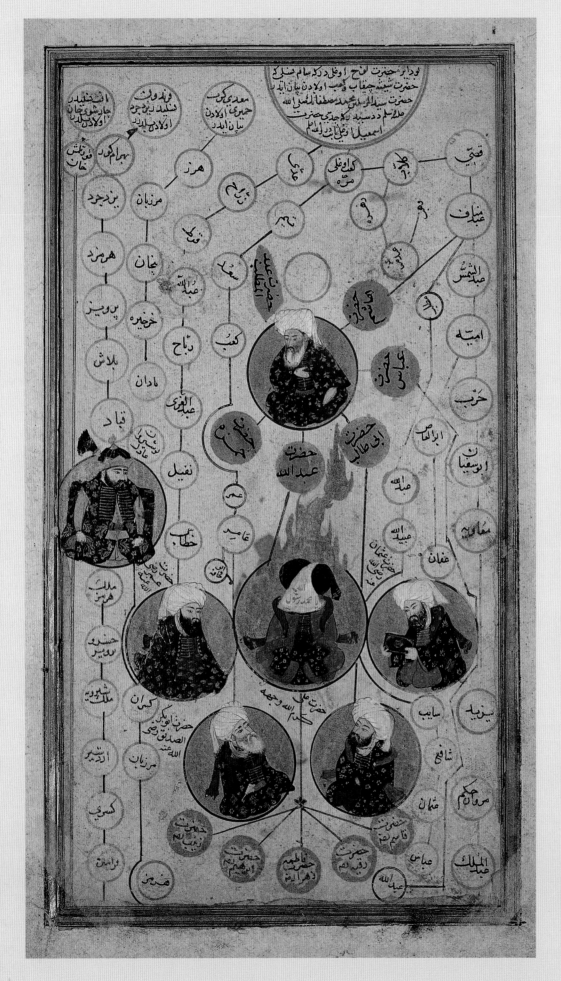

Silsila-nama

This is a folio from one of a small group of manuscripts produced in the late sixteenth and early seventeenth centuries, apparently in Baghdad, for Ottoman Turkish patrons. These manuscripts are generally classed as genealogies (though they in fact do not function strictly as such) and are known by the name *silsila-nama* (*silsila* meaning 'chain', in Arabic, and *nama* meaning 'book' or 'story', in Persian). They usually begin with an account of the Prophet Muhammad (in Arabic), followed by a history of the world (in Turkish) from Adam to the reigning Ottoman sultan, and are illustrated with numerous small, medallion-like portraits of prophets and kings. Illustrated on this folio is Muhammad, with his face veiled, surrounded by the *rashidun*, the first four caliphs; placed above him is his grandfather, Abd al-Muttalib. (The figure to the left is the pre-Islamic, Persian king Anushirvan, *r.* 531–79.) Both the text and illustrations of these manuscripts served as a means by which the Ottoman rulers could symbolically incorporate their own (non-Arab) dynastic lineage into the framework of Islamic world history, thereby 'justifying' what they regarded as their rightful place as Muslim kings.

Fig. 11
**Muhammad and the *Rashidun*,
from a *Silsila-nama* (Genealogy)**
Arabic and Turkish text

1598 (AH 1006), Baghdad, Iraq
26 x 16.4cm, CBL T 423.21b

Murad III's 'Life of the Prophet' and the Production of Images

In the late sixteenth century, the Ottoman sultan Murad III (r. 1574–95) commissioned an illustrated copy of the Life of the Prophet (*Siyar-i nabi*). This would prove to be a monumental work, composed of six volumes of approximately five hundred folios (1000 pages) each. Five of the original six volumes exist today: three remain in the Topkapi Palace Library, in Istanbul, where they were originally produced, one is in the New York Public Library, and one is in the Chester Beatty Library (fig. 12).

The text itself had been written some two hundred years earlier, the work of Mustafa ibn Yusuf ibn Umar al-Mawlawi al-Erzerumi, known as al-Darir, the Blind Man. Al-Darir lived and worked in Cairo and his text was produced at the behest of the then ruling Mamluk sultan, al-Mansur (r. 1376–82), who wished to have a biography, or *sira*, of the Prophet in Turkish, the language spoken by the Mamluk ruling class. His text, which he completed in 1388 after the sultan's death, was not original, or at least not completely so. Most authors of the time relied heavily on earlier works, often merely elaborating on the work of their predecessors. Thus al-Darir's *sira* is a translated and slightly expanded and altered version of the thirteenth-century Arabic text of Abu al-Hasan al-Bakri al-Basri, whose text is in turn a re-working of that of the ninth-century *sira* of Abd al-Malik ibn Hisham. But the origins of al-Darir's text can be traced yet further back, to Muhammad ibn Ishaq, who was born in Medina in about 704 and died in Baghdad in 768. Ibn Hisham added to Ibn Ishaq's text, but he may also have omitted parts of it and re-ordered other parts. What changes he actually made are not certain because Ibn Ishaq's original text has not survived.

Besides *sira*s, another type of text that preserves details of the Prophet's life are the accounts of his military campaigns *(maghazi)*. The information found in the *sira*s and *maghazi* books would origi-nally have been preserved orally, passed from generation to generation, and when it was first recorded in written form is uncertain. Information on the history of the Prophet can also be found in the Qur'an, though because the information there is almost never accompanied by specifics of time or place, it is often of limited use in this regard (though not surprisingly since the purpose of the Qur'an was of course religious not historical). *Hadith*s, or recorded sayings of the Prophet, are another source of information.

Perhaps the most original aspect of al-Darir's text, therefore, was that it was in Turkish rather than Arabic. However, there is something very startling about the specific copy of al-Darir's text that was produced for Murad III, namely that it is an illustrated copy – and, moreover, a heavily illustrated one, with an estimated total of over 800 paintings in the original six-volume manuscript. Most paintings cover about two-thirds of the page and the majority of them depict the Prophet himself, though always very respectfully with his face veiled, wearing a green robe and with his head engulfed by a flaming halo (fig. 13, and also from this manuscript, figs. 5–6, 10, 29–30, 32 and 35). It was the first time any recension of the text had ever been illustrated and still today the existence of an illustrated history of the Prophet comes as a great surprise to many people, both Muslim and non-Muslim alike.

The Qur'an is never illustrated, and in Islam imagery in any strictly religious context is exceedingly rare, but contrary to the belief of most non-Muslims, the Qur'an itself does not actually forbid images *per se*. Instead it warns against the worship of idols. In verses 21:63–66 of the Qur'an, the Prophet Abraham (Ibrahim) encounters a group of idol worshipers and, when their backs are turned, he smashes all but the largest of their idols. He then taunts the people, saying they should ask the remaining idol who broke the others, but when the people reply that of course the idol cannot speak, Abraham

Fig. 12
**An Illuminated Heading,
from *Siyar-i nabi*
(The Life of the Prophet)**
Turkish text in *naskh* script

1594–95 (AH 1003), Istanbul, Turkey
37.4 x 27cm, CBL T 419, f. 1b

Fine manuscripts such as this normally begin with a frontispiece or an illuminated heading giving the name of the text, in this case 'The Book of the Life of the Prophet, Volume Four'. The illumination is typical of manuscripts produced in the sixteenth century in Istanbul, capital of the Ottoman Turks from 1453 to 1922. This style, however, evolved from Persian illumination. In particular, note the scrolling arabesques and the gold cloud scrolls (the latter derived, ultimately, from Chinese art).

Fig. 13
Jibril (the Archangel Gabriel)
Before Muhammad,
from *Siyar-i nabi*
(The Life of the Prophet)
Turkish text in *naskh* script

1594–95 (AH 1003), Istanbul, Turkey
37.4 x 27cm, CBL T 419, f. 7b

In the gold dish, covered with a red
cloth, that is set before Muhammad are
dates brought from Paradise by the
Archangel Gabriel (who is incorrectly
identified in the text as Michael). The
richly robed Gabriel, with his gold
crown and multi-coloured wings, is a
typical depiction of an Islamic angel in
this period.

chastises them for worshipping such useless objects, objects that can bring them neither harm nor good. And in verse 22:30, the Qur'an states 'shun the abomination of idols and shun the word that is false'. To share one's worship of God with any being, such as idols, is *shirk*, meaning 'polytheism' or 'idolatry' (a word deriving from the Arabic verb 'to share'), and

in Islam *shirk* is considered a heinous sin. Thus images, and, in particular, three-dimensional forms, should not be produced if they are intended for worship. The proscription against images in fact comes across more definitively in a *hadith*, or saying of the Prophet, that damns those who produce images, because of the maker's apparent attempt to usurp the

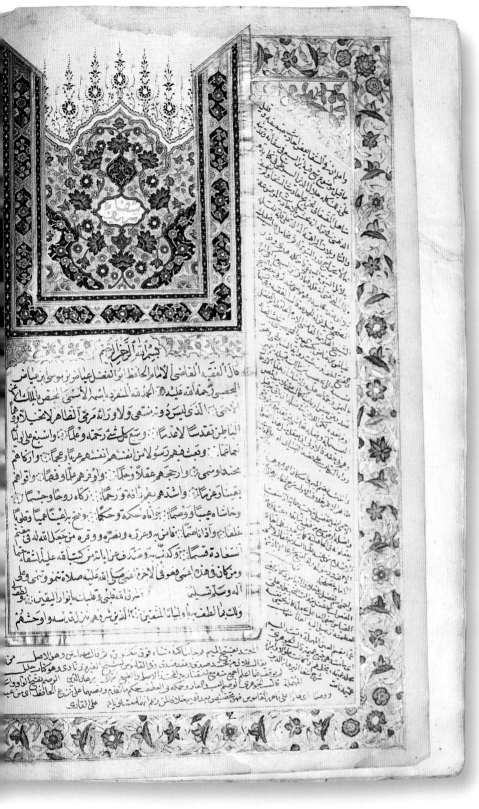

Fig. 14
*al-Shifa bi-ta'rif huquq al-
mustafa* (A Devotional Biography
of Muhammad)
Naskh script

1753 (AH 1166), Turkey
19.1 x 12.5cm, CBL Ar 4936, ff.
10–11a

Illustrated manuscripts depicting
Muhammad, such as the Life of the
Prophet and others reproduced here,
are a rarity, as most texts dealing with
him are not illustrated, though they may
be beautifully decorated with non-
figural designs, as is the first opening
and the binding of this devotional
biography of the Prophet.

that images of both sacred and secular figures were produced by and for Muslims throughout history, though the context in which the images appear is almost never religious and the images were not intended as objects of idolatry. (It is very much the maker's intent that determines the lawfulness of the images produced.) Texts such as the Life of the Prophet and the other illustrated texts reproduced here, such as accounts of the lives of other prophets, are not sacred or even religious texts *per se*, though they may deal with topics that touch upon aspects of religion, sometimes to a considerable degree. Moreover, many stem from popular religion and, as in almost any country and any religion, the strictures of orthodoxy are much less rigorously adhered to (if at all) within the realm of popular piety. Even today, in Iran, where the government is run on strictly Islamic principles, images are widely used in some aspects of popular religion; in particular, paintings and prints of Ali, the first Shi'a Imam, and of his two sons, Hasan and Husayn, are especially popular there during the month of Muharram, when the martyrdom of Husayn at Kerbala, in the year 680, is remembered. It is also important to note that many of the illustrated manuscripts that are reproduced here were made for sultans, princes, and other members of the ruling classes and would therefore not have been seen by the general populace. It should be further noted that generally the production of images has always been a more prominent feature of book production in regions such as Turkey, Iran and India, where strong, pre-Islamic traditions of figural imagery existed (fig. 14).

creative function of God. Indeed, the maker of images is challenged to breathe life into them, for by attempting to do so, he will see the futility of his work, because the images will of course remain lifeless, only God having the ability to create life.

As is evident throughout this book, despite the orthodox ban on figural imagery, it is a historical fact

An Islamic World History: Mirkhwand's *Rawdat al-safa*

The *Rawdat al-safa* ('Garden of Purity') is the work of the historian Mirkhwand (d. 1498), who lived and worked in Herat, which at the time was part of Iran and served as the capital for the Timurids, the descendants of Timur (or Tamerlane), then rulers of north-eastern Iran (figs. 4, 9 and 15–16). He was descended from a family of *sayyid*s (the term used to refer to descendants of the Prophet) in Bukhara, a family closely connected to the court, having served various Timurid rulers. Mirkhwand compiled his history at the instigation of Mir Ali Shir Nava'i, the renowned *wazir* (minister) of the ruling sultan, Husayn Bayqara. The *Rawdat al-safa* conforms to the usual style of Islamic 'world' histories of the time in that the text begins with the creation of the world and continues to the time of Muhammad and the establishment of Islamic rule; it then follows on with the succession of Islamic dynasties up to the time of the author and the family of his patron, in this case up to the conquests of Timur and his descendants, finally ending with the rule of Husayn Bayqara himself. Such a format enabled contemporary events to be incorporated into the overall scheme of Islamic history from the time of creation and the subsequent rise of Islam, the implication being that current events, in this case the rule of Husayn Bayqara and his family, were a part of a pre-determined, 'natural' progression from the time of Muhammad and even earlier. For rulers such as the Timurids, whose ancestors were not Muslims, this provided a convenient means of legitimising their rule – at least in their own eyes – and thus the text served the same basic function as did the later, Ottoman *silsila-nama*s (see fig. 11).

Fig. 15
Illumination Surrounding the Opening Text in a copy of *Rawdat al-safa* (The Garden of Purity)
Persian text in *nasta'liq* script

1617–18 (AH 1027), Iran
41.3 x 27.6cm, CBL Per 368, ff. 1b–2a

Fig. 16

Yazdagird III at the Mill in Merv, from a copy of *Rawdat al-safa* **(The Garden of Purity)**

Persian text in *nasta'liq* script

1595 (AH 1003), Shiraz, Iran
35.5 x 25.4cm, CBL Per 254.128

Under the *rashidun*, the first four orthodox caliphs, the boundaries of the Islamic state increased rapidly. In 642, the Arabs defeated the Sasanians at the Battle of Nihavand, in the Zagros Mountains of western Iran, and although this marked the *de facto* end of the Sasanian empire, the actual end did not occur for several more years, when, in 650, Arab armies sacked Ctesiphon, the Sasanians' great capital on the Tigris River in Iraq. This painting, one of thirteen in this copy of Mirkhwand's history, shows the last Sasanian ruler, Yazdagird III (*r.* 632–51), who fled to the city of Merv in north-eastern Iran, and, according to tradition, was killed there in 651 while hiding in a mill.

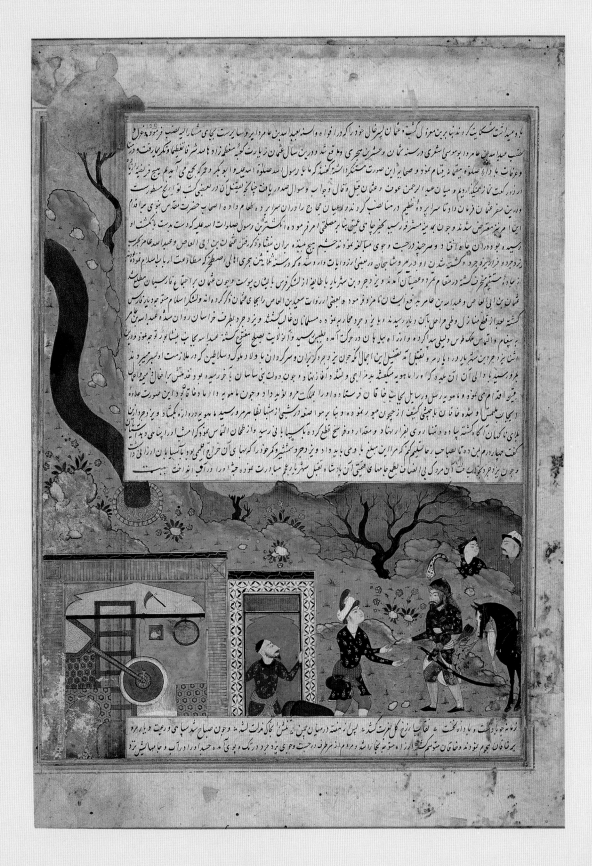

2 MUHAMMAD AND HIS FAMILY

The Names of the Prophet

MUHAMMAD ibn Abd Allah ibn Abd al-Muttalib al-Hashimi al-Qurayshi is the personal name, in its Arabic form, of the Prophet of Islam and explains that Muhammad is the son (*ibn*) of Abd Allah, who is in turn the son of Abd al-Muttalib (hence the grandfather of Muhammad), and also that he is a member of the Hashim clan which is part of the tribe known as Quraysh (fig. 17). He was also known as Abu al-Qasim the father (*abu*) of al-Qasim, his first child. The name Muhammad means 'the praised one' or 'the one worthy of praise' and it is today the most common boy's name in the world.

Like Allah, who has ninety-nine beautiful names (as discussed in chapter 5), Muhammad is known by a varying number of epithets. These include, *al-rasul*, the Messenger, the name by which Muslims most frequently refer to him (as opposed to the non-Muslim practice of referring to him as 'the Prophet'). But perhaps first and foremost amongst these names is *khatm al-nabiyyin*, the Seal of the Prophets, used in reference to the fact that just as Muslims consider Islam the final revelation to mankind, so Muhammad is considered the final prophet of God. This latter name derives from the Qur'an (33:40), but other of the *al-asma al-sharifa* (the noble names), as they are usually known, derive from different sources, mainly *hadiths* (sayings of the Prophet) as recorded by various compilers, but also pre-Islamic sources such as the Christian and Jewish traditions. The devout will recite or meditate upon the names, though lists of them are less commonly reproduced than are those of God, perhaps because of the traditional fear on the part of many that devotion to these names is in conflict with the devotion traditionally extended to the names of God. These names – both Qur'anic and non-Qur'anic and some of which are likewise included amongst the names of God – generally refer to Muhammad's role as the Messenger of God and include names such as *al-mustafa* (The Chosen

One), *al-bashir* (The Announcer) and *al-mubashshir* (The Bringer of Good News), *al-shahid* (The Witness), *al-siraj* (The Lamp) and *al-siraj munir* (The Shining Lamp), *al-nur* (The Light), *al-munir* (The Radiant), *al-amin* (The Trustworthy), *al-habib* (The Beloved) and *al-habiballah* (The Beloved of God), *al-mansur* (The Victorious), *ruh al-haqq* (The Spirit of Truth), *al-muqaddas* (The Holy One), and *al-khalil* (The Friend). Many of these names, but without the definite article (*al*), are also commonly used as names for boys and, in the feminine form, as names for girls, such as Shahida, Habiba and Mansura (fig. 18).

Poems in Praise of the Prophet

Over the centuries, innumerable poems in praise of the Prophet have been composed, two of the most well known and well loved of which are *Banat su'ad* and *Al-Kawakib al-durriyya fi madh khayr al-bariyya*, each of which is often referred to by the alternative title, *Qasidat al-burda* (a *qasida* being a specific verse form and *burda* the Arabic word for 'cloak' or 'mantle'). The earlier of these two panegyric poems is *Banat su'ad* (Su'ad Left), composed by Ka'b ibn Zuhayr, who lived in Mecca and came from a family of poets (his grandfather, father, an aunt, a brother and three nephews were all poets). It is said that Ka'b's brother, Bujayr, who had converted to Islam, begged him to come to Medina and join the Prophet, but Ka'b's only response was to express, in verse, his disapproval of his brother's adoption of the new faith and of the Prophet himself. The Prophet is said to have retaliated with a death sentence against Ka'b, which quickly convinced the poet to travel to Medina, embrace Islam and present himself before Muhammad, who graciously pardoned him. *Banat su'ad*, which praises the Prophet's generosity, was Ka'b's gift of thanks to the Prophet. The poem is sometimes referred to as *Qasidat al-burda* because in some versions of the story the Prophet indicates his protection of the

Fig. 17
Nasab Rasul Allah
(A Genealogy of the
Messenger of God)
Thulth script in gold and colours,
naskh script mainly in black

1594 (AH 1002), Turkey
38 x 26.3cm, CBL T 418, ff. 2b–3a

Presented on the first two pages of this manuscript is the full, genealogical form of the name of Muhammad, indicating his ancestors all the way back to Adam, with each name linked by *ibn* (son of). Written in gold ink and running from right to left across the centre of the pages is the first portion of his name: Muhammad ibn Abd Allah ibn Abd al-Muttalib ibn Hashim ibn Abd Manaf ibn Qusay ibn Kilab ibn Murra ibn Ka'b ibn Lu'ay ibn Ghalib. The remaining portion, naming his more distant ancestors, continues on in large black letters, following a path defined by two thin bands of gold, and reading down, around, up, around and back down,

ending with the name of Adam, which, like the names of Isma'il (Ishmael) and Ibrahim (Abraham), at the far left, is written in gold. The remaining space of these two pages is filled with further details of Muhammad's genealogy, including information on his various ancestors, written in black, red and burgundy ink. Other pages in the manuscript contain genealogical diagrams detailing the family of Muhammad, including his aunts, uncles, cousins, wives, children, grandchildren, and even information on his servants, the members of his army, and events of his life.

Fig. 18
The Names of the Prophet,
from a copy of *Dala'il al-khayrat*
(The Guide to Happiness)
Naskh script

1782 (AH 1196), Turkey
16 x 10.8cm, CBL T 459, ff. 9b–10a

The Guide to Happiness is primarily a collection of prayers for the Prophet. Compiled in the fifteenth century by Muhammad ibn Sulayman al-Jazuli, a native of Morocco, it was a particular favourite during the eighteenth and nineteenth centuries, in both Turkey and north-west Africa, though it remains popular to this day. Like many prayer books of its type, al-Jazuli's text includes a range of devotional material besides prayers, such as lists of *al-asma al-sharifa*, 'the noble names' accorded the Prophet, arranged in a decorative manner across several pages, as in this manuscript. The list begins with 'Muhammad', written in red ink beneath the illuminated heading on the right-hand page.

newly converted Ka'b by presenting him with his cloak (figs. 19–20).

Al-Kawakib al-durriyya fi madh khayr al-bariyya (The Shining Stars in Praise of the Best of Creation) is held in especially high esteem by Muslims (fig. 21). It is a much later poem, the work of a thirteenth-century Egyptian poet, al-Busiri. Tradition has it that al-Busiri suffered a stroke which left him paralysed down one side of his body, but that he was cured when, in a dream, the Prophet threw his cloak over the poet's shoulders. Both the poem as a whole and its individual verses are considered to have magical or amuletic power, being particular favourites to recite at funerals. Several verses of the poem are devoted to relating miracles attributed to the Prophet. These miracles are attributed to the Prophet by popular tradition, for the Qur'an itself credits no miracles to him (other than the receiving of the Qur'an, considered the greatest of all miracles), though it does refer to and accept the miracles performed by Moses, Jesus and other prophets. In fact, it is said that when pressed to perform miracles to prove his prophethood, Muhammad would point out that he was only God's messenger and could only do what God willed him to do, and, besides, the miracles performed by earlier prophets had done nothing to convince man of the Truth. According to the Qur'an, 'We refrain from sending signs (i.e. miracles) only because the men of former generations treated them as false' (17:59).

Hilya al-nabi

A *hilya* (meaning 'external form', 'quality' or 'bearing of a person' and also 'embellishment' or 'ornament') is a written description of the physical traits of the Prophet Muhammad. Different *hilya* texts exist, but the most common is that credited to the Prophet's son-in-law and cousin, Ali, and of the surviving examples of *hilya*s, most were produced in Turkey. Sometimes they appear in small

prayer books, with the text of the *hilya* spread over two facing pages (fig. 22), but most often the text is arranged on a single page, in a standard format, one developed in the seventeenth century by the Ottoman calligrapher Hafiz Osman (d. 1698). Although variations do occur, in most single-page examples (fig. 23), the description of the Prophet, written in small black script, is divided between the central, circular space – usually surrounded by a crescent – and a lower, rectangular space, which

Figs. 19–20
Banat su'ad (Su'ad Left)
Thulth script

Late 15th–early 16th century, prob.
Yemen
19.2 x 14.3cm, CBL Ar 4204

The pointed-oval *shamsa* (sun) on the first page of this precious little manuscript bears the name of the Sultan of Yemen, al-Malik al-Zafir Salah al-Din Amir ibn Abd al-Wahhab (*r.* 1489–1516; fig. 19). The manuscript consists of just seventeen folios, but, truly befitting a royal manuscript, on each one the text is written in blue ink with short vowels and certain other orthographic marks indicated in gold, and each line is surrounded by narrow bands of gold (fig. 20). At the end of the manuscript, the calligrapher has signed his name as Mahmud ibn Muhammad *al-shirazi*, indicating that he was originally from the city of Shiraz in south-western Iran. The illuminator who painted the *shamsa* and also the heading on the following page was probably also from Shiraz as both are illuminated in an exuberant and boisterous version of an illumination style closely associated with that city (see fig. 182).

Fig. 20
CBL Ar 4204, ff.1b–2a

Fig. 21
**Illuminated Frontispiece, from
*al-Kawakib al-durriyya fi madh
khair al-bariyya* (The Shining Stars
in Praise of the Best of Creation)**
Thulth script

15th century, Cairo, Egypt
43 x 29.8cm, CBL Ar 4168, ff. 1b–2a

In this poem in praise of the Prophet (cited in the title as 'the best of creation'), he is referred to as 'the master of the two universes [material and spiritual], of the two ponderable classes [mankind and demons], and of the two groups [of mankind] Arabs and non-Arabs'. One of the many verses extolling his virtues affirms that 'he surpassed all other prophets in manly form and moral qualities' and that 'no one has ever attained his rank in knowledge or in generosity'. The poet, al-Busiri, ends by begging God to pardon him and all those who read his poem. As indicated in the illuminated frontispiece, this particular, lavish copy of the poem was produced for the Mamluk sultan of Egypt, Qayt Bay (*r.* 1468–95).

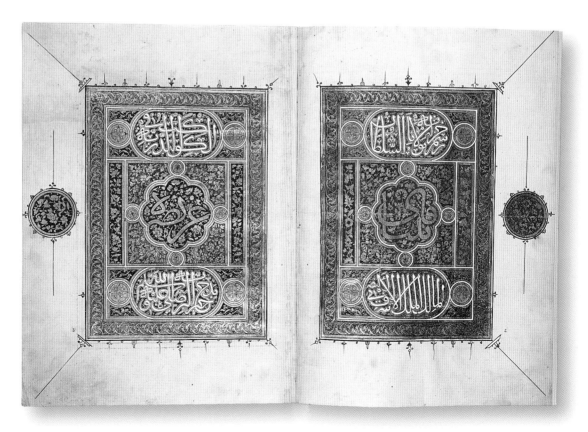

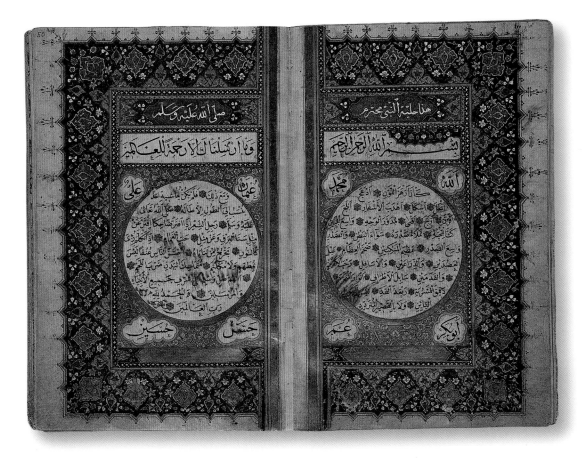

Fig. 22
***Hilya al-nabi* (A Description of the Prophet), from a Book of Prayers**
Naskh script

1749 (AH 1162), Turkey
16.5 x 11cm, CBL T 449, ff. 49b–50a

The Arabic word *hilya* means 'external form', 'quality' or 'bearing of a person' and also 'embellishment' or 'ornament' and is used to refer to a written description of the physical traits of the Prophet Muhammad. Most *hilyas* are single-page works (as is fig. 23), not double-page compositions as is the *hilya* in this small prayer book. Usually the circular space in the centre of the page is surrounded by the names of the first four orthodox caliphs, but here the names of God, Muhammad and the first two caliphs (Abu Bakr and Umar) appear on the right-hand page and on the left are the names of Uthman and Ali (the next two caliphs) and also those of Ali's son's, Hasan and Husayn.

usually also contains a prayer to the Prophet and the name of the calligrapher. Written in large black script and placed in the corners of the central space are the names of the four Orthodox caliphs, namely Abu Bakr, Umar, Uthman and Ali. Two bands of even larger script border the central space. The upper band consists of the *basmala*, the Islamic invocation that states, 'In the name of God, the Merciful, the Compassionate'. The lower band is a verse from the Qur'an, usually verse 21:107, which proclaims, 'We (God) sent you not, except as a mercy for all creatures', though verses 48:28–29 and 68:4 are also sometimes used. The description of the Prophet, as recorded in the *hilya* associated with Ali states:

> He was not too tall nor too short. He was medium-size. His hair was not short and curly, nor was it lank, but in between. His face was not narrow, nor was it fully round, but there was a roundness to it. His skin was white. His eyes were black. He had long eyelashes. He was big-boned and had wide shoulders. He had no body hair except in the middle of his chest. He had thick hands and feet. When he walked, he walked inclined, as if descending a slope. When he looked at someone, he looked at them full-

face. Between his shoulders was the seal of prophecy, the sign that he was the last of the prophets. He was the most generous-hearted of men, the most truthful of them in speech, the most mild-tempered of them, and the noblest of them in lineage. Whoever saw him unexpectedly was in awe of him. And whoever associated with him familiarly, loved him. Anyone who would describe him would say, I never saw, before him or after him, the like of him.

THE PROPHET'S NIGHT JOURNEY

One night, on the 27th of the Muslim month of Rajab, a few years after Muhammad had begun to receive the revelations of God, he was awoken by the Angel Gabriel. Verse 17:1 of the Qur'an speaks of the event that followed (fig. 24):

> Glory to God who took His servant
> For a journey by night
> From the sacred mosque
> To the farthest mosque,
> Whose precincts We did bless
> In order that We might show him
> Some of Our Signs;
> For He is the One who hears
> And sees (all things).

Fig. 23
***Hilya al-nabi* (A Description of the Prophet)**
Small *naskh* and large *thulth* scripts

1691 (AH 1103), Turkey
47 x 34cm, CBL T 559.4

The text of this *hilya* has been copied by the renowned Turkish calligrapher Hafiz Osman, who has signed his name and given the year in which he worked, in the last two lines of text. The wide band of green and gold floral decoration that surrounds the *hilya* was probably added about a century after Hafiz Osman wrote the text, an indication of the regard in which his work continued to be held long after his death.

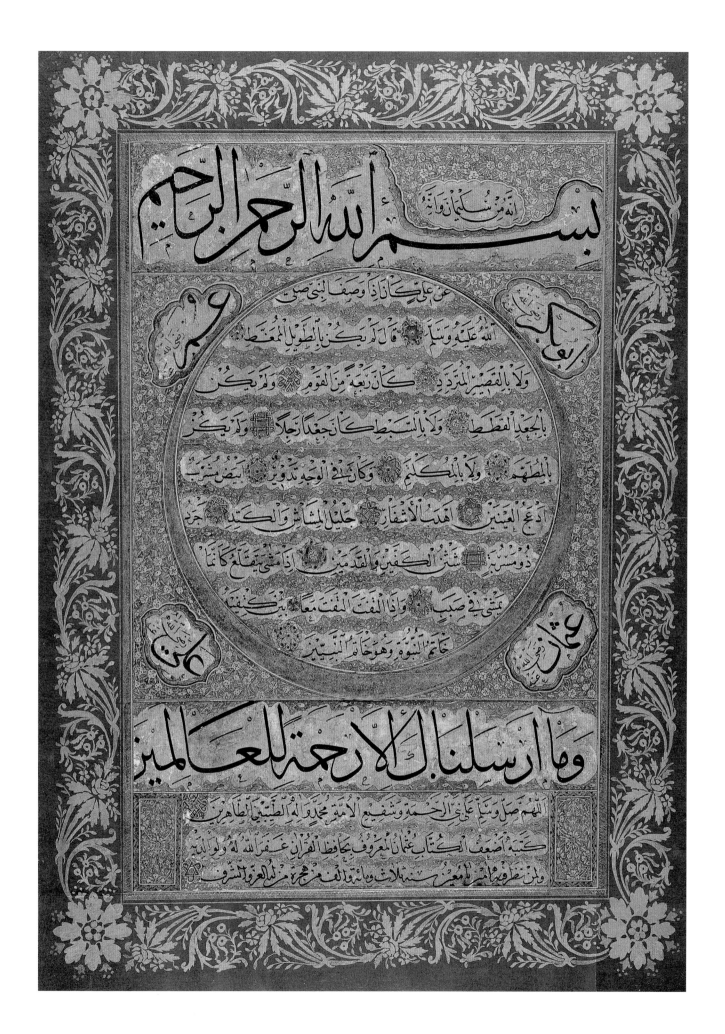

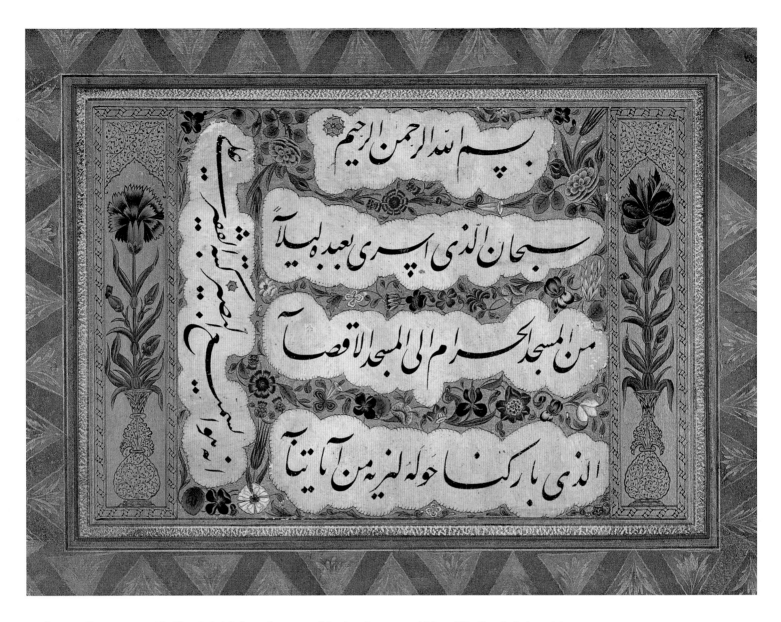

Muhammad's journey, guided by Gabriel, from the 'sacred mosque' (namely, the Ka'ba in Mecca) to the 'farthest mosque' (namely, Jerusalem) is known as the *isra* (Night Journey). Once they had reached Jerusalem, Muhammad ascended to heaven; this second part of the journey is known as the *mi'raj* (Ascension), though in fact the name is often applied to both segments of the journey. The rock around which the Dome of the Rock shrine in Jerusalem is built is said to bear Muhammad's footprint, being the spot from which Muhammad ascended.

With Gabriel still guiding him, Muhammad travelled through the seven celestial spheres. At the entrance to each of the heavens he was met by angels and a multitude of other celestial beings, and when he passed through each of the heavens, he met the various prophets who had preceded him, including Adam, David, Solomon, Moses, Noah, Abraham and Jesus. At last he reached the Throne

of God and prostrated himself before it. It is at this point that God is said to have commanded Muhammad to tell all believers that they must pray fifty times a day, but on his return journey, Muhammad encountered Moses who, based on his own experience, informed him that this was too much to expect of humans and so advised him to return and beg God to reduce the number of required prayers. Muhammad did so and God agreed, reducing the number by five, but Moses told Muhammad that this was still too many and once again advised him to return and request yet a further reduction. This continued, with God decreasing the number of prayers by five each time, until at last he agreed that all true believers should pray just five times a day, but noting that those who do indeed pray five times a day will be recompensed tenfold, in other words the equivalent of the original fifty prayers a day. After finally departing from the presence of

Fig. 24
Verse 17:1 of the Qur'an, from an album of mixed contents
Nasta'liq script

Calligraphy 16th century, Iran
Illumination 18th century, Turkey
29.2 x 21.8cm, CBL T 447, f. 7b

This folio is from an album which includes pictures of the Ka'ba in Mecca, the Prophet's Mosque in Medina and the Aqsa Mosque on the Temple Mount in Jerusalem. Written on this particular folio is the whole of verse 17:1 of the Qur'an, which refers to the *isra*, or Night Journey, of Muhammad. Although the album was compiled and illuminated in the eighteenth century, the calligraphy on this page is signed by Ali, and thus may be the work of the renowned, sixteenth-century Persian calligrapher, Mir Ali.

Fig. 25
The Ascension (*Mi'raj*) of the Prophet, from a *Khamsa* (Five Poems) of Nizami

Persian text in *nasta'liq* script

1463 (AH 868), prob. Baghdad, Iraq
32.4 x 21.7cm, CBL Per 137.3a

During the course of his *isra* (Night Journey) and subsequent *mi'raj* (Ascension), Muhammad is said to have travelled on a mythical beast known as Buraq, usually depicted as a winged horse or ass with a human head and here also shown wearing a crown of gold, as do many of the angels who escort the Prophet on his journey. Although the veil covering the Prophet's face has been slightly damaged, this is an especially fine example of this popular scene.

God, Gabriel guided Muhammad through Paradise, so he might see what awaited the true believer, and then to Hell, to see the horrors in store for the damned. (While many consider the *mi'raj* to have been an actual event, others consider it to have been a purely mystical experience.)

Although not mentioned in the Qur'an itself, according to popular tradition, Muhammad travelled through the night and into the Heavens mounted on a fabulous beast called Buraq, usually depicted as a winged horse or ass with a human head. Many illustrations exist in which Muhammad is portrayed against a dark blue night sky, mounted on Buraq and guided by angels. These images of course never illustrate the Qur'an, but instead they are most often to be found in copies of the *Khamsa* of the Persian poet Nizami. *Khamsa* is the Arabic word for 'five' and Nizami's *Khamsa* is a compilation of five poems, composed in the late twelfth and early thirteenth centuries. Each poem includes a version of the *isra* and *mi'raj* story, though it is usually only that included in the first poem, the *Makhzan al-asrar* (Treasury of Mysteries), which is illustrated (figs. 25–26).

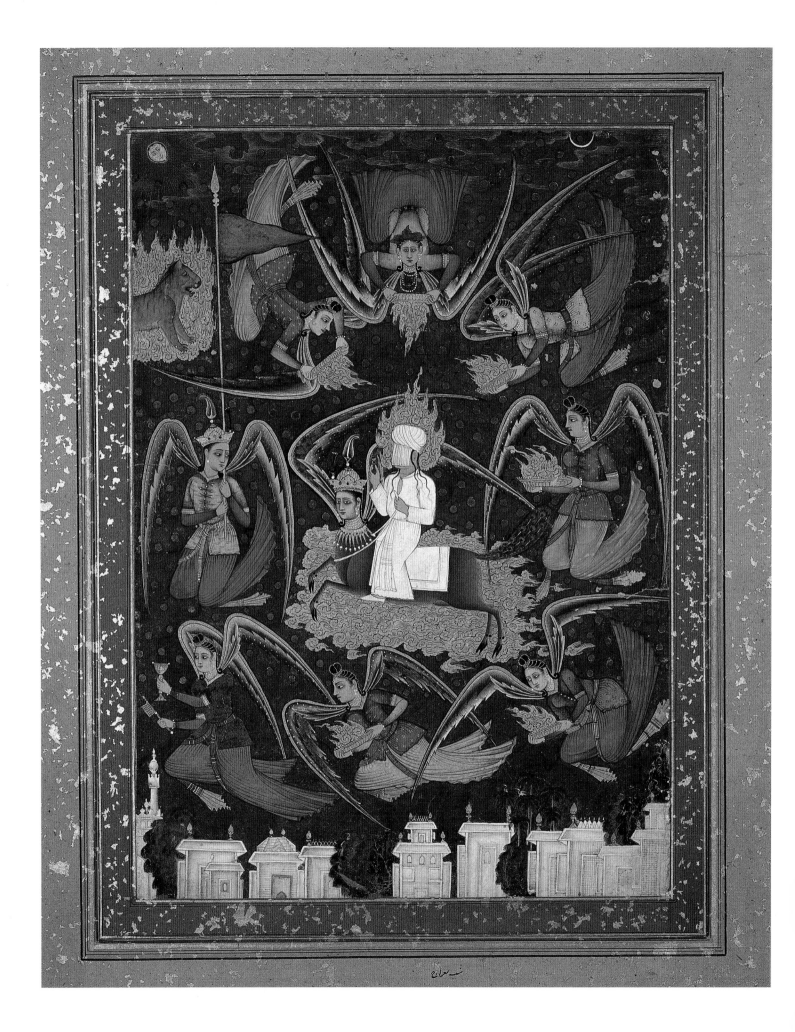

Fig. 26
**The Ascension (*Mi'raj*)
of the Prophet**

*c.*1680, Golconda, India
48.7 x 32.6cm, CBL In 69.1

This single-page depiction of the *mi'raj*
was originally part of an album of
assorted paintings. Although both this
and the painting from Baghdad (fig. 25)
are highly appealing, the Indian artist
has taken a bolder, more innovative
approach to his subject, in particular in
his depiction of the angels flying above
Muhammad.

MUHAMMAD'S WIVES AND CHILDREN

When Muhammad married his first wife, Khadija, a
wealthy merchant who was his employer, he was
about twenty-five years of age and she about forty.
Although the marriage is always presented as a love-
match, there is at the same time a belief that it was
through divine intervention that the two met. Verse
93:8 of the Qur'an, which states, 'And He found you
in need and so He enriched you,' is usually taken to
refer to their union, for it was Khadija's wealth that
enabled Muhammad to devote himself fully to his
role as the messenger of God. However, of equal
benefit to him was her devotion to and unwavering
belief in his mission. Khadija had already been mar-
ried twice and had three children when she met
Muhammad, and she then had another six with him,
the only one of his wives to bear children by him
(though in about 629, a slave named Mariya bore
him a son, Ibrahim, who died in infancy). Their first
child, al-Qasim, died before his second birthday,
while a second son, Abd Allah, also died in infancy.
Of their four daughters – Zaynab, Ruqayya, Umm
Kulthum and Fatima – each of whom converted to
Islam and migrated to Medina, all, except Fatima,
predeceased him, and she died shortly after her
father. (Ruqayya married Uthman, and, after her
death, her sister Umm Kulthum was married to
him; Fatima married Ali, who was raised in Muham-
mad's home as his foster-son; Uthman and Ali each
served as caliph after Muhammad's death.) Muham-
mad also had an adopted son, Zayd ibn Haritha, who
had been Khadija's slave and whom she presented as
a gift to Muhammad on their wedding day. Muham-
mad became so attached to the then fifteen-year-old
youth that he later adopted him. Also on the day of
their wedding, Muhammad freed Baraka, a slave he
had inherited from his father and who later came to
be known as Umm Ayman (mother of Ayman). She
was greatly loved and respected by Muhammad who
once said, following the death of her husband, 'he
that would marry a woman of the people of Par-
adise, let him marry Umm Ayman'. It was Zayd who
then asked to be married to her, even though she
was much older than he, and together they then had
a son, Usama, who was also greatly loved by
Muhammad.

Khadija died in 619, and thus before the *hijra*,
when she was in her sixties, and it was only after her
death that Muhammad took further wives. The
Qur'an (4:3) stipulates that a man may marry up to
four wives, but only on the condition that he is able
to provide and care for them equally. However, this
limitation on the number of wives did not apply to
the Prophet himself, for he was free to marry 'any
believing woman' (33:50). In fact, the names of ten
wives are known (Khadija, Sawda, A'isha, Umm
Salama, Hafsa, Zaynab, Juwayriya, Umm Habiba,
Safiyya and Maymuna), though some sources sug-
gest that he may have had as many as twelve wives.
His later marriages (those after the death of Khadija)
were probably all made for political reasons.

Two wives – A'isha and Hafsa – were the
daughters of close companions, Abu Bakr and
Umar, respectively, each of whom would later serve
as caliph. Several of his wives were also widows of
close friends or relatives. Zaynab bint Khuzayma,
for example, was the widow of Ubayda, a cousin of
Muhammad who died at the Battle of Badr
(Ubayda's grandfather and Muhammad's great-
grandfather were brothers). But Zaynab was also of
the Bedouin tribe Amir, based in Najd, the region
to the north-east of Mecca and Medina. As the
Amir were a potential threat to the Medinans (and
to the Meccans as well), the marriage was likely to
have been made with an aim to forming an alliance
with the tribe. In 620, the year following the death
of Khadija, Muhammad married the widow
Sawda, whose husband Sakran had been the
brother of the chief of the Amir, one of the clans
of the Quraysh (and not to be confused with the
Amir tribe of Najd). Sawda and Sakran had been
amongst those who emigrated to Abyssinia, and

shortly after their return Sakran died. Faithful Muslims who were the widows of equally faithful Muslims would prove to be typical of the women Muhammad chose to be his wives. Shortly after his marriage to Sawda, the sixteen-year-old A'isha was betrothed to the Prophet, though she did not move into his home until three years later. She was to become the Prophet's favourite wife, a point made abundantly clear in the sources where it is, for example, recorded that during the last days of his life his other wives, perceiving his eagerness to be with A'isha, agreed that he should stay with her even though it was not, according to their usual rotation, his usual days to do so.

In 625, Muhammad married the widow Umm Salama, a first cousin to Abu Jahl, perhaps Muhammad's most fervid opponent. She and her husband, Abu Salama, another cousin of the Prophet, had also been amongst the Abyssinian emigrants. When Abu Salama died of a wound suffered at the Battle of Uhud, Muhammad asked Umm Salama to marry him and she accepted. That same year Muhammad also married both Hafsa and Zaynab. Two years later, in 627, the Muslims marched against the Bani al-Mustaliq, a Red Sea coastal clan who were allies with the Meccans and who were planning a raid on Medina. The Muslims, however, were forewarned of the planned attack and thus managed to catch the Bani al-Mustaliq off-guard, defeat them, and take some two hundred families and several thousand head of livestock captive. Amongst the captives was a beautiful young woman named Juwayriya, the daughter of the chief of the clan, whom the Prophet offered to marry in lieu of her being ransomed back to her family. As a result of their now close ties with the Bani al-Mustaliq, the Medinans set free all others who had been taken captive.

Umm Habiba of the Umayya clan was the widow of the brother-in-law and cousin of the Prophet, Ubayd Allah ibn Jahsh, but she was also the daughter of Abu Sufyan, one of the Meccan leaders and an arch rival of Islam. She and her husband had also emigrated to Abyssinia, but once there her husband reverted to his original Christian faith though she remained a Muslim. Several months after the death of her husband in 628, Umm Habiba was married by proxy to Muhammad, eventually joining him in Medina. That same year Muhammad married Safiyya, a Jewish woman of the Bani Nadir from the oasis of Khaybar. She had been married to Kinana, whose family, one of the wealthiest clans of the Bani Nadir, possessed the fort of Qamus. Following a two-week-long siege of the fort, Muhammad agreed neither to kill nor take captive any of the fort's inhabitants if they surrendered and left taking none of their possessions with them. Kinana agreed, but then deceived the Prophet, smuggling out most of the clan's renowned wealth. When this was discovered, he was killed and his fellow clansmen were taken as slaves. It is said that the then-widowed Safiyya had in fact long been intrigued by stories she had heard of the coming of a prophet and that, shortly before the siege of the fort, she had a dream in which a shining moon moved from its position above the city of Medina towards Khaybar and then fell into her lap; her furious husband interpreted the dream as symbolic of her lusting after the Prophet of Medina. As a result, when the beautiful young widow was offered the choice of returning to her people or accepting Islam and marrying Muhammad, she readily accepted the latter.

Umm Fadl was the first woman after Khadija to become a Muslim; though both Muslims, she and her husband Abbas (who is depicted in fig. 10) had chosen not to follow the other Muslims to Medina and so were still resident in Mecca at the time of the Muslims' first pilgrimage there in 629, and it was at that time that Abbas offered his wife's sister, Maymuna, in marriage to the Prophet. Maymuna and Umm Fadl were half-sisters to Salma, the widow of Muhammad's heroic and much loved uncle Hamza,

Figs. 27–28
Qur'an
Naskh script

*c.*1430, prob. Herat, Afghanistan
25.8 x 19cm, CBL Is 1500

The heading in the middle of the right-hand page of fig. 27 indicates the start of Chapter 33, *al-Ahzab* (The Confederates), a chapter in which there are several references to the wives of the Prophet. The heading is simply treated: the gold script set in 'clouds' against a ground lightly cross-hatched in gold, interspersed with blue-tipped leaves and scattered with groups of three tiny blue dots. The precise style and the very fine rendering of the arabesques of the beautiful double-page frontispiece at the beginning of the manuscript (fig. 28) suggests that it was produced for Baysunghur, one of the grandsons of the Turco-Mongol warlord Timur, or Tamerlane, as he is known in the West. Baysunghur, who served as 'second-in-command' to his father, Shah Rukh, at the Timurid capital, Herat (then considered part of Iran), was a major patron of the arts of the book. (The colophon at the end of the manuscript falsely claims it to have been copied by the great medieval calligrapher Yaqut al-Musta'simi.)

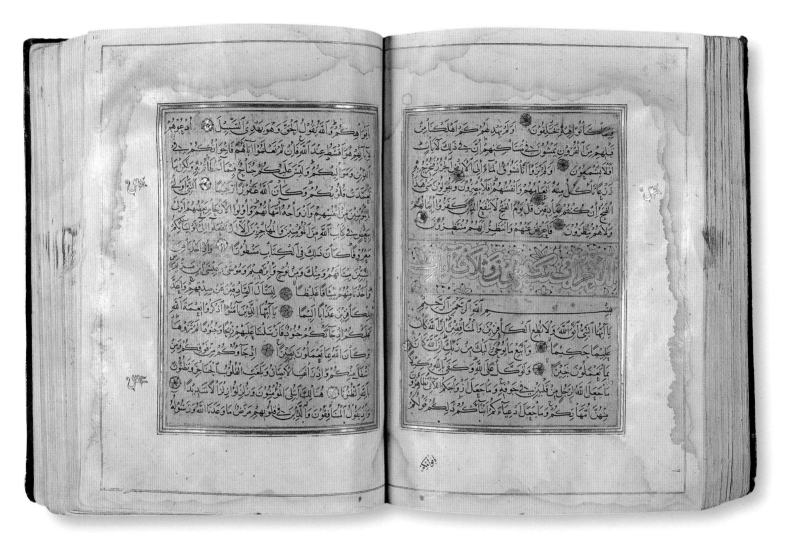

Fig. 27
CBL Is 1500, ff. 185b–186a

which undoubtedly made this, his last marriage, especially agreeable to the Prophet.

None of the Prophet's wives are referred to by name in the Qur'an, though several verses refer to them collectively. In Chapter 33, for example, the admonition to women to cover themselves for their own protection whenever outside the home is made with specific reference to the wives of the Prophet (33:59):

O Prophet! Tell your wives and daughters
And the believing women,
That they should cast their outer garments

Over their persons (when abroad)
That is most convenient,
That they should be known
(As such) and not molested.
And Allah is oft-forgiving,
Most merciful.

Other verses in this same chapter refer to their special position within the Muslim community, in particular by referring to them as the mothers of all believers (33:6) and by the proscription against their re-marrying after the Prophet's death (33:53) (figs. 27–28).

Fig. 28
CBL Is 1500,
ff. 1b–2a

Fig. 29
Muhammad Presents a Red Silk Banner to Hamza, from *Siyar-i nabi* (The Life of the Prophet)
Turkish text in *naskh* script

1594–95 (AH 1003), Istanbul, Turkey
37.4 x 27cm, CBL T 419, f. 342a

At the time of the Battle of Uhud, in March 625, Muhammad presented his uncle Hamza with a red silk banner and placed under his command a detachment of Emigrants (*muhajirun*), Muslims who had migrated from Mecca to Medina with the Prophet three years earlier.

Muhammad's Uncle: Hamza ibn Abd al-Muttalib

Hamza, one of the heroes of the Battle of Badr, was a close friend and relative of the Prophet (fig. 29). They were of the same age, had the same wet-nurse, and Hamza was both Muhammad's paternal uncle and his cousin through his mother. Renowned for his great stature and physical strength, he is recorded as being, depending on the circumstances at hand, both friendly and easy-going and formidable and inflexible. When Muhammad wished to marry Khadija, it was Hamza who went with him to her father to request permission for him to do so. And when Muhammad's bitter opponent Abu Jahl taunted him as he sat quietly outside the mosque in Mecca one day, it was Hamza who came to his defence, delivering a sound beating on Abu Jahl – and it was in the midst of doing so that Hamza is said to have finally, and vociferously, embraced Islam.

During the Battle of Badr, one of the many Meccans Hamza killed was Tu'ayma, whose nephew later sought to avenge his uncle's death by offering his Abyssinian slave Wahshi – an expert javelineer – his freedom in exchange for killing Hamza, which he succeeded in doing the following year at the Battle of Uhud (fig. 134). Another of the Meccans Hamza killed at the Battle of Badr was Utba, whose daughter Hind likewise wished to avenge her father's death (and that of her two sons who were also killed at Badr). Hind's husband was Abu Sufyan. A prominent figure in Mecca and a member of one of the city's noble families, he had once been Muhammad's friend, but friendship turned to hatred when Muhammad began to preach his new religion. Although he eventually converted – just prior to the fall of Mecca – at the time of the Battle of Uhud he was still a strident opponent of Islam and served as the Meccans' commander-in-chief during the battle. Hind accompanied her husband on the expedition to face the Muslim army, and, hearing of the bargain

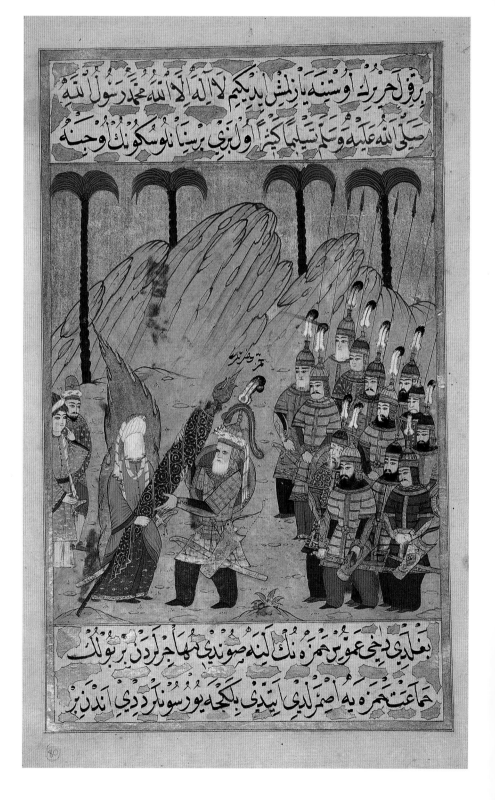

Fig. 30
Hind and the Meccan Women Before the Muslim Dead at the Battle of Uhud, from *Siyar-i nabi* (The Life of the Prophet)
Turkish text in *naskh* script

1594–95 (AH 1003), Istanbul, Turkey
37.4 x 27cm, CBL T 419, f. 384b

The body of the slain Hamza, identified by his white beard, lies at the feet of the Meccan women, who adorn themselves with bits of the mutilated remains of the Muslim dead.

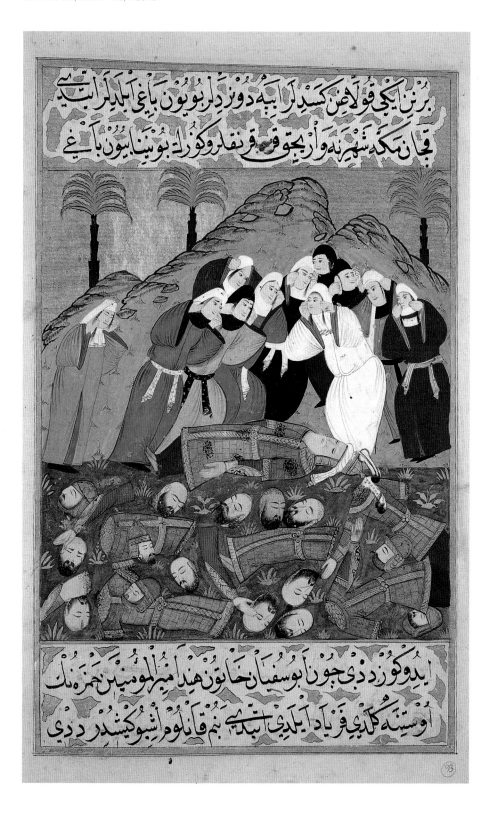

Wahshi had struck with his owner, she further encouraged him in his task of killing Hamza by promising him her share of the booty from Uhud if he succeeded. Thus, when Wahshi killed Hamza, he sliced open his belly, tore out his liver, and took it to Hind as proof of his success. Hind reportedly bit off a piece of the hero's liver, chewed and swallowed it, and then went to the body and further mutilated it, cutting off Hamza's nose, ears and various other bodily parts, all the while inciting the rest of the Meccan women to assist her in the mutilation of the bodies of the dead Muslims and to adorn themselves with the bits of flesh they cut from the bodies (fig. 30).

The story of Hamza became highly popular throughout the Islamic world, in large part because of the horrors inflicted upon the remains of this much-loved friend and relative of the Prophet by the despicable Hind. The exploits of Hamza are recorded in the *Hamza-nama* (Story of Hamza) but are in many cases a conflation of stories concerning another Hamza, Hamza ibn Abd Allah, who lived in Iran in the late eighth and early ninth centuries. The action-packed stories, which often, if not usually, have little to do with historical fact, were first written down in Persian and were especially popular in Iran and India, though Arabic, Turkish, Georgian, Urdu and Malay versions are also known. The stories were, however, mainly transmitted orally and were greatly embellished and altered with each telling, with the result that no definitive version of the stories exists. Akbar, the third Mughal emperor of India (*r.* 1556–1605), was especially taken by the stories and one of the first tasks he assigned the artists of his atelier upon becoming emperor was the production of a massive fourteen-volume *Hamza-nama*, which took fifteen years to complete (fig. 31). Each volume consisted of a hundred folios, each about 90 cm (35 in.) high and mostly with text on one side and a painting on the other. The 1,400 folios (2,800 pages) seem never to have been bound

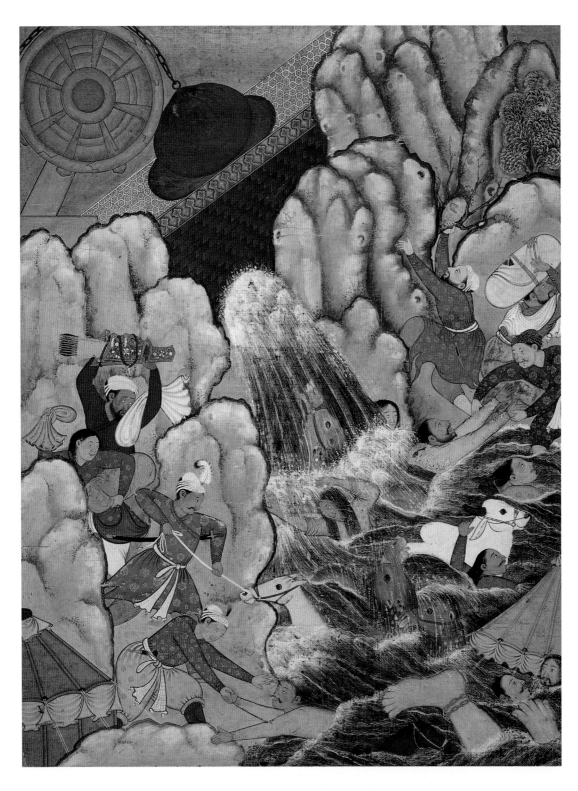

Fig. 31
Turning of the Wheel on the Shisan Dam, from a *Hamza-nama* (The Story of Hamza)

1558–73, India
67.5 x 51.5cm, CBL In 01.1

Depicted here is an episode in the life of Hamza during which one of his adversaries opened a dam, flooding the hero's camp. The artist has aptly portrayed the confusion surrounding the event, during which the men, camels and horses overwhelmed by the floodwaters desperately try to make their way to dry land. In the background is the dam, shown as a brick wall with a patterned stone edge and tiled top. In the centre of the dam is a giant stopper, poised above a large hole that is usually (but not now) plugged by the stopper, and in the upper left corner is a wheel, the turning of which raises and lowers the stopper.

and may have been used for public, oral recitations, the succinct text functioning as an aide-mémoire for the story-teller, while the lively and detailed paintings served to delight the listeners. Fewer than 170 of Akbar's original 1,400 illustrations have survived, today preserved in collections throughout the world where they continue to enchant whoever sees them.

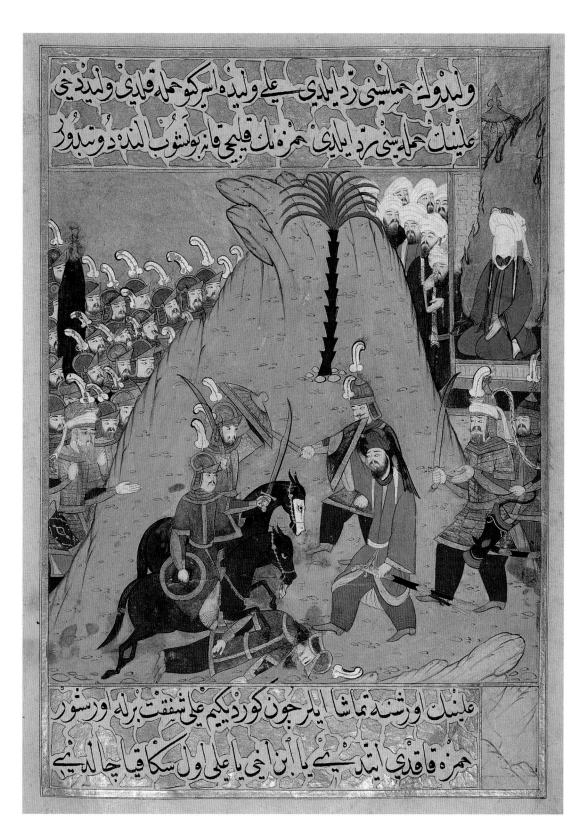

Fig. 32
Ali with his Sword *Dhu'l-Faqar* at the Battle of Badr, from *Siyar-i nabi* (The Life of the Prophet)
Turkish text in *naskh* script

1594–95 (AH 1003), Istanbul, Turkey
37.4 x 27cm, CBL T 419, f. 225b

Included in the booty the Prophet received from the Battle of Badr was the sword of an unbeliever named al-As bin Munabbih. The sword eventually passed to Ali and is regarded as an attribute of him and a symbol of his followers, even though after his death it became the property of the Abbasid caliphs, heads of the Islamic community who ruled from Baghdad for the years 750–1258. (The artist has erroneously depicted Ali at the Battle of Badr with the sword, though at the time it was not yet in his possession.)

The sword is generally depicted as having two points (supposedly allowing for the quick and easy piercing of enemy eyes) though this apparently is incorrect, because it came to be known by the name *dhu'l-faqar*, an Arabic word that suggests that the blade of the sword was instead grooved or notched. *Zulfiqar* – the transliterated form of the Persian pronunciation of the Arabic *dhu'l-faqar* – is a popular name for Muslim boys, especially among the Shi'a.

ALI AND SHI'A ISLAM

The majority of Muslims are known as Sunni Muslims, because they follow the *sunna*, or customary practice, of the Prophet; Sunnis consider themselves adherents of orthodox Islam. The Shi'a form the second largest group of Muslims and take their name from the fact that they adhere to the *shi'a*, or 'party', of Ali and his descendants. Adherents of Shi'ism form the majority of the population in both Iran and Iraq, and overall they amount to slightly more than ten percent of the world's Muslim population. The fundamental difference between the two groups is that the Shi'a maintain that only a direct descendent of the Prophet can serve as caliph – or *imam* in Shi'a terminology. They therefore regard Ali (the fourth orthodox or Sunni caliph) as the true first caliph and Abu Bakr, Umar and Uthman as mere usurpers (fig. 32).

Fig. 33
**Shi'a Muslims Mourning
Before a *Ta'ziya***

c.1800, Lucknow, India
28.1 x 43cm, CBL In 69.18

Muharram is considered the Islamic
month of mourning for it was on the
tenth day of the Islamic month of
Muharram in the year AD 680 that
Husayn was martyred at Kerbala. This
tragic event is honoured by many
Muslims, but for the Shi'a Muharram is
an especially poignant time, one
marked by public displays of mourning.
The various commemorative rituals that
take place aim to invoke within the
mourner an intense sympathy for and
identification with the suffering and pain
endured by Husayn and his family.
Throughout Iran, passion plays known
as *ta'ziya* (meaning 'mourning' or
'consoling') that re-enact the death of
Husayn are performed during
Muharram, either in the open or in
specially constructed buildings (usually
with circular stages) known as
*husayniya*s. However, in India *ta'ziya*
refers to the models of the tomb of
Husayn that are a prominent feature of
the Muharram rituals of that country's
Shi'a population. Those painted red
represent the blood Husayn shed when
killed. Less common are those painted
green, which represent Hasan, who
was poisoned in 669. The tenth day of
Muharram is known as Ashura, and the
buildings in which the *ta'ziya*s are kept
are known as *ashur-khana*s (Ashura
houses). During Muharram
processions, *ta'ziya*s are carried
through the streets by large groups of
men, their heavy weight symbolic of the
weight of Husayn's sacrifice. In this
painting, men are gathered together,
presumably in an *ashur-khana*, before a
ta'ziya, seen at the far right.

Ali's years as caliph were fraught with difficulties, mainly in the form of opposition to his rule by Mu'awiya, the long-time governor of Syria who had been appointed to the post by Ali's predecessor, Uthman. (Mu'awiya's father was Abu Sufyan, once a major rival, it will be recalled, of the Prophet; both he and Uthman were of the Umayya, a different clan to that of the Prophet and Ali.) As a result of this dispute, Ali eventually lost the support of a group who came to be known as the Khariji, and in 661 it was a member of this group who assassinated him in the mosque in Kufa, the Iraqi city that served as his capital. His elder son, Hasan, quickly agreed not to lay claim to the caliphate, leaving the way clear for Mu'awiya. However, upon the death of Mu'awiya almost twenty years later, in 680, Ali's younger and last surviving son, Husayn, set off from his home in Medina to Iraq in search of supporters, in the hope of making a bid for the caliphate. He had not yet reached Kufa when his progress was halted by the forces of Mu'awiya's son Yazid, who had assumed the caliphate upon the death of his father. Husayn and his small band of companions – which included his

children and other close family members – were cut off from the Euphrates River, the only nearby supply of water, yet Husayn refused to surrender. After several days and with Husayn and his followers near death from lack of water, a battle ensued, and on 10 Muharram in the Islamic year 61 (AD 10 October 680), at Kerbala, in Iraq, Husayn and most of his small band of companions were massacred and the surviving women and children taken to the caliph in Damascus. Although Shi'ism as a distinct party or sect did not evolve until the tenth century, the martyrdom of the Prophet's beloved grandson Husayn is viewed as a critical event in the gradual emergence of Shi'ism. Revulsion at what had taken place and sympathy for Husayn and his family was intensely felt by almost all Muslims and Husayn quickly became a symbol of all who are weak, defenceless and unjustly treated. Yazid's assumption of the caliphate had been opposed by many who feared the development of a hereditary monarchy (he had been nominated by his father before his death), and Husayn's death at the hands of what were regarded by many as the unjust forces of Yazid only served to

Fig. 34
**Muhammad and Ali at Ghadir
Khumm, from a copy of**
Athar al-muzaffar
(The Exploits of the Victorious)
Persian text in *nasta'liq* script

1567 (AH 974), Iran
26.0 x 17.8cm, CBL Per 235, f. 152a

Shi'as believe it was at Ghadir Khumm
that the Prophet designated Ali as his
successor, although Sunnis interpret
the remarks he made there as merely
an indication of his especial fondness
for his cousin Ali, whom he had raised
as his foster-son and who married his
daughter Fatima.

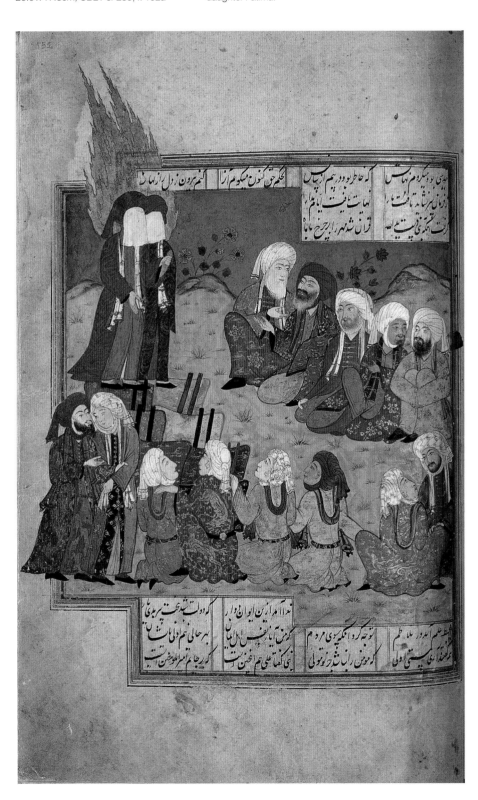

strengthen their support of and devotion to the family of Ali (fig. 33).

Muhammad is recorded as having said 'I am the city of knowledge and Ali is its gate', a reference to and prediction of the important role that Ali was to play in the preservation and transmission of the Prophet's knowledge after his death. Because of the Prophet's great love and high regard for his cousin, who was also his foster-son and the husband of his daughter Fatima, and equally because of his public recognition of the role Ali was to play, a special reverence for Ali and the members of his family has always been common among Muslims. However, in the tenth century in Iraq (and more specifically in Baghdad), three outward and very public manifestations of this reverence evolved, marking the emergence of Shi'ism as a distinct politico-religious entity. The first was the development of public festivals to commemorate specifically Alid events, in particular the martyrdom of Husayn and the supposed naming by the Prophet of Ali as his successor at Ghadir Khumm (fig. 34). The latter event occurred in 632 as a result of resentment towards Ali that had arisen amongst the troops over the distribution of goods confiscated during a campaign he led to the Yemen. The troops arrived back in Mecca in time to greet Muhammad while he was still in the city at the time of his Farewell Pilgrimage, and many of the men complained openly to him about Ali. However, during a stop in their journey back to Medina, at Ghadir Khumm, Muhammad quickly put an end to their grumbling complaints by asking them, 'Am I not nearer to the believers than their own selves?' And when they agreed he continued, 'Whose nearest I am, his nearest Ali is. Oh, God, be the friend of him who is his friend, and the enemy of him who is his enemy.' While Shi'as interpret this as a nomination by the Prophet of Ali as his successor, Sunnis reject this interpretation, claiming it was instead merely a statement of his closeness to Ali and of his merits.

The second manifestation of the reverence for Ali and his family to arise was the development of the tombs of members of the *ahl al-bayt*, or 'People of the House' (meaning the family of the Prophet and specifically Ali and his descendants) as places of pilgrimage. Uppermost amongst these are Kerbala, the site of the martyrdom of Husayn, and Najaf in southern Iraq, where Ali is buried, both of which rival Mecca and Medina as Shi'a pilgrimage sites. And finally, there began the practice of the public refutation and cursing of the three caliphs who preceded Ali.

Sunnis and Shi'as alike believe in the Mahdi, a figure whose appearance on earth will bring about the elimination of all evil and the establishment of a world of just rule. His arrival will be followed by that of the Messiah, who is Jesus. (Muslims believe that Jesus did not die a bodily death but that he continues to live in heaven and will die a bodily death only after his second coming.) Jesus will pray behind the Mahdi, lead all people to the acceptance of Islam, and kill the Anti-Christ. As noted previously, the Shi'a do not accept the *rashidun* and later caliphs, instead they recognise a succession of *imam*s ('leaders' or 'guides'), all direct descendants of the Prophet and who served successively as the sole religious authority after his death, beginning with Ali, Hasan and Husayn. There are different groups of Shi'as, the two largest of which are those known as the Twelvers (*Ithna ashari*s or *Imami*s) and the Isma'ilis. The Twelvers, the largest group, live mainly in Iran and Iraq. They take their name from their belief in the existence of twelve Imams. They believe that the successor of the sixth Imam, Ja'far Sadiq (d. 765), was his younger son Musa, and that the line of descent then continued through to the twelfth Imam, whose name was Muhammad. According to the Twelvers, Imam Muhammad did not actually die but instead went into a state of occultation, or hiding, and he has remained hidden throughout the centuries. They believe that it is this Hidden Imam who will return on the Last Day as the Mahdi. The Isma'ilis, the second largest group, live mainly in East Africa, India, Pakistan, and, since the last century, Europe and North America. Unlike the Twelvers, they believe that the successor of the sixth Imam was his older son, Isma'il (from whom they take their name), even though he died a few years before his father. From this seventh Imam, spiritual authority then continued to pass through a series of succeeding Imams until the present one, the forty-ninth Isma'ili Imam, who is known by the Persian title Aga Khan. Thus the Isma'ilis, unlike the Twelvers, bear allegiance to a living Imam. (Other smaller groups of Shi'as also exist.)

Many of the practices of the Shi'a differ somewhat from those of the Sunni; for example, the Shi'a refer to Ali as the *wali*, or 'friend', of God, which is reflected in the Shi'a profession of faith and the call to prayer, which differ from those of the Sunnis, through their reference to Ali: 'There is no god but God, Muhammad is the Messenger of God and Ali is the Friend of God' (fig. 135).

FATIMA: DAUGHTER OF MUHAMMAD AND WIFE OF ALI

Fatima was the only one of the Prophet's children to outlive him, but she did so by only about six months. As the wife of Ali and the mother of Hasan and Husayn, she is venerated by all Muslims but in particular the Shi'a, and one of the most common symbols throughout the Islamic world is the 'hand of Fatima', a hand with fingers splayed that is generally meant to represent the five members of the *ahl al-bayt*, or Family of the Prophet, namely the Prophet himself, Fatima, Ali, Hasan and Husayn. Worn as a pendant or inscribed on any number of objects, it functions as an amulet to ward off evil.

Fatima is a major figure in Shi'a belief and folklore, and numerous stories and legends exist concerning her birth, life and death. As for her birth, it is said that the Prophet ate fruits from Paradise that

turned into water in his loins, and that from this paradisiacal water, which he implanted in Khadija, Fatima was conceived. Four women, including Mary, came down from Paradise to assist with her birth, at the exact moment of which the sky was filled with a light that spread over the whole earth (and because of this, and other associations with light, she is known as *al-zahra*, 'The Shining One') and houris (angels) bathed the new born child in water from al-Kawthar, one of the rivers of Paradise. When she reached a marriageable age, several prospective, wealthy husbands came forth, but it was the impoverished Ali to whom she was married, in the first or second year after the *hijra* to Medina (fig. 35). Not only is the marriage said to have been divinely ordained, as was her birth, but a heavenly marriage is said to have taken place some forty days prior to the one on earth. She was exceedingly close to her father and when Ali later attempted to take another wife, Muhammad intervened on her behalf proclaiming, 'what hurts her hurts me also'. After Muhammad's death, Fatima came into conflict with both Umar and Abu Bakr, and their poor treatment of her at that time remains one of the factors underlying the Shi'a hatred of these two Sunni caliphs. When she died, she was buried in the Baqi Cemetery in Medina, where so many other important figures from the early years of Islam are buried, but the location of her grave is no longer known and it may in fact be, as some believe, in the courtyard of the Prophet's Mosque in Medina.

SHI'A IRAN

Since 1501, Twelver Shi'ism has been the official state religion of Iran, imposed upon the country through a policy of forced conversion of its then predominantly Sunni population by Isma'il, the fourteen year-old head of the Safavid religious sect. In the fourteenth century, Shaykh Safi al-Din (d. 1334), the founder of the sect and eponymous ancestor of the Safavid dynasty (1501–1722), estab-

lished himself in Ardabil, near the Caspian Sea in north-western Iran. Shaykh Safi and his followers were Sufi (mystical) adherents of Sunni Islam. By the mid fifteenth century, the order had become very wealthy and, then, in the second half of the century, by means not yet completely understood, the order managed to transform itself, as one scholar has phrased it, 'from a peaceful and essentially apolitical Sufi organisation to a militant, through not yet necessarily Shi'a, political movement'. The final move to Shi'ism seems to have occurred at the end of the century when Isma'il, then seven years old and already head of the order, was forced to take refuge in Gilan, on the west coast of the Caspian Sea, with a local Shi'a ruler, and under whose tutelage he remained for the next five years. In 1501 he and his Turkman-tribesmen followers won their first battle against the Turkman rulers of western Iran and eastern Anatolia, the Aq Qoyunlu, who were not only Isma'il's rivals but also his close relatives. Although he had captured Tabriz, the Aq Qoyunlu capital, the Aq Qoyunlu were still a threat, but over the next several years he conquered most of their lands as well as other parts of western Iran. Why the new young shah, who was regarded as divine by his followers, chose to proclaim specifically Twelver Shi'ism as the state religion remains something of a conundrum, but whatever his reason, Iran has remained a staunchly Twelver state ever since (figs. 36–37).

A particular feature of many Qur'ans made in Iran in the sixteenth century for Shi'a patrons is the inclusion, at the end of the Qur'anic text, of a *falnama*, or 'book of divination' (and often also a prayer to be read once one's reading of the Qur'an is completed). This usually is in the form of an illuminated table in which each letter of the alphabet is listed along with phrases indicating the good or bad fortune associated with that particular letter, this information then being used to guide the individual in deciding upon a certain course of action (fig. 38).

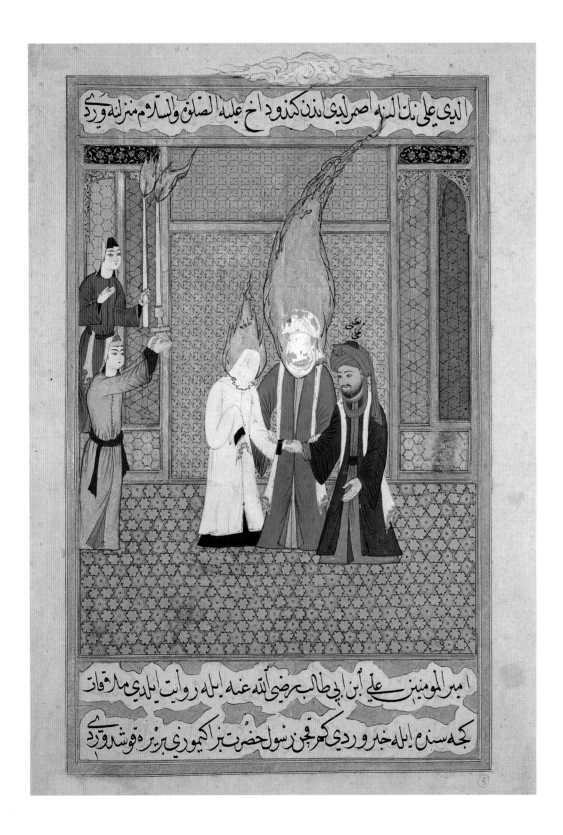

Fig. 35
The Marriage of Fatima and Ali, from *Siyar-i nabi* (The Life of the Prophet)
Turkish text in *naskh* script

1594–95 (AH 1003), Istanbul, Turkey
37.4 x 27cm, CBL T 419, f. 24b

In the first or second year after the *hijra* to Medina, Muhammad's daughter Fatima was married to his cousin, Ali, a union that is said to have been ordained by God. Because of her many associations with light, Fatima is known as *al-zahra* (The Shining One).

Figs. 36–37
Tarikh-i jahanara (The Chronicle of the World-Adorning One)
Persian text in *nasta'liq* script

1683 (AH 1094), Iran
26.5 x 18cm, CBL Per 278

This manuscript is one of a group of anonymous 'pseudo-histories' of the Safavid Shah Isma'il, who, in 1501, established Twelver Shi'ism as the state religion of Iran. The text has been described as a 'delightful agglomeration of tall tales' about Isma'il, his ancestors and his followers. That the tales are derived from the oral storytelling tradition of Safavid Iran is reflected in the language used, which often encourages the reader with phrases such as 'now listen to a few words about so-and-so'. In this particular illustration to the text, Isma'il and his men clamber up a mountainside as the enemy (a group of Lurs) hurl rocks down upon them (fig. 36). The manuscript begins with a flamboyant heading bearing the title of the text (fig. 37).

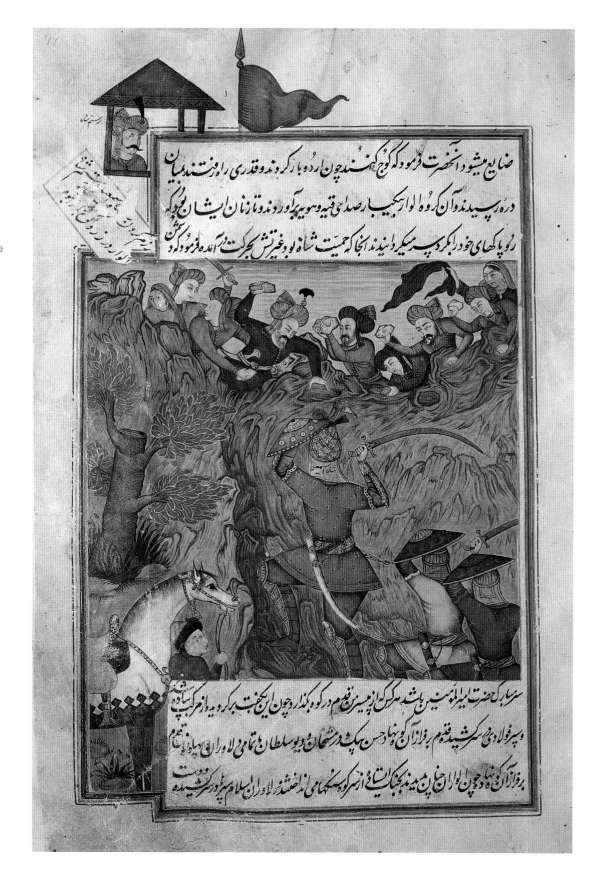

Fig. 36
CBL Per 278, f. 77a

Fig. 37
CBL Per 278, f.1b

اوّرده اند که چون مفتر ضل الطّاعه و اجب العصمه امام موسی کاظم علیه السّلام

که جدّ ما وجدّ سلطان محمّد فیروز شاه بود و سیّد سلطان فیروز شاه در دارالارشاد

اردبیل وطن داشت و حق تعالی از نور علوم غیبی و فیض فیوض لا رپسی آن سهریارا

فیرومند و ارجمند و پسندید گردانیده بود و در زمان سلطان ادهم شاه فرزند

زاده های ابراهیم ادهم که پادشاه ایران بود آن شهریار کشور پلوک بکمال مکنت

و عقار و ضیاع در بلده مزبور با میدان و صوفیان خودبذ که وفک احد قدیم مشغول

بود و در آن زمان الکشف بلده آذربایجان و دامغان از ظرایف پسی و ظرایف بود بند

Fig. 38
Illuminated Tables Used for Divination, from a copy of the Qur'an

Nasta'liq script, with *thulth* script in heading

1567–68 (AH 975), Iran
43.3 x 29cm,
CBL Is 1544, ff. 308b–309a

A *falnama* – a book or tables of divination – such as on these two pages was often included at the end of Qur'ans produced in Safavid Iran and was consulted when decisions needed to be made concerning events in one's life.

3 THE QUR'AN

FORMAL STRUCTURE AND HISTORY OF THE QUR'AN

THE QUR'AN is regarded by Muslims as an exact record of the words that God spoke to Muhammad, through the intermediary of the angel Gabriel, and is considered the final portion of God's revelation to mankind. It is thought to complete but not supplant God's earlier revelations to the Jews and Christians who, like Muslims, are considered People of the Book (namely those who have a holy scripture).

The Qur'an was revealed to Muhammad over a period of more than twenty years, from 610, when the first revelation was received, until a few days before his death in 632. The revelations are arranged in the Qur'an in the form of *sura*s and *aya*s, generally referred to by non-Muslims as chapters and verses. However, these terms are not strictly appropriate (though they will be used here), because they suggest thematically coherent units, while in the Qur'an each chapter usually deals with a number of topics or themes, though one theme may dominate. The 114 chapters that comprise the Qur'an are of varying lengths and are arranged not in the order in which they were received but instead in order of diminishing length, more or less, with the longest chapters placed at the beginning of the text. (All but six of Chapters 2–26 consist of 98 or more verses and all but one of Chapters 27–114 consist of fewer than 98 verses.) However, one of the shortest chapters, with just seven verses, is the first chapter, entitled *al-Fatiha* (The Opening). In manuscript copies of the Qur'an, the text is most often arranged so that the whole of this first chapter appears on one page with the first verses of the second chapter, *al-Baqara* (The Cow), on the facing page, and with the text of both pages surrounded by illumination (fig. 39); there may also be preceding pages of decoration to highlight further the beginning of the holy text. Sometimes the chapter marking the approximate middle of the Qur'an is also singled out for special treatment. Usually this is considered to be Chapter 18, *al-Kahf* (The Cave), but sometimes it is the fol-

lowing chapter, *Maryam* (Mary), that is instead highlighted (fig. 40). The start of all other chapters is usually marked by an illuminated heading, with there being a greater density of decoration at the end of a manuscript where several short chapters and thus several headings can appear on a single page (fig. 1). The heading provides the title of the chapter, and sometimes also the number of verses of which it is comprised and the city, either Mecca or Medina, in which it was revealed to Muhammad (fig. 41).

The end of each verse is marked by a small gold device, usually a roundel or rosette. Placed in the margins are other decorative devices that serve as guides to the reading of the text by indicating every fifth and tenth verse; usually inscribed in the centre of each device is either the Arabic word *khamsa* (five) or *ashara* (ten), or else they may simply be differentiated by size and shape. Sections of the text requiring ritual prostration may likewise be indicated by marginal devices inscribed with the word *sajda* (prostration), or else *sajda* may merely be written in gold in the margin. For purposes of reading and recitation, the Qur'an is also divided into various numbers of sections or parts: the division into seven parts allows for one part, known as a *manzil* or *sub*, to be read each day of the week; the thirty-part division corresponds to the thirty days of the month of Ramadan, the month of fasting during which one part, referred to as a *juz*, is read each day. Each *juz* may be further divided into two, to make a division of sixty parts, each of which is known as a *hizb* (meaning 'party' or 'group'); sometimes, half- and quarter-*juz* or -*hizb* divisions are also indicated. If these divisions of the text are indeed marked, it might be by a simple inscription in gold in the margin of the page, by a marginal device inscribed with the appropriate word or words, or by more elaborate displays of illumination (figs. 42–44). Although single-volume Qur'ans are the most common, seven-, thirty- and sixty-volume manuscripts, reflecting the main divisions of the text, were also

Figs. 39–41
Qur'an
Naskh script

*c.*1430, Iran
17.3 x 12.8cm, CBL Is 1521

This fine, small Qur'an contains no documentary information on its production; however, its style of decoration suggests that it was produced in the city of Shiraz, in south-western Iran, in about 1430, possibly for Ibrahim Sultan, another of the grandsons of Timur (see figs. 27–28). The manuscript is copied in *naskh* script and begins with a double page of illumination (fig. 39), surrounding all of the first, short chapter of the Qur'an (*al-Fatiha*) on the right page and the start of the second chapter (*al-Baqara*) on

the left. A second, similar double opening of illumination (fig. 40) marks the middle of the holy text and introduces the beginning of Chapter 18 (*al-Kahf*). On folio 241b (fig. 41) is a typical chapter heading: inscribed in gold in a fine *thulth* script is the title of the chapter (*al-Tur*/The Mount) and the number of verses it comprises (49). The small, pointed-oval devices in the margin indicate every fifth verse of the text and the larger, circular devices every tenth verse.

Fig. 39
CBL Is 1521,
ff. 1b–2a

Fig. 40
CBL Is 1521,
ff. 134b–135a

Fig. 41
CBL Is 1521,
ff. 241b–242a

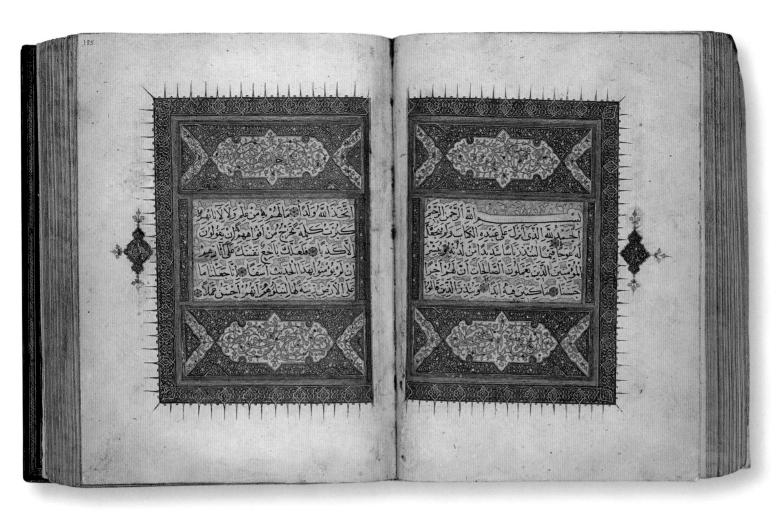

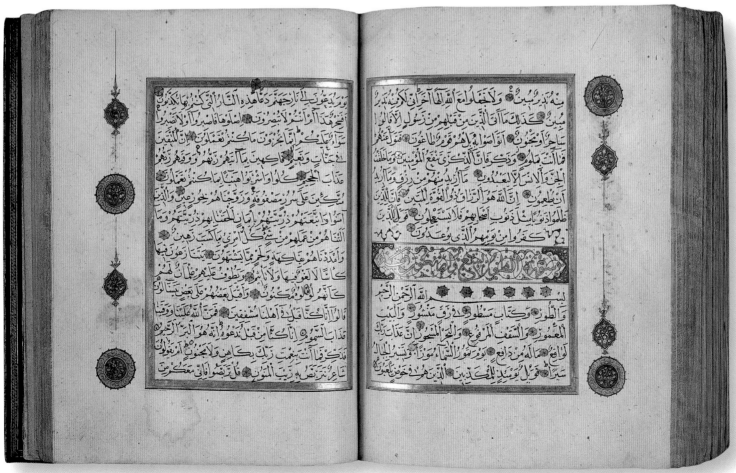

Fig. 42
CBL Is 1466,
f. 1a

Figs. 42–43
Qur'an
Naskh script

1278 (AH 677), Konya, Turkey
10.5 x 8cm, CBL Is 1466

These two folios are from a superb, palm-sized and heavily illuminated manuscript. It now includes seven double-page openings of illumination, plus this single page (fig. 42), which introduces the manuscript and is probably the remains of what was once yet another double-page composition. The page of text (fig. 43), is from Chapter 8, *al-Anfal* (The Spoils of War). Throughout the text, the name of God, *Allah*, is written in gold, and the end of each verse is indicated by a small gold rosette. Large and small circular marginal devices mark every tenth and fifth verse, respectively; the hexagonal device is inscribed with the word *juz* ('part' or 'section') and marks the beginning of the tenth *juz* of the Qur'an. According to the colophon, the text was copied by al-Hasan ibn Juban ibn Abd Allah al-Qunawi (the latter meaning 'from Konya') and illuminated by Mukhlis ibn Abd Allah al-Hindi (the latter meaning 'from India').

Fig. 43
CBL Is 1466,
f. 90b

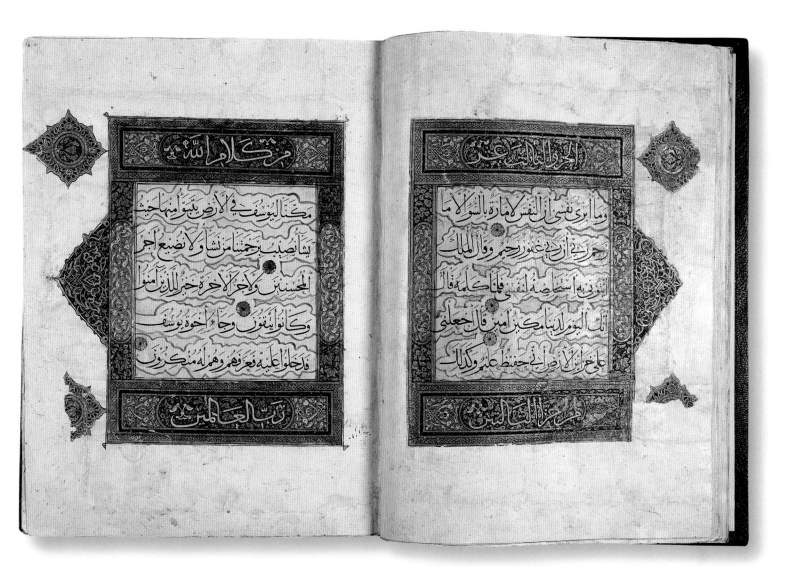

Fig. 44
Qur'an
Rayhan script

Early 15th century, Egypt
35.5 x 26.4cm,
CBL Is 1494, ff. 13b–14a

In this single-volume Qur'an, the
beginning of each *juz*, or part, is
highlighted by a double page of
illumination, in this case the start of the
thirteenth *juz* of thirty, as stated in the
panels of white *thulth* script bordering
the main text.

often produced, with thirty-part Qur'ans being the most frequent multi-volume type (figs. 45–51).

No manuscripts containing the complete text of the Qur'an were produced until after the death of the Prophet. During his lifetime, the Qur'an was preserved and transmitted primarily through memorisation and oral recitation, although some of it was certainly written down before his death. In Medina, especially, Muhammad is said to have employed scribes to copy down the revelations, sometimes on the very day that they were received, and other literate individuals may have made their own copies of certain revelations. Different accounts exist of the collecting and writing down of the Qur'an after the Prophet's death, but according to the most widely accepted account, the compilation of the first authoritative version of the Qur'an was begun by Umar and completed by Uthman. Different versions of the Qur'an had arisen, usually

associated with different cities of the expanding empire. These discrepancies in the holy text arose in part through orthographical and phonemic ambiguity. Although the modern Arabic alphabet includes three long vowels with short vowels indicated by marks placed above or below the consonants (see fig. 53 and the section 'The Arabic Alphabet' below), in the early Islamic period, the alphabet initially included no long vowels and no system for indicating short vowels was yet in use. Moreover, several consonants are orthographically identical, and the current practice of differentiating one such letter from another by the addition of one to three dots placed above or below the letter was also not yet known. Therefore, variations in readings could occur. There were, however, also questions regarding the authenticity of some of the verses included in some versions of the text. Not surprisingly, disputes over which was the correct

Figs. 45–46

Qur'an

Late 9th or early 10th century, Iran
12 x 9.2cm, CBL Is 1417

While the large, elaborately decorated, single-volume Quran in fig. 44 was probably produced as a display manuscript, this tiny, multi-volume manuscript was surely made for private use. The illumination is modest but lovely, with matching bands of decoration marking the beginning, here, of the third *juz*, or part, of the Qur'an (fig. 45). Not all volumes have survived, but it seems that, somewhat unusually, some volumes contained more than one *juz* and so there may have been fewer than the expected thirty volumes. All volumes, however, would have been protected by identical leather bindings (fig. 46). The year in which the manuscript was produced is not stated but it does include a note stating that the text was corrected in 905 (AH 292).

Figs. 47–51
Qur'an
Rayhan-naskh script

Calligraphy and illumination
14th century, Egypt
Binding prob. 15th century, Egypt
27.1 x 19.8cm, CBL Is 1463

This Qur'an originally consisted of thirty volumes, though not all volumes have survived. The extensive illumination of each individually bound volume and the heavy use of gold suggest a wealthy, if not royal, patron. Each bound volume begins with two double openings of illumination (figs. 47–48), the second of which surrounds the first lines of text, in this case the beginning of *juz* 4. The folios of text that follow (fig. 49), with their stately black script and shimmering gold marginals, are as elegant and beautiful as are the more fully illuminated folios. The manuscript's fine leather binding appears to be later than the text folios and was presumably added about a century after the manuscript was first produced to

replace the original, damaged binding. The geometric decoration of the covers (fig. 50) is the result of tooling, a technique in which a design is built up one motif at a time, using an array of tools (e.g. punches, small stamps and fillets, or rollers). The 'envelope' flap is a typical feature of Islamic bindings: it extends from the back cover, wraps around the fore-edge of the folios to protect them, and is tucked under the front cover. The curvilinear arabesque pattern of the doublures (inside covers, fig. 51) was produced by pressing carved wood blocks onto large sheets of soft leather, the different tones the result of using either heat or dye in the printing process.

Fig. 47
CBL Is 1463,
ff. 1b–2a

Fig. 48
CBL Is 1463,
ff. 2b–3a

Fig. 49
CBL Is 1463,
ff. 36b–37a

version of the holy text arose, and so the caliph Uthman turned to Zayd bin Thabit, one of the individuals who, like Uthman himself, is said to have copied down revelations for Muhammad. Uthman charged Zayd and a group of assistants with sourcing all existing revelations, determining which were genuine and therefore which ones were to be included or excluded. Furthermore, whenever discrepancies in reading arose due to the different dialects in which the text had been memorised, they were instructed to follow the dialect of Mecca (though that the Qur'an is indeed in the dialect of Mecca has recently been disputed). This authoritative text, brought to completion under the guidance

of Uthman between about 650 and his death in 656, is the same basic text that is used today – at least in terms of the arrangement of the text (the number and order of the chapters) and its consonantal structure (the outline of the consonants without any distinguishing dots). Several copies of this text were made and distributed to the major cities of the new empire, presumably to Mecca, Medina, Kufa, Basra and Damascus, to be used as models for all future copies, and it is said that all other, earlier copies were destroyed. However, as the noted Islamic scholar W. Montgomery Watt has pointed out, memory and recitation continued to be the main means by which the Qur'an was transmitted and studied, and

Fig. 50
CBL Is 1463,
back cover

Fig. 51
CBL Is 1463,
inside back cover
(doublure)

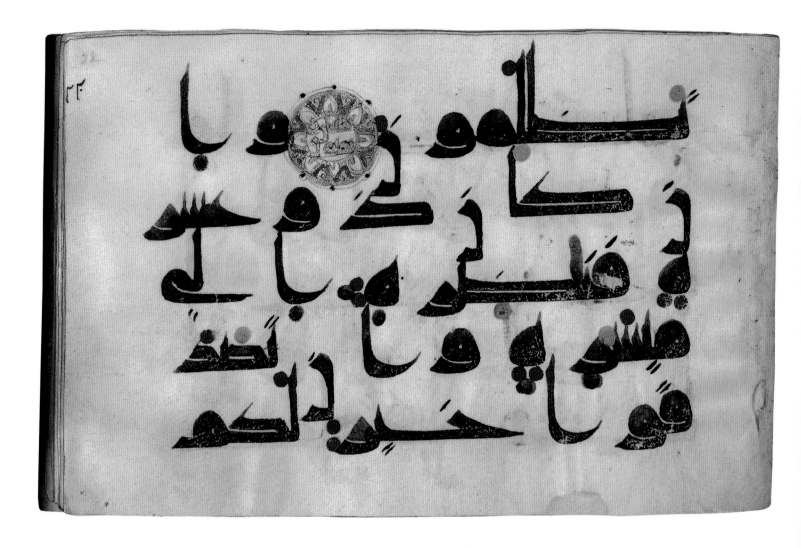

the written form probably served primarily as an 'elaborate mnemonic device' for readers who were already well acquainted with the holy text.

In most of the earliest surviving Qur'ans, those of the late eighth to tenth centuries, long vowels are used, with short vowels and other types of vocalisation (and at times variant readings also) being indicated by various coloured dots. However, the system used is not consistent from manuscript to manuscript; parallel strokes and other marks are also sometimes used to distinguish between identical consonant forms (fig. 52). This system, which had been developed in the late seventh century, eventually gave way to a more precise system, devised about a century later and first used for non-Qur'anic manuscripts. By the early eleventh century, this new system, which is basi-

cally the same one used today, was being used for manuscripts of all types (e.g. fig. 49). The earliest extant, dated Qur'an with a text that is fully vow-elled and with fully pointed consonants may be the Ibn al-Bawwab Qur'an, produced in Baghdad in the year 1000–01 (figs. 87–95). With the introduction of a standard system of vocalisation came the acceptance of standard readings of the sacred text. There are in fact several accepted readings, but the version that is today most widely used, in particular in Egypt and areas further east, as 'the' standard version (and which was first printed in Cairo in 1925) is the reading based on that of the eighth-century scholar Asim, from the city of Kufa in Iraq. A second reading, that of Nafi, an eighth-century scholar from Medina, tends to be used in North Africa, in areas west of Egypt.

Fig. 52
Qur'an

Early-*kufic* script on parchment

9th or 10th century, Iran or Iraq
11.5 x 17.8cm, CBL Is 1416, f. 22a

The Arabic Alphabet

On each of these two pages (fig. 53) are the twenty-eight letters of the Arabic alphabet, each set in a small diamond-shaped space, and with the addition, in the middle space of the lower line, of *lam-alif*, the configuration typically used when the letters *lam* ('l'; middle space, second-last row) and *alif* (long 'a'; far-right space, upper row) are written together. (Remember, Arabic is read from right to left.) Several letters are orthographically identical and are differentiated one from the other by the addition of dots placed above or below the letter, as, for example, is the case with the second ('b'), third ('t') and fourth letters ('th') in the upper row on the right-hand page.

Only the three long vowels – 'a', 'i' (second from the left, bottom row) and 'u' (far right space, bottom row) – are written as actual letters, with the corresponding short vowels indicated by marks placed above and below preceding consonant letters. On the left-hand page, the letters are shown with the addition of these vowel marks (though confusingly with all three marks shown on each letter). These vowel marks are always used in the Qur'an to guard against any misreading of the text, but they are not usually included in other types of texts. Because Arabic is the language of the Qur'an and therefore the language of the Islamic faith, conversion to Islam of peoples beyond the borders of Arabia frequently led to the adoption – and adaptation – of the Arabic alphabet and script for local languages. Thus, Persian and Ottoman Turkish use the same alphabet, but with four additional letters.

Fig. 53
The Arabic Alphabet
Naskh script

18th century, Turkey
22.5 x 16cm, CBL T 490, ff. 1b–2a

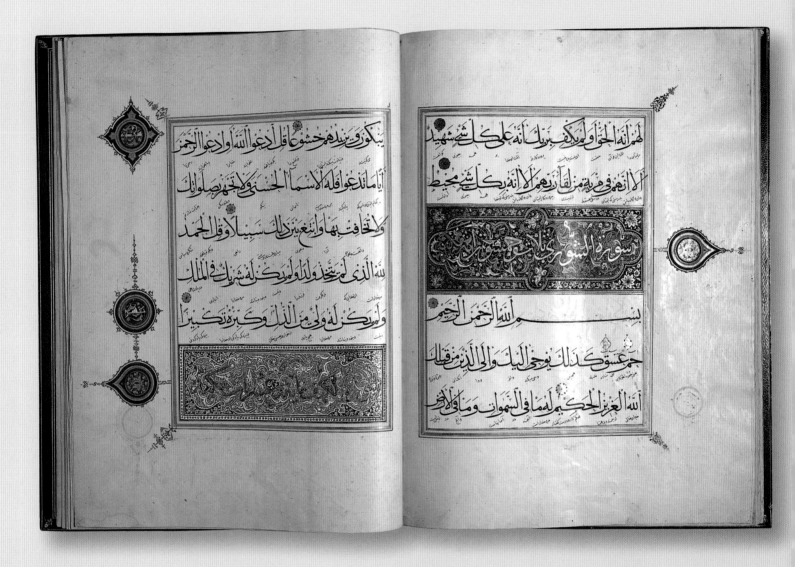

The Language of the Faith

The Qur'an expressly states in several verses that it was revealed in Arabic, the language of the Arab people, in order that it could be clearly understood. Gabriel transmitted God's words to Muhammad, who then repeated them back word for word and so committed the words to memory. As the Qur'an is accepted by Muslims as God's actual words, they believe that it is only in Arabic that the Qur'an can be recited and recorded accurately without fear of altering the precise and full meaning of the divine revelation. However, the Islamic faith spread to many countries in which Arabic was not the language spoken by the native inhabitants, such as Iran, which was conquered by the forces of Islam in the mid seventh century. In such regions, an interlinear translation was some-

times added to manuscript copies of the holy text (fig. 54). Similarly today, the pages of printed copies of the Qur'an produced in the West and other mainly non-Arabic-speaking regions are often divided vertically in two, with the Arabic text appearing on one side of the page and the English translation, for example, on the other. For a practising Muslim, however, Arabic is important not only to enable one to read the precise words of God, but also because it is mandatory that the ritual, daily prayers that Muslims are required to perform be said in Arabic. It is also said to be the language of those who reside in Paradise. Knowledge of Arabic therefore is an integral part of being a Muslim and serves to bind together the community of Muslims from around the world.

Fig. 54
Qur'an
Muhaqqaq script with Persian interlinear translation in *naskh*

Mid to late 15th century, Turkey
35.6 x 26.2cm, CBL Is 1492, ff. 4b–5a

Only a few folios of this Qur'an have survived, none of which include information on its production. Nevertheless, the style and quality of the illumination suggest that it was probably made for the Ottoman sultan, Fatih (the Conqueror) Mehmed, who captured the Byzantine capital, Constantinople, in May 1453, renaming it Istanbul.

The *Basmala*

The *basmala* is the common Islamic invocation that states, 'In the name of God, the Merciful, the Compassionate' (*bism allah al-rahman al-rahim*). The text of each chapter of the Qur'an (except Chapter 9) begins with this statement, usually with the letters of the first word extended so that it fills the whole of the first line immediately beneath the chapter heading (e.g. on the right-hand page of fig. 54). Most other written documents, of both a religious and non-religious nature, also open with it, and it should be repeated before undertaking any act of importance. Muhammad is recorded as having said that whosoever recites the *basmala* will enter paradise, and, especially in esoteric thought, it is considered the key to every chapter of the Qur'an (figs. 55–58).

Fig. 55
An Illuminated Heading, from a copy of *al-Mathnawi al-ma'nawi* (The Poem of Poems) of Jalal al-Din Rumi
Persian text in *thulth* script

1442 (AH 846), Iran (prob. Shiraz)
23.6 x 16.1cm, CBL Per 125, f. 1b

The *basmala* is written in an elegant white *thulth* script against a bed of scrolling arabesque forms on a blue ground. Headings usually contain the name of the text or of the particular section of the text that the heading introduces, but sometimes, as here, a heading instead contains the *basmala*.

**The *Basmala*, in
a Book of Prayers**

Poss. 16th century, Turkey or India (?)
12.5 x 8cm, CBL T 429

An intriguing feature of the decoration
of this small book of prayers is the
fourteen pages on which the *basmala*
appears. Each calligraphic composition
is as ingenious and inventive as are the
three examples reproduced here.
Where this manuscript might have
been made is perplexing, as neither the
palette nor the precise types of motifs
used in its illuminations conform to that
of any known centre of production.

Fig. 56
CBL T 429,
f. 32a

Fig. 57
CBL T 429,
f. 46a

70

Fig. 58
CBL T 429,
f. 70a

The Qur'an: Content and Style

The precise style in which the Qur'an is written is difficult to describe. It is neither prose nor poetry and is more aptly termed rhymed or assonanced prose, though one scholar has noted that the revelations received by the Prophet in Medina tend more towards prose than do those received in Mecca. It has also been suggested that oral recitations of the verses (which of course was the original means of transmitting and preserving the text) were likely to have been accompanied by both gestures and changes in tone of voice, the latter in particular complementing the rhythmic nature of the text. Recitation and memorisation of the Qur'an continue to be important features of the study and practice of the faith; one who has memorised the complete Qur'an is known as a *hafiz*.

The revelations were delivered, through Gabriel, specifically to Muhammad, and this is made clear throughout the Qur'an, as in verse 33:45 which states, 'O Prophet! Truly We have sent you as a witness, a bearer of glad tidings and a warner.' However, such instances of Muhammad being addressed directly are relatively rare. Moreover, the revelations seldom give any obvious indication of time or place, and as a result the reader often feels as though God is speaking directly to him (or her), so that the act of reading (or listening to a recitation of) the Qur'an becomes a highly personal and hence emotionally charged experience.

As noted previously, the revelations are preserved in the form of chapters and verses. Each chapter bears a title (and some chapters are known by more than one title), but these are not part of the Qur'an itself and it is not known if they originated before or after the death of Muhammad. Usually the title gives little if any indication of the actual contents of the chapter, for the chapter may deal with a number of topics. Only in the case of Chapters 12 and 71, named for the Prophets Yusuf (the biblical Joseph) and Nuh (Noah), respectively, does the title

indicate the topic of the whole chapter. Instead, the title usually functions as a mnemonic device of sorts: it may be a word that occurs in the first few verses of the chapter or it may be a word that occurs only in that specific chapter, as with the title of Chapter 7, *al-A'raf* (The Heights), a word which is used twice there (in verses 7:46 and 7:48) but nowhere else in the Qur'an. As the chapters were not originally numbered, titles were necessary as a means of distinguishing one from the other.

That the chapters are arranged, more or less, in order of decreasing length has already been mentioned. It has been suggested, however, that there are likely to have been other factors, as yet not fully determined, which conditioned the ordering of the chapters and that the arrangement according to length may merely be a coincidental off-shoot of these other factors. Some of the very obvious exceptions to the decreasing length 'rule' may have resulted from the desire to keep certain chapters together, but for what reason is still under study.

The actual chronological order in which the chapters were revealed is also uncertain. In manuscript copies of the Qur'an, chapter headings often state if the chapter was revealed in Mecca or Medina, but, like the titles, this information is not part of the Qur'an itself. Moreover, lists stating the chronological order of the chapters do exist, but these differ, even if only slightly, and all are thought to date from the eighth century or even later. To a certain extent, whether a chapter was revealed in Mecca or Medina (and thus a general indication of date) can be ascertained from the content of the chapter, and it is generally accepted that most of the longer chapters were revealed in Medina. It is, however, also generally accepted that many of the longest chapters are likely to have been revealed over a long period of time and also that many of the Meccan chapters include insertions from the Medinan period and *vice versa*.

It is clear that revelations were made to suit the specific circumstances and needs of the Muslim

community at any given time: revelations received by the Prophet in Medina tend to deal more with rules and regulations concerning the governing of a new community, and they often deal with very specific topics, while those received in Mecca – which constitute the greater bulk of the Qur'an and which were delivered when a community as such did not yet exist – are more theological in nature, dealing more specifically with, for example, the glory and omnipotence of God. Many topics are dealt with more than once in the Qur'an, revelations having been made, as noted, to meet the specific – and often changing – needs and circumstances of the community. But this means that the contents of one revelation might contradict (or at least differ to varying degrees with) what was said about a given topic in another revelation. One example frequently referred to in this regard is the four revelations that discuss the drinking of wine, one of which appears to be non-committal (merely stating that an intoxicating drink is obtained from the fruits of the date palm and the vine), another of which states that you should not pray while intoxicated, while the other two condemn the drinking of wine outright (one of which states that wine and other vices are an abomination and the work of Satan). If taken as indicating a gradually changing view of the topic, then the verses can be arranged in their apparent chronological order (16:67, 2: 219, 4:43 and 5:90), with the result that the only verse revealed in Mecca is the non-committal verse, while the others were revealed in Medina, when clear-cut rules were being laid down for the community.

To some extent, the question of chronology concerns the question of abrogation, a topic of considerable dispute. Within the context of the Qur'an, one of the definitions of the term is the suppression of a Qur'anic ruling without the suppression of the actual wording, or that the content of a given verse may be superseded by a (presumably) later revelation. Thus, in the case of the four revelations on the drinking of wine, the former of the two verses cited (in particular the one which implies that intoxication is permitted as long as one is not praying) are abrogated, having been superseded by the latter of the two verses cited. Two other forms of abrogation exist, namely cases wherein the written word is believed to have somehow disappeared from the text of the Qur'an yet the ruling it laid down remains in force (the most frequently cited example being the ruling that adulterers be stoned to death, which does not occur in the Qur'an) and cases where both the written word and its content have disappeared.

It is now clear that not only may a single chapter deal with a variety of subjects, but a single subject may be dealt with in several chapters (though usually subsequent discussions of a subject do not contradict earlier statements but instead expand upon them, or perhaps different aspects of the subject are emphasised depending on the circumstances that might have prompted the revelation). Specific types of subjects and forms of presentation are found throughout the Qur'an. For example, many of the chapters are introduced by oaths, such as in 93:1–4:

> By the glorious morning light,
> And by the night when it is still,
> Your Guardian-Lord has not forsaken you
> Nor is He displeased;
> And verily the Hereafter
> Will be better for you than the present.

As is typical, the oath begins with God swearing by a cosmic phenomenon (in this case the sequence of day and night) and ends with a statement of promise (that life in the Hereafter will be better than one's earthly existence). Not spoken but clearly implied is the curse to be brought down upon the speaker (God) if his promise proves false (which of course in the mind of any true believer is not a possibility). Related to oaths are woes and curses, such as 104:1–3:

Woe to every (kind of) scandalmonger and
backbiter,
Who piles up wealth and lays it by,
Thinking that his wealth would make him last
forever!

Proclamations of the glory, omnipotence and
essence of God are numerous, the most well known
and most beloved of which is the Throne Verse
(2:255):

God, there is no god but He.
The Living, the Everlasting.
Slumber seizes Him not, nor sleep.
To Him belongs all that is in the heavens and on
the earth.
Who is there that can intercede with Him, save
by His leave?
He knows what lies before them and what is
after them,
And they will comprehend nothing of His
knowledge
Except such as He wills.
His throne comprises the heavens and the earth;
The preserving of them oppresses Him not;
For He is the All-high, the All-glorious.

References to particular signs of God's creative pow-
ers and his beneficence towards mankind are also
frequently encountered throughout the text. These
include, again, references to cosmic phenomena and
the natural world, all of which are created by God.
Verse 42:29 states:

And among his Signs
Is the creation of the heavens and the earth
And the living creatures
That He has scattered through them:
And He has the power to gather them
Together when He wills.

In this verse, the universe in general and all in it is
stated as a sign of God, while other verses single out
specific elements within the universe that have been
created by God for the benefit of mankind. Verse
40:79, for example, points out that 'It is Allah who
made cattle for you; That you may use some for rid-
ing and some for food'. Verse 42:32, on the other
hand, notes the benefit to mankind of ships, which
are of course produced only by means of the intelli-
gence and artifice bestowed on mankind by God:

And among His Signs
Are the ships, smooth running
Through the ocean, tall as mountains.

Statements referring to the Revelation itself are
common, affirming that it is a gift from God, as in
verses 55:1–2, which state: 'Allah Most Gracious! It
is He who has taught the Qur'an, He has created
man' (see also fig. 59). Other verses affirm that
Muhammad is God's messenger, entrusted with the
delivery of the Revelation, as in verse 48:28:

It is He who has sent His Messenger
With the guidance and the religion of truth
To proclaim it over all religion.

As noted previously, sometimes God addresses
Muhammad directly, as in verse 9:73, where He
encourages him in his task:

O Prophet! Strive hard against
The disbelievers and the hypocrites!
And be harsh with them.
Their ultimate abode is hell –
An evil refuge indeed.

Muhammad's opponents accused him of being a
mere soothsayer and a madman who made up the
revelations himself, in which cases God suggested
rebuttals and offered Muhammad solace and

Fig. 59
Qur'an
Naskh script

14th century, Egypt
35.3 x 25.3cm, CBL Is 1472,
ff. 142b–143a

The illuminated heading on the left-
hand page marks the beginning of
Chapter 27, *al-Naml* (The Ants), the first
few verses of which state emphatically
that the Qur'an is a gift from God:
'These are verses of the Qur'an, a book
that makes things clear, a guide and
glad-tidings for the Believers . . .
bestowed upon you from the presence
of One who is Wise and All-Knowing.'
The beginning verses of the chapter
also note the duty of believers to
'establish regular prayers' and to 'give
in regular charity', two of the basic
duties incumbent upon all Muslims.

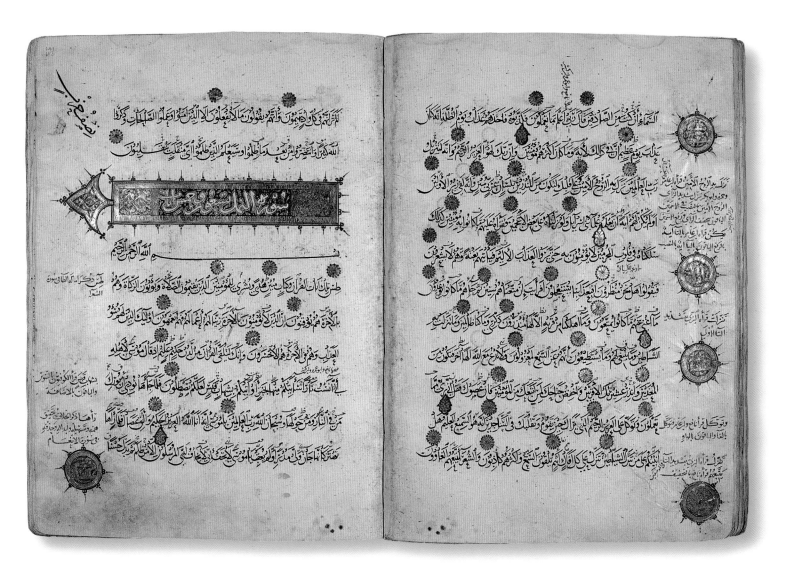

assurance. In verse 52:29, God states:

> Proclaim the praises of your Lord,
> For by the grace of your Lord,
> You are no soothsayer
> Nor are you one possessed.

And then in verses 52:34, God instructs Muhammad to challenge those who believe he is a mere poet (and hence the author of the Qur'an) to produce a revelation such as that which Muhammad has received, noting that only if they can will their accusations be proven true.

As one would expect, eschatology (things concerning the end of the world) is dealt with extensively, in particular descriptions of the rewards that await believers (e.g. 31:8–9) and the torments in store for disbelievers (e.g. 76:4):

> For those who believe
> And work righteous deeds
> There will be Gardens of Bliss –
> To dwell therein; the promise of Allah is true,
> And He is exalted in power, wise.

and

> For the Rejectors (of the Qur'an)
> We have prepared
> Chains, yokes and a blazing fire.

Stories about figures from the past, mainly biblical figures, play a major role in the Qur'an and are generally used to illustrate the punishment of unbelievers who rejected earlier prophets, and so they offer a warning to those who do not accept Muhammad as the messenger of God and who dare to reject his message. The story of Noah is one of the most well-known and well-loved biblical stories and it likewise plays a major role in the Qur'an. References to Noah's building of the ark and the flood that engulfed those who mocked him is made in fourteen chapters, but his story is dealt with most extensively in Chapters 11 and 71, the latter of which (as noted previously) is entitled *Nuh* and deals exclusively with this subject. Of these fourteen chapters, all but three were, not surprisingly, delivered in Mecca, a time when Muhammad's message was more strictly focused on the conversion of his fellow tribesmen and women. That those who reject God's prophets will suffer dire consequences, as did the people of Noah's time, is stated clearly and with force in verse 7:64:

> But they rejected him (Noah)
> And so We delivered him
> And those with him in the ark;
> But We overwhelmed in the flood
> Those who rejected Our Signs;
> They were indeed a blind people!

As already noted, Medinan revelations often deal with the laying down of laws and regulations for the edification and guidance of the Muslim community. Chapter 2, *al-Baqara* (The Cow), for example, includes rules on a variety of subjects. Verse 2:221

discusses marriage, stating:

> Do not marry unbelieving women
> until they believe;
> A slave-woman who believes
> Is better than an unbelieving woman,
> Even though she allures you.
> Nor marry (your daughters)
> To unbelievers until they believe.
> A man-slave who believes
> Is better than an unbeliever.

In verse 2:228, the ruling is laid down that after divorce a woman must wait three months before re-marrying to ensure that she is not pregnant by her previous husband:

> Divorced women
> Shall wait concerning themselves
> For three monthly periods.
> Nor is it lawful
> To hide what Allah
> Hath created in their wombs.

A person is morally responsible to ensure that parents and other relatives will be cared for in the event of his or her death, as put forth in verse 2:180:

> It is prescribed,
> When death approaches any of you,
> If he leave any goods, that he make a bequest
> To parents and next of kin,
> According to reasonable usage;
> This is due from the God-fearing.

Many matters concerning the practice of the faith are also dealt with in Chapter 2, such as the duty to fast (2:183):

> O you who believe!
> Fasting is prescribed to you,

As it was prescribed
To those before you,
That you may learn self-restraint.

Other chapters revealed in Medina likewise deal with rules for the new community, with verse 33:53 discussing points of good social behaviour:

O you who believe!
Enter not the Prophet's house
For a meal until leave is given to you,
(And then) not so early as to wait
For its preparation; but when
You are invited, enter;
And when you have taken
Your meal, disperse,
Without seeking familiar talk.
Such (behaviour) annoys the Prophet:
He is ashamed to dismiss you, but
Allah is not ashamed
(To tell you) the Truth.

Though the verse lays down rules of etiquette for dealing with the Prophet in particular, advising that one should never arrive too early for a dinner invitation nor linger so long afterwards as to wear out one's welcome, the advice can be taken more generally as a model for how to behave towards any host.

According to Faruq Sherif, with the move to Medina there is also a change in Muhammad's attitude towards his opponents, namely from that of victim in Mecca to that of avenger in Medina, and this change is also reflected in the topics dealt with in the Medinan chapters. Specifically, it is during the Medinan period that raids on and battles with the Meccans occur, and sections of Chapter 8, *al-Anfal* (The Spoils of War), deal with the very practical issue of the distribution of booty taken in these raids and battles. Verse 8:41 explains:

And know that out of all the booty
That you may acquire (in war)
A fifth share is assigned to Allah and to the
 Messenger,
And to near relatives (who have need),
Orphans, the needy and the wayfarer –
If you do believe in Allah
And in the revelation that
We sent down to Our servant
On the day of testing,
The day of the meeting of the two armies,
For Allah hath power over all things.

The 'day of testing, the day of the meeting of the two armies' is taken as a reference to the Battle of Badr, which was the first time that a Muslim army took booty. The revelation was in response to the dispute that arose over the distribution of the large amount of booty taken and the ransom paid by the Meccans for the release of prisoners of war. While the revelation refers only to the assigning of one-fifth of the booty to the Prophet, orphans and the needy, it is assumed that the remaining four-fifths were to be divided between those who took part in the battle – and it was a rule of distribution that would be followed for future battles as well. Other revelations received in Medina were also made in the context of war and deal with topics such as the care of orphans.

Although the most noticeable difference between the Meccan and Medinan revelations of the Qur'an is the laying down of rules and regulations in the later period, in fact less than five per cent of the total Qur'an can be considered as providing actual instructions on how to live. Nevertheless, it is to the Qur'an that a Muslim first turns for guidance both on how to live one's spiritual life and in dealing with the practical, day-to-day matters of one's earthly existence.

Death and Paradise

Muslim burials should take place before sunset on the day that the person has died. The body of the deceased is ritually washed (preferably by a person of the same sex and a member of one's family), shrouded in plain white, unseamed pieces of cloth, and usually placed directly in the grave without a coffin. At the graveside, prayers are said and verses of the Qur'an are read. In a similar fashion to Christian burials, a bit of earth is thrown into the grave while verse 20:55 of the Qur'an is recited:

From the (earth) We created you,
And into it We return you,
And from it shall We
Bring you out once again.

The grave should be unmarked, but this is almost never the case. Instead, tombstones usually mark graves and shrines are often built over the graves of saints and other important figures. The prohibition against the latter is due to the fear that, as is so often the case, the shrine will become the focus for the worship of the deceased person, with people praying *to* (as opposed to praying *for*) the deceased, in the hope of receiving the blessing (*baraka*) of the deceased and hence his or her aide and intervention with various matters – a popular one always being the granting of children. As noted previously, to worship any thing or being in addition to God is *shirk* (meaning 'polytheism' or 'idolatry'), but although *shirk* is considered a grievous sin, the building of shrines has long been overlooked. They are found throughout the Islamic world and are often referred to by the term *qubba*, meaning 'dome' or 'cupola', because, no matter how simple or elaborate a structure, it is usually topped by a dome (figs. 60–61).

As noted in the Qur'anic verse quoted above, God will raise the dead from their graves, and when he does their deeds on earth will be judged and they will accordingly be consigned to heaven or hell. Belief in the Day of Judgement – and thereby in the Hereafter – is a basic tenet of the Muslim faith. For unbelievers, eternal damnation awaits (32:20):

As to those who are rebellious and wicked,
Their abode will be the Fire;
Every time they wish to get away from it
They will be forced back into it;
And it will be said to them:

'Taste the penalty of the Fire,
Belief in which you rejected as false'.

But for believers, the reward is Paradise, the pleasures of which are described in several verses of the Qur'an:

Allah has promised to Believers –
men and women,
Gardens under which rivers flow,
And to dwell therein, beautiful mansions
In gardens of everlasting bliss. (9:72)

and

The Righteous will be amid gardens
And fountains (of clear flowing water). (15:45)

and

They (the Righteous) will recline on carpets
Whose inner linings will be of rich brocade,
And the fruit of the Gardens will be near and
easy of reach. (55:54)

The Arabic word *janna* means 'garden' but when used with the definite article it usually refers specifically to Paradise; similarly, the word *firdaws* means both 'garden' and 'Paradise' in Persian – and gardens in Islamic lands are ultimately modelled on these Qur'anic descriptions of Paradise. Earthly gardens are designed to excite and satisfy all the senses, just as their heavenly counterparts will do. Thus the air is filled with the sweet scent of blossoms, water softly trickles and glistens in the sun, a refreshing breeze wafts through the air, and ripe fruit and nuts hang in abundance from the trees. There are said to be four rivers of Paradise and so Islamic gardens are usually of the *chahar bagh* (meaning 'four-garden' in Persian) plan. Channels of water (to irrigate the garden) and walkways divide the space of the garden into four, each space then being further divided into four, and so on. At the intersections of the channels, there might be fountains and brightly tiled pavilions or simple platforms where people may gather to listen to poetry or music or simply to relax on thick carpets and enjoy their heavenly surroundings. Gardens of this type are frequently depicted in paintings, in particular those produced in India for Mughal patrons, mainly from about the seventeenth to eighteenth centuries (fig. 62).

Fig. 60
Funeral Procession, from the History of Sultan Suleyman

1579 (AH 987), Istanbul, Turkey
39.5 × 25cm, CBL T 413, f. 115b

This is one of twenty-six illustrations to a history of the Ottoman sultan Suleyman the Magnificent (r. 1520–66), produced for Suleyman's grandson Murad III, in 1579. This particular painting depicts a procession of *mullas* (jurists and other religious scholars), carrying Suleyman's coffin, perched on the front of which is the sultan's turban. A figure walks before the coffin holding above his head a gold box containing a Qur'an. Anyone who visits Istanbul today will surely visit the Suleymanlye Mosque, built by Suleyman along with a surrounding complex of theological schools and shops. In the walled cemetery adjoining the mosque are the two octagonal domed *turbas*, or tombs, depicted in the background of this painting: one contains the body of Suleyman himself, the other that of his wife Roxelana. Both tombs were already built at the time of the sultan's death in 1566, as indicated, yet the artist clearly chose to exercise a degree of artistic licence by including a small group of men digging what is undoubtedly, though confusingly, intended as the sultan's grave. Chronological accuracy was clearly less important than the added measure of pathos brought to the composition by the inclusion of the scene of the sultan's grave being dug at the very moment that his funeral procession passed.

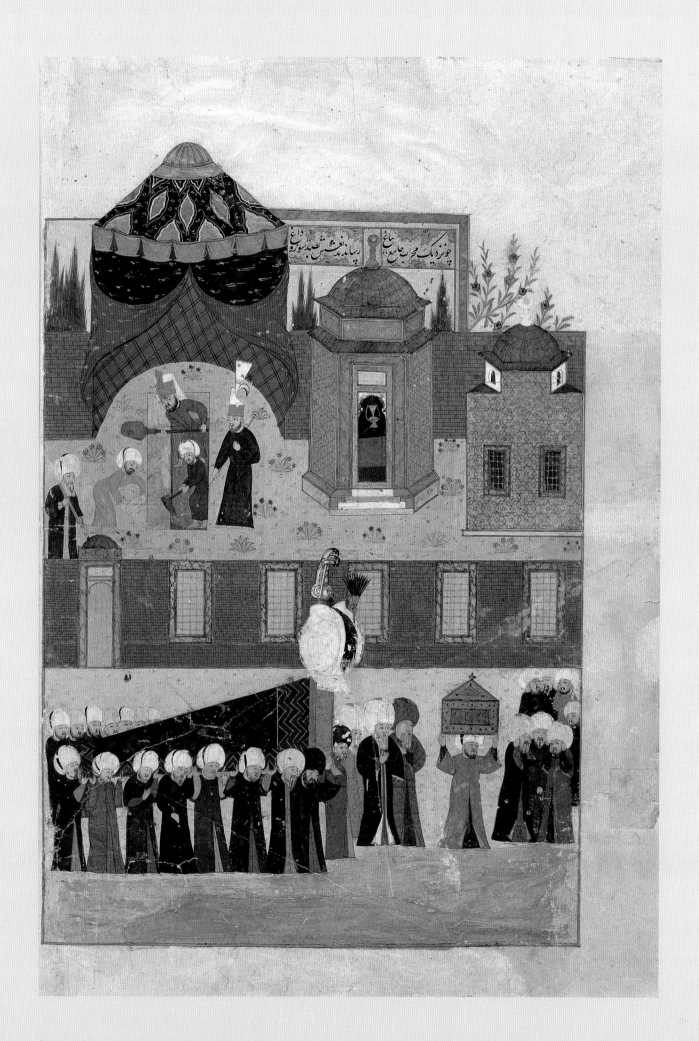

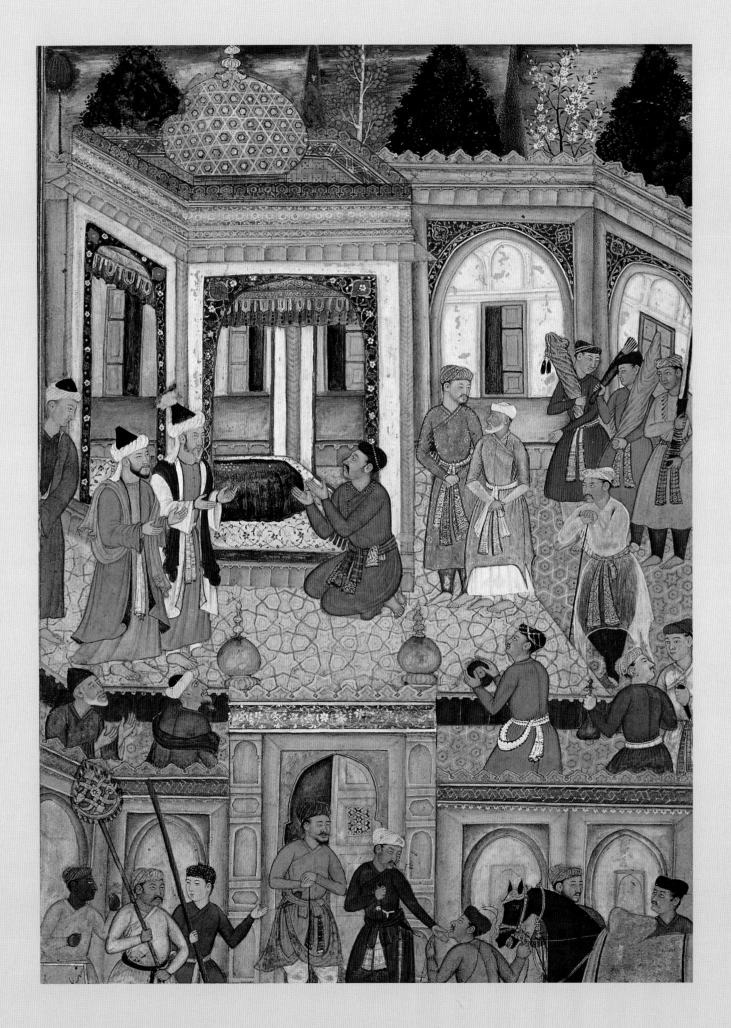

Fig. 61
Akbar Visits the Shrine of Shaykh Farid al-Din Ganj-i Shakar, from an _Akbarnama_ (The Story of Akbar)

_c._1603–05, India
34.5 x 23cm, CBL In 61.9

The painting depicts an event that took place in 1578 and is recorded in the _Akbarnama_, the official biography of the Mughal emperor Akbar (_r._ 1556–1605). Farid al-Din Ganj-i Shakar (or, Shakarganj, meaning 'Treasury of Sugar'; d. 1265) was a Sufi shaykh of the Chishti order, who is still today a highly revered figure. His shrine, which Akbar is shown visiting, is at Pakpattan, in the Punjab in Pakistan, on the banks of the River Ravi south of Lahore. The emperor is shown kneeling in prayer before the domed shrine of Baba Farid, as the shaykh is more familiarly known. The empty coffin (beneath which the body is buried) sits in the centre of a walled compound, below a richly tiled dome.

Fig. 62
A Garden Gathering with a Prince in a Green _Jama_, from the Minto Album

_c._1635, India
28 x 20.2cm, CBL In 07A.7a

Earthly gardens are modelled on Qur'anic depictions of Paradise, and within the enticing and heavenly environment of the garden, canopied pavilions and carpeted platforms provide a stage for social gatherings, during which, as here, the participants partake of light refreshments and are entertained by musicians and singers. The garden is laid out in the typical _chahar bagh_ plan with walkways dividing the space of the garden into rectangular sections in which, unlike a typical 'Western' garden, flowers and trees grow seemingly at random amongst the long grass.

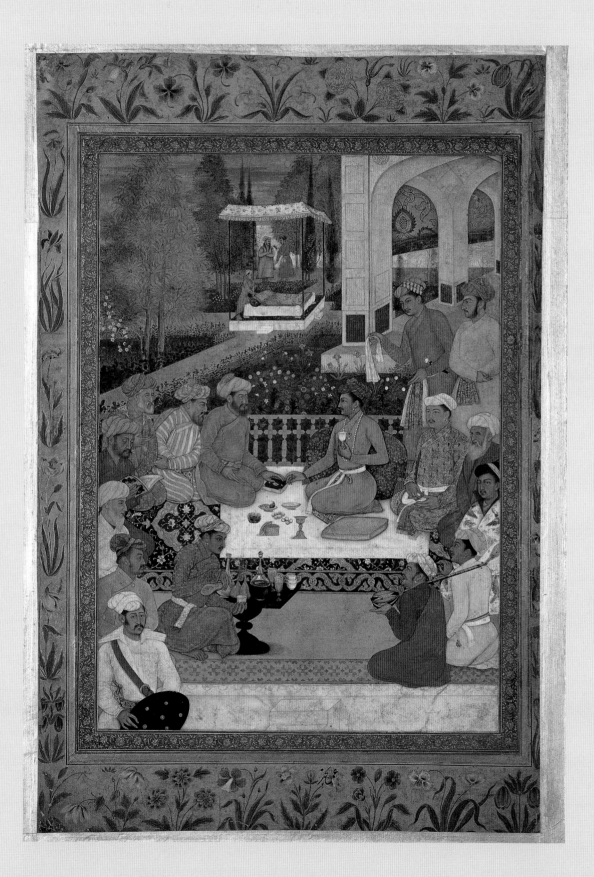

Uses of the Qur'an and Qur'anic Inscriptions

The Qur'an is considered to be imbued with amuletic power and therefore small copies of the holy text are often carried to protect the bearer against evil and ill-will. To this end, Qur'ans produced as scrolls are tightly rolled and placed in metal containers which are worn, even today, on a chain around the neck (fig. 63). Small octagonal Qur'ans (usually Persian or Ottoman and first produced in about the sixteenth century) served the same function, although (likewise placed in metal cases) they were often worn strapped around the upper arm or attached to battle standards. The last two chapters of the Qur'an, *al-Falaq* (Daybreak) and *al-Nas* (Mankind), which are in the form of prayers or charms, are also thought to have amuletic powers, and the text of these two very short chapters is also often copied out and likewise worn or simply recited as protection against evil. They state:

Say: I seek refuge
With the Lord of the Dawn,
From the mischief of things created;
From the mischief of darkness as it overspreads;
From the mischief of those
Who practice secret arts;
And from the mischief of the envious one
As he practices envy. (113)

Say: I seek refuge
With the Lord and Cherisher of Mankind,
The Ruler of Mankind,
The Judge of Mankind –
From the mischief of the Whisperer (of Evil)
Who withdraws (after his whisper) –
(The same) who whispers
Into the hearts of Mankind –
Among jinns and among men. (114)

According to tradition, these two chapters were revealed to the Prophet and then recited by Ali in order to undo a spell cast upon the Prophet by a sorcerer in Medina. Various other verses of the Qur'an might also be inscribed on carved pieces of stone and carried as amulets in the pocket or around the neck, and throughout the centuries water that has touched verses of the Qur'an has been considered to have a protective and curative power, in particular to heal the ill, ease the pain of childbirth and generally maintain good health: verses of the Qur'an are written in ink on paper or cloth, this material is washed in water, and then the water is drunk. Alternatively, water can be drunk from a metal bowl, the interior of which is inscribed with Qur'anic verses. Such bowls are common and still produced today. Related to these objects are talismanic shirts, the oldest extant example of which was produced for an Ottoman prince in the late fifteenth century. Written on these shirts are various verses of the Qur'an, prayers and usually also magic squares. Their precise function is not clear, though the inclusion on some of them of all or parts of Chapter 48, *al-Fath* (The Victory), suggests that at least some were worn in battle as undergarments to protect the wearer and help assure victory. Not surprisingly, arms and armour and other accoutrements of war, such as battle standards, were also frequently inscribed with the Victory Sura, as it is commonly known. The metal cases of some of the small octagonal Qur'ans referred to above are also inscribed with verse 48:1 ('Verily, We have granted thee a manifest victory') or with verse 61:13 ('Help from God and a speedy victory'), suggesting that they too were intended to be worn or carried into battle.

Inscriptions on other types of objects also frequently relate to the function of the object, such as verse 2:144, which is often found woven into grave or cenotaph covers, in particular those that were used in Ottoman Turkey:

Fig. 63
Qur'an (scroll)
Ghubar script

18th century, Iran
9.2cm wide, CBL Is 1622

The minute script used on this and other similar scrolls is known as *ghubar* (dust) script, a form of *naskh* that is said to have been developed for messages written on extremely thin paper and tied to the legs of carrier pigeons. The beginning verses of the Qur'an are here arranged so that the area left plain and not covered by script spells out the *basmala*.

We see the turning of your face
(For guidance) to the heavens,
Now shall We turn you to a qibla
That shall please you.
Turn your face in the direction
Of the sacred mosque
Wherever you are, turn your faces in that
 direction.
The People of the Book know well
That it is the truth from their Lord,
Nor is God unmindful of what they do.

The 'sacred mosque' referred to is the Ka'ba in Mecca and thus the reminder to turn one's face in the direction of Mecca is in this case especially appropriate, for the Muslim dead are placed in their graves laying on their right sides with their faces looking towards Mecca. Chapter 112, *al-Ikhlas* (The Purity of Faith), is often found on tombstones:

Say! He is Allah,
The One and Only;
Allah the Eternal, Absolute;
He begets not,
Nor is He begotten;
And there is none like Him (fig. 105).

As the tombstone was regarded as a marker of the deceased's faith, use of this chapter, with its clear denunciation of the Christian Trinity, is also highly fitting. The interior and exterior of mosques are also inscribed with Qur'anic verses, traditionally one of the most popular of these being verse 9:18, one of only a few verses that makes any reference to mosques:

The mosques of Allah
Shall be visited and maintained
By such as believe in Allah and the Last Day;
Establish regular prayers and
Practice regular chastity
And fear None except Allah.
It is they who are expected
To be on true guidance.

Also popular for decorating mosques are the Throne Verse (2:255) and the Light Verse (24:35), both of which are amongst the most well-known and well-loved of all Qur'anic verses. The latter is frequently used on *mihrabs*, the decoration of which often includes a depiction of a lamp (a *mihrab* being the niche in the *qibla* wall of a mosque, marking the direction of Mecca, towards which Muslims must

pray). It is also commonly found inscribed on mosque lamps, in particular ones that were produced in Mamluk Egypt, mainly in the fourteenth century:

God is the Light of the heavens and the earth,
The likeness of His light is as if there were a
 niche
And within it a lamp;
The lamp enclosed in glass,
The glass as it were a shining star
Kindled from a blessed tree,
An olive, neither of the east nor of the west
The oil thereof blazes in splendour,
Even though fire has not touched it:
Light upon light!
Allah does guide whom He will to His light:
Allah does set forth signs for men,
And Allah does know all things.

Placed within the dome of a mosque or high on the sides of a minaret, Qur'anic inscriptions may often be difficult or even impossible to read, but their legibility seems a matter of little concern. What is instead important is the very presence of the word of God and the reassurance and the comfort that comes simply from knowing that God's words are there. Likewise, an inscription on an object may not be easily deciphered, depending on the particular script used, or the ornateness with which it is written; what is important is not necessarily knowing precisely what it says but knowing that it is the word of God.

QUR'ANIC COMMENTARIES

The Arabic word *tafsir* translates as 'explanation', 'elucidation', 'interpretation' or 'commentary', and although it can be used in relation to a commentary or interpretation of any text, it is used most frequently to refer to commentaries on the Qur'an and to the science or process of its interpretation. Qur'anic exegesis, or *tafsir*, is a fundamental aspect of traditional education as carried out in a *madrasa* (theological school). With the aim of clarifying the words of the Qur'an, the *tafsir* scholar may deal with matters such as grammar, lexicography and philology, or the providing of more precise identifications of and information on individuals referred to in the Qur'an.

The arrangement of the text of a *tafsir* usually follows that of the Qur'an, providing a commentary on the various chapters in the same order that they appear in the sacred text, as in the *tafsir* of the Persian jurist and theologian Nasir al-Din al-Baydawi (d. 1286–1316), which bears the title *Anwar al-tanzil wa asrar al-ta'wil* (The Lights of Revelation and the Mysteries of Interpretation). In a mid fifteenth-century copy of al-Baydawi's text (fig. 64), a simple illuminated heading presents the name of the chapter of the Qur'an that is to be discussed, and then beneath the heading the sacred text is presented in short sections, written in gold, with the commentary in black. Al-Baydawi produced his *tafsir* as a textbook and, indeed, this extremely popular *tafsir* continues to be widely used throughout the Muslim world.

Fig. 64
Anwar al-tanzil wa asrar al-ta'wil (The Lights of Revelation and the Mysteries of Interpretation) of Nasir al-Din al-Baydawi
Naskh script

1444 (AH 848)
36 x 27cm, CBL Ar 4188, f. 163b

This manuscript is a *tafsir*, a commentary on the Qur'an. On each page, the text of the Qur'an is written in short sections, in gold ink, while the commentary has been added in black ink. An illuminated heading at the beginning of each section gives the name of the chapter of the Qur'an that is being discussed, in this case chapter 48, *al-Fath* (The Victory).

سورة الفتح

4 QUR'ANIC CALLIGRAPHY AND CALLIGRAPHERS

THE ROLE AND ART OF THE CALLIGRAPHER

BECAUSE THE Qur'an is considered by Muslims to be a record of the actual words that God spoke to the Prophet Muhammad, the copying of the Qur'an is an act imbued with sanctity, making calligraphy the most highly esteemed art in Islam and placing the calligrapher in a position of pre-eminence over all other artists. This favoured position of calligraphy and the calligrapher in the religious domain extends to the secular domain as well as to other media. Thus, inscriptions, both Qur'anic and non-religious, decorate almost every object imaginable, such as ceramic bowls, glass mosque lamps, arms and armour, textiles, and buildings of all types, both sacred and secular. Calligraphy is indeed the most characteristic element of Islamic art and architecture of all periods and all regions.

Of the many great calligraphers the Islamic world has produced, none are more highly revered than Ibn Muqla (d. 940), Ibn al-Bawwab (d. 1022) and Yaqut al-Musta'simi (d. 1297–99), each of whom lived and worked in Baghdad. The second of this great medieval triumvirate, Ibn al-Bawwab, wrote a treatise on 'How to Become a Calligrapher', in which he warns the student of calligraphy that 'even the best beginner finds things difficult' and not to be put off if 'at first your reed [pen] yields naught but ugly scratches'; be patient, he counsels, for 'only patience brings desire to its fulfilment'. And this desire should be to write only the 'good and true', for not only will the calligrapher's work live on long after his departure from this world, but it will also be taken into account on the Day of Judgement. Ibn al-Bawwab thereby implies that a calligrapher's work will be seen as a reflection of his true nature, a view shared by other, later writers such as Sultan Ali (d. 1520), a renowned Persian calligrapher, who, in his own treatise on calligraphy, wrote that 'he who knows the soul knows that purity of writing proceeds from purity of heart' and that 'writing is the distinction of the pure'.

A calligrapher began his training at an early age and learned to write in the style of his master. Eventually, once he had completed his training and was himself a master, he would teach his own students in this same style, and they, in turn, would pass on what they had learned to their own students, and so on. In this way, 'chains' of calligraphers all working in the style of a specific master were developed over the years.

The calligrapher, young or old, would sit on the floor, with his work propped upon his knee, and write with reed pens of varying sizes. How the nib of the pen was trimmed was of great importance for it of course affected the writing of the script, and one of the great innovations in calligraphy occurred in the thirteenth century when Yaqut al-Musta'simi revolutionised Arabic calligraphy by introducing the trimming of the pen's nib at an angle to produce a more elegant script. The ink into which the calligrapher dipped his reed pen was made from a basic mixture of lampblack (soot), gum arabic (a gum exuded by the acacia tree) and vitriol, though sometimes with the addition of other ingredients such as saffron water, myrtle-leaf water, rosewater and narcissus liquor, or even more expensive substances such as pulverised pearl, gold, cinnabar or lapis lazuli. Until about the third quarter of the tenth century, Qur'ans were copied on parchment, even though for at least a century before that paper had been in use for the copying of all other types of texts. (In Spain and North Africa, however, it was still common practice in the fourteenth century to copy Qur'ans on parchment.) Sheets of parchment were produced by curing skins (usually sheep or goat skins), scraping them to remove all traces of flesh and fat, then stretching and drying them. The calligrapher's reed pen glided easily across the smooth, hard, and slightly waxy surface that was the final result of this long and arduous process. In order to produce a similar surface on which to write, paper had to be specially treated:

detail of fig. 82

usually wheat starch was brushed or sprinkled onto the damp paper and then the dried sheet was polished with a smooth, hard stone such as agate or rock crystal, thus creating a smooth, non–absorbent surface.

CALLIGRAPHIC SCRIPTS

Over the years a number of different scripts developed, most of which could be used for copying both sacred and secular texts. The earliest surviving Qur'ans are all mere fragments that are undated (those produced before the late tenth century). Manuscripts from the following period, up to the early thirteenth century, are more often intact, and therefore there is usually more documentary information retained in them on the manuscript's production, such as the date when the copying of the text was completed. Nevertheless, working out a chronology for the development of the scripts used in Qur'ans during this long period is, to a great extent, a matter of guesswork. A further problem concerns the naming of the scripts used. The two basic Qur'anic scripts of this period are both most

commonly known as *kufic* (after the city of Kufa in Iraq, though no link between the city and the scripts has ever been proven), but this erroneously implies a linear development from the earlier to the later script. Moreover, the usual addition of modifiers, such as 'Eastern' or 'Persian', to distinguish the *kufic* script of the later period from that of the earlier is confusing and equally erroneous, suggesting an unproven geographical bias in terms of use. Recently it has been suggested that these scripts would be better named Early Abbasid and New Style Abbasid, after the caliphal dynasty, based in Baghdad, that reigned from 750 to 1258. Resolving this matter of names is quite beyond the scope of this discussion, and so *kufic* will be retained as a generic name for the main Qur'anic scripts of the period, though with the addition, as necessary, of the adjectives 'early' and 'later'.

Early-*kufic*, the script used until the tenth century (and perhaps even much later), was almost exclusively a Qur'anic script (figs. 52 and 65–67). Most Qur'ans copied in this script consist of parchment folios in a horizontal format, the script itself

Figs. 65–66
Qur'an
Early-*kufic* script on parchment

9th or 10th century, North Africa or Muslim Spain
12.8 x 20.2cm, CBL Is 1411

Chapter headings in this Qur'an consist only of the title of the chapter, in this case al-Duha (The Glorious Morning Light), and the number of verses (eleven), written in gold ink, and a large, highly stylised palmette element in the margin (fig. 65). A similar (but badly worn) palmette extends into the margin of the frontispiece (fig. 66), only the right-hand page of which has survived. These stylised palmettes, the boldly interlaced forms of the frontispiece, and the palette (in which gold prevails, though here with the addition of burgundy, blue and green) are all typical features of manuscripts copied in early-*kufic* script. This manuscript is the final volume of what was apparently a sixty-part Qur'an.

Fig. 65
CBL Is 1411,
f. 2a

Fig. 66
CBL Is 1411,
f. 1b

being strongly horizontal, with a tight, compact feel: uprights are comparatively short and letters that would in other scripts extend below the baseline are kept tightly in check and made either to sit almost on the baseline or else dip only hesitantly below it; round letter forms that in other scripts are open in the centre are tightly closed; the penstroke is uniformly thick, adding to the squat plumpness of most examples of the script; and single letters are frequently stretched across the page – a technique known as *mashq*. Groups of connected letters are evenly spaced, causing words to be divided, often between lines. Although early-*kufic* is visually very appealing, these various traits make the script difficult to read, suggesting that Qur'ans written in this script were not produced to be read as such, but instead functioned as mnemonic devices or prompts for official reciters of the Qur'an, who knew the holy text by heart.

Official government documents and correspondence, as well as manuscripts other than copies of the Qur'an, were written in a variety of other scripts, ones less formal, more flowing and thus more easily executed than early-*kufic*. Many great calligraphers were in fact trained and worked throughout their lives in the government chancery, where these less majestic scripts flourished. One such individual was the early tenth-century calligrapher Ibn Muqla, who served as a government official, first as a secretary, then later as *wazir* (minister) to the caliph. Referred to previously as the first of the three great medieval calligraphers, Ibn Muqla is credited with having devised a system of geometrically proportioned writing; he also laid down a number of general guidelines for good writing, such as noting that lines of script should be straight and even, letters should not be cramped and crowded together, and round letter forms should be open in the centre. From this it is clear that Ibn Muqla was concerned with the legibility of scripts, and, indeed, this and the ability to write swiftly and efficiently were the major concerns of chancery scribes. The few extant samples of script attributed to Ibn Muqla (though none are certainly by him) are in the script referred to here as later-*kufic*, a development and refinement of the scripts used by the chancery

scribes and others for copying government documents and secular manuscripts (fig. 68).

Later-*kufic* was used to copy both Qur'ans and secular texts and also official documents, and by the end of the tenth century it had replaced early-*kufic* as the standard Qur'anic script. Unlike early-*kufic*, in later-*kufic* the thickness of the penstroke varies, sometimes dramatically so; letters dip well below the line, often forming deep curves; uprights may be slanted, sometimes curved, and sometimes dramatically elongated; and generally the script is more legible (in part because words are not divided between lines as is often the case with early-*kufic*). Some examples of the script, however, are highly stylised, at times so much so that they are difficult to read (fig. 69). All but a few of the very earliest Qur'ans in later-*kufic* are copied on paper in a vertical format. The script continued to be used for

Fig. 67
Qur'an
Early-kufic script

Mid 10th century, North Africa, prob.
Tunisia
27.8 x 36.8cm, CBL Is 1405, f. 1b

The text of this highly prized
manuscript is written in gold ink on
blue-dyed parchment, with marginal
devices in silver, though all are now
badly tarnished (as is the one in the
upper right margin of this page). It is
thought that the inspiration for this
Qur'an arose from contact between
the North African (Islamic) Fatimid
dynasty and the Byzantines, who
produced manuscripts copied in gold
ink on parchment coloured with the
dye Tyrian purple.

Fig. 68
Qur'an
Later-kufic script

972 (AH 361), Iran
26 x 17.8cm, CBL Is 1434, f. 55b

This manuscript is the earliest surviving,
dated Qur'an on paper.

some Qur'ans until the early thirteenth century, after which time it was relegated to the status of a decorative script. It then survived in this capacity until well into the fifteenth century, at least, and was used for various purposes such as the inscriptions in illuminations, in both Qur'ans and secular manuscripts (fig. 70 and see also figs. 1, 47–48 and 180).

Cursive scripts are those in which the letters of each word are joined, and thus, by definition, all Arabic writing is cursive as all but six letters of the alphabet are always joined to those that both precede and follow them. For children learning to write the Arabic alphabet, there is no equivalent to the progression – one that all school children in the West must undergo – from learning to print the letters of the Roman alphabet to learning cursive ('joined-up') handwriting. Nevertheless, some Arabic scripts can be considered 'more cursive' than others, and Ibn al-Bawwab, a follower of Ibn Muqla

and the second of the three great medieval calligraphers, is credited as being the first to copy a Qur'an in a truly cursive script. However, the precise identification of the script that he used (in what is today known eponymously as the Ibn al-Bawwab Qur'an, figs. 87–95) is a matter of some disagreement among scholars and calligraphers, some stating that it is *naskh*, others that is *rayhan*, and still others that it is a blend of these two scripts. In the thirteenth century, under Yaqut al-Musta'simi, these two scripts and four others were canonised as the so-called Six Pens. Many, if not all, of these scripts were in use long before Yaqut's time, so he in no way invented them, but instead he 'merely' perfected them by establishing standards for their execution (fig. 71).

Historically, calligraphers in Persian lands regarded the Six Pens as pairs of related large and small scripts, though the scripts could of course be written in any size: *thulth* and *naskh*, *muhaqqaq* and *rayhan*, and *tawqi* and *riqa* (the first of each pair being the larger). Calligraphers working in Arab lands instead more often grouped them as wet (in the sense of round and plumped up by the addition of moisture) and curvilinear (*thulth*, *tawqi* and *riqa*) or dry and rectilinear (*naskh*, *muhaqqaq* and *rayhan*). The dry scripts were the main book-hands, those used for copying out the Qur'an and other manuscripts, while the wet hands, which often incorporated numerous 'unauthorised' ligatures between letters that are not normally joined and which therefore enabled the script to be written more quickly, were used more by the chancery scribes for writing government documents and correspondence, but they were also the main decorative scripts, used for inscriptions in illuminations. Frequently the text of large Qur'ans was copied in different types and sizes of script, both 'wet' and 'dry', such as in an intriguing example incorporating three different scripts and copied in Iran in 1186 by one Abd al-Rahman ibn Abi Bakr ibn Abd al-Rahim, known as *zarin qalam*

Fig. 71
Qur'an
Muhaqqaq script copied by
Yaqut al-Musta'simi

Calligraphy 13th century, Iraq
Illumination late 16th century, Turkey
35.8 x 24.8cm, CBL Is 1452, f. 3a

Within his own lifetime and throughout
the following centuries, examples of
Yaqut's hand have been eagerly
collected. Not surprisingly, this quickly
led to the production of copies of
authentic Yaqut manuscripts, some of
which were undoubtedly produced in
homage to the great master but others
as actual fakes intended to deceive the
unwary collector. Compounding the
problem is the fact that, like some other
great masters, Yaqut apparently
granted certain of his most
accomplished students the privilege of
signing his name to their own work.
Thus many of the Qur'ans with
colophons 'signed' by Yaqut are of
questionable origin (e.g. figs. 27–28).
This particular Qur'an, however, is one
of those considered to be authentic (as
is the small prayer book in figs.
108–109). By the late sixteenth century
the manuscript was obviously in need
of repair and thus was given new, gold-
decorated borders. At the same time,
the lines of text were outlined and the
surrounding spaces filled with
illumination.

Fig. 72
Zarin Qalam's Qur'an
Naskh-muhaqqaq script
(main text only)

1186 (AH 582), Iran
43 x 31.5cm,
CBL Is 1438, ff. 124b–125a

Zarin Qalam's Qur'an

This superb Qur'an (fig. 72) was copied by Abd al-Rahman ibn Abi Bakr ibn Abd al-Rahim, who identifies himself in the colophon at the end of the manuscript as *al-katib al-maliki*, indicating his position as secretary or scribe to the ruler, and noting that he was known as *zarin qalam* (Golden Pen). On each page of the manuscript, a number of different scripts are used, both 'wet' (i.e. round) and 'dry' (i.e. rectilinear) scripts. As on the right-hand folio reproduced here, all regular pages of text are arranged as two, eight-line blocks of script set between three slightly longer lines of larger script. The two scripts are similar and each is a sort of *naskh-muhaqqaq* blend (both of which are 'dry' scripts). Chapter headings, as in the middle of the left-hand folio, consist of the *basmala* written in a large later-*kufic* script in black ink (perhaps tarnished silver), with the chapter title (*al-Nur*/The Light) and verse count (sixty) – and sometimes, but not here, the city in which the chapter was revealed

– written in a small gold *thulth* script and set between the stretched-out letters of the *basmala*. The text in red beside each heading is usually a *hadith* (a saying of the Prophet) relating to the chapter. Throughout the text the word 'Allah' is written in gold, as are any other words or phrases pertaining specifically to God (such as the words describing God as the 'oft-forgiving' and 'most merciful' at the end of last line of the left-hand folio). The end of each verse is marked by a small gold roundel inscribed, in *kufic*, with the word *aya* (verse); pointed marginals are inscribed with the word *khamsa* (five) and circular ones with the word *ashara* (ten). Very unusually, the decoration of the marginals includes, in addition to gold, a grey metallic pigment (which is probably not silver). In the upper margin of the left-hand folio is a diagonally placed line of black script indicating this point as the three-quarter mark of the thirty-sixth *hizb* of the Qur'an (each *hizb* being a one-sixtieth part of the Qur'an).

Figs. 73–74
Qur'an
Thulth script

12th–13th century, Iran
21.2 x 16cm, CBL Is 1448

This lovely page of illumination (fig. 73)
appears at the end of the manuscript;
however, its later-*kufic* inscription
incorrectly states that it marks the end
of parts thirteen and fourteen of the
Qur'an. The manuscript in fact contains
the text of part twelve, written on every
page In *thulth* In gold ink with the letters
all outlined in black (fig. 74).

Fig. 73
CBL Is 1448,
f. 52b

Fig. 74
CBL Is 1448,
f. 12b

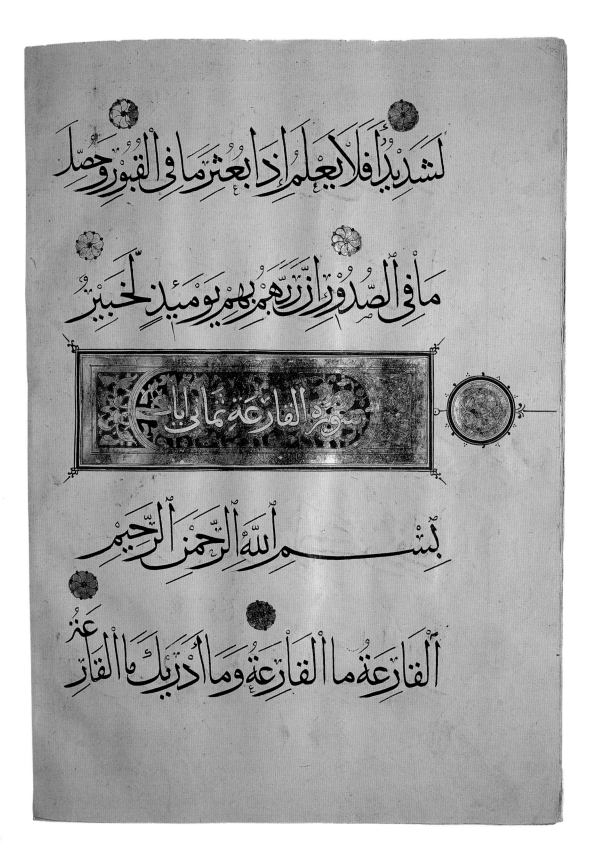

Fig. 75
Qur'an
Muhaqqaq script

14th century, Egypt
35.8 x 25.2cm, CBL Is 1493, f. 37b

The white *thulth* script of the heading identifies the text as that of Chapter 101, *al-Qari'ah* (The Great Calamity). The style of illumination used here is typical of manuscripts produced for the Mamluk rulers of Egypt in the late fourteenth and fifteenth centuries: the ground of the heading was completely covered with a layer of gold paint, which was then overpainted with coloured pigments, usually red and blue, as here, but leaving the motifs in reserve, resulting in a pattern of gold blossoms and leaves on a coloured ground (see figs. 21 and 137 for other manuscripts illuminated in this same style).

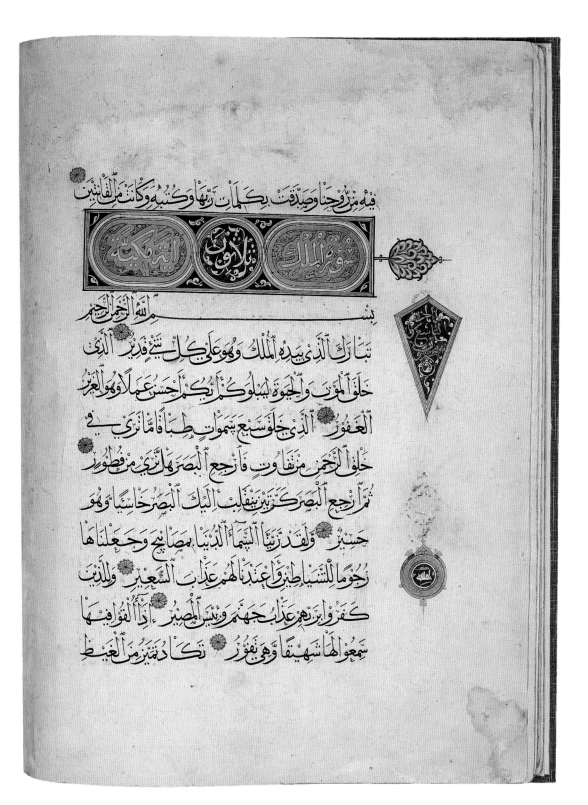

Fig. 76
Qur'an
Rayhan script

*c.*1335, prob. Baghdad, Iraq
37.5 x 27.7cm, CBL Is 1498, f. 19b

A specific feature of *muhaqqaq* and
rayhan scripts is that all vowel marks
are made using a pen with a nib that is
finer than that used for the actual text.
This heading is inscribed (in white
thulth) not only with the name of the
chapter, *al-Mulk* (The Dominion), and
the number of verses it comprises
(thirty), it also states that it was revealed
to the Prophet in Mecca. The kite-
shaped device in the margin notes that
this is not only the beginning of a new
chapter, it is also the beginning of the
twenty-ninth *juz*, or part, of the Qur'an.

Figs. 77–78
Qur'an
Naskh script

19th century, prob. Istanbul, Turkey
19 x 11.7cm, CBL Is 1570

A feature of manuscripts produced between the late seventeenth and nineteenth centuries for Ottoman Turkish patrons is their abundant use of gold (usually in at least two different shades or colours), but this small Qur'an surpasses almost all others in this respect. In this very fine frontispiece (fig. 77), the dazzling brilliance of the gold is offset by the posies of richly coloured flowers ('borrowed' from contemporary European art) that have been inserted into the border. The binding of the manuscript, too, employs an unusual amount of gold: the diaper pattern of the doublure (inside cover), visible here, is typical, but not so its unrelenting 'goldness' (nor the unusual contour of its 'envelope' flap). This overbearing use of gold plays out less well within the body of the manuscript, where the almost total absence of any contrasting colours in headings and marginals has a negative effect, weakening, not strengthening, the visual impact of the illuminations (fig. 78); the heading marks the beginning of Chapter 21, *al-Anbiya* (The Prophets).

Fig. 77
CBL Is 1570,
ff. 1b–2a

(Golden Pen, fig. 72). The difference between the so-called wet and dry scripts is, however, especially apparent on a folio from another such manuscript, also produced in Iran, but in the late fifteenth century (fig. 2). The text is written as three lines of large gold script sandwiching shorter lines of black script; the top line consists of the *basmala* (the invocation, 'In the name of God, the Merciful, the Compassionate') in the dry *muhaqqaq* script, but in the middle of the page the *basmala* is repeated, this time in the wet and much more curvilinear *thulth* script. *Thulth* was most often used, as here, for just a few lines of large script on each folio of a manuscript, or else as a decorative script (figs. 70 and 72); only rarely was it used to copy a complete Qur'an (figs. 73–74), although it has always played a major role as a monumental script, used for inscriptions on mosques and other buildings. *Muhaqqaq* emerged as the main Qur'anic script (fig. 75), while Qur'ans copied in *rayhan*, its smaller 'partner', are relatively uncommon (fig. 76). *Muhaqqaq*'s long-term popularity as a Qur'anic script was, however, outstripped by that of *naskh*, which not only became one of the most popular Qur'anic scripts (figs. 77–78), but also the standard script for copying all secular texts (though in Iran its popularity in this latter respect was rivalled by the distinctly Persian script *nasta'liq*, e.g. fig. 37).

Other scripts, besides the six canonical ones, were also used. Most of these are associated with specific regions of the Islamic world, such as the area encompassing all Arab countries west of Egypt and including Muslim Spain – the region known as the Maghrib (*maghrib* meaning 'west'). It was here that the script *maghribi* was used, for Qur'ans and all other types of texts, and it appears to have developed by the mid tenth century. At its finest, *maghribi* is a highly appealing, somewhat voluptuous script, full of deep, well-rounded and elegant curves (fig. 79). In the six canonical cursive scripts, there is usually a clear division between the lines of script, each line maintaining its individual integrity, but in *maghribi*,

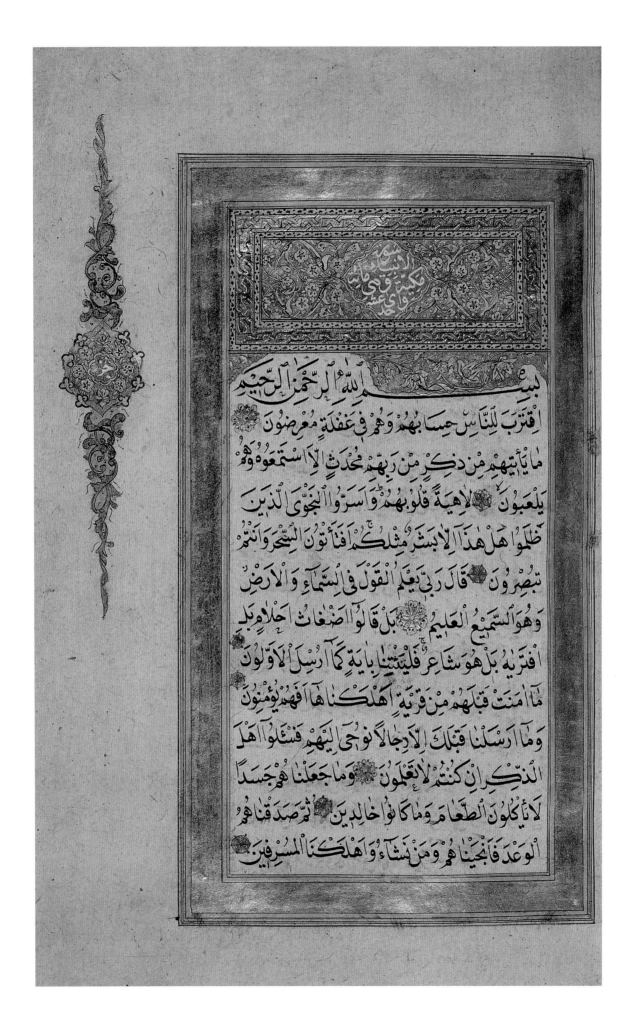

Fig. 78
CBL Is 1570,
f.152a

Fig. 79
Qur'an
Maghribi script

Late 16th century, North Africa, poss. Morocco
26 x 20.8cm, CBL Is 1560, ff. 19b–20a

The Arab countries west of Egypt and Muslim Spain were known as the Maghrib (*maghrib* meaning 'west'), and the script that developed in that region is known as *maghribi*. This is an extremely appealing example of this script, one characterised by especially deep and elegant curves.

the sublinear strokes often dip so far below the base-line – intruding upon the letters below – that the page sometimes seems less a series of distinct lines of script than a single mass of intertwined curves and sweeping strokes. Brown, not black, ink is often used in *maghribi* manuscripts, and in some examples of the script there is little variation in the width of the pen-stroke (fig. 80). Square format Qur'ans are typical of the region, often very small in size and copied in gold ink, on parchment folios, in a minute *maghribi* often referred to as *andalusi* (in reference to al-Andalus, the name given to Islamic Spain) (fig. 81). As noted previously, parchment was still in use in the Maghrib several centuries after it had gone out of

fashion in all other regions of the Islamic world.

Sudani is a form of *maghribi* used in the sub-Saharan regions of north-west Africa. (The script is named, not for the modern country of Sudan in the east of the continent, but for the geographical region, south of the Sahara Desert and north of the tropical zone, that stretches across the width of Africa.) Although *sudani*, too, is characterised by deep sublinear strokes, it is a more angular script than *maghribi* (figs. 82–83). There is also less definition between the baseline letters and the upstrokes, and the letters are generally more closely spaced, creating an overall denser appearance than in *maghribi*, an effect enhanced by the uniformly thick penstroke.

Fig. 80
Qur'an
Maghribi script

16th–17th century, North Africa
24.2 x 18.8cm, CBL Is 1522,
ff. 19b–20a

This Qur'an is highly unusual in that
several pages are decorated with gold,
long-stemmed plants. The word 'Allah'
is written in gold throughout.

below: a detail of fig. 81

Fig. 81
Qur'an, with heading for Chapter 19, *Maryam* (Mary)
Maghribi script on parchment

Early 13th century, Islamic Spain or North Africa
9.2 x 8.7cm, CBL Is 1444, ff. 63b–64a

The calligrapher of this small, square Qur'an has copied the text in gold ink, using a small *maghribi* script that is sometimes referred to as *andalusi*. Gold script is usually outlined in black to make it stand out against the light-coloured paper or parchment on which it is written (as in fig. 74); however, because of its small size, the script in this Qur'an has not been outlined, making it difficult to read. Most chapter headings in the manuscript consist of only a line of larger (outlined) gold *kufic* script and a stylised palmette in the margin, but because this heading marks the middle of the Qur'an, it is more elaborately treated.

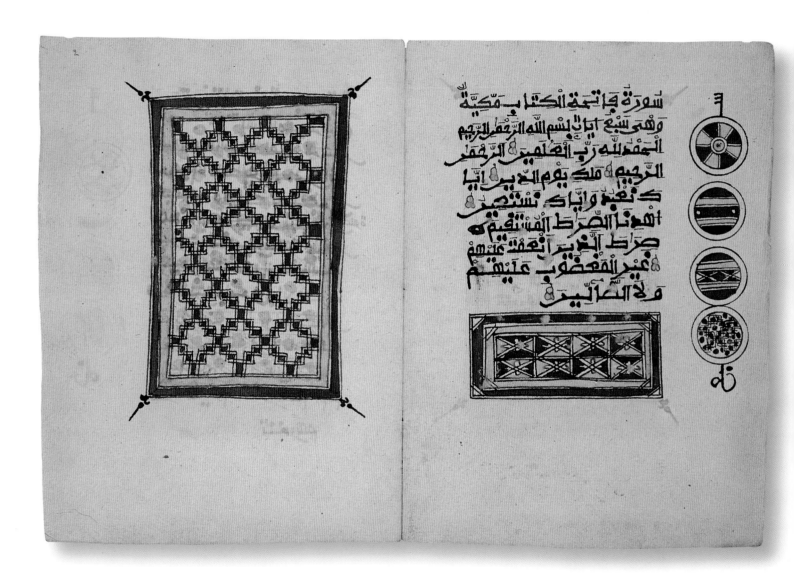

Qur'ans (and other manuscripts) in *sudani* script are highly distinctive, not only because the script itself is written in a brown ink on paper (often of European manufacture) that is only lightly burnished, but also because of their strictly geometrical ornamentation, mostly in browns, reds and yellows (there is never any gold pigment). Furthermore, the folios of these manuscripts are usually not bound but are kept loose between two boards and stored in a satchel with a long cord for carrying (fig. 84). Most Qur'ans in this style are undated but based on the evidence of

the few that are, they seem generally to have been produced in the nineteenth century.

Qur'ans produced in China followed developments in Iran and Central Asia and were often copied in *naskh* or *muhaqqaq* (fig. 85). However, a particularly Chinese version of *naskh* known as *sini* evolved (*sin* meaning 'China'), one which often has an obvious left slant, greatly extended sublinears trailing off in extreme fineness and, sometimes, overly rounded forms (fig. 86). In non-Qur'anic contexts, *sini* could be extremely intricate.

Fig. 82
Qur'an
Sudani script

19th century, North-west Africa
23 x 17cm, CBL Is 1601, ff. 1b–2a

Sudani is a form of *maghribi* that was used in the sub-Saharan regions of north-west Africa. It is generally a much more angular script than *maghribi*, but while this particular example is exceptionally angular, other examples of this same script are much less so and bear a closer resemblance to the *maghribi* used in the Qur'ans reproduced here as figs. 79–80.

Fig. 83
CBL Is 1598,
ff. 1b–2a

Fig. 84
CBL Is 1598,
cover board
and satchel

Figs. 83–84
Qur'an
Sudani script

19th century, North-west Africa
22 x 16.5cm, CBL Is 1598

An odd feature of Qur'ans of this type
(see also fig. 82) is that the introductory
illumination does not precede but
follows the first chapter (*al-Fatiha*), thus
highlighting the division between the
end of this chapter and the beginning
of the second chapter (*al-Baqara*).
This arrangement is presumably in
recognition of the very different nature
of *al-Fatiha*, which is in the form of a
prayer, in comparison with all other
chapters (see the discussion of
al-Fatiha, in Chapter 5).

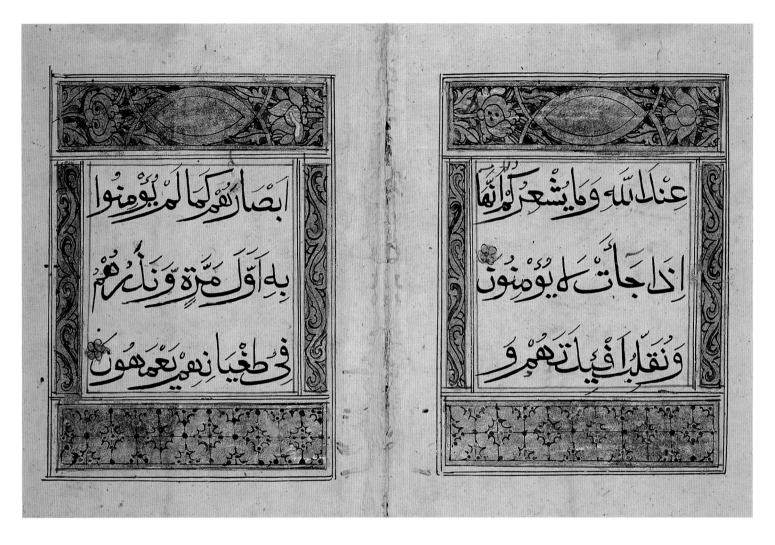

THE COLOPHON

Whether the calligrapher chose to copy the text of the Qur'an in *kufic, muhaqqaq, maghribi, sini* or some other script was obviously conditioned by the time and place in which he worked, and the script therefore can often provide an immediate clue as to where and when a manuscript was copied. However, having completed the copying of the text, the calligrapher (of both Qur'ans and secular manuscripts) often conveniently recorded such documentary information in a colophon at the end of the manuscript. The colophon is often set off from the rest of the text in a framed and clearly demarcated rectangular or triangular space, illuminated in gold and other pigments, and written in a script different from that used for the main text – often a highly decorative script and sometimes written in

gold ink, perhaps finely outlined in black (fig. 93, but see also fig. 141 for a colophon in a secular text). Most often, the information recorded includes the date when the copying of the text was completed. However, as the text was copied first, then the manuscript was illuminated and finally bound, the date provided is not the date at which all work on the manuscript was finished. The year, given according to the Islamic lunar calendar, is almost always written out in words, not given in numerals. Often the month and the actual day of the month is also stated and sometimes even the day of the week on which the calligrapher completed his work. He might also provide the name of the city in which the manuscript was copied, and if the city is referred to simply as *dar al-sultani*, meaning 'the abode of the sultan', then the manuscript was copied in the capital of the

Fig. 85
Qur'an
Muhaqqaq script

17th–18th century, China
21 x 15.4cm, CBL Is 1602, ff. 66b–67a

Like the script used, the illumination of Chinese Qur'ans was modelled on that of manuscripts produced in the central Islamic lands: the division of space in the upper panel of this frontispiece (in which stemmed lotus blossoms are placed at either end of a central, oval cartouche), the side panels of scrolling forms that border the text, and the predominantly gold palette are all features of illuminated manuscripts produced in Shiraz, in south-western Iran, in the late thirteenth and fourteenth centuries (and which, in turn, were derived from earlier Arab illumination).

Fig. 86
Qur'an
Sini script

18th century, China
25.8 x 17.5cm, CBL Is 1588, f. 7a

This very dramatic script is a version of *naskh* known as *sini* (*sin* means 'China'). In addition to the sweeping letter forms themselves, the intense blackness of the ink, the unusually white paper and the touches of red for certain orthographical marks all contribute to the very striking appearance of the folios of this Qur'an.

empire. Baghdad, a major centre of calligraphy and book production for many centuries, is often referred to not by name but as *dar al-salam*, 'the city of peace'.

The great respect in which calligraphers were (and still are) held is reflected by the frequency with which their names appear in colophons. Although it was of course the calligrapher himself who wrote the colophon, if he had been regarded as an insignif-icant artisan, he would not have been so bold as to sign his name. Having said that, he always preceded his name by a number of self-deprecating adjectives, such as the *al-da'if* (the weak), *al-faqir* (the poor) and *al-mudhnib* (the sinner), thus humbling himself before God (and his patron). If he was in the employ of the ruler, he might add *al-sultani* to his name, or he might add the name of his patron to his own name, as did the thirteenth-century calligrapher Yaqut *al-musta'simi* who worked for the caliph al-Musta'sim. He might also indicate the city from which he orig-inated (if working elsewhere) by referring to himself, for example, as *al-shirazi* ('the Shirazi', Shi-raz being a city in south-western Iran) or *al-harawi* ('the Herati', indicating Herat in Afghanistan). Or he might simply add *al-katib* (the scribe) to the end of his name. A modifier to one's name such as these is known as a *nisba*. Less frequently, the colophon will include the name of the patron of the manu-script (which, if included at all, is more likely to be stated at the beginning of the manuscript), and it will almost always include a number of blessings and per-haps short prayers. Sometimes, however, even if the calligrapher documented his work in a colophon, the information may now be lost to us, as the first and final folios of a manuscript, those on which doc-umentary information is usually recorded, are always the first to be lost if the manuscript should suffer any damage, such as loss of its binding.

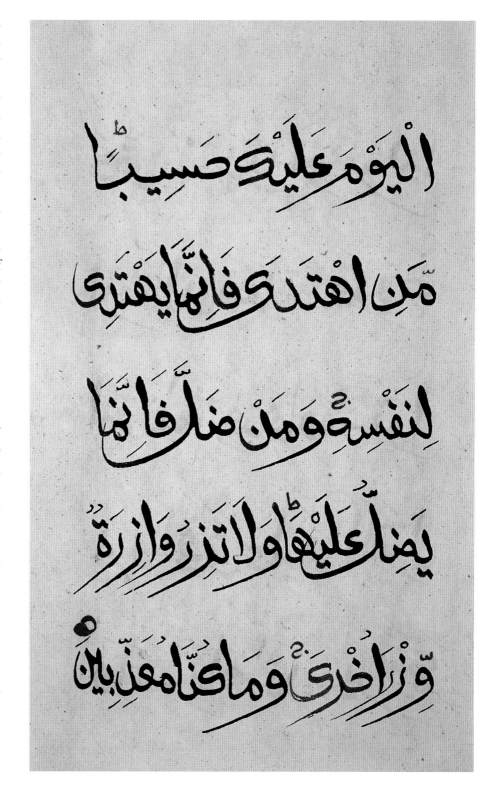

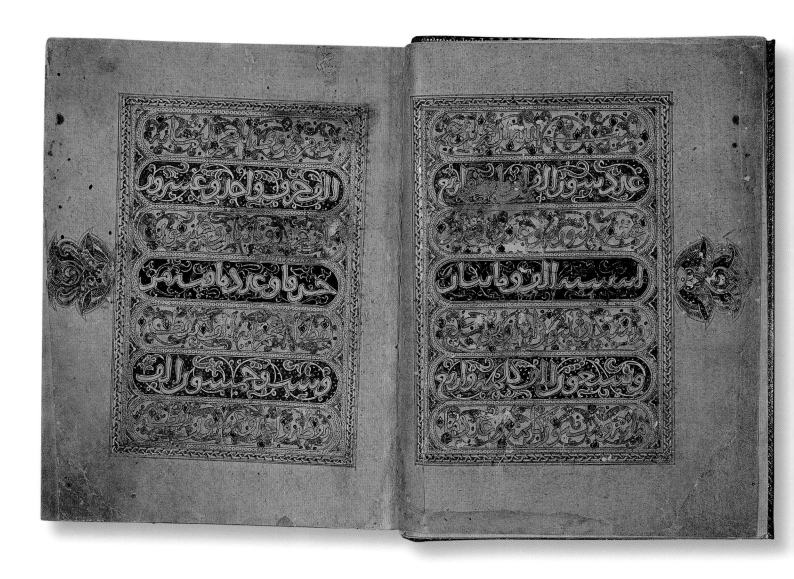

The Ibn al-Bawwab Qur'an

In 1000–01, in Baghdad, Ibn al-Bawwab both copied and illuminated a Qur'an that is today one of the most renowned Qur'ans in existence (figs. 87–92), its fame outstripped only by the folios of a Qur'an that allegedly, but surely not, once belonged to the caliph Uthman. Ibn al-Bawwab's name was actually Abu'l Hasan Ali ibn Hilal, but his father, Hilal, was a doorkeeper, or *bawwab*, and so his son became known as Ibn al-Bawwab, 'the son of the doorkeeper'. Six manuscripts bear Ibn al-Bawwab's name, but this Qur'an is widely considered to be the only genuine work by him to have survived. It is also important for being the earliest dated Qur'an copied in a truly cursive script, and it is one of the earliest Qur'ans copied on paper. As noted previously, the script used to copy the text is described by some as *naskh*, by others as *rayhan*, and by yet others as a combination of the two; *kufic*, *thulth* and *riqa* are used for more decorative purposes in headings, marginals and other inscriptions (e.g. see fig. 92).

The manuscript is surprisingly small, but impressive for its extensive illumination, with the holy text enveloped in a 'casing' of five double pages

Figs. 87–95
The Ibn al-Bawwab Qur'an
Naskh-rayhan script

1000–01 (AH 391), Baghdad, Iraq
17.7 x 13.7cm, CBL Is 1431

Fig. 87
Folios stating the chapter, verse count etc. of the Qur'an
CBL Is1431, ff. 6b–7a

Fig. 88
The continuation of the count of the preceding folios
CBL Is 1431, ff. 7b–8a

of illumination, three at the beginning of the manuscript and two at the end. Two are purely decorative, but the other three include text that is unusual in its recording, in painstaking detail, of statistical information on the Qur'an. The first of these double pages (fig. 87, ff. 6b–7a; the first folios are preceded by five blank, modern flyleaves included in the pagination of the manuscript) records that the Qur'an consists of 114 chapters, divided into a total of 6,236 verses, which in turn comprise 77,460 words made up of a total of 321,250 letters and 156,051 points (dots to distinguish letters with the

same outline). The somewhat simple, but lovely, composition of these two pages is followed by the more complex composition of the second opening (fig. 88): on each page, a single, continuous gold band wends its way across the page, encapsulating the text in six octagonal 'cages'. The text here continues the verse count of the preceding opening and also informs the reader that the verse count is that of the Qur'anic scholars of the city of Kufa, which in turn derives from the count of Ali, the fourth caliph.

The third opening (fig. 89) is purely decorative, with no text at all, and is a brilliant summation of

Fig. 89
CBL Is 1431,
ff. 8b–9a

Fig. 90
Headings for Chapter 1, *al-Fatiha*, and for Chapter 2, *al-Baqara*
CBL Is 1431, ff. 9b–10a

Islamic illumination of the time and of years to come. Geometry prevails: interlaced bands of gold define and divide space, with the areas between the interlacement filled with a groundcover of interlocking and interconnected motifs, while a band of gold strapwork (itself a composite of interlaced bands) establishes the rectangular boundary of the composition. Vegetal motifs abound: a lush arabesque sits in the centre of each page surrounded by four small, short-stemmed lotuses, one at each of the four cardinal points, while a stylised palmette occupies the margin, beyond the space of the main composition. These, along with the palette in which gold

and blue prevail, are the 'tools' of the Islamic illuminator, the basic elements and motifs that will appear and re-appear, in slightly altered forms, throughout the centuries and which, even today (along with calligraphy itself), are the hallmarks of Islamic art.

At the end of the manuscript, facing the final page of text, is an illuminated colophon (fig. 93), followed by two further double pages of illumination, of which the first (fig. 94) is the counterpart of that in fig. 89. The second (fig. 95) continues the theme of the introductory openings: in a column at the right side of each page, in blue *kufic* script, is the name of each letter of the Arabic alphabet, and writ-

Fig. 91
Heading for Chapter 28, *al-Qasas* (The Narrations)
CBL Is 1431, ff. 177b–178a

ten beside each name, in gold *riqa* script, is the number of times the letter appears in the Qur'an.

Sandwiched between this extravaganza of illumination and data is the actual text of the Qur'an. On the first page of text are headings announcing the beginning of the first two chapters, each heading consisting of text inscribed within an illuminated panel (fig. 90). All successive chapter headings are, however, treated more simply, instead consisting only of a line of gold *thulth* script, at the end of which, set in the margin of the page, is a stylised palmette (figs. 91–92). Each heading states the name of the chapter and the number of verses

it contains, and sometimes also the city in which the chapter was revealed. The end of each verse is marked by three tiny blue dots, but with no actual break between verses. However, at the end of every fifth verse is a small gold device in the shape of the Arabic letter *ha*, the letter that corresponds to the number five in the so-called *abjad* system in which each letter of the Arabic alphabet is given a numeric value (e.g. see fig. 91 with a gold *ha* in the second line from the top on the left-hand page). Likewise, at the end of every tenth verse there is a small gold circle filled with a letter corresponding to the number of verses, either ten, twenty, thirty

Fig. 92
**Headings for Chapter 97, *al-Qadr*
(The Night of Power), and
Chapter 98, *al-Bayyina* (The Clear
Evidence); with *sajda* marker**
CBL Is 1431, f. 280a

Fig. 93
Colophon
CBL Is 1431, f. 284a

etc., but, also, in the margin, there is always a device inscribed with the corresponding word. Thus, on the right-hand page of fig. 91, there is a marginal inscribed with the Arabic word for 'seventy' and beneath it one inscribed with the word for 'eighty', and in the text are corresponding circles with the Arabic letters *ayn* and *fa*, the *abjad* equivalents of seventy and eighty, respectively. It seems, however, that Ibn al-Bawwab made a slight mistake on the facing page, because the marginal there is correctly inscribed with the word for 'ninety', but he has again, incorrectly, placed an *ayn* in the circle in the text. These marginals are all a single type – simple

circular forms surrounded by tiny rays – and quite unlike the elaborate and diverse assortment of marginals that indicate places in the text requiring ritual prostration and which are inscribed with the word *sajda* (prostration), such as the fine example in fig. 92.

In the colophon facing the final chapters of the Qur'an (fig. 93), Ibn al-Bawwab has recorded his completion of the copying of the text in Baghdad, in the Islamic year 391 (AD 1000–01). He then ends by praising God, calling for blessings upon Muhammad and his family, and begging forgiveness for his own sins.

Fig. 94
CBL Is 1431,
ff. 284b–285a

Fig. 95
Folios stating individual letter counts
CBL Is 1431,
ff. 285b–286a

Figs. 96–104
The Ruzbihan Qur'an
Copied and illuminated by Ruzbihan
Muhammad al-Tab'i al-Shirazi

Mid 16th century, Shiraz, Iran
42.7 x 29cm, CBL Is 1558

THE RUZBIHAN QUR'AN

One of the most magnificent Qur'ans ever produced is the work of Ruzbihan Muhammad al-Tab'i al-Shirazi. Quite unlike the Ibn al-Bawwab Qur'an, this is a large, heavy and very 'showy' manuscript, almost every square centimetre of it being covered with decoration. It was produced in the city of Shiraz, in south-western Iran, in the mid sixteenth century. Ruzbihan, one of the most renowned calligraphers of his time, not only copied the text of the manuscript, but, as did Ibn al-Bawwab in his Qur'an, he also illuminated it, though surely with the help of a number of assistants. On the opening pages of the manuscript (fig. 96), the words of God appear as though set in the midst of a blaze of light: spread across two star-shaped medallions encircled by long rays – known as *shams*s (*shams* meaning 'sun') – is verse 17:88 of the Qur'an (*al-Isra*/The Night Journey), written in white *tawqi* script. The verse states:

> Say: If the whole
> Of mankind and jinns
> Were to gather together
> To produce the like of this Qur'an,
> They could not produce the like thereof,
> Even if they backed up each other
> With help and support.

This verse is found at the beginning of many Persian Qur'ans of the sixteenth century, wherein it functions as a sort of conceit, because, while the reference is to the actual Revelation itself, it can also be taken to refer to the spectacular decoration of the particular manuscript at hand, and thereby as a challenge to others to produce a manuscript as beautiful.

Following the *shams*s is a double-page frontispiece in which *al-Fatiha* – the first short chapter of the Qur'an – is written in white *rayhan* script, spread over the two central, oval medallions (fig. 97). The title of the chapter and the verse count are

Fig. 96
**Shamsas containing verse 17:88
of the Qur'an**
CBL Is 1558, ff. 1b–2a

given in the two upper cartouches, one above each central medallion. In the two cartouches below the medallions are verses 56:79–80 of the Qur'an (*al-Waqi'a*/The Inevitable), but the inclusion of these two verses presupposes that one knows the two preceding verses of the chapter. Thus the complete Qur'anic quotation reads – or is intended to be read as:

[This is indeed a Qur'an most honourable
 In a book well-guarded]
Which none shall touch but those who are clean;
A revelation from the Lord of the Worlds.

A third double opening of illumination (fig. 98) marks the beginning of the second chapter, *al-Baqara*: a large and beautiful heading is placed at the top of the right-hand page, with the text on both pages set against either a blue or gold ground. In the approximate middle of the manuscript (fig. 99) is a very similar double page of illumination, marking the start of Chapter 18, *al-Kahf*.

The quintessentially Islamic decorative element is the arabesque, a scrolling, interlacing vine that winds its way across the page. In early examples of the Islamic arabesque, it is palmette leaves only – whether half-, split or full-palmettes – that spring from the vine, but by the sixteenth century, it is the floral-arabesque that dominates – as it does in Ruzbihan's Qur'an: a myriad of brightly coloured blossoms all linked one to the other by a thin swirling vine. The pigments Ruzbihan used for his arabesques were derived from minerals (such as gold or lapis lazuli) and organic substances (plant and animal stuffs, such as indigo), while others were the result of chemical reactions (such as the green pigment verdigris made from exposing copper to acetic acid). The minerals and other substances were ground to a fine powder and then mixed with a binding agent, for example, albumen (egg white). Colours were built up through the application of numerous thin layers of paint, using

Fig. 97
**Double-page
frontispiece containing
Chapter 1,** *al-Fatiha*
CBL Is 1558, ff. 2b–3a

brushes made from the hair of cats, squirrels, goats, or the inside of a calf's ear, depending on the fineness or coarseness required. It is said that kittens were often bred specially, as the very finest brushes were those made from hair cut from the throat of white kittens, two months old. Once dry, the pigments were burnished with a hard stone such as an agate or a piece of rock crystal. Burnishing took place throughout the painting process, but especially at the end; it

helped to bind the particles of the pigments together and made them shine.

In Ruzbihan's Qur'an, even the pages of text are extravagantly decorated, and, as in most fine manuscripts of the time, the text of each page has been copied onto a small sheet of paper which was later inserted into the surrounding borders, the join between the two pieces ingeniously hidden by a series of coloured rulings and a band of gold. The

Fig. 98
Heading for Chapter 2, *al-Baqara*

Fig. 98a
CBL Is 1558, f. 4a

Fig. 98b
CBL Is 1558, f. 3b

Fig. 99
**Heading for Chapter 18, *al-Kahf*,
marking the middle of the Qur'an**
CBL Is 1558, ff. 208b–209a

layout of the text (fig. 100) is also typical in that a variety of sizes and types of script, written in gold and coloured inks, appear on every page. Three lines of large and bold script dominate each page – *muhaqqaq* script at the top and bottom and *thulth* in the middle – each line written on paper that has been lightly coloured. Set between these lines of large script are blocks of shorter lines of black *naskh* script, at either end of which are panels of coloured pigment, overpainted with delicate gold blossoms. This basic layout of the text is interrupted only on those pages where chapter headings appear (figs. 101–102). Once the copying of the text was complete, the paper of each small sheet was generously sprinkled with flecks of gold. A final touch of elegance is the careful treatment of the verse markers: some consist of a simple swirl of gold, but most are finely worked rosettes or else interlaced knot devices, the gold of which has been carefully punched, each tiny indentation catching, and glimmering in, the light. (The gold of all marginal devices has been likewise punched.)

Fig. 100
Chapter 25, *al-Furqan* (The Criterion)

Fig. 100a
CBL Is 1558, f. 258a

Fig. 100b
CBL Is 1558, f. 257b

Fig. 101
Heading for Chapter 43, *al-Zukhruf* (The Gold Adornments)
CBL Is 1558, f. 354b

Fig. 102
Heading for Chapter 74,
al-Muddaththir
(The One Wrapped Up)
CBL Is 1558, f. 421b

The manuscript – such a breath-taking *tour de force* of the illuminators' art – ends with a final burst of magnificence. Yet another double page of decoration (fig. 104) surrounds the final, short chapters of the holy text, the main feature of which is an elaborate border, from which emerges an apparent explosion of light – long and elegant rays surely intended to symbolise the radiance of the words of God. The following, final page is as spectacularly lovely (fig. 103). It consists of a prayer to be read upon completion of the reading of the Qur'an, introduced, at the top of the page, by a beautifully illuminated heading, with the text of the prayer written below in widely spaced lines of a large white *muhaqqaq* script, set against a ground of gold and interspersed by brightly coloured blossoms.

Fig. 103
**Prayer to be read upon
completion of the Qur'an**
CBL Is 1558, f. 445b

Fig. 104
Headings for Chapters 112,
al-Ikhlas **(The Purity of Faith);**
113, *al-Falaq* **(Daybreak);**
and 114, *al-Nas* **(Mankind)**
CBL Is 1558, ff. 444b–445a

5 THE PRACTICE OF THE FAITH

THE FIVE PILLARS OF ISLAM

THERE ARE FIVE basic duties and observances that are obligatory for all Muslims. Known as the pillars (*arkan*) of Islam, they are the foundation of the faith and consist of the profession of the faith, daily prayer, the giving of alms, observance of the annual fast, and the pilgrimage to Mecca.

THE FIRST PILLAR OF ISLAM: THE PROFESSION OF THE FAITH

The Muslim profession of faith (or *shahada*, meaning 'witnessing' or 'testifying') states that 'There is no god but God [Allah] and Muhammad is the Messenger of God'. The Qur'an clearly states that 'It is not consonant with the majesty of Rahman Most Gracious [meaning God] that He should beget a son' (19:92). God can have no son, divine or otherwise, and it is this belief that is expressed in the first part of the *shahada*, while the second part recognises Muhammad's role as the one who delivered the message of God to the people. Thus the *shahada* is a succinct and direct assertion of the two leading principles of Islam: monotheism and the apostolate of Muhammad. Anyone wishing to convert to Islam need only repeat the *shahada* before Muslim witnesses, while truly believing the words in one's heart (fig. 105).

THE SECOND PILLAR OF ISLAM: DAILY PRAYER

For a practising Muslim, the rhythm of one's day is dictated by the obligation to perform the ritual prayer, known as *salat*, five times each day. It may be carried out almost anywhere, as long as one is facing the Ka'ba in Mecca, but communal prayer is deemed more meritorious and all adult male members of the community should perform the noon prayer on Friday in the mosque (fig. 106). Female members of the community may also attend Friday prayers but it is equally acceptable for them to pray at home. During the Friday congregational prayer,

the *imam*, or prayer-leader, will deliver a sermon, or *khutba*, while standing on the steps of a pulpit-like structure known as a *minbar* (fig. 107). There is often a strong political dimension to the *khutba*: historically, not only might the content of the *khutba* be of a political nature but, because it was usually delivered in the name of the ruler, the sovereignty of a new ruler (whether legitimate or not) would be proclaimed and asserted by the inclusion of his name in the *khutba*.

Five times each day a *mu'adhdhin* (or *muezzin* in Persian transliteration) calls the faithful to prayer. The call to pray is known as the *adhan* (announcement) and consists of set formulae, which include the profession of faith or *shahada*, the invocation 'God is most great', and the phrases 'Come to prayer' and 'Come to salvation', each repeated two or more times. Before the morning prayer the *mu'adhdhin* ends with the reminder that prayer is better than sleep. Although it is generally said that prayers take place each day at sunrise, midday, afternoon, sunset (the start of the Muslim day) and evening, they in fact must occur during much more specifically described periods of time. For example, the 'sunrise' prayer may take place between the moment when the first sign of light appears in the sky until immediately *before* sunrise, often described as the time during which the light is such that a white thread cannot be distinguished from a black thread. Similarly, the true time of the 'midday' prayer is from immediately *after* the sun has reached its zenith until the sun has declined to the point that an object's shadow is double its length. In the past, quadrants and astrolabes were used to determine the time and direction of prayer and manuals for assisting in the making of these calculations were frequently produced. Today, this can be done by computers, and special watches can be purchased which determine the times of prayer in any region and season, and prayer mats with built-in compasses are also available if one is not praying in a mosque (in which the

Fig. 105
Qur'an, with headings for Chapters 108–114

Naskh, muhaqqaq and *thulth* scripts

1574–75 (AH 982), Iran
38.5 x 24cm, CBL Is 1534,
ff. 307b–308a

The illuminated heading in the upper left-hand page announces the start of Chapter 112, *al-Ikhlas* (The Purity of Faith). The text of this chapter upholds one of the basic principles of Islam by declaring: 'Say! He is Allah, the One and Only; Allah, the Eternal, Absolute; He begets not, nor is He begotten; And there is none like Him.' Each page of text (as on the right-hand page) consists of blocks of shorter lines of small black *naskh* script with a longer line of a large *muhaqqaq* script at the top and bottom of the page and a line of a large *thulth* script in the middle; as on these two facing pages, these longer lines are always written in an alternating pattern of blue and gold ink.

Fig. 106
**The Suleymaniye Mosque, from
the History of Sultan Suleyman**

1579 (AH 987), Istanbul, Turkey
39.5 x 25cm, CBL T 413, f. 119a

The Suleymaniye mosque is part of a
large complex built in Istanbul by the
Ottoman sultan Suleyman the
Magnificent and completed in 1557,
some twenty years before his grandson
Murad III had this painting of the
mosque produced as an illustration to a
history of his grandfather's reign. The
section at the right is the spacious
prayer hall, topped by a large dome
which is encircled by a number of
smaller domes and semi-domes.
Extending to the left is the courtyard,
surrounded by a high wall, within which
is a fountain for ablutions. A typical
feature of a mosque is the minaret –
here there are four – from which the call
to prayer is made. Adjoining the
mosque, to the right of the prayer hall
and not visible in this painting, is a
walled cemetery, in which are the
tombs of Suleyman and his wife
Roxelana (fig. 60).

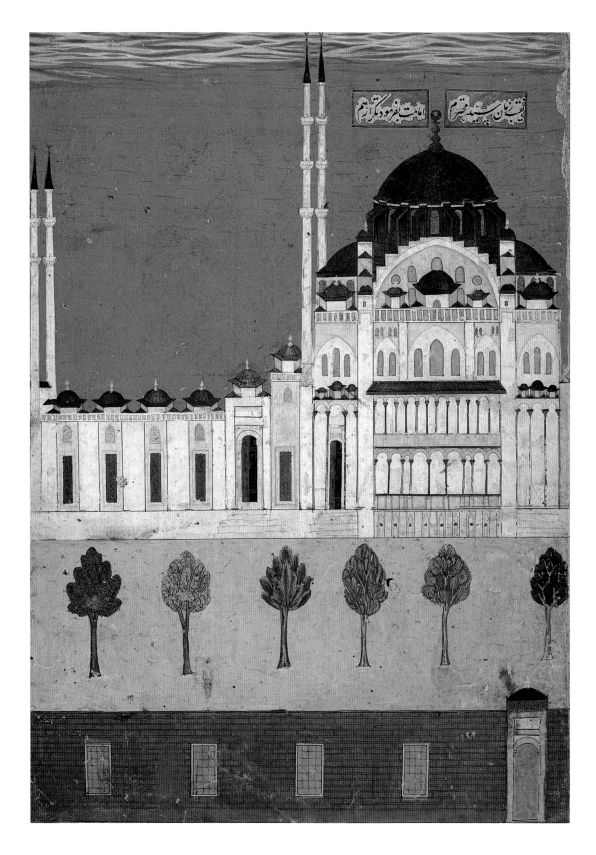

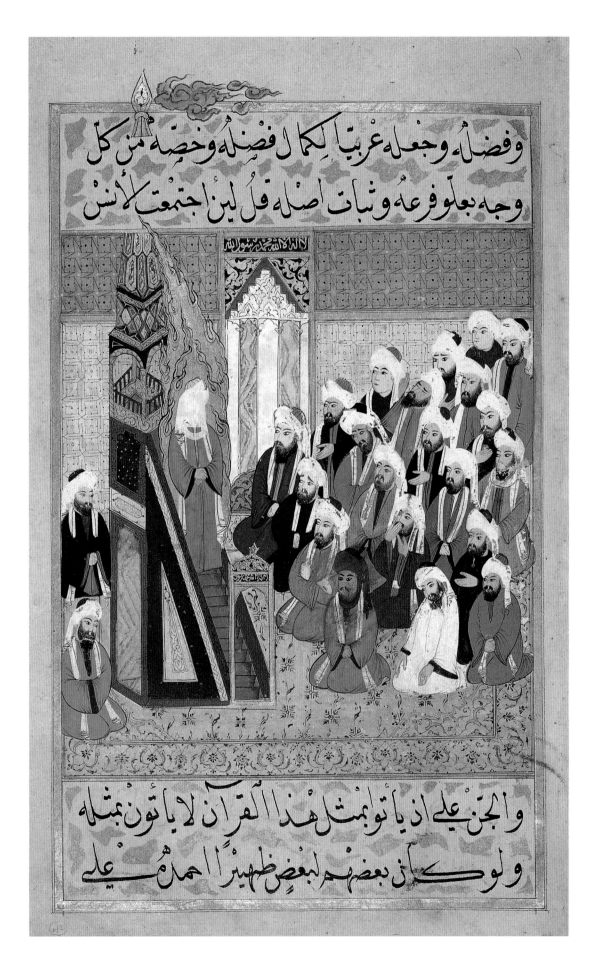

Fig. 107
**Muhammad Delivers a Sermon,
from *Siyar-i nabi* (The Life of the
Prophet)**
Turkish text in *naskh* script

1594–95 (AH 1003), Istanbul, Turkey
37.4 x 27cm, CBL T 419, f. 173a

Muhammad is shown standing on a
minbar, or pulpit, within the prayer hall
of a mosque. In the wall to the right is
the *mihrab*, an arched niche that
indicates the direction of Mecca, the
direction which Muslims must face
when praying. (Usually, however, the
minbar is placed to the right of the
mihrab.) In the small rectangular panel
above the *mihrab* and also in the one
above the arched entrance to the steps
of the *minbar* is the *shahada*, the
Muslim profession of faith, written in
gold on a blue ground.

qibla, or direction of Mecca, is indicated by a niche in the wall known as a *mihrab*).

Prayer must be preceded by ritual washing, or ablutions, for purification. There are two types of purification – *ghusl*, the major ablution, and *wudu*, the lesser ablution. *Ghusl* is the washing of the whole body that must take place after events such as sexual contact, menstruation or childbirth. In pre-modern times (and often still today depending on one's circumstances), this would normally take place at the public bath or *hammam*. *Wudu* consists of washing the face and head (including the mouth, nose and ears), the hands and arms up to the elbows, and the feet to the ankles (and assumes that *ghusl* has previously taken place). Facilities for carrying out *wudu* are usually provided in the form of a fountain in the courtyard of a mosque or else taps around the exterior edge of the mosque itself. If water is not easily available, as may be the case when travelling, then clean sand or earth or even a clean stone may be substituted for water. Once the ablutions are complete, one must announce to God the intention to perform *salat*; only then can prayer actually begin. Each prayer consists of a minimum of two, three or four prayer units (depending on the time of day) and each unit, or *rak'a* (from the Arabic verb meaning 'to bend'), consists of Qur'anic verses and set invocations or formulae recited while standing, bowing, prostrating and sitting. A total of seventeen prayer units are said each day if all five prayers are recited, although most individuals will perform extra units. At the beginning of each prayer unit, one must recite the first chapter of the Qur'an, appropriately entitled *al-Fatiha* (The Opening), which, as noted previously, is one of the shortest chapters in the Qur'an. *Al-Fatiha* is considered to have special spiritual power and inscriptions on tombstones frequently include the request that visitors say a *fatiha* for the soul of the deceased. The text of this much-loved chapter praises God and begs for His guidance along the right path (fig. 124).

Because all Muslims, no matter where they live and no matter what their native tongue might be, must perform *salat* in Arabic from memory, all practising Muslims must know at least a little Arabic. *Du'a*, however, is a voluntary and private prayer which may be said in any language at any time (but which does not replace the obligation to perform *salat*). Numerous manuscripts exist that are collections of prayers that fall into the category of *du'a*, many of which are in languages other than Arabic. Some are prayers for the various days of the week, with each day's prayer introduced by a small, illuminated heading inscribed with the name of the day (figs. 108–109). Others consist of prayers for specific occasions or requirements, such as the citing of the new moon, the destruction of one's enemies or the averting of specific illnesses. A large number of prayer books have survived from Ottoman Turkey (e.g. figs. 110–111), produced mainly between the late seventeenth and nineteenth centuries, and, like many Qur'ans of this same period, they are, as a group, distinctive for their small format (frequently only about 15 x 10cm/6 x 4in.), extensive decoration marked by an abundant use of gold both within the manuscript and on its covers, and frequent incorporation of motifs derived from Western art. The contents of most of these small prayer books is diverse, including, besides prayers, various chapters of the Qur'an and a variety of other devotional material. This might include lists of the ninety-nine names of God (fig. 125) and of Muhammad (fig. 18), litanies in praise of Muhammad, descriptions of the Prophet's physical appearance (*hilya*s, see fig. 22) and a mystical description of Muhammad's tomb. The latter is usually accompanied by illustrations, on facing pages, of the Prophet's Mosque in Medina, where the tomb is located, and of the Great Mosque of Mecca (fig. 112). Many of these small prayer books also include a number of diagrammatic illustrations, usually expressive of particular

Figs. 108–109
**Ad'iyat al-aiyam al-sab'a
(Prayers for the Seven Days
of the Week)**

1283 (AH 682), Baghdad, Iraq
16.5 x 12.3cm, CBL Ar 4237

The Arabic names of the days of the week are basically numbers, with Sunday being day one. However, Friday, the day when the community of Muslims gather at the mosque for communal prayer, is referred to not as the sixth day but as *al-jum'a*, from the verb meaning 'to gather' or 'to collect'. This small manuscript is a compendium of daily prayers, with each of its seven sections introduced by an illuminated heading bearing the name of the day of the week on which the prayers are to be said. The heading shown here is for Wednesday (fig. 108). These prayers fall into the category of *du'a*, voluntary and private prayers. The title of the text appears in a simple medallion on the first folio of the manuscript (fig. 109). According to the colophon, the text was copied by Yaqut al-Musta'simi; thus this small, unassuming manuscript is an important record of the hand of this great calligrapher.

Fig. 108
CBL Ar 4237,
ff. 15b–16a

Fig. 109
CBL Ar 4237,
f. 1a

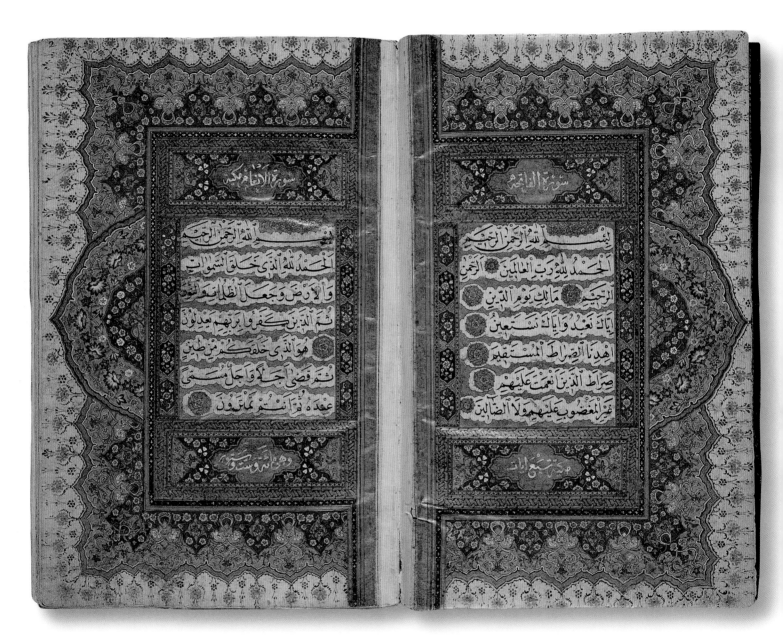

Fig. 110
Book of Prayers
Naskh script

1749 (AH 1162), Turkey
16.5 x 11cm, CBL T 449, ff. 1b–2a

This small prayer book includes various verses of the Qur'an, and indeed it begins as would a Qur'an, with this gorgeous little frontispiece surrounding, on the right-hand page, *al-Fatiha*, the first chapter of the Qur'an. However, on the facing page is the beginning, not of Chapter 2, but Chapter 6 of the Qur'an, *al-An'am* (The Cattle), which begins by proclaiming, 'Praise be to Allah, Who created the heavens and the earth, And made the darkness and the light.'

Fig. 111
Book of Prayers
Naskh script

1798 (AH 1213), Turkey
17.7 x 11.2cm, CBL T 464,
front cover and inside back flap

The exterior decoration of this binding consists of a painted design of mainly European inspiration. The large leaves, known as *saz* leaves, which divide the space of the composition, are Turkish, but the way in which they are deployed here is not. Likewise is the use of two shades of gold Turkish but the various types of floral motifs are purely European. The interior of the binding (doublure), visible on the 'envelope' flap, is, however, decorated in a typical Turkish style (see also the doublure of fig. 77).

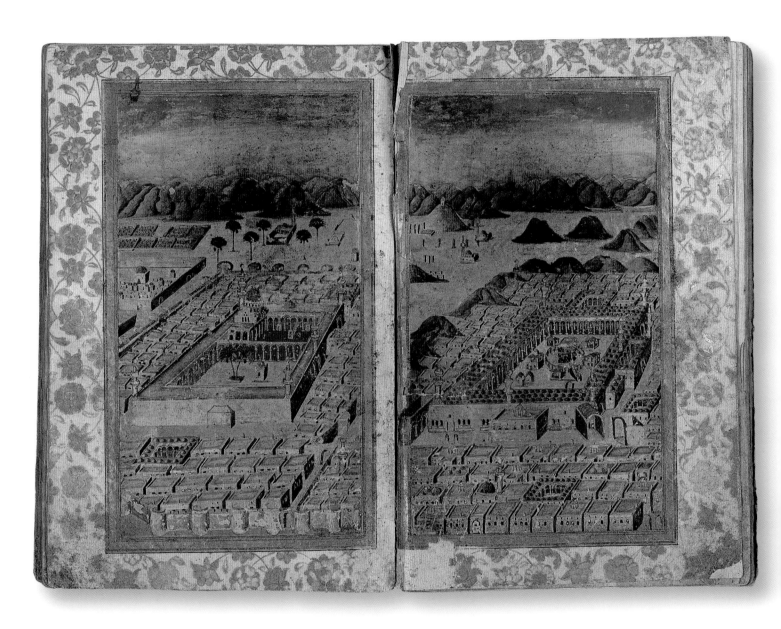

Fig. 112
Mecca (right) and Medina (left),
from a Book of Prayers

1749 (AH 1162), Turkey
16.5 x 11cm, CBL T 449, ff. 62b–63a

Depictions of the Great Mosque of Mecca and of the Prophet's Mosque in Medina are frequently included in the many small prayer books produced for Ottoman Turkish patrons in the late seventeenth to nineteenth centuries. In this example, the mosques are shown in perspective, providing a more realistic view of how they looked at the time than do the schematic depictions found in many other of these prayer books (see fig. 116). Note, in particular, the houses and other buildings built almost right up to the walls of each mosque, and in the background, beyond the walls of the Great Mosque of Mecca, are the sites where the various other rites of the *hajj* are enacted, including, at the left, a lighter-coloured mountain which is Mount Arafat (see also fig. 130).

Figs. 113–119
Book of Prayers
Arabic and Turkish text in *naskh* script

1798 (AH 1212), Turkey
17 x 11cm, CBL T 463

Small Ottoman prayer books of this type frequently include paired diagrams and drawings of the type reproduced here, though the considerable number of consecutive pairs (eight) in this manuscript is slightly unusual. These pocket-sized manuscripts were extremely popular and, although most are finely decorated, the fact that almost identical copies exist suggests that they were 'mass produced' according to set patterns. The various drawings and diagrams functioned as devotional aides.

Fig. 113
CBL T 463, ff. 90b–91a

In the large circular seal on the right-hand page the word 'Allah' (God) is written repeatedly in small letters, while on the left-hand page the name 'Muhammad' fills the whole seal; in the small rectangular spaces above and below each seal are the names of God.

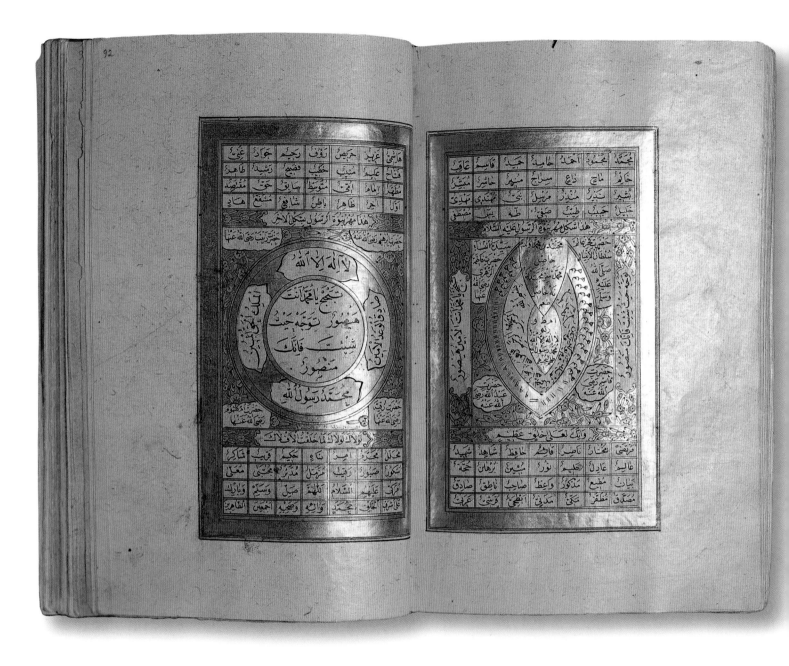

concepts of popular belief (figs. 113–119). A considerable number of prayer books of a similar type but produced in the Maghrib have also survived. They are, however, distinct in a number of ways from those made in Turkey for Ottoman patrons. Besides standard differences in decoration between the two regions, such as the incorporation of mainly geometric as opposed to floral motifs and patterns (fig. 120), Maghribi prayer books frequently employ fewer illustrations, with sparser, simpler compositions, reduced to their most essential elements (fig. 121). They often also represent concepts and objects never, or only rarely, included in contemporary Ottoman examples, such as a drawing of the Prophet's sandal (fig. 122) and the iconic image of a lamp hanging in a *mihrab* above the tombs of Muhammad, Abu Bakr and Umar (fig. 123).

Fig. 114
CBL T 463, ff. 91b–92a

On each page is a depiction of a seal, each described as the seal of prophethood (*muhr al-nubuwa*), the mark which Muhammad is said to have borne between his shoulders. Although differently shaped seals are depicted in different manuscripts, it is unusual for two such examples to be depicted in a single manuscript. In the small rectangular spaces above and below each seal are the names of Muhammad. (On folios 92b–93a, not reproduced here, is a *hilya*, similar to, but much more simply illuminated than that in fig. 22).

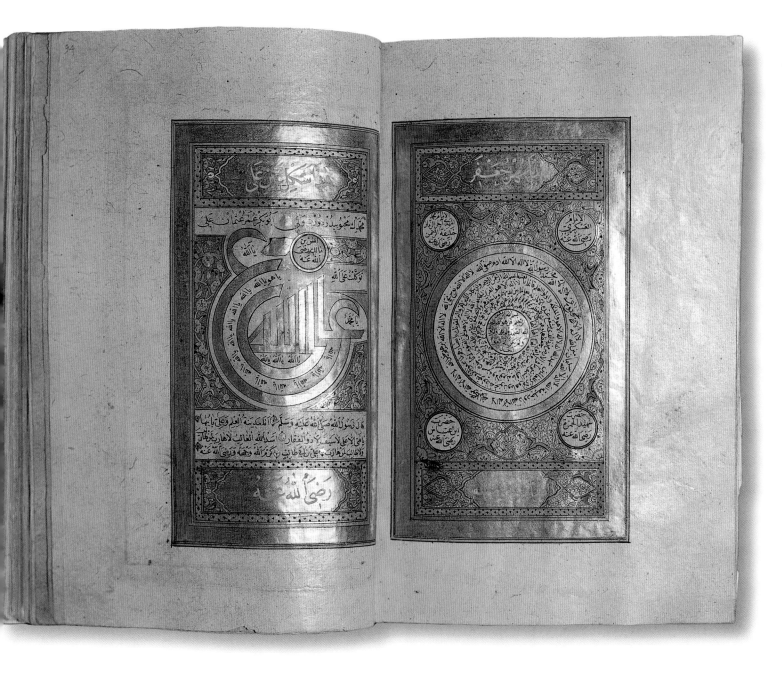

Fig. 115
CBL T 463, ff. 93b–94a

On the right-hand page is the seal of
Ja'far Sadiq, the sixth Shi'a Imam. On
the left-hand page is a seal symbolising
the concept of *al-tawakkul ala Allah*,
meaning 'trust in God', and consisting
of the word 'Allah' written in large gold
letters in the centre of the page and
with the word *ala* (meaning 'in') written
twice, also in large gold letters, on
either side of and encircling the word
Allah; between these words, the
invocation *ya Allah* ('Oh God') is written
repeatedly in small letters in black ink.

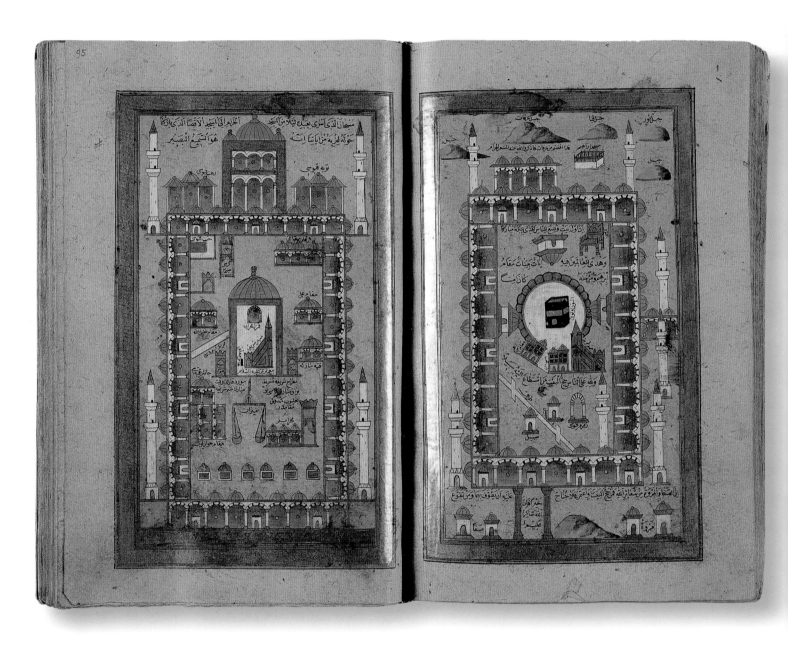

Fig. 116
CBL T 463, ff. 94b–95a

On the right-hand page is a schematic depiction of the Great Mosque of Mecca and in the centre of the courtyard is the Ka'ba, the ancient stone sanctuary covered in a black cloth. The mountain in the upper right corner is identified as Mount Thawr, where Muḥammad and Abu Bakr hid during the course of their *hijra* (migration) to Medina in 622 (see also fig. 4), and the largest mountain to the left of it is Mount Arafat. On the left-hand page is the Aqsa Mosque in Jerusalem, including a depiction of, among other objects, the scales (*mizan*) by means of which the resurrected souls will be weighed on the Day of Judgement.

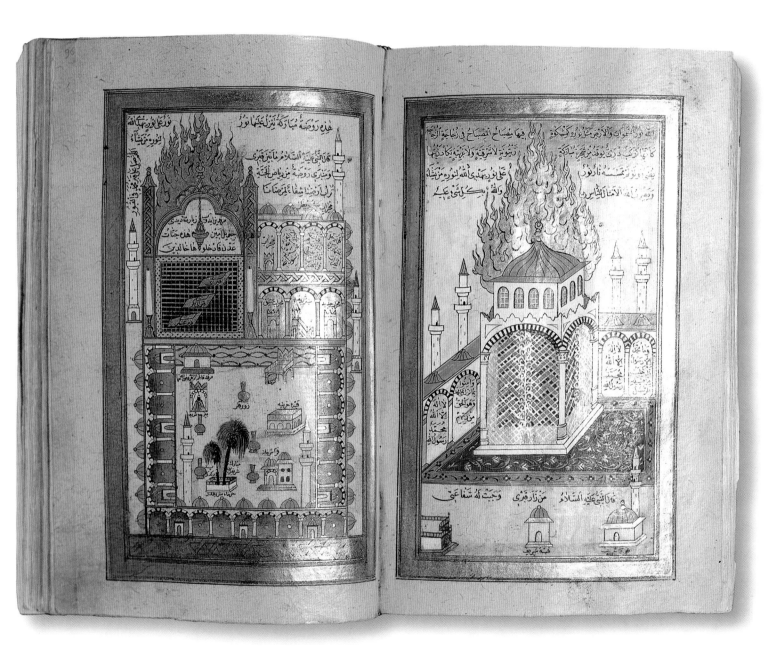

Fig. 117
CBL T 463, ff. 95b–96a

The depiction on the right-hand page is of Muhammad's tomb in the Prophet's Mosque in Medina, but the tomb, the dome of which is engulfed by a flaming halo, has been made overly large, dwarfing even the minarets of the mosque. On the left-hand page is a more distant, schematic view of the mosque, one in which the whole courtyard of the mosque is visible.

Muhammad's tomb is again clearly indicated by a flaming halo; also shown in the same space are the tombs of the caliphs Abu Bakr and Umar. The objects in the three large arches of the prayer hall, to the right of the tomb, are identified as the 'holy *minbar*' and, on either side of it, the 'old *mihrab*' and the 'new *mihrab*'.

Fig. 118
CBL T 463, ff. 96b–97a

In the centre of the illustration on the right-hand page is the Prophet's 'banner of praise' (*liwa al-hamd*). It is said that during his heavenly journey (*isra*) God granted Muhammad the right to intercede with him on behalf of the community of Muslims; thus on the Day of Judgement, when all others are pleading for themselves only, Muhammad, his green banner of praise in hand, will cry out *ummati, ummati*, meaning 'my community, my community'. To the right of the banner is Muhammad's rosary (*subha*) of ninety-nine beads and to the left is his tooth-stick, or toothbrush (*miswak*), the end of which is chewed to make it soft before rubbing it over the teeth; it is said that whenever the Prophet entered his house, he immediately used his *miswak*. Several *hadith* extol the use of a *miswak*, and it is believed that the benefit of one's prayers will increase seventy-fold if they are preceded by use of a *miswak*. Illustrated on the left-hand page are the standards that accompanied Muhammad when he went into battle.

Fig. 119
CBL T 463, ff. 97b–98a

Illustrated on the right-hand page is the Prophet's favourite rose-tree, on the leaves of which are written the names of some of his Companions and some members of his family, namely Abu Bakr, Umar, Uthman, Ali and Ali's sons, Hasan and Husayn; three other individuals, each identified by first name only, are probably Talha ibn Ubaydallah al-Taymi, Zubayr ibn al-Awwam, Sa'd ibn Abi Waqqas and Sa'id ibn al-As, all four of whom were early converts to Islam. On the left-hand page are depictions of the Blessed Palm Tree and the Tuba Tree (*tuba* meaning 'blessing' or 'goodness'); the latter, which is said to grow upside down in Paradise, is adorned with jewels and produces fruit and blossoms of every sort. In the rectangular spaces at the top of the page are the names of the Eight Paradises or Gardens, identified as: the Garden of the Abode of Glory (*jannat dar al-jalal*), the Garden of the Abode of Peace (*jannat dar al-salam*), the Garden of Refuge (*jannat al-mawa*), the Garden of Perpetuity or The Eternal Garden (*jannat al-khuld*), the Garden of Paradise (*jannat al-firdaws*), the Garden of Bliss (*jannat al-na'im*), the Garden of Eden (*jannat al-and*) and the Garden of Entreaty (*jannat al-wasilat*).

Figs. 120–123
Dala'il al-khayrat **(The Guide to Happiness) of al-Jazuli**

1638–39 (AH 1048), North Africa
20.7 x 14.8cm, CBL Ar 4223

Fig. 120
CBL Ar 4223, ff. 4b–5a

The illuminated frontispiece of this prayer book employs the style and palette typical of manuscripts produced in the Maghrib.

Fig. 121
CBL Ar 4223, ff. 3b–4a

As in contemporary prayer books made in Turkey, this *maghribi* example also includes a double-page depiction of Mecca and Medina, but here the images are stark and minimalist in the extreme. On the right is the Great Mosque of Mecca, the image consisting of little more than the Ka'ba itself – the most important structure within the mosque precinct. Facing

this, on the left, is the Prophet's Mosque in Medina, again reduced to its most important structures: on the left, the rectangular tombs of Muhammad, Abu Bakr and Umar, and, in the prayer hall to the right, a side-view of the Prophet's *minbar*. The semi-circular form at the upper edge of the mosque is the *mihrab*, indicating the direction of prayer.

Fig. 122
CBL Ar 4223, ff. 2b–3a

Within the realm of popular piety, the image of Muhammad's sandal functions as an amulet, protecting the wearer from harm and evil. Images such as this, as well as those of other objects associated with Muhammad, such as his rosary, his battle standards and his *minbar*, are religiously acceptable means of representing one, who, according to the orthodox strictures of Islam, should never be depicted.

Fig. 123
CBL Ar 4223, f. 18b

This, too, is an image of the Prophet's Mosque in Medina, but, as in fig. 121, only essential items of the mosque are depicted: the three tombs and a lamp hanging within the *mihrab*.

al-Fatiha

*A*l-Fatiha (The Opening) is the name of the first chapter of the Qur'an (fig. 124). It is the most frequently recited chapter and recitation of it is an integral part of the daily life of any practising Muslim. So important a feature is it that recitation of *al-Fatiha* and the *shahada* are considered defining marks of being a Muslim. As part of the daily ritual prayers, it is the one chapter of the Qur'an that all Muslims must know by heart. It is recited at times of sorrow and joy and at the beginning and conclusion of almost all matters of importance – indeed, according to the Prophet, any important matter not begun with its recitation will be void. Similarly, recitation of it at the conclusion of any agreement or contract is considered a seal or promise binding all parties to the terms laid out – whether it be, for example, a marriage or business contract. It is also considered to have talismanic and amuletic powers, functioning as a healing aid and as a means of warding off evil and all forms of danger. In form and style it differs from most other chapters of the Qur'an in that it is a plea *to* God ('Show us the straight way'), not a proclamation *from* God (e.g. verse 8:15:'Oh ye who believe') and as such takes the form of a prayer. Its power is evident from Muhammad's declaration that anyone who recites *al-Fatiha* will gain as much merit as if he had recited two-thirds of the Qur'an. The text of *al-Fatiha* is:

> Praise be to God,
> The Cherisher and Sustainer of the Worlds;
> Most Gracious, Most Merciful,
> Master of the Day of Judgement,
> You do we worship,
> And Your aid do we seek.
> Show us the straight way,
> The way of those on whom
> You have bestowed Your Grace,
> Those whose portion is not wrath,
> And who do not go astray.

Fig. 124
Qur'an

15th century, Iran
18.7 x 13cm, CBL Is 1519, ff. 1b–2a

The text of *al-Fatiha* is spread over the two large, central cartouches of this frontispiece.

The Most Beautiful Names of God

According to Muslim tradition, God has ninety-nine most Beautiful Names (al-asma al-husna), mainly drawn from the Qur'an (though the exact number of God's Names is said to be known only to Him). Each name refers to one of God's attributes, such as al-rahman (The Beneficent), al-rahim (The Merciful), al-aziz (The Mighty), al-sami (The All-Hearing), al-basir (The All-Seeing), al-adl (The Just), al-kabir (The Most Great), al-hakim (The Wise), al-majid (The Most Glorious One), al-samad (The Eternal), al-badi (The Everlasting), al-nur (The Light) and al-hadi (The Guide). A pious Muslim repeats and meditates on the divine names, usually with the help of the ninety-nine beads of a rosary

(subha), and it is said that whosoever memorises and regularly repeats the ninety-nine Names of God will enter paradise. Moreover, the recitation of each specific name is considered to bring specific results. For example, a person who repeats the name al-quddus (The Holy), one hundred times each day will be free of anxiety and stress, while repeating the name al-nafi (The Propitious) forty-one times at the start of any (good) act or venture will ensure its success. Lists of the ninety-nine names are frequently included in prayer books (fig. 125). Today, framed and elaborately decorated lists of the ninety-nine names are favourites in homes or on the walls of shops.

Fig. 125
The Ninety-Nine Most Beautiful Names of God, from a Book of Prayers
Naskh script

1903 (AH 1321), Turkey
18.2 x 11cm, CBL T 493, ff. 7b–8a

The names of God are separated from one another by small wreaths, of either red or green leaves, and in the centre of each wreath are the words *jalla jalalahu* (May His glory be Glorified!).

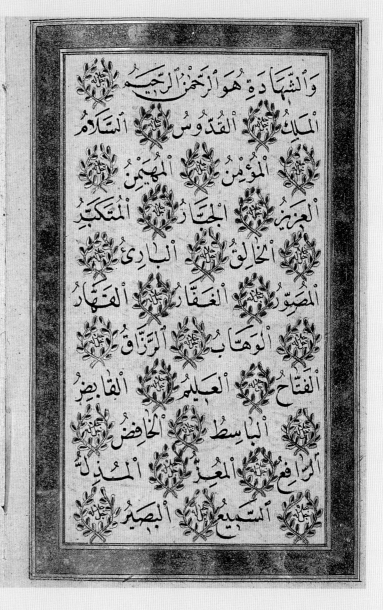

THE THIRD PILLAR OF ISLAM: THE GIVING OF ALMS

Zakat is the obligatory alms tax, or annual donation to the poor and needy. The word *zakat* means purification, and the giving of *zakat* is therefore understood as purifying the soul of the giver from greed and selfishness. Today the means of collection and distribution of *zakat* varies from country to country, as does the decision as to who should benefit from it, either Muslims only or the needy of any religion. However, the obligation to help those less fortunate than oneself is not necessarily fulfilled by payment of *zakat*, for one is expected to give as much as can be afforded; this voluntary alms giving is known as *sadaqa*, which among the very wealthy often took (and still takes today) the form of a pious endowment (or *waqf*).

These pious endowments traditionally consisted of the construction and donation to the community of a mosque, religious school or public fountain. Many legal documents recording these endowments survive, such as one dated May 1729 that was drawn up on behalf of Princess Fatima-Sultan, daughter of the Ottoman sultan Ahmad III (r. 1703–30), and her husband Damad Ibrahim Pasha, who served as the sultan's Grand *wazir*, or

Fig. 126
***Waqfnama* of Princess Fatima and Ibrahim-Pasha**
Turkish text in *naskh* script

1729 (AH 1141), Istanbul, Turkey
32.5 x 22.2cm, CBL T 442, ff. 1b–2a

This beautifully illuminated double-page opening appears at the beginning of the *waqfnama* (book, or deed, of donation) that records the charitable construction and donation of a *madrasa* (theological school) to the community by the Ottoman princess Fatima-Sultan and her husband Damad Ibrahim Pasha.

Fig. 127
Qur'an
Thulth-naskh script

1323 (AH 723), Tripoli, Lebanon
34 x 24.3cm, CBL Is 1473, f. 176b

At the top of the folio is a heading
marking the beginning of Chapter 13,
al-Ra'd (The Thunder), and above this,
written in black ink, is the word *waqf*,
indicating that the manuscript was
once given as a charitable donation,
probably to a mosque.

minister, from 1718 until the sultan's death (fig.
126). The couple built a theological school
(*madrasa*) in Istanbul and the document stipulates
that the income from some eighty shops in Istan-
bul, as well as the income from numerous (named)
villages elsewhere in the Ottoman domains, all of
which were owned by the couple, was to be used
to maintain the school, including the payment of
salaries to the school staff and subsidies to scholars
studying at and residing in the school. The staff
listed includes teachers (such as a teacher of math-
ematics to explain the division of an inheritance
amongst the relatives of the deceased), a librarian
(who is to compile a catalogue of the manuscripts
in the school's library and ensure that no books are
removed from the premises), a bookbinder, a
mu'adhdhin (one who makes the call to prayer), a
burner of incense, men to serve water from the
school's fountain to passers-by, a plumber and a
cleaner of sewers. The salary that each individual
was to receive is clearly stated. As well as the funds
that are to be paid for the running and upkeep of
the school, money was also allocated to pay for
Qur'an readers at the mosques in the holy cities of
Mecca and Medina, nurses at a lunatic asylum, and
for celebrations to mark the Prophet's birthday.
Such endowments were often used as a means of
fulfilling one's duty to the less fortunate while
avoiding the taxman and, at the same time, keep-
ing one's money in the family, so to speak: the
document states both that the founding couple's
son is to manage the *waqf* and the substantial salary
he is to be paid for doing so; after his death, another
member of the family was to be placed in charge.

 More modest endowments could consist of the
donation of a finely calligraphed and richly illumi-
nated copy of the Qur'an to a mosque or *madrasa*.
Such manuscripts usually include an inscription
detailing their endowment or they may simply be
inscribed with the word *waqf* at the top of several
pages (fig. 127).

The Fourth Pillar of Islam: Observance of the Annual Fast

Ramadan is the ninth month of the Muslim calendar, and it was during the night between the 26th and 27th of Ramadan, known as *laylat al-qadr* (The Night of Power), that the Qur'an was first revealed to Muhammad in a cave on Mount Hira outside Mecca. According to a *hadith*, or saying of the Prophet, during the holy month of Ramadan 'the gates of mercy are opened, the gates of hell are locked, and the devils are chained'. Ramadan is also the month during which practising Muslims undertake the fast (*sawm*), the obligation to do so being the fourth pillar of Islam. As stated in the Qur'an (2:183), fasting was not an innovation of Islam as it was a practice also undertaken by earlier religions as a means of learning restraint. In fact, when the Muslim community first moved to Medina, Muhammad instructed the people to fast on Ashura, the Jewish Day of Atonement, or Yom Kippur (and perhaps a number of preceding days), an act interpreted by some as an attempt to encourage the Jews to convert. However, this was changed following the revelation of verse 2:185, in which Ramadan is specified as the month of fasting. In general, Ramadan is a time during which one should attempt to live a better life, one not driven by passion and greed, and it is a time during which one comes to understand the hardships of those less fortunate than oneself. Throughout the month, from daybreak to just after sunset each day, every adult Muslim must refrain from eating, drinking, smoking, indecent talk, slander and sexual contact. Those who might put themselves in danger by fasting, such as anyone who is ill, pregnant, or employed in heavy manual labour, may postpone their fast until they are fit to undertake it, or if, say in the case of the elderly, one simply cannot fast, then it may be replaced by a charitable act of some kind. Besides fasting, during Ramadan Muslims are expected to read through the complete Qur'an, reading one *juz*, or section, each day, and they may also undertake extra prayers each day.

Because the Muslim calendar is lunar (rather than solar), Ramadan does not fall at precisely the same time each year but instead always arrives about ten or eleven days earlier than the preceding year. This of course means that the fast can be more or less physically taxing depending on the season in which it falls and the climatic region in which one resides. However, for devout Muslims the month of Ramadan is not considered in any way a time of hardship, but a time of celebration and family gatherings. After long hours without food, it is of course not wise to indulge immediately in a large meal and so people usually break their fast with the *iftar* (breakfast), a small meal perhaps consisting only of juice and fruit, and then after the evening prayers they will join with family and friends for a much larger meal. Ramadan is indeed a highly festive time and with the setting of the sun, an air of joy and celebration permeates every city and town: the exterior of mosques are often adorned with lights throughout the night, restaurants are packed, parks are filled with stalls selling special foods and snacks and the poor flock to the rows of *iftar* tents set up in parking lots and other open spaces where free food is provided.

The sighting of the new moon marks the end of the month of Ramadan and the start of the three-day-long *id al-fitr*, the 'festival of the breaking of the Ramadan fast', also known as the minor feast (as opposed to the four-day-long *id al-adha*, the 'festival of the sacrifice', or major feast, which takes place at the end of the pilgrimage to Mecca), also known in Turkish as *shekar bayram*, the 'sweet festival'. During this time Muslims celebrate their successful completion of the fast: schools and businesses are closed, large congregational prayers are held with women and children also in attendance, special donations are made to the poor, cards are sent to friends and relatives, children receive gifts and extra spending money and of course friends and family gather for

huge meals, especially at midday of the first day. It is particularly regarded as a time to remember family and friends, both those still with you and those deceased, and also to remember and to give to those less fortunate than yourself.

THE FIFTH PILLAR OF ISLAM: THE HAJJ

The fifth pillar of Islam is the pilgrimage, or *hajj*, to Mecca, which it is incumbent upon every adult Muslim to undertake at least once in his or her life, if at all possible. Successful completion of the *hajj* brings total forgiveness of sins and is regarded as the peak of one's religious life; one who has successfully completed the *hajj* is rewarded with the title *hajji* (*hajja* for women). If unable to undertake the journey to Mecca for reasons of health or old age or because of constrained financial circumstances, it is possible to appoint someone to complete the *hajj* for you by proxy. However, the individual appointed can represent only one person at a time and must also have previously completed the *hajj* on his or her own behalf. (It is also possible to complete the *hajj* on behalf of someone who is deceased.)

The *hajj* entails visiting the Ka'ba, the stone sanctuary situated in the precincts of the Great Mosque of Mecca, and the other holy places nearby, collectively and in a particular ritualistic order, between the eighth and thirteenth days of Dhu'l-Hijja, the last month of the Muslim lunar calendar. Following their completion of the *hajj*, most pilgrims will take the opportunity to travel to Medina to visit the Prophet's Mosque, his tomb and those of the members of his family, as well as the tombs of the many other early Muslims who lived in Medina at the time of Muhammad, though doing so is not a required part of the *hajj*. Alternatively, one may complete the *umra,* or lesser pilgrimage, which consists of visiting the Ka'ba only, at any time of the year, but this does not fulfil one's religious obligation.

Currently over two million people from around the world gather each year to perform the *hajj*, most arriving by plane at the Red Sea port of Jeddah and then travelling inland by bus to Mecca. (Non-Muslims are prohibited from entering the holy city.) Before arriving in Mecca, the pilgrim must enter a temporary state of consecration, known in Arabic as *ihram*. This consists of stating (orally or mentally) the intention to perform the *hajj*, washing the whole body thoroughly, shaving underarms and beards, trimming hair and nails and, finally, donning the sacred *ihram* attire, which consists of two pieces of seamless white cloth (one of which is wrapped about the lower half of the body and the other around the shoulders and chest), simple sandals (or else one may go barefoot) and, if one wishes, a small shoulder bag. Heads are left bare as a sign of humility. With all indication of rank and wealth thus cast aside, pilgrims present themselves before God as equals. Women may wear whatever they wish, as long as their bodies and heads – but not their faces – are well covered; most choose to wear a plain, full-length and loose-fitting dress. While in this state of *ihram*, the pilgrim is forbidden to wear sewn clothes, trim the hair or nails, engage in sexual contact, get married, enter into arguments, wear perfume or use scented soaps.

Upon entering the precinct of the Great Mosque, the pilgrim goes directly to the Ka'ba to touch the Black Stone, set into the eastern corner of the Ka'ba; if the crowds are too dense, it may not be possible to do more than reach out in the direction of the Stone. Then the *tawaf* is performed, which consists of circumambulating the Ka'ba seven times in an anti-clockwise direction, running, or at least walking quickly if able, the first three times, then four times at a normal pace (fig. 128). Once completed, the pilgrim goes to the *maqam Ibrahim* (the 'place' or 'stage of Abraham'), a small domed structure built around a stone on which are two footprints said to have been made by Ibrahim as he stood there directing the building of the Ka'ba; here two *rak'a*s, or

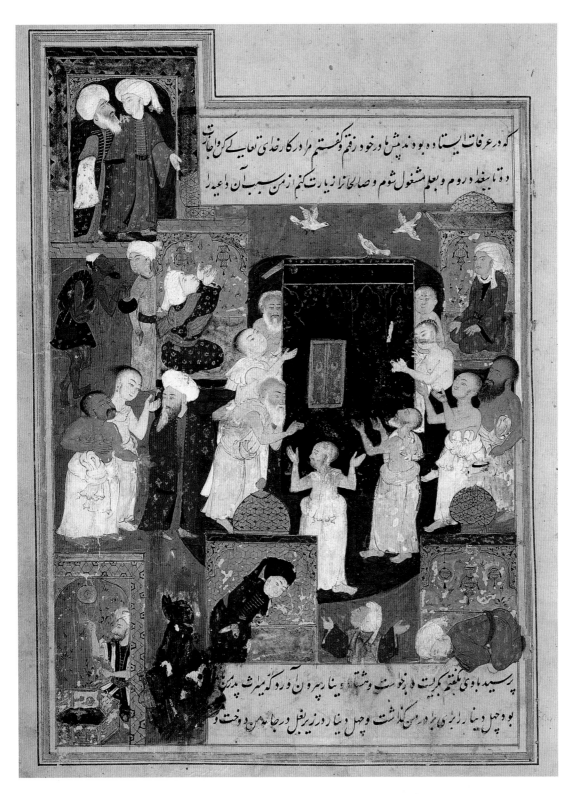

کہ درعرفات ایستاده بودم وبدیدستا درخود رقتم وکفتم مرادرکارخدای تعالی کن واجیت

دة تا بینیند وروم وبعلم مشغول شوم وصالحانرا زیارت کنم از سبب آن واعیده را

پرسیده باوی نگفته که رست با نخواست ومشتاب یا رپور ول آورده که میراث پدرش

بود وچهل دینار زیر ی پرو در می کذاشت وچهل دینار درزیر بغل وردرجا مرد و دخت و

Fig. 128
The Vision of Muhyi al-Din Ibn al-Jilani, from a copy of *Nafahat al-uns* (Breaths of Fellowship) of Jami
Persian text in *nasta'liq* script

1595 (AH 1003), Turkey
30.6 x 19cm, CBL T 474, f. 276a

In the centre of the composition are several figures dressed in the sacred *ihram* attire and circumambulating the Ka'ba, a representation, it is intended, of a vision of the *hajj* experienced by the Sufi Shaykh Muhyi al-Din Ibn al-Jilani.

prayer units, are performed. This is followed by the *sa'y*, the ritual of walking and running seven times between the hills of Safa and Marwa, both of which are today enclosed within the precincts of the Great Mosque with the path between the two now a covered walkway. The ritual is intended to recreate the frantic search for water by Hajara (Hagar) for her son Isma'il (Ishmael) after they were expelled from the home of Isma'il's father, Ibrahim. According to some versions of the story, when she placed the baby on the ground, water suddenly appeared: this is the Well of Zamzam from which pilgrims eagerly drink and wash themselves, and some pilgrims fill small vials with the water to take home as souvenirs. In other versions, it was through the intervention of Gabriel that the well appeared (fig. 129). The graves of Hajara and Isma'il are said to be within the small paved area next to the Ka'ba.

The *sa'y* completes the *umra* (the lesser pilgrimage) and male pilgrims now shave their heads or cut their hair while female pilgrims trim their hair by about an inch. With this they may now remove themselves from the state of *ihram*, or they may immediately embark upon the *hajj* proper. On the day before the *hajj* begins the pilgrims attend a sermon in the mosque reminding them of what lies ahead over the next few days.

The first major ritual of the *hajj* takes place at Arafat, a plain some twenty-five kilometres (15 miles) east of Mecca (fig. 130). Some pilgrims spend the first night at the town of Mina, in the 'city of tents' especially erected for them, proceeding to Arafat on the following day. It is said that it was at Arafat that Adam first sought God's mercy after having sinned and been expelled from the Garden, and it was also here that he and Eve were reunited. The ritual of *wuquf*, or the solemn 'standing', during which pilgrims contemplate and pray to God, commemorates these events and takes place on or around the *jabal al-rahma* (The Mount of Mercy), a large rocky mound on the plain. Pilgrims believe those who spend the day on the mount are cleansed of all their past sins. It was also at Arafat, in 632, that Muhammad preached his last sermon, and to honour that event a commemorative sermon is delivered to the pilgrims. The day at Arafat is the most important and most moving day of the *hajj*. Before sunset, the pilgrims travel to Muzdalifa, between Arafat and Mina, where they spend the night in prayer, progressing to Mina by early morning.

According to Muslim belief, Ibrahim dreamt that God ordered him to sacrifice his then only son Isma'il as a sign of his submission to the will of God. Iblis (Satan) appeared in disguise to both Ibrahim and his son (and to Hajara), hoping to tempt them to disobey God's command, but each resisted, driving him off by pelting him with stones; in the end God stopped Ibrahim from sacrificing Isma'il and a ram was sacrificed instead. At Mina, where the sacrifice

is said to have taken place, the pilgrims throw stones at three large pillars, or *jamra*s, to symbolise the driving off of the devil and the pilgrim's own rejection of evil (fig. 131). (However, in order to accommodate the huge numbers of pilgrims that today make the *hajj*, the *jamra*s have been converted into long walls.) This takes place during the four-day *id al-adha*, the Feast of Sacrifices (or 'major feast'), the main religious festival of the Muslim year, and on the first day of which pilgrims sacrifice an animal in commemoration of Ibrahim's sacrifice. Groups of pilgrims will often make a joint sacrifice if they cannot afford to buy an animal – usually a sheep, goat or camel – on their own, and today they may also choose to pay someone to make the sacrifice on their behalf. The vast amount of surplus meat that results is always carefully distributed to the poor so that none is wasted, much of it being frozen and shipped to other Islamic countries. After the sacrifice, the pilgrims return to Mecca and repeat the *tawaf*, ending their *hajj* just as they began it. They then remove themselves from their state of *ihram*, don new clothes and return to Mina for the remainder of the festival, a fun-filled event noted for its huge feasts and great fair. *Id al-adha* is celebrated not only by those completing the *hajj*, but by all Muslims, who should make their own sacrifice wherever they are. At the end of the festival most pilgrims continue to Medina, where they will visit the Prophet's mosque and other sites, such as the Baqi Cemetery where Muhammad's followers and the members of his family are buried (figs. 132–134).

In earlier times, pilgrims travelled to Mecca together in huge caravans, primarily for reasons of safety, as the journey was long and hazardous. The two main caravan-routes were from Cairo to Mecca along the Red Sea coast and, during the Ottoman era, from Istanbul via Damascus. Organising a caravan was a hugely complicated and costly affair, the responsibility of the caravan-commander on behalf of the ruler of the country in which the caravan

Figs. 129–134
**Futuh al-haramayn (The Triumph
of the Holy Places)**
Persian text in *nasta'liq* script

1595 (AH 1003), Mecca, Saudi Arabia
22.7 x 14.2cm, CBL Per 245

Futuh al-haramayn

Futuh al-haramayn, which translates as
the 'Triumphs (or 'Conquests') of the
Two Holy Sites', is the title of a versi-
fied account, written in Persian in
1506, of the pilgrimage to Mecca and
Medina of Muhyi al-Din Abd al-Rah-
man al-Lari al-Ansari (d. 1527) and
dedicated to his patron, Muzaffar ibn
Mahmud, the ruler of Gujarat, India.
Muhyi al-Din's account (he records
that he actually wrote several versions
of it) became very popular and many
copies of it have survived. The text is
always illustrated with simple, usually
schematic depictions of the various
sites in and around the two holy cities,
with most structures in the illustra-
tions clearly identified in black script.
Although the number of illustrations
included is not standard, seventeen
seems to be most usual, and while the
quality of the illustrations varies from
manuscript to manuscript, even the
simplest are highly appealing. Included
in the colophon of several of these
manuscripts is the name of the callig-
rapher who copied out the text and
the year and city in which he carried
out his task – the latter usually stated as
being Mecca. Although copies of the
text were certainly produced else-
where (for example, in India), the
evidence suggests that in Mecca illus-
trated copies of the text were 'mass
produced' as souvenirs – probably
in a number of different workshops –
and bought by pilgrims eager for a
remembrance of their *hajj*
(figs. 129–134).

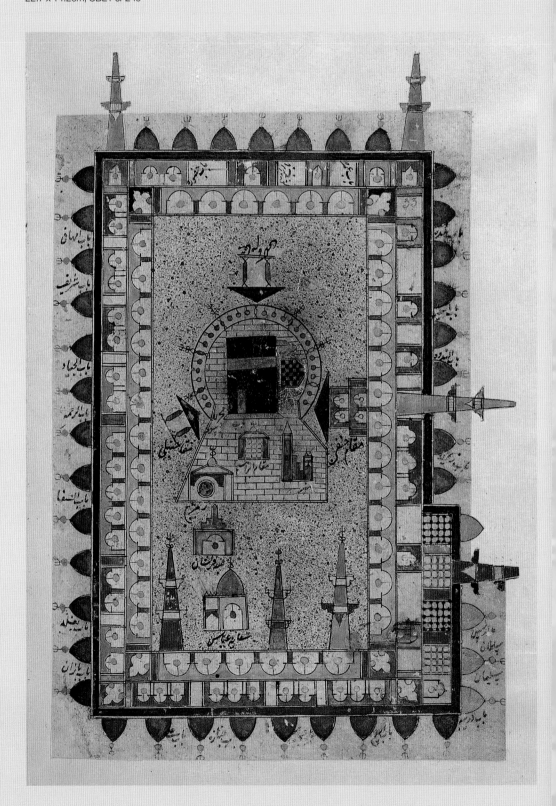

Fig. 129
The Great Mosque of Mecca
CBL Per 245, f. 23b

A two-storied, domed arcade (with suspended, spherical gold lamps) marks the outer boundary of the mosque; the script between the domes of the arcade gives the names of the various gates and doors leading into the mosque. In the centre of the courtyard is the Ka'ba surrounded by a keyhole-shaped paved area, within which, immediately below the Ka'ba, is a square, domed structure – the *maqam ibrahim* – which is believed to cover the footprints of Abraham. Beneath this, at the edge of the pavement, is the Well of Zamzam, shown as a grey circle beneath (but actually painted on the side of) a larger domed structure. Seven minarets are depicted protruding from the interior and exterior walls of the mosque.

Fig. 130
Arafat
CBL Per 245, f. 36b

At the top of the illustration is Mount Arafat (also known as *jabal al-rahma*, 'The Mount of Mercy') with a small shrine built at its peak; to the right are three *mahmil*s, or camel-litters, identified as being from Syria, the Yemen and Egypt. Two rows of tents are set up at the base of the mountain to offer shade and housing for the pilgrims and beneath these, at the lower left, is a multi-tiered lamp and, to the right, an area for prayer, at the lower edge of which is an arcade with spherical lamps hanging from its arches.

Fig. 131
Mina
CBL Per 245, f. 41a

The colonnades bordering the main road of the small town of Mina are identified in the drawing as the village bazaar, behind which are rows of tents, presumably housing for the pilgrims. Between the colonnades are two *jamra*s, the pillars symbolising the devil at which pilgrims throw stones; the third and larger *jamra* is in the lower left of the illustration. In the upper right, at the far end of the road is a mosque, Masjid al-Khayf, said to mark the site where the Prophet's tent used to stand.

Fig. 132
The Prophet's Mosque in Medina
CBL Per 245, f. 49a

The domed structure in the upper left of the mosque is the site of the Prophet's tomb, surrounded on three sides by an iron and gold grille. The rectangular space next to it is the prayer hall of the mosque, in which are two *mihrabs* that indicate the *qibla*, the direction of prayer (one of which is identified specifically as the Prophet's *mihrab*). The stepped, pulpit-like structure beneath the *mihrabs* is the Prophet's *minbar*, from which he delivered sermons to those gathered for prayer. The small domed building in the lower left of the courtyard of the mosque is identified as the mosque treasury.

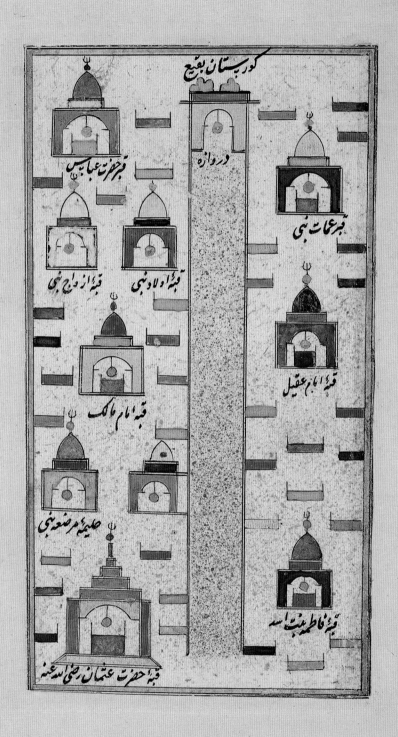

Fig. 133
The *Guristan* (Cemetery)
of Baqi in Medina
CBL Per 245, f. 51a

Near the upper edge of the illustration is
an arched gate leading onto a road that
runs through the cemetery, on either
side of which are domed tombs
described as *qubba*s. Included
amongst these are the tombs of the
Prophet's wives, his children and
Halima, his wet-nurse, all situated on
the left side of the road. The location of
the tomb of Muhammad's daughter
Fatima is uncertain, but it is shown here
as the tomb in the lower right corner of
the cemetery. (It is also often depicted
as being in the courtyard of the
Prophet's Mosque in Medina.)

Fig. 134
Mount Uhud
CBL Per 245, f. 54a

Mount Uhud is the site of the battle that took place between the Muslims and Meccans in March 625. At the base of the mountain, which is loosely rendered in blue and placed in the upper portion of the illustration, are the graves of the Muslims killed in the battle, identified only by the word *shuhada* (martyrs). The arcade with hanging lamps marks the boundary of a mosque, in the lower left corner of which is the tomb, or *qubba*, of Hamza, the Prophet's uncle who was also killed in the Battle of Uhud.

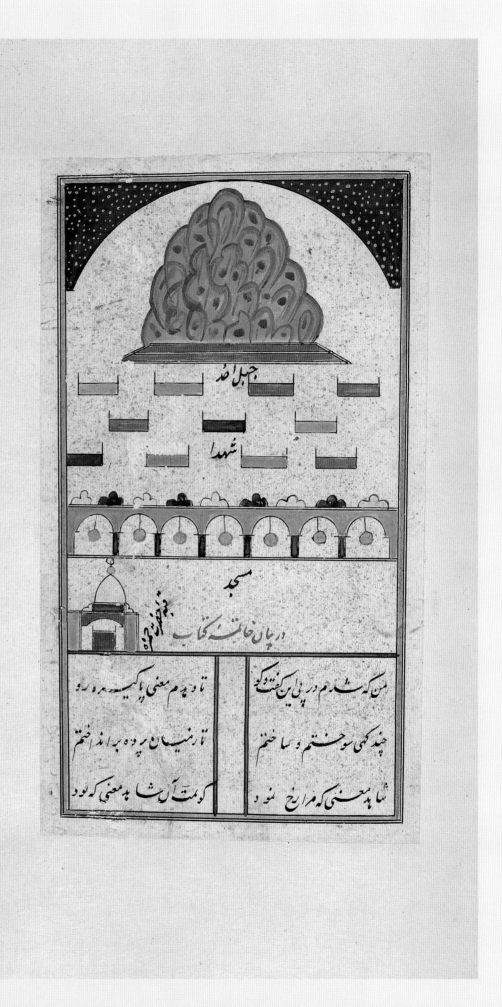

The *Kiswa*

The Ka'ba (meaning 'cube') is the shrine in the precinct of the Great Mosque in Mecca that was built (or more correctly rebuilt) by Ibrahim (Abraham) and his son Isma'il (Ishmael). It is the geographical and spiritual centre of Islam and Muslims must pray in the direction of the Ka'ba, though they do not worship it. The shrine is the focus of the annual pilgrimage, or *hajj*, and the dead are buried facing it. Built into the eastern corner of the Ka'ba is the Black Stone; once white, it is said to have blackened gradually with the accumulated sins of mankind.

The Ka'ba is covered with a black cloth known as the *kiswa* (meaning simply 'apparel', 'attire', 'dress' or 'covering'). Made of pure black silk into which the *shahada*, the profession of faith, is woven, the *kiswa* is further embellished with verses of the Qur'an embroidered in gold and silver (fig. 135). A new *kiswa* is produced each year and put in place on 10 Dhu'l-Hijja, the month during which Muslims make the pilgrimage to Mecca. Before the *kiswa* is changed, the interior of the Ka'ba is washed, and, then, once the old *kiswa* is removed, it is cut into small pieces that are sold or given to pilgrims and sometimes other various individuals and organisations. These precious relics are thought to be charged with *baraka* (blessing) and are used as amulets to ward off evil, keeping the owner safe and free of harm.

Originally the *kiswa* was not always black, with *kiswa*s in colours such as green and white recorded as having been used at times. Likewise, it was originally plain, the tradition of decorating it with embroidery having begun in the fourteenth century. It is not clear when the Ka'ba first began to be covered, but initially the clans of Mecca took turns providing the *kiswa*. Later, providing the *kiswa* became one of the duties of the sultan who bore the title 'Servant and Protector of the Holy Places'. During the Mamluk era in Egypt, when the reigning Mamluk sultan bore this title, the *kiswa* was produced in Cairo and then sent to Mecca with great pomp and ceremony at the head of the annual pilgrimage caravan. Although in 1517 the Ottomans defeated the Mamluks, the *kiswa* continued to be produced in Egypt until 1927, at which time the responsibility for, and the honour of, its production passed once again to the residents of the holy city of Mecca.

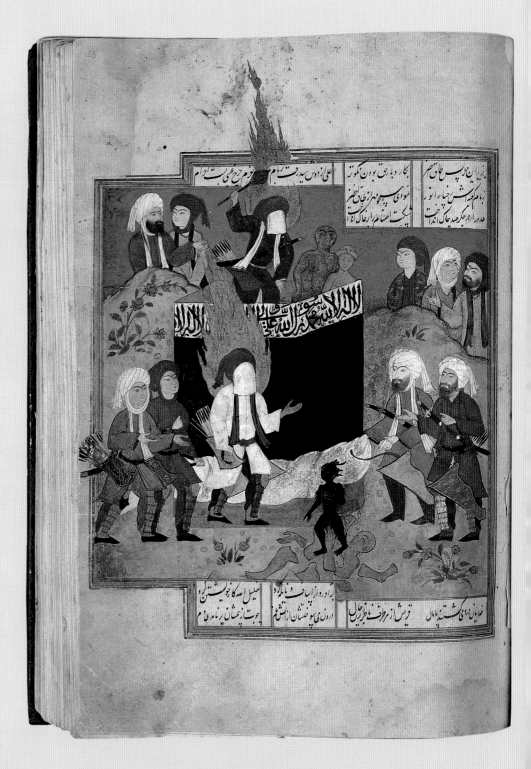

Fig. 135
Muhammad and Ali Destroying the Idols in the Ka'ba, from a copy of *Athar al-muzaffar* (The Exploits of the Victorious)
Persian text in *nasta'liq* script

1567 (AH 974), Iran
26.0 x 17.8cm, CBL Per 235, f. 55a

Ali is shown standing on the roof of the Ka'ba assisting Muhammad with the destruction of the idols. In this illustration, woven (or embroidered) into the upper edge of the black covering of the Ka'ba is the Shi'a profession of faith: 'There is no god but God, Muhammad is the Messenger of God, and Ali is the Friend of God'.

originated; the position of caravan-commander was a highly important and prestigious one that frequently served as a pathway to high political office. The journey to Mecca was fraught with dangers, and the bribing of Bedouin tribes to allow the safe-passage of the caravan through the lands they inhabited was a major concern, both financial and otherwise, as caravans were frequently attacked and robbed. A caravan that arrived without having suffered any major catastrophe along the way was seen as a sign of a safe and secure empire and thus a positive reflection upon the ruler.

From the late thirteenth century until 1517, the Mamluk sultans of Egypt also ruled over the Hijaz, the western area of the Arabian Peninsula in which Mecca and Medina are situated. As such, one of the titles of the ruling sultan was 'Servant and Protector of the Holy Places', a title of great prestige for it placed him in a position of pre-eminence over all other Muslim rulers. Although the title referred primarily to the holy sites of Mecca and Medina, it also included Jerusalem, and it made the sultan responsible for the protection of all pilgrims. In 1517, Selim I, the Ottoman ruler of Turkey (r. 1512–20), defeated the Mamluks and from then until the end of Ottoman rule in 1922 the title 'Servant and Protector of the Holy Places' and all the duties and obligations inherent in that title were borne by the Ottoman sultans.

The process of transporting pilgrims to and from Mecca remained basically unchanged for centuries until the advent of air travel. The first pilgrims to travel by plane did so in 1936 and by shortly after the mid twentieth century the camel caravans had completely disappeared. The trip to Mecca may now be less arduous for the pilgrim, both physically and financially and thus enabling ever-increasing numbers the opportunity to embark upon the journey, but the spiritual rewards are no less, with successful completion of the *hajj* still today, as in earlier centuries, regarded as the pinnacle of one's spiritual life.

ISLAMIC LAW: THE *Shari'a* AND *Sunna*

Shari'a is the name given to the Holy Law of Islam. The word *shari'a* derives from the Arabic verb meaning 'to go', 'enter' or 'begin', and though it is usually translated as the 'way', in its original, non-religious sense it meant more precisely the 'way' or 'approach' to a drinking hole or watering-place; thus *shari'a* implies not only a path to a source of sustenance and life, but one that is well trodden by one's forebears. The first of the two primary sources of the *Shari'a* is the Qur'an, which records the immutable and infallible words of God. As has been pointed out by many scholars, although the Qur'an is often referred to as providing a guide to a way of living for Muslims, it does so much more in the religious than legal sense, for in fact fewer than one hundred of its more than six thousand verses actually deal with what can be considered strictly legal matters. When no solution to a legal problem can be found in the Qur'an itself, jurists turn to the *Sunna*, the other primary source of Islamic law. *Sunna* can be translated as the 'trodden path' or 'customary practice' of the Prophet Muhammad. The Qur'an itself (33:21) states clearly that one should follow the example of the Prophet:

> You have indeed
> In the Messenger of Allah
> A beautiful pattern (of conduct),
> For anyone whose hope is
> In Allah and the Final Day,
> And who engages much
> In the praise of Allah.

The two secondary sources of law are *ijma* and *qiyas*. *Ijma* is the consensus of opinion, with respect to the interpretation (or *ijtihad*) of the Qur'an and the *Sunna* in regard to legal matters, of the community of religious scholars, jurists and other learned individuals, who are referred to collectively as the *ulama*. *Qiyas* is analogical reasoning or deduction: if no

Fig. 136
al-Jami al-sahih of al-Bukhari
Kufic script

14th century, Egypt (or Iran?)
27.2 x 18.4cm, CBL Ar 4180, f. 40a

This magnificent, pointed-oval
medallion announces the beginning of
one section of al-Bukhari's well-known
collection of *hadith*.

precedent exists for a particular legal problem that
has arisen, a decision on how to act may be extrapo-
lated through analogy to related matters dealt with in
the Qur'an and *Sunna*, with the decision or conclu-
sion usually subject to *ijma*.

HADITH

Knowledge of the *Sunna*, or customary practice of
the Prophet, is derived from the large corpus of lit-
erature comprising the reported sayings and deeds
of the Prophet and known as the Hadith (Tradi-
tions). Each individual tradition is likewise referred
to as a *hadith* and consists of two integral parts, the
matn or 'body' of the *hadith*, namely the saying or
deed that is being reported, and an *isnad*, or chain of
authorities that proves the authenticity of the *hadith*
by tracing its origins back to Muhammad. Basically,
this means that the saying or *hadith* itself will be pre-
fixed by phrases such as, 'I was told by so-and-so,
who was informed by so-and-so, to whom it was
reported by so-and-so, who announced on the
authority of…', and so on down the line, with the
last person named being the one who was purport-
edly actually present when Muhammad himself said
or did whatever it is that is being reported. (Unlike
the Sunnis, the Shi'as recognise only those *hadith* that
have been transmitted through members of the fam-
ily of Ali, and they also recognise *hadith* attributed
to the Imams.) Individual *hadith*s are classified
according to the trustworthiness and reliability of
their *isnad*s as being *sahih* (sound), *hasan* (fair or
good), *da'if* (weak) or *saqim* (sick or infirm). Many
collections of *hadith* exist, six of which are consid-
ered canonical and which were compiled in the
ninth century. The two most highly regarded of the
so-called 'six books' are those of Muhammad ibn
Isma'il al-Bukhari (d. 870) and Muslim ibn al-Haj-
jaj al-Naysaburi (d. 874), which together are ranked
in importance as second only to the Qur'an (figs.
136–137). The other main collections are those of
Abu Daud Sijistani (d. 888), Ibn Maja Qazvini (d.

Fig. 137
***al-Jami al-sahih* of Muslim**

1449 (AH 853), Egypt
26.7 x 19cm,
CBL Ar 5193, f. 2a

This is the frontispiece to one section of the famous collection of *hadith*s by Muslim ibn al-Hajjaj al-Naysaburi. The title of the text is given in the upper panel and the author's name is in the lobed roundel, or *shamsa*. A typical feature of Mamluk illuminations such as this is the use of white ink for the inscriptions, which often discolours, turning a dark grey, as here. The gold used in Islamic illuminations is almost always gold paint. One of the few exceptions, when gold leaf is used instead, is for small rosettes such as the four that surround the *shamsa* and which are usually used as verse markers in Mamluk Qur'ans: note the haphazard application of small squares of gold leaf to cover the lobed rosettes (see also fig. 75).

886), Ahmad bin Shu'ayb al-Nasa'i (d. 915) and Muhammad ibn Isa al-Tirmidhi (d. 892). The collections of al-Bukhari and Muslim actually bear the title *al-Sahih* as these two scholars each set out to find and record only *hadith*s that were classified as 'sound' and thus with secure and unquestionable *isnad*s linking them to the Prophet. The other four of the 'six books' are referred to as *Sunan* (the plural of *Sunna*) because the *hadith* they record tend to be concerned more exclusively with legal and ritual matters than are those of al-Bukhari and Muslim, and they also differ from the latter two collections in that they are not all restricted to *hadith* that are *sahih*.

In addition to the system of classifying *hadith*s according to their reliability, the compiling of biographies of the individuals listed in the *isnad*s evolved, likewise in recognition of the need to verify the reliability of *hadith*s. Based on the details of when and where an individual lived, it could be determined if he (or she) could actually have received the *hadith* from the person it was claimed it had been received. Transmitters were also assessed as to their personal and scholarly merit, taking into consideration such matters as how strictly they practised their faith, their overall trustworthiness as individuals and the capacity and reliability of one's memory; the latter was especially critical as, in theory, *hadith*s were supposed to be transmitted orally, the person receiving the *hadith* committing it – and its complete *isnad* – to memory. Although the copying of *hadith*s from written sources was in fact common, the problem with doing so was that, due to the nature of written Arabic, there was always the danger of misreadings. The exceedingly high esteem in which al-Bukhari and Muslim are each held is in part due to the accounts of their prodigious memories and the ability of each man to repeat, verbatim, great numbers of *hadith*s along with their complete and lengthy *isnad*s.

Many collections of *hadith*s exist in addition to those listed above and though some early collec-

tions are arranged according to transmitter, most are more conveniently arranged by subject. A vast range of subjects are dealt with as almost every action of and word uttered by the Prophet was avidly chronicled by those around him, nothing being considered too personal or too insignificant to record. The collections of al-Bukhari and Muslim each contain some four thousand individual *hadith*s, but collections not restricted, as are these two, to the highest classification of *hadith* are often very much larger. Smaller collections focusing on specific subjects were also produced, such as one popular type commonly titled *Arba'un* (meaning 'forty') which presents forty *hadith*s, usually on a single topic (fig. 138).

THE FOUR SCHOOLS OF ISLAMIC (SUNNI) JURISPRUDENCE

The discipline of Islamic law and its study is known in Arabic as *fiqh* (meaning 'understanding' or 'knowledge'). The origins of *fiqh* can be traced to the early years of Islam, when circles of scholars gathered together to debate religious, and specifically legal, issues. These scholars passed on their interpretations and understanding of legal matters to their students, who then themselves added to and further developed what they had received from their teachers, many in turn then passing on their knowledge to their own students. As time went by many *madhhab*s (schools) developed, named for and based on the teachings of a single individual. Four of these schools

Fig. 138
Illuminated Frontispiece, from an *Arba'un hadith* (Forty Hadith)

14th century, Iran
27.3 x 20cm, CBL Ar 4181, ff. 1b–2a

Although badly damaged, this frontispiece is a fine example of illumination produced during the period of Il-Khanid (Mongol) rule in Iran (1256 – c. 1335). The bands of geometric interlacement and the arabesque are characteristic features of Islamic illumination of all periods, but typical of this particular period are the overall bold aesthetic, the band of gold strapwork inset with tiny rectangular bits of blue, and the petal-like motifs that form the contour of the cornerpieces.

Fig. 139
The Founders of Four Schools of Islamic (Sunni) Law, from *Zubdat al-tawarikh* (The Cream of Histories)
Turkish text

Late 16th century, Istanbul, Turkey
39.5 x 25cm, CBL T 414, f. 130a

The four figures, anachronistically dressed in the garb of sixteenth-century Ottoman Turks, are identified by inscriptions as, clockwise from the upper left, al-Shafi'i, Abu Hanifa, Malik ibn Anas and Ibn Hanbal, founders of the four main schools of Islamic law.

emerged as the most prominent and exist today as four separate schools of Sunni law, each named for a prominent Islamic jurist: Abu Hanifa (d. 767), Malik ibn Anas (d. 795), Muhammad ibn Idris al-Shafi'i (d. 820) and Ahmad ibn Hanbal (d. 855) (fig. 139). However, as Wael Hallaq has suggested, these four schools should perhaps be classed as 'doctrinal' as opposed to 'personal' schools, because the doctrine and methodology of each is based not only on that of its founder. Each of these individuals should instead be understood as serving as an 'axis of authority', 'the leading jurist in whose name the cumulative, collective principles of the school were propounded'. Thus the doctrine (primarily the body of legal opinions) of these schools developed not only from the scholarly and juristic input of the eponymous founder of the school and those who preceded him, but continued to evolve 'in the name of the founder' in the years after his death. (Indeed, the two earlier doctrinal schools, the Hanafi and Maliki, did not emerge as such until the end of the ninth century and the two later ones, the Shafi'i and Hanbali, in the first half of the tenth century.) The founder's teachings may not even be the most prominent within the school, but nevertheless the school's 'cumulative juristic history' is generally credited to the 'founder' alone, with his legal opinions considered to be the result of 'direct confrontation with the revealed texts'.

The four schools differ mainly in details of their interpretation and application of various aspects of law and each rose to prominence in different areas of the Muslim world. Today the Hanafi school, the most liberal of the four schools, prevails in the majority of Islamic countries, in particular in the Muslim areas of south-eastern Europe, Turkey, Iraq, Central Asia, Afghanistan, Pakistan, northern India and China. The Maliki school is followed throughout much of North and West Africa, the more southerly regions of Egypt, and certain of the Gulf States, while the Shafi'i school is dominant in north-

Fig. 140
CBL Per 148,
ff. 191b–192a

Figs. 140–141
Ihya ulum al-din
**(The Revival of the Religious
Sciences)**
Naskh script

1474 (AH 879), Shiraz, Iran
18.6 x 13cm, CBL Per 148,
ff. 191b–192a

This volume consists of the first two of the four sections of al-Ghazali's text, and this frontispiece (fig. 140) marks the beginning of the second section. In the colophon, in the lower block of text on the final page of the manuscript (fig. 141), the calligrapher tells us that he completed this section of the text in the month of Muharram in 879 of the Islamic calendar (April–May 1474). However, in the colophon to the first section of the manuscript, he gives the date 875 (1471), indicating it took an unusually long time to complete the copying of the text of the second section, presumably because his work was interrupted for some reason. The calligrapher also records his name: Muzaffar ibn Ali, who was, he says, known as Sadr al-Din al-Sadiq.

ern Egypt (where al-Shafi'i lived and taught for much of his life), East Africa, the Yemen, Syria, parts of Iraq, South India, Sri Lanka and South-east Asia. Hanbali, the smallest of the four schools, is now the official school of Saudi Arabia and Qatar.

The Shi'a do not adhere to any of these four schools of law, and as they also recognise the authority of *hadith*s of the Imams, these also serve as a source of law; however, Shi'a law does not, in most aspects of actual practice, vary greatly from that of the Sunni schools. There are also other, more localised schools of law, such as the Ibadi school of Oman (the modern state of Oman is ruled by an Ibadi sultan), which is closer to Sunni than Shi'a law.

THE STUDY OF THE FAITH: AL-GHAZALI

Abu Hamid Muhammad ibn Muhammad al-Tusi al-Ghazali (d. 1111) is renowned as one of Islam's greatest theologians, jurists and philosophers. He was born and died in the town of Tus, in the province of Khurasan in north-eastern Iran, and it was there, at a young age, that he began his legal studies, which he would continue in Tus and elsewhere under the tutelage of some of the greatest jurists and theologians of his day. At age thirty-four, at the behest of Nizam al-Mulk (d. 1092), *wazir* of the ruling Seljuq dynasty, he took up a position teaching law in Baghdad at the prestigious Nizamiyya *madrasa* (theological college),

Fig. 141
CBL Per 148,
f. 383b

founded by and named for the *wazir*, where he remained for four years, relinquishing his post in 1095, ostensibly to undertake the pilgrimage to Mecca. Although he did eventually reach Mecca, he did so only after many years of travelling in Syria and other parts of the Middle East. The greatest part of his teaching career was spent in Nishapur (at another Nizamiyya *madrasa*), but he also taught in Damascus and in his hometown of Tus. According to his auto-biography, al-Ghazali was a follower of Sufism and it was largely after his return to his hometown of Tus and while living the life of an ascetic that he com-piled his monumental treatise, *Ihya ulum al-din* (The Revival of the Religious Sciences; figs. 140–141). Considered by many to be one of the great works of Islamic theology – and specifically a work on Sufism – it has also been described as basically a book on ethics and conduct and is divided into four major sections, each of which is divided into ten 'books'. These four major sections, with samplings of topics covered in the books, are: religious duties (the mys-teries of legal purification, prayer, alms-giving and pilgrimage; rules for the recitation of the Qur'an, etc.), social duties (arguments for and against mar-riage; manners and customs when eating, drinking and travelling; rules of brotherhood and companion-ship, etc.), faults or traits that lead one to damnation (hunger and sexual desire; avarice and love of wealth; anger, hatred and envy, etc.), and virtues or traits that lead one to salvation (repentance; trust in God; poverty and asceticism; remembrance of death and the afterlife, etc.).

6 PROPHETS AND OTHER PEOPLE OF THE QUR'AN

SOURCES FOR THE LIVES OF THE PROPHETS

As MUSLIMS REGARD the Qur'an as the final portion of God's revelation to mankind – completing but not supplanting God's earlier revelations to the Jews and Christians – the prophets of the Old and New Testaments are also considered prophets in Islam, and likewise many other biblical figures are referred to in the Qur'an and revered by Muslims. Although the Qur'an is never illustrated, depictions of these individuals appear in other types of texts (only a few of which will be mentioned here), though their depiction of course falls beyond the realm of orthodox Islam. As mentioned earlier, the text of Islamic histories, such as *Rawdat al-safa* (The Garden of Purity) by the Persian historian Mirkhwand, typically extends from God's creation of the world to Adam and the prophets and Muhammad, to subsequent caliphs and imams, and ends with the ruling dynasty that is contemporary with the author of the text. In the late sixteenth century, the Ottoman court historian, Luqman Ashuri of Urmya, composed another history of this same type, entitled *Zubdat al-tawarikh* (The Cream of Histories; fig. 142). As with Mirkhwand's text, there were political undertones to Luqman's text, which functioned as a means of situating the Ottoman Turkish rulers within the broader scheme of Islamic history and more specifically as affirming what they perceived as their rightful position within the preordained, divine scheme of Islamic kingship – a point made even more powerfully through the illustration of the text.

A second major type of text to include stories and illustrations of the prophets is that known generically as *Qisas al-anbiya* (The Tales of the Prophets), a genre whose origins are thought to extend back to stories transmitted orally in pre-Islamic Arabia and which draw on Jewish, Christian and in some cases other Middle Eastern sources as well (fig. 143). Various written versions of these highly popular stories exist, mostly bearing the same title, and though the earliest examples of this genre are in Arabic, there

are also several in Persian and at least one in Turkish. Not only do they include stories of the biblical prophets, but also of other specifically Islamic prophets mentioned in the Qur'an, the stories functioning (as they do in the Qur'an itself) as warnings by relating the fate of those who ignored the message of earlier prophets sent by God.

The story of Yusuf and Zulaykha (the biblical Joseph and the wife of Potiphar), by the fifteenth-century Persian poet Abd al-Rahman Jami, is a third type of text dealing with the prophets, but one that focuses on a single prophet only. In Jami's hands, the traditional and well-known story of Yusuf was transformed into a work of poetry – one with a decidedly mystical twist (fig. 144). Jami's poem was immensely popular and many illustrated copies of it exist. Several other poetic versions of this story also exist, one of which is a slightly later version in Turkish, by Hamdi Chelebi, but which never equalled Jami's in popularity.

In illustrating these and other historical and religious or quasi-religious texts, artists usually employed somewhat simple and sparse compositions, ones that serve to tell the story at hand in a direct and uncomplicated manner and in which the heads of prophets are often engulfed by large flaming halos.

ADAM AND HAWWA

Eve is known to Muslims as Hawwa, though she is not actually named in the Qur'an but is only identified as the spouse of Adam. In the *Qisas al-anbiya* tradition, she and Adam are usually portrayed wearing skirts made of leaves that they sewed together to hide their nakedness after the Fall (Qur'an 7:22). Depicting them instead in white robes, as in some illustrations, is probably a reference to the white garments worn by pilgrims to Mecca (fig. 145). According to popular tradition, when Iblis (Satan) was expelled from the Garden for having refused to prostrate himself before Adam along with the other

خمد وسپاس فراوان وشكروستايش چى پايان اول سلطان خالق الاكوان وصانع بلا امتنان جل جلاله وتعالى

وعمه نواله وتولى حضرتنه كه عامة مخلوقات وكانّة مصنوعاتى جريدة انشا وابداعك قلم تقديريله خلق كل شى

Fig. 142
Zubdat al-tawarikh
(The Cream of Histories)
Turkish text in *naskh* script

Late 16th century, Istanbul, Turkey
39.5 x 25cm, CBL T 414, f. 5b

This lovely illuminated heading marks
the beginning of the text of the
manuscript and is inscribed with the
title in white *thulth* script.

angels, he went to the peacock (the head of the
Garden animals) and told him that all the animals
were going to die, but that he could show them the
location of the Tree of Eternity. The serpent, hearing
of Iblis's offer, sought him out, but only to be duped
by Iblis who sneaked inside his mouth and was thus
carried by the serpent back into the Garden to exe-
cute his evil deed of tempting Adam and Eve to eat
from the Tree of Eternity. (The serpent's punishment
for its part in this event was the loss of its four legs,

Fig. 143
Qisas al-anbiya
(The Tales of the Prophets)

1570–80, Iran
31.7 x 19.9cm, CBL Per 231, ff. 2b–3a

This superb frontispiece is preceded by
two large, facing roundels, or *shamsa*s,
and is followed by an illuminated
heading bearing the title of the text.

Fig. 144
Yusuf u Zulaykha (Joseph and Zulaykha) of Jami

Persian text in *nasta'liq* script

1540 (AH 947), Iran
22.6 x 13.6cm, CBL Per 251, f. 1b

The illuminated heading is inscribed with the title of the poem, 'The Book of Joseph and Zulaykha'.

Fig. 145
Adam and Hawwa (Eve), from Qisas al-anbiya (The Tales of the Prophets)

Persian text in *nasta'liq* script

1570–80, Iran
31.7 x 19.9cm, CBL Per 231, f. 13b

Adam and Eve are shown being expelled from Paradise, with the peacock and serpent seen in the background.

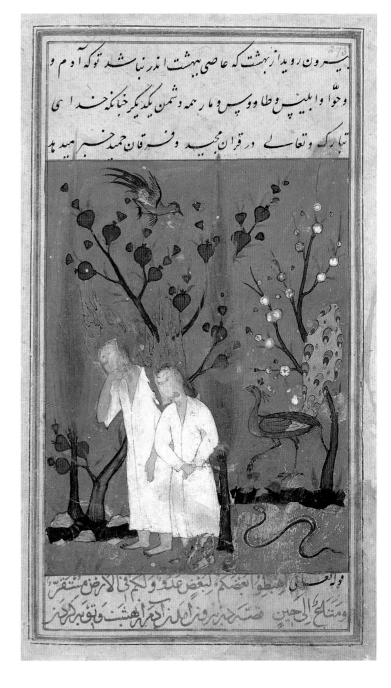

Fig. 146
**Adam and Hawwa (Eve),
from *Zubdat al-tawarikh*
(The Cream of Histories)**

Late 16th century, Istanbul, Turkey
39.5 x 25cm, CBL T 414, f. 53a

Adam and Eve with some of the
numerous pairs of twins to whom Eve
gave birth. The two wrestling figures in
the lower left are their sons Cain and
Abel, each of whom had a twin sister.

and thus to this day, snakes are legless creatures.)

In an illustration to a copy of the *Zubdat al-tawarikh*, Adam and Eve are depicted amongst some of the several (some sources say as many as twenty) pairs of twins that Eve bore: pregnancy and childbirth are, according to popular belief, amongst the ten punishments inflicted upon Eve and her female offspring for her sin, although the orthodox Islamic belief is that Adam and Eve were forgiven by God (fig. 146) and the 'sin' was not inherited by their descendants. The two figures fighting at the lower left of the composition are their sons, Cain and Abel, identified in the composition by their Arabic names of Qabil and Habil. In both the Qur'anic and biblical account of the story of Cain and Abel, Cain's killing of his brother was the first time a murder had ever been committed. However, the Quranic version (5:31) expands upon the biblical one and describes how Cain, who did not know what to do with his dead brother's body, was sent a raven by God. The raven having just killed another of its kind, scratched at the ground to show Cain how to dig a grave to hide Abel's body (fig. 147).

IDRIS

Idris is a specifically Islamic prophet, though he is sometimes identified with various biblical figures, in particular Enoch. He is mentioned just twice in the Qur'an and both times only briefly. In verses 19:56–57 he is noted as a man of truth, whom God raised 'to a lofty station', and in verses 21:85–86 he is noted as a man of 'constancy and patience', along with Isma'il (Ishmael) and Dhu'l-Khifl (an unidentified figure who might be Ezekiel), all of whom 'We admitted to Our mercy, for they were of the righteous ones'. Thus the Qur'an itself gives little hint as to the true identity of Idris or his actions. That he was raised 'to a lofty station' is generally held to mean that he ascended to heaven (as did Enoch) without ever having died a human death and, according to tradition, there he was granted immortality, contin-

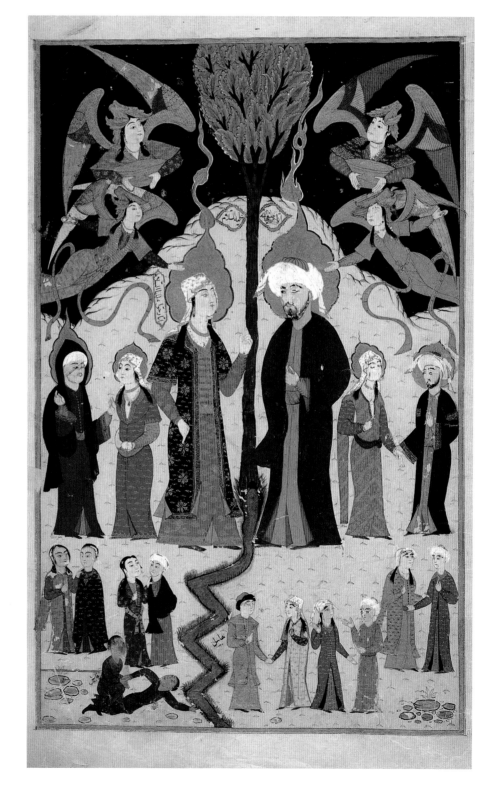

ا د میان آن بود جنانکه خدای تعالی فرمود فنعت الله غرابا
یجث فی الارض لیریه کیف یواری سوآة اخیه
خدای تعالی کلاغی را بفرستا د تا زمین را بکاو ید که بنماید و یرا مرده

نهان کرد نبعد از ان برادر خو یش را بپوشید و پشمان شد وکو یند

Fig. 147

**Qabil (Cain) Carrying the Body
of his Slain Brother Habil (Abel),
from *Qisas al-anbiya*
(The Tales of the Prophets)**
Persian text in *nasta'liq* script

1570–80, Iran
31.7 x 19.9cm, CBL Per 231, f. 18b

Cain carries the body of his dead
brother towards the raven (at the right
of the composition) that has been sent
by God to show him how he must dig a
grave in which to bury his brother. The
autumn foliage of the tree may seem to
symbolise death and dying and hence
the murder that Cain has committed,
yet the very pretty, flower-strewn grassy
ground across which he carries his
dead brother's body in turn belies the
tragedy of the event.

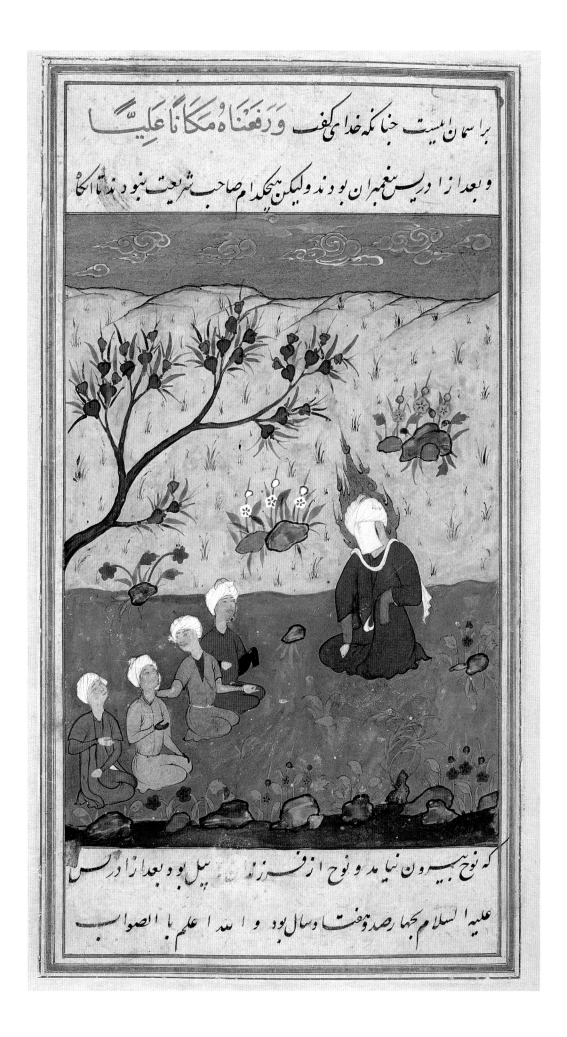

Fig. 148
**Idris Instructing his Children,
from *Qisas al-anbiya*
(The Tales of the Prophets)**
Persian text in *nasta'liq* script

1570–80, Iran
31.7 x 19.9cm, CBL Per 231, f. 22a

The prophet Idris, his face hidden
behind a veil and his head engulfed in a
flaming halo, sits by a stream (once
silver but now tarnished) instructing his
children.

uing to reside in heaven forever. Idris is credited with a number of pioneering feats, including being the first to weave cloth and wear woven clothes, the first to write with a pen and the first astrologer, and it is also said that he was responsible for preserving human knowledge and passing it onto mankind after the flood; related to this latter capacity are depictions of him instructing his children (fig. 148).

NUH

The story of Nuh (Noah), his building of the ark and of the flood, is told at considerable length in the Qur'an, in particular in Chapter 71, which bears the title 'Nuh' and deals exclusively with his story, and in verses 11:25–49, but he is also named or details of his story are specifically dealt with in more than a dozen other chapters. Noah's role, like that of all prophets, is as a warner of the fate that will befall those who ignore the word of God, and he frequently states this, as in verse 71:2: 'I am to you a Warner, clear and open' (i.e. a warning that is unambiguous and publicly proclaimed). As in the Jewish and Christian traditions, once it is certain that the people will not give up their sinful ways, God commands Noah, saying (fig. 149):

Construct an ark
Under Our eyes and Our inspiration
And address Me no further on behalf of
Those who are in sin,
For they are about to be overwhelmed in the
flood. (11:37)

Fig. 149
**Nuh (Noah) and the Ark,
from *Zubdat al-tawarikh*
(The Cream of Histories)**

Late 16th century, Istanbul, Turkey
39.5 x 25cm, CBL T 414.61

Noah is clearly distinguished from the other men on the ark by his greater size and haloed head. Many of the animals he has saved are visible through the arched windows in the mid-section of the ark.

Fig. 150
The Destruction of Sodom,
from *Qisas al-anbiya*
(The Tales of the Prophets)
Persian text in *nasta'liq* script

1570–80, Iran
31.7 x 19.9cm, CBL Per 231, f. 59b

Having lifted the sinful city of Sodom
high as the heavens, Gabriel then turned
it upside down sending all its inhabitants
– men, women and even babies in their
cradles – hurtling to the ground,
together with all their belongings (note
the falling horse and household items
such as the silver ewer).

LUT

Lut (Lot) is named in fifteen chapters of the Qur'an,
though this extensive treatment of him and the story
of the destruction of the city of Sodom is not sur-
prising as the latter ranks as the second most
dramatic example of divine punishment in the
Qur'an after the flood. Lot and his people lived
spread amongst several cities, of which Sodom,
where Lot and his family resided, was the capital.
Unable to convince his fellow citizens of the
immorality of their ways, Lot and his family were
ordered by God to leave the city before dawn,
though his immoral wife, who connived with the
other citizens, was made to lag behind and suffer the
punishment of the others. Verses 11:82–83 of the
Qur'an state:

> When Our decree was issued,
> We turned (the cities) upside down,
> And rained down on them brimstones
> Hard as baked clay,
> Spread, layer on layer –
>
> (And) marked as from thy Lord:
> Nor are they ever far
> From those who do wrong!

Popular tradition has it that when dawn broke,
Gabriel lifted the city and its wicked inhabitants up
with one wing while offering protection to Lot and
his family with the other. So high did Gabriel lift the
city of sinners that the angels in heaven could hear
the dogs bark and the cocks crow. The city was then
turned upside down, flung to ground and then show-
ered with stones, each of which is said to have been
marked with the name of the disbeliever it was des-
tined to kill. While the last two lines of the Qur'anic
verses cited above are somewhat ambiguous, they
probably should be interpreted very straightforwardly
as meaning that the stones themselves are never far
from the heads of sinners (fig. 150).

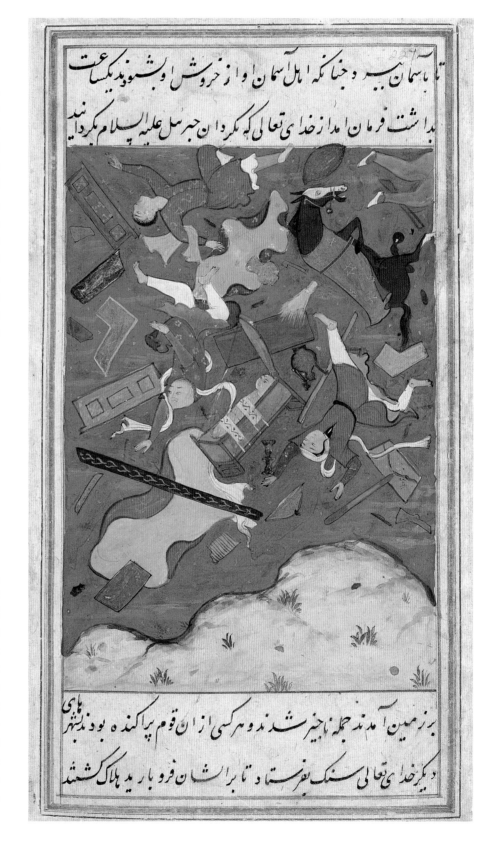

Fig. 151
Qur'an

14th century, Egypt,
46.6 x 33.7cm, CBL Is 1485, f. 128a

This lovely, predominantly gold heading marks the beginning of Chapter 12, which tells the story of the prophet Yusuf (the biblical Joseph). Besides the title, the heading also states that this chapter consists of 111 verses.

YUSUF

One of the most well known of the prophets revered by the three religions is Joseph, known to Muslims as Yusuf. The longest of the few narrative sections in the Qur'an is Chapter 12 (fig. 151), which bears the title 'Yusuf' and tells the story of how he was sold into slavery by his brothers, thrown into prison in Egypt when Zulaykha attempted to seduce him, and then freed and eventually appointed to a high-ranking position in Egypt because of his ability to interpret dreams and foretell the future for the Pharaoh. It is a moralistic tale in which Yusuf, because he resisted Zulaykha, is regarded as a model of virtue and wisdom, while Zulaykha's suffering in later life (once her husband dies she falls on hard times) is regarded as a just reward for her lusting, as a married woman, after the young and beautiful Yusuf. As retold and expanded in verse by the renowned, fifteenth-century mystical poet Jami, the story of Yusuf's encounter with Zulaykha, composed in 1483, can be interpreted as an allegory of the mystical search for union with the divine, wherein the figure of Zulaykha represents the longing of the imperfect human soul for the divine perfection of Allah, represented by the figure of Yusuf. Jami's poem was popular in India as well as in Iran, the poet's homeland, and one of the most extensive series of illustrations to his poem is found in an eighteenth-century Indian manuscript; the compositions of most of its fifty-six illustrations (seven of which are reproduced here) are exceedingly simple, yet highly appealing (figs. 152–158).

MUSA

More than thirty chapters of the Qur'an include verses relating the life of Musa (Moses). The story of his visit to Pharaoh, King Far'un of Egypt, to deliver to him the Word of the one true God and to request the release of the Children of Israel, and his subsequent performing of the miracle of turning his staff into a serpent, is often illustrated in a variety of texts. It is told at considerable length in verses 7:103–126, 20:42–76 and 26:10–51 of the Qur'an, though popular tradition, drawing on Jewish and Christian

Figs. 152–158
**Yusuf u Zulaykha
(Joseph and Zulaykha)**

1740–50, India
26 x 15.6cm, CBL In 18

The illustrations in this manuscript are clearly based on Jami's version of the story of Yusuf and Zulaykha; however, in its present state the manuscript includes no text other than descriptions of the illustrations.

Fig. 152
CBL In 18, f. 31a

Yusuf's brothers decide to rid themselves once and for all of their young brother, their father's favourite son, and so they gather on a terrace to hatch their evil plot to throw him into a deep well.

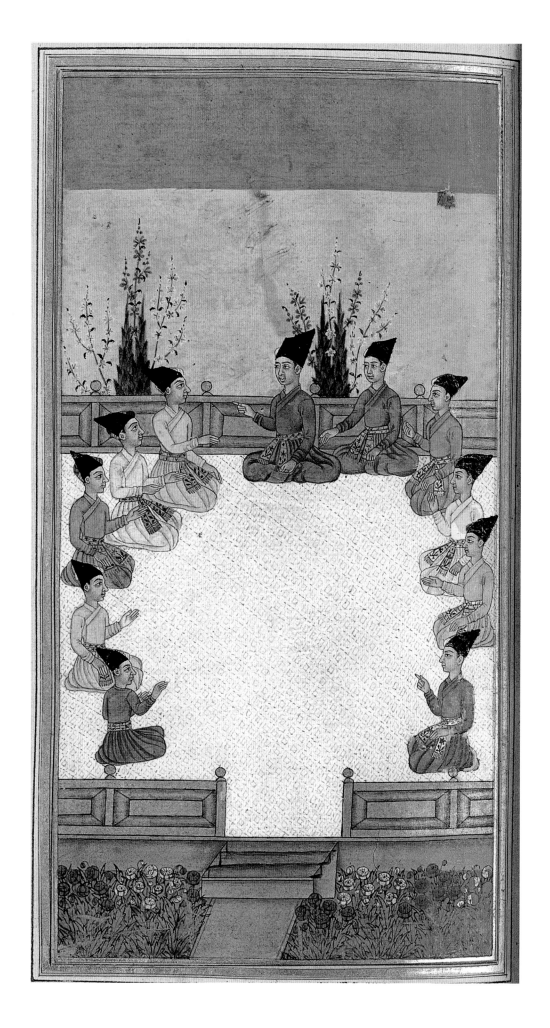

Fig. 153
CBL In 18, f. 38a

A group of passing merchants find the young and very beautiful Yusuf and take him to Egypt, where they sell him to Qitfar (Potiphar), the bearded figure in orange who is shown negotiating Yusuf's purchase with one of the merchants.

Fig. 154
CBL In 18, f. 54a

Zulaykha quickly becomes infatuated with her husband's new slave; she is shown sitting in a garden pavilion discussing with her elderly nurse her love for Yusuf.

Fig. 155
CBL In 18, f. 65a

The wily old nurse suggests a plan for Zulaykha to beguile Yusuf and so a beautiful seven-roomed pavilion is built, its walls, carpets, and every conceivable space covered with depictions of the couple in amorous embraces.

Fig. 156
CBL In 18, f. 68b

One day, having adorned herself in sumptuous Chinese textiles and rich jewels, Zulaykha sends for Yusuf to come to the pavilion where, in each of its rooms, she does her best to seduce him. Yusuf, fearful that he will not be able to resist her charms, dares not look into her face and instead looks away, but everywhere he looks he sees images of the two of them embracing. When he finally decides to flee, she pursues him through each of the rooms of the pavilion, and just before he escapes, she grasps and rips an edge of his robe.

Fig. 157
CBL In 18, f. 81b

Angered by Yusuf's rejection of her, Zulaykha accuses him of trying to seduce her (presenting the piece of cloth torn from his robe as evidence) and he is thrown in prison, where, accompanied by her nurse and in a state of deep regret over her false accusation of him, she later visits the poor, shackled Yusuf.

Fig. 158
CBL In 18, f. 100b

Yusuf is eventually released from prison because of his ability to interpret dreams, which he does for the pharaoh, correctly forewarning him of the coming cycle of seven years of plenty followed by seven of drought. His reward is to be named *wazir* of Egypt, a position that brings him wealth and power. Zulaykha, however, is less fortunate; her husband dies and she falls on hard times, ageing prematurely and living a life of extreme poverty. Once re-united with Yusuf, his prayers and her renunciation of her past allow her beauty and youth to be restored, and they are at last married. When he later dies (she is pictured here at his tomb), she is disconsolate and dies herself soon after.

Fig. 159
**Musa (Moses) Transforms his Staff into a
Serpent before Pharaoh, from *Tarikh-i
bal'ami* (The Annals of Bal'ami)**
Persian text in *nasta'liq* script

1470 (AH 874), Iran
35.3 x 24.5cm, CBL Per 144.68

The small serpents created by the magicians can be seen squirming across the green grass, but they are quickly being devoured by the much larger serpent created from Moses' staff. The semi-circular arrangement of the magicians' heads, many of which are seen from behind, is an unusual and somewhat innovative device for Persian painting of the time. This manuscript was probably produced in Herat, which, though now part of Afghanistan, was at the time part of Iran and an important centre of book production.

sources, further explains the story.

Pharaoh requested that Moses produce a sign of his prophethood, and so he threw down his staff which was promptly transformed into a serpent. He then put his hand into his armpit and when he withdrew it, it glowed brilliantly. Thinking Moses and his brother Aaron mere sorcerers, Pharaoh challenged them to face the finest magicians in the land. The magicians performed first, turning ropes and sticks into a whole field of wriggling snakes. (However, their magic was a mere trick of the eye, because they had placed on the ground hollowed-out sticks filled with quicksilver which they had tied together with ropes; as the sun warmed the earth, the quicksilver expanded, causing the ropes to move and creating the appearance of squirming snakes.) Moses was at first frightened by their apparent ability, but then God reassured him, saying (20:68–69):

> Fear not! For you have indeed the upper hand.
> Throw that which is in your right hand
> (his staff),
> Quickly will it swallow up
> That which they have faked;
> What they have faked
> Is but a magician's trick,
> And the magician thrives not
> (No matter) where he goes.

Moses then threw his staff again and this time it turned into an even mightier serpent that quickly devoured the magicians' snakes, thereby convincing the magicians to denounce Pharaoh and believe in the Lord (fig. 159).

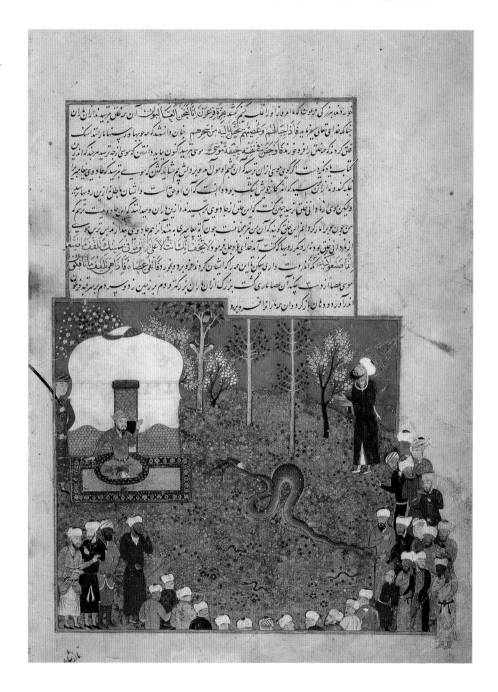

Fig. 160
Yunus (Jonah) Cast from the Belly
of the Fish, from *Qisas al-anbiya*
(The Tales of the Prophets)
Persian text in *nasta'liq* script

1570–80, Iran
31.7 x 19.9cm, CBL Per 231, f. 156a

This illustration follows exactly the story of Jonah as related in the Qur'an (37:143–146), which states that once Jonah was cast from the fish's belly, God caused a 'spreading plant of the gourd kind' to grow over him. The plant, replete with gourds, white blossoms and leaves grows on the rocky shore, in slight advance of Jonah's imminent arrival.

YUNUS

The intriguing story of Yunus (Jonah) and the whale is as much a favourite in the Islamic tradition as it is in the Jewish and Christian traditions. Jonah himself is mentioned several times in the Qur'an, the various details of his story told in verses 21:87–88 (where he is referred to only as Dhu'l-Nun, the man of the big fish or whale), 37:139–148 and 68:48–50, and with the information presented there elaborated upon in the *Qisas al-anbiya* and other sources, as it is for all of the prophets named or at least referred to in the Qur'an. Verse 21:87 states:

And remember Dhu'l-Nun,
When he departed in wrath;
He imagined that We
Had no power over him!
But he cried through the depths of darkness:
'There is no god but Thou,
Glory to Thee; I was indeed wrong!'

Angry with events concerning his prophetic mission to bring the wicked inhabitants of the city of Nineveh to heed the word of God, Jonah departed from the city and embarked on a sea voyage which ended in him being forced overboard. The depths of darkness in which Jonah then found himself after being swallowed by the fish is the obvious darkness of his new abode in the creature's belly, but it is also the spiritual darkness of his loss of faith in God, whose actions in dealing with the people of Nineveh he had questioned. Once Jonah repents, however, he is saved and cast out of the belly of the fish (37:143–146; fig. 160):

Had it not been
That he (repented and) glorified Allah
He would certainly have
Remained inside the fish
Till the Day of Resurrection.
But We cast him forth

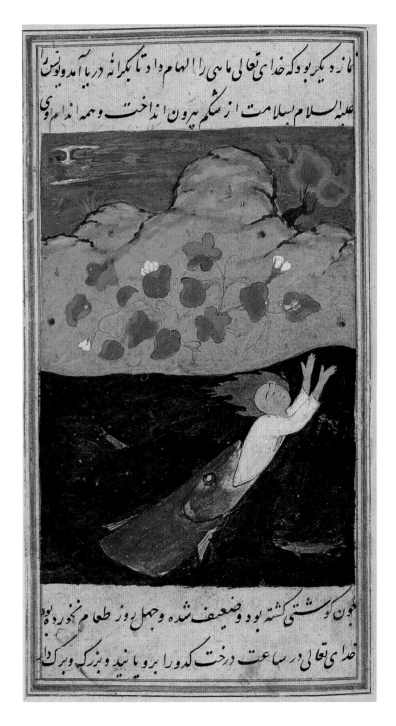

On the naked shore in a state of sickness.
And We caused to grow over him
A spreading plant of the gourd kind.

Fig. 161
**Sulayman (Solomon) and Daud
(David), from *Zubdat al-tawarikh*
(The Cream of Histories)**

Late 16th century, Istanbul, Turkey
39.5 x 25cm, CBL T 414, f. 73a

In the lower register, an enthroned
Solomon (along with three unidentified
figures) is surrounded by the birds and
animals whose speech God has
granted him the ability to understand. In
the upper register are two angels and
his father David, who is also mentioned
in the Qur'an.

SULAYMAN

Sulayman (Solomon) is mentioned several times in the Qur'an. Granted both Judgement and Knowledge by God, he is noted for his great wisdom, just as he is in the Jewish and Christian traditions. As recorded in the Qur'an (27:16), God also blessed him with the ability to understand the speech of the birds and so he is most often shown seated in the midst of various real and mythical birds (fig. 161). Solomon was a highly popular figure and many images of him exist. In Iran, in the early sixteenth century, double-page frontispieces depicting Solomon and the Queen of Sheba, or Bilqis as she is known in the Muslim tradition, were particularly popular and were often included in copies of the *Shahnama*, the Persian Book of Kings, and in the *Khamsa*, or Five Poems, of the Persian poet Nizami (fig. 162). Typically, Solomon is shown on the right, enthroned amongst birds, jinns and angels, with Sheba on the left. Verses 27:22–44 of the Qur'an tell how the hoopoe bird reported to Solomon that he had seen a country ruled by a woman who provided her subjects with everything they needed, but that she and her people were pagans. Solomon wrote a letter inviting Sheba to accept Islam and though she initially refused, she eventually saw the folly of her ways and joined Solomon in the worship of the one true God.

ISKANDAR, KHIDR AND ILYAS

In Chapter 18, the Qur'an speaks of a person named Dhu'l-Qarnayn, the 'Possessor of Two Horns', who is popularly taken to be Alexander the Great (356–323 BC), and is known to Muslims as Iskandar. Various explanations have been suggested for the name Dhu'l-Qarnayn, including that it refers to the fact that Alexander was ruler of both Greece and Persia or, more likely, that it refers to the two ram's horns that he wears on some coins minted during his reign. Stories of the exploits of Alexander evolve mainly from the Alexander

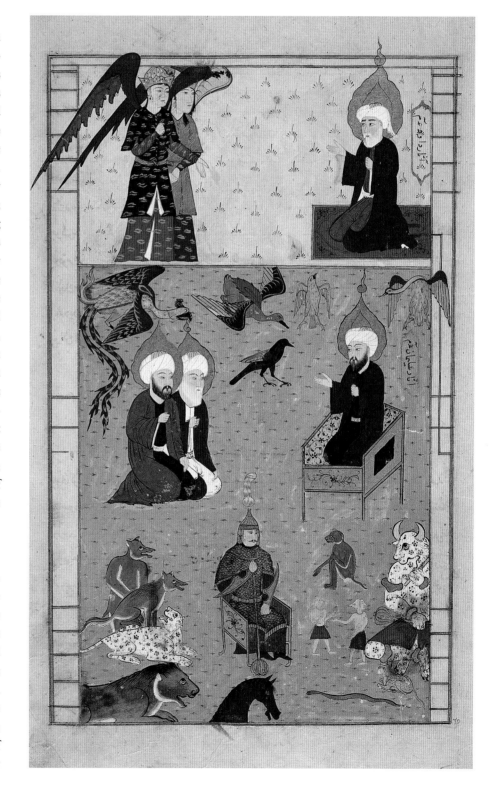

Romance, a multi-varied collection of legends, the earliest of which date back to within about a hundred years of his death. In Islamic texts, Alexander is transformed from a hated invader of Iran into a Muslim king (and sometimes prophet), the model man and ruler. One of the most well-known stories of his life is that of his quest for immortality and his subsequent travels through the Land of Gloom in search of the Water of Life. His guide on his quest is usually said to have been Khidr, a specifically Islamic figure, who is often considered a prophet and whose name means 'green'. During their quest, Alexander and Khidr became separated, and Khidr unwittingly encountered and touched the Water of Life, thereby gaining immortality, and from that moment onwards, whatever he touched is said to have become instantly green and lush, thus explaining not only his name but also why he is typically depicted in a green robe (fig. 163).

Khidr is referred to by some authors as the 'brother' of another figure, Ilyas (usually identified as the biblical Elijah), because he too gained immortality, through his Ascension to Paradise. The story of Alexander's quest (and other stories of his life) is included in both the great Persian epic, the *Shahnama* (Book of Kings), of the Persian poet Firdawsi (composed in the late tenth–early eleventh century), and the *Khamsa* of the Persian poet Nizami (composed about 1191–1200). However, in Nizami's version, which treats the search in mystical terms as a quest for knowledge of the divine, Alexander's guide is not Khidr but Ilyas (who is named in verses 6:85 and 37:123–132 of the Qur'an). This confusion as to who served as Alexander's guide is reflected in the iconography of illustrations portraying this story, which typically depict Alexander and his entourage passing by the Water of Life in the dark, with both Khidr and Ilyas seated at the edge of the pool, just out of sight of Alexander (fig. 164).

Verses 18:83–101 of the Qur'an relate another favourite tale of Alexander's exploits, that of his

Fig. 162
**Sulayman (Solomon) and Bilqis
(The Queen of Sheba), from a
Khamsa (Five Poems) of Nizami**

1529 (AH 936), Iran
29.7 x 18cm, CBL Per 195, ff. 1b–2a

Copies of the *Shahnama* (the Persian
Book of Kings) and the *Khamsa* (Five
Poems) of the Persian poet Nizami,
produced in Iran in the early sixteenth
century, frequently include frontispieces
of this type, with Solomon (who could
understand the speech of the birds)
enthroned on the right-hand page and
with Sheba on the left. Besides the
wonderful depictions of so many birds,
animals and other creatures, the
intricate decoration of Solomon's
throne is worthy of special note, as is
the pool with its three water channels
that is placed in front of Sheba's throne.

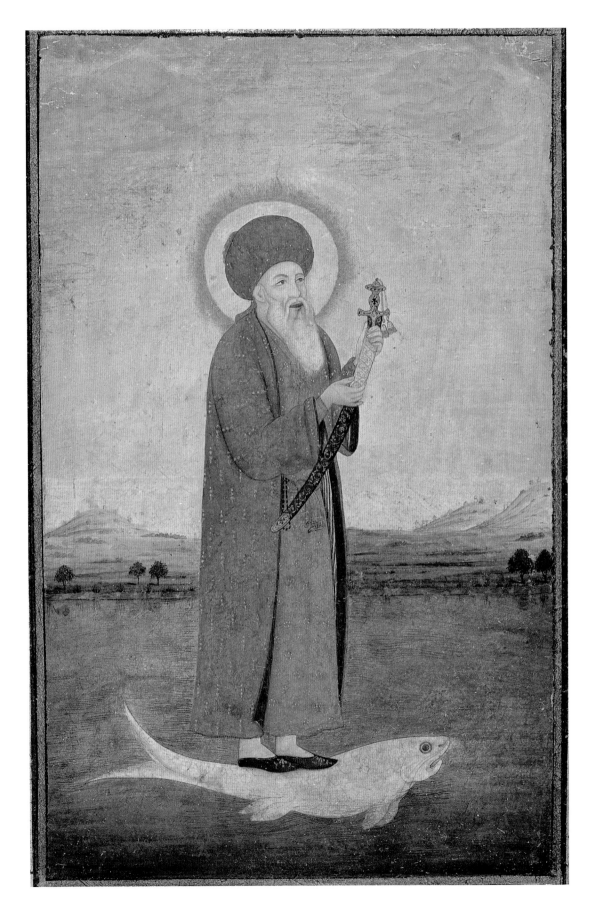

Fig. 163
Khidr, from the Shuja al-Dawla Album

*c.*1770, Faizabad, India
28.5 x 17.9cm, CBL In 34.14

The story of Moses' encounter with Khidr is related in verses 18:60–82 of the Qur'an. Khidr, whose name means 'green', is typically depicted in a green robe, but in India, where he is revered by Muslims and non-Muslims alike, he is popularly considered a river-god and usually is also shown standing or sitting on a fish. This association with a fish actually derives from his connection with Moses, who, having been told by God that there is in fact someone (namely Khidr) more knowledgeable than himself, sets off in search of him. God instructs Moses to take along a salted fish that he says will swim away once he reaches his goal. When he unwittingly happens upon the Water of Life, the fish touches the water, springs to life, and swims away, and, just as God predicted, there Moses finds Khidr, who resides by the Water of Life.

encounter with a land of people who request his aid in building a wall between two mountains to prevent the Gog and Magog people from descending upon their land and ravaging it. (Known to Muslims as Yajuj and Majuj, in the Jewish and Christian traditions they are usually regarded as two individuals not peoples.) Alexander fulfils the request that he should build a wall, but then warns that on a day chosen by God the wall will crumble, releasing the Gog and Magog people who 'will swiftly swarm from every hill' (21:96) to wreak havoc and destruction upon the earth, and the trumpet will be blown to signal the imminent arrival of the Day of Judgement when all those who do not believe in God will be doomed to an eternity in hell. Indeed, according to a *hadith*, the unleashing of the Gog and Magog people upon the world is one of ten primary signs marking the arrival of the Last Day. Alexander's building of the wall is also frequently illustrated in copies of Nizami's *Khamsa*, but it also appears in a widely dispersed copy of the *Falnama* (Book of Divinations), produced in Iran in the sixteenth century for the Safavid ruler Shah Tahmasp (fig. 165). In this manuscript, the iconography is again confused: in the foreground a group of industrious *divs* (demons) construct the wall, while in the background Alexander sits facing two haloed figures, Khidr and Ilyas. Although Khidr and Ilyas are said to have met each night on the wall, remaining there, praying, till daybreak, they in fact played no part in the actual building of the wall and so have again been erroneously included in the composition.

Fig. 164
Iskandar (Alexander) in the Land of Gloom, from a *Shahnama* (Book of Kings)
Persian text in *nasta'liq* script

*c.*1650, Iran
35.3 x 24cm, CBL Per 270.80a

Iskandar, wearing a plumed crown, is seen passing by the Water of Life, at the edge of which sit Khidr and Ilyas, their status as prophets indicated by their flaming halos.

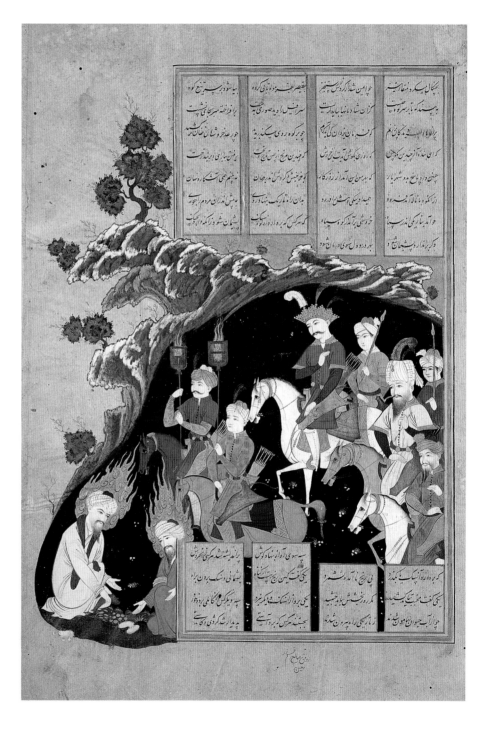

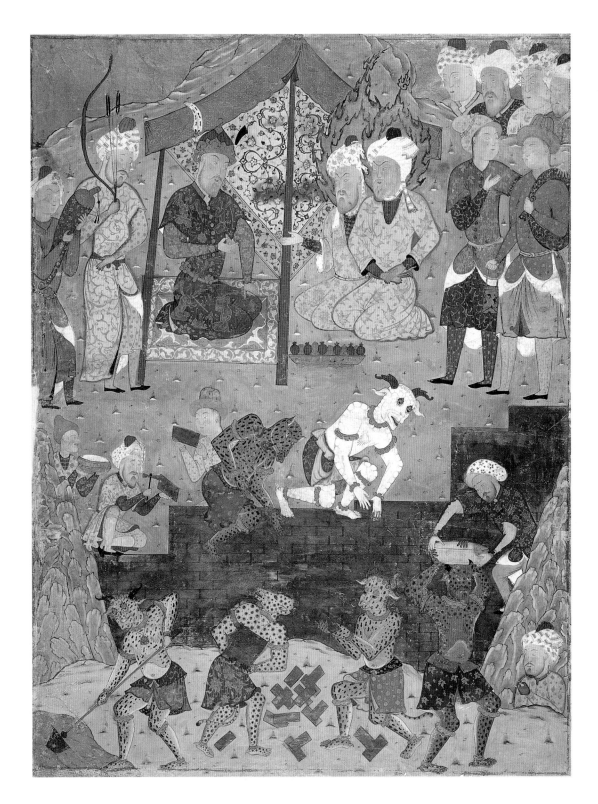

Fig. 165
Iskandar (Alexander) Oversees the Building of the Wall, from a *Falnama* (Book of Divinations)

1550–60, Iran
59.4 x 45cm, CBL Per 395.1

While a group of men and several rather horrific-looking *div*s (demons) busily build the wall that Alexander has been asked to build, Alexander himself sits under a richly embroidered canopy conversing with two holed figures, the prophets Khidr and Ilyas, who, like every other man depicted by the artist, wear fine garments decorated with patterns woven with gold thread. For their refreshment, a dish of pomegranates and what appears to be some kind of green fruit has been placed before the two prophets.

Fig. 166
**Maryam (Mary) Shakes a Palm
Tree to Provide Food for the Baby
Isa (Jesus), from *Qisas al-anbiya*
(The Tales of the Prophets)**

1570–80, Iran
31.7 x 19.9cm, CBL Per 231.227

It is said that as soon as Mary touched
a dead palm tree, it sprang to life, a feat
symbolised here by the half-dead, fruit-
bearing tree. To the right of the tree lays
a tightly swaddled, newborn Jesus, his
whole upper body engulfed by a
flaming halo.

MARYAM

Known to Muslims as Maryam, Mary is the most
prominent female figure in the Qur'an and the only
one identified by name. She is referred to in some
sources as a prophet and is named in seven chapters
of the Qur'an, including Chapter 19, the title of
which is *Maryam*. As stated in verse 3:42, she is con-
sidered pre-eminent over all other women:

> Behold! the angels said:
> 'Oh Mary! Allah has chosen thee
> And purified thee – chosen thee
> Above all women of all nations.'

Verses 19:22–26 tell how she removed herself to a
place of seclusion to give birth to her son and that,
alone and suffering the first pangs of childbirth, she
immediately expressed the thought that perhaps it
might have been better if God had overlooked her.
Seeking to comfort her, God created a small stream
so she might have water to cool herself and
instructed her to shake a palm tree and eat its dates to
replenish her strength. According to some *Qisas al-
anbiya* texts, it was Jesus who, immediately after his
birth, told his mother to shake a dead palm tree,
which, the instant she touched it, sprang to life,
sprouting leaves and dates for her to eat (fig. 166).

Fig. 167
The Ascension of Isa (Jesus), from
Zubdat al-tawarikh
(The Cream of Histories)

Late 16th century, Istanbul, Turkey
39.5 x 25cm, CBL T 414, f. 102b

A turbaned Jesus is shown ascending to heaven escorted by two crowned angels and watched in amazement by a group of men on the ground. The Muslim belief is that Jesus did not die a human, bodily death but that he continues to live in heaven and will return on the Last Day, at which time he will lead all people to the acceptance of Islam.

Isa

In the Muslim tradition Jesus is known as Isa and, as the most revered of the prophets after Muhammad, he is mentioned numerous times in the Qur'an. For example, the beginning of verse 3:55 states:

> Behold! Allah said: 'O Jesus!
> I will take you and raise you to myself
> And clear you (of the falsehoods)
> Of those (meaning the Jews) who blaspheme.'

The falsehood of which Jesus was accused by the Jews was of course that he proclaimed himself to be the son of God. Muslims regard Jesus as human only, not divine (though the miracle of his virgin birth is upheld). However, verses 4:157–158 proclaim that:

> They (meaning the Jews) said:
> 'We killed Jesus Christ, the son of Mary,
> the Messenger of Allah,'
> But they killed him not, nor crucified him,
> But so it was made to appear to them....
> They killed him not.
> Nay, Allah raised him up unto himself.

The usual interpretation of these verses is that, though human, Jesus did not die a usual, human death, but instead continues to live, in the body, in heaven (fig. 167).

Numerous images of Jesus and other figures based on Christian iconography were produced in the late sixteenth and early seventeenth centuries for the Mughal rulers of India. They were often surrounded by elaborate borders and included in albums, where they were devoid of any associated, relevant text (fig. 168). Despite the fact that Jesus is a Muslim religious figure, such images are an expression of the emperors' interest in other religions, but should also be considered artistic curiosities, for they often incorporate elements of Western painting techniques and as such were equally made to test the artist's skill.

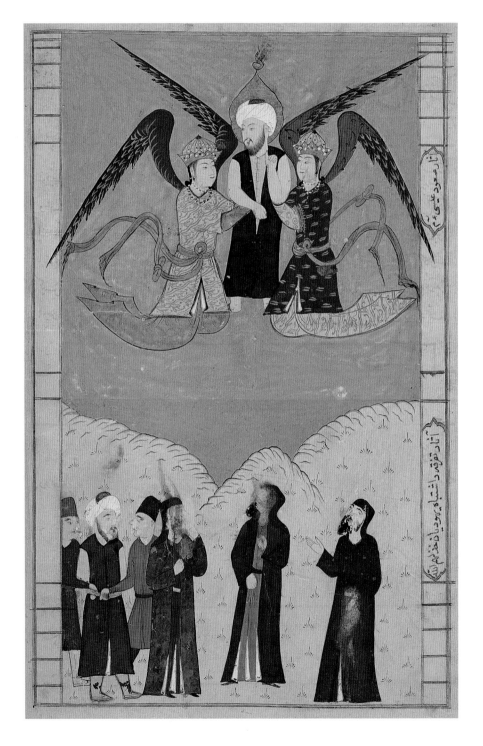

Fig. 168
Jahangir and Jesus, from the Minto Album
Persian script in *nasta'liq* script

*c.*1610–20, India
38.7 x 25.5cm, CBL In 07A.12b

In the upper register is a portrait of the Mughal Emperor Jahangir (*r.* 1605–27), and in the lower register, a painting of Jesus, by an Indian artist but presumably based on a European print. The folio was originally part of a bound album, compiled under Jahangir and his son Shah Jahan (*r.*1627–58). On the reverse of the folio is Persian poetry unrelated to the paintings. Throughout the album, both paintings and calligraphy are surrounded by ornate borders such as the beautiful ones seen here, which consist of brightly coloured flowering plants all carefully outlined in gold.

7 MYSTICAL ISLAM

SUFISM

SUFISM IS THE term used to describe the mystical or esoteric dimension of Islam. The word Sufi derives from the Arabic word *suf*, meaning wool, and is thought to refer to the rough wool garments once worn by Sufis as a sign of humility (for only the poor wore wool) and hence as a symbol of their rejection of the material world. The term *tasawwuf*, referring to the actual wearing of wool, is often used as a synonym for 'Sufism', or to refer to the mystical journey upon which the Sufi must embark. It has, however, also been argued that 'Sufi' derives from the Greek *sophos*, meaning 'wise'.

One of the most renowned of all Sufis is Junayd of Baghdad (d. 910), who is recorded as having stated that 'Sufism is that God makes one die to oneself and become resurrected in Him'. Indeed, the goal of the Sufi is knowledge of God and, specifically, full realisation of union with God. To achieve this – or to attempt to do so – the adherent is guided by a master, or *shaykh* (or *pir*, in Persian), as he travels along a spiritual Path or Way (*tariqa*), consisting of numerous stations (*maqams*) and states (*hals*). The stations tend to be associated with specific virtues and are regarded as permanent, in that once an adherent has truly attained a station, he passes onto a new level of being, his level of consciousness and existence permanently and completely altered, and there is no regressing to a lower station. Some of the many stations through which one must pass are repentance (*tawba*); conversion (*inaba*), meaning the decision to turn away from the material world and devote oneself to God; asceticism or renunciation (*zuhd*) of all worldly pleasure; sorrow (*huzn*) for past sins; and confidence or trust (*tawakkul*) in God. Manuals outlining and describing the various stations (and states) exist, though in fact they are enumerated differently by various individuals and Sufi orders. Indeed, it is said that in order to know the actual number of stations and states one must pass through, the adherent must already be on the Path, and the stations in particular may not be the same for everyone. Progression from one station to the next is achieved through the will and effort of the individual, and having successfully attained the final station, the adherent passes onto a series of states. The stations have been described as being earned, while the states are gifts from God. In other words, in contrast to the stations, the states, which are transient, are achieved or granted through the will of God and therefore the individual cannot through his own effort achieve any given state or even retain that state once it has been achieved, except by the grace of God. Moreover, any state can be experienced briefly at any point along the Path if God wills it.

The final two states are *fana* and *baqa*. As the Sufi nears these two final states he achieves gnosis (*ma'rifa*), direct knowledge of God. As do all metaphysical doctrines, Sufism views gnosis in terms of light or illumination. *Fana*, the penultimate state, may be translated as 'extinction', 'cessation', 'annihilation' or 'passing away' and in this state the Sufi's links to the material world are extinguished. From here the Sufi passes to the state of *baqa*, meaning 'survival'. Some regard this state as occurring after death, but most regard it as the final state of the mystical experience in this world. In either case, the Sufi is now considered to survive or exist within God, who is seen everywhere. At this point the Sufi has achieved realisation of the Divine Unity, the transcendent oneness of God (*tawhid*), equated by some as unity with God. The Sufi has now completed the mystical journey. The attainment of these final two states is often viewed as a form of death, because once the splendour and glory of God is truly known, the mortal self seems of little consequence or value even though physical life continues. Or, as the poet Jalal al-Din Rumi explains it, it is like the light of a candle in front of the sun. Yet at the same time, just as the light of the sun makes objects visible, so the light of the knowledge of God makes the true essence of all things visible. Everything in the world has both an external form (*surat*) visible to all and an inner

Figs. 169–170
Hafiz and his Spiritual Master, from a *Divan* (Collected Poems) of Hafiz

1838 (AH 1254), Iran
15.4 x 9.3cm, CBL Per 389

These two images decorate the front inside and back inside covers of a collection of poems by the Persian mystical poet Hafiz (d.1389). The Sufis depicted are probably intended to represent Hafiz himself (fig.169) and his spiritual master, or *shaykh* (fig.170). However, these are highly idealised images, as indicated by how well-dressed the figures are and, especially, by the flower-filled 'begging bowl' held by the *shaykh*.

Fig. 169
CBL Per 389,
back inside cover (doublure)

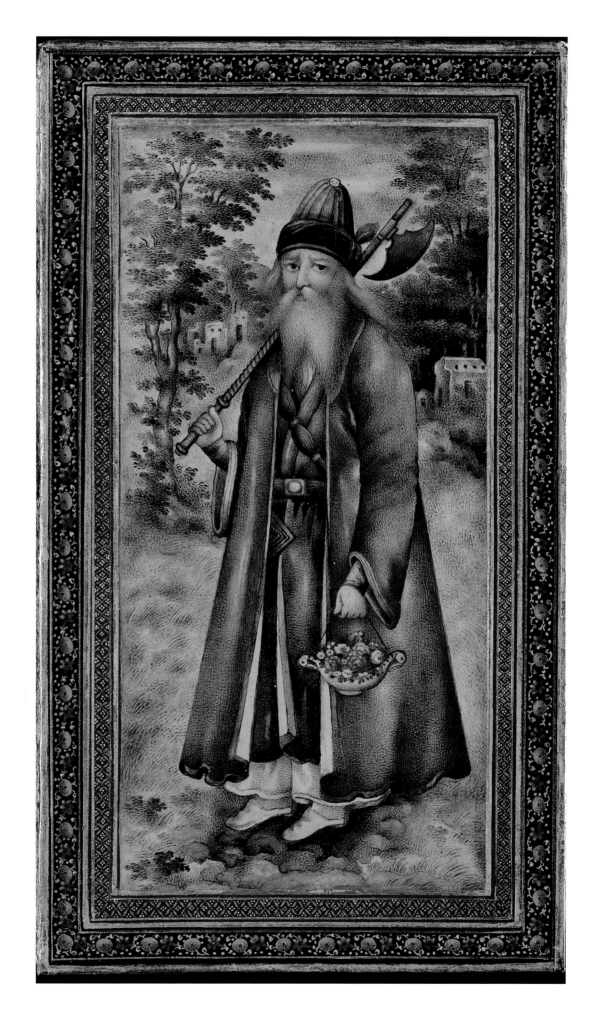

Fig. 170
CBL Per 389,
front inside cover (doublure)

meaning (ma'na). Realisation of this dichotomy between what can also be termed the exterior (zahir) and interior (batin) and the revelation of the latter to the mystic comes only once one has travelled along the Path.

A rounded cap, rough wool cloak, begging bowl, axe, and twisted wooden stick or staff, are all traditional accoutrements of a Sufi, whether serving a practical or ceremonial function (figs. 169–171). Traditionally, a Sufi master would present a certificate (ijaza) to a novice once his instruction of him was completed, the certificate signifying the Sufi's link with the order's founder. Likewise, the Sufi might receive a patched cloak (khirqa or muraqqa), another symbol of poverty, the ceremonial investiture of which came to symbolise initiation into a given order and thus also a link with its founder (fig. 172). Unlike Christian monks, a Sufi takes no vows when joining an order or brotherhood (tariqa) and is not required to be celibate. While a Sufi might choose to live communally in a Sufi lodge (variously referred to as a khanagah, zawiya or ribat) or live the solitary life of a wandering mystic, one could also (and more usually does today) choose to continue to follow a 'normal' life, residing with one's family and continuing with one's job in the everyday world of the 'non-Sufi' community. A Sufi is often referred to as a dervish (or darvish) or faqir, both of which basically mean 'poor', and though these terms are generally used to refer to any mystic, they more correctly refer to one not associated with any order or with any other institutional ties. Similarly, while the term qalandar is often used to mean any wandering mystic, it more correctly refers to a member of the Sufi order known as the Qalandariyya, who must wander continually and live strictly off the charity of others.

Fig. 171
A Wandering Dervish, detail of the border decoration of a copy of the Bustan (Orchard) of Sa'di

1649 (AH 1059), Iran
18.7 x 11cm, CBL Per 274.143

This apparently impoverished figure – wearing a tall conical hat and carrying a staff and begging bowl – is a more realistic depiction of a dervish, or Sufi, than are the two well-fed and well-clothed individuals in figs. 169–170. He is one of many figures (painted mostly in gold) that fill the borders of a copy of the Bustan of the Persian poet Sa'di, all of which appear to have been added several years after the manuscript was originally produced in 1649, and none of which appear to relate to the text they surround.

Fig. 172
Shah Dawlat, from the Late Shah Jahan Album

c.1640–50, India
38.5 x 27.8cm, CBL In 07B.25a

Shah Dawlat (d. 1676) was a Sufi shaykh widely known for performing miracles. Although he lived and taught in Gujarat, in India, he had connections with the Mughal courts in Delhi and Agra and this depiction of him, wearing a patched cloak, was originally part of an album made for the Mughal emperor Shah Jahan (r. 1627–58). Of the many figures that surround the shaykh, note the two dervishes seated in the lower border, each of whom holds a typical Sufi crutch and one of whom has a patched cloak slung over his shoulder. The standing figure in green, at the side, holds a peacock fan to cool the shaykh, and the seated figure at the upper left fingers the beads of a rosary.

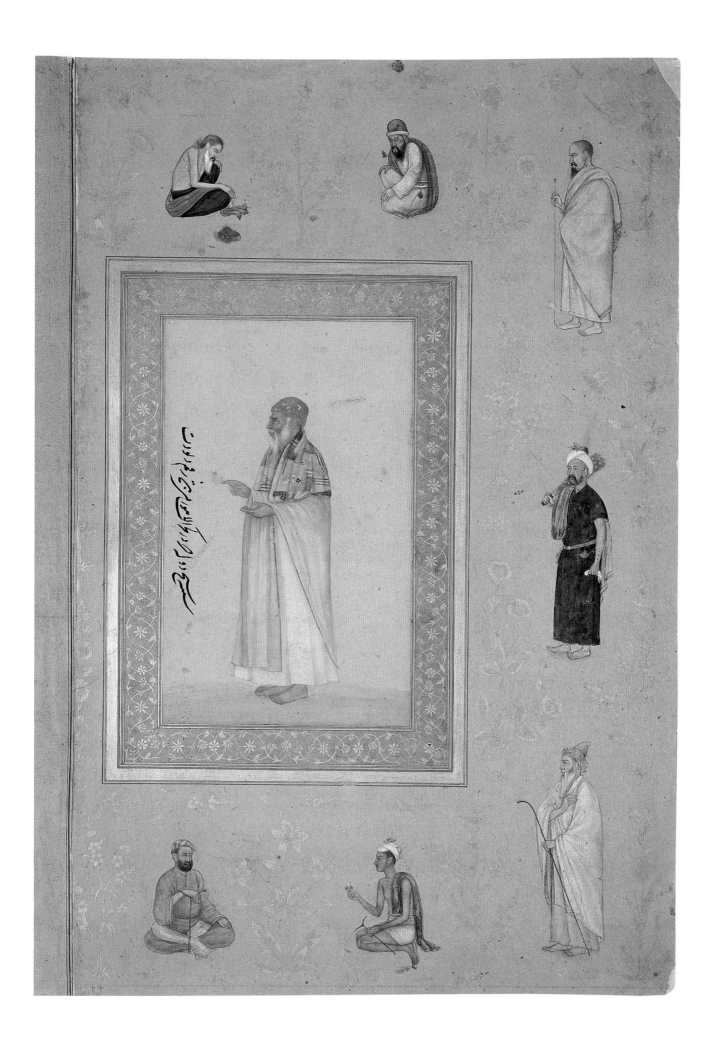

Sama and Dhikr

Musical ceremonies, known as *sama* ('hearing' or 'listening') and involving dancing and listening to music, are important practices for certain Sufi orders, though such activities are generally frowned upon by orthodox Islam. The dance induces an ecstatic state that is seen as assisting the adherent in his journey along the Path. More typical practices undertaken for this purpose include prayer, both communal and private, and meditation and contemplation, which can involve spiritual retreats for extended periods of time. The most important Sufi practice (though one not limited to Sufis) is *dhikr* ('remembrance' or 'recollection'). This involves the constant repetition of the names of God or of short formulae including the name of God. *Dhikr* may be silent or practised in an audible voice, and it is usually carried out in conjunction with rhythmical bodily movements and breathing (figs. 173–174).

Fig. 173
Sufis Performing *Sama* before Shaykh Nizam al-Din Awliya, from a copy of the *Khamsa* (Five Poems) of Amir Khusraw Dihlavi
Persian text in *nasta'liq* script

1485 (AH 890), Herat, Afghanistan
25.3 x 16.7cm, CBL Per 163.6

Amir Khusraw Dihlavi is regarded as India's greatest mystical poet. He was a prominent member of the Chishtiyya Sufi order, one of the great leaders of which was Nizam al-Din Awliya (both men died in 1325). In this illustration to Amir Khusraw's *Khamsa*, the work of the celebrated Persian artist Bihzad, Nizam al-Din is portrayed in the centre of the composition, with musicians, dancers and onlookers, presumably all members of the order, spread out in a semi-circle around him.

Fig. 174
Sufis Performing *Sama*, from the Shuja al-Dawla Album

c.1600, India
30.5 x 22.2cm, CBL In 34.3

The focus of this composition is an elderly dancing Sufi, surrounded by younger adherents, some of whom provide the music which assists him in attaining a state of ecstasy. The work is executed in the technique known as *nim qalam* (half-pen), in which the artist enlivens a drawing through the addition of gold and light washes of coloured pigment.

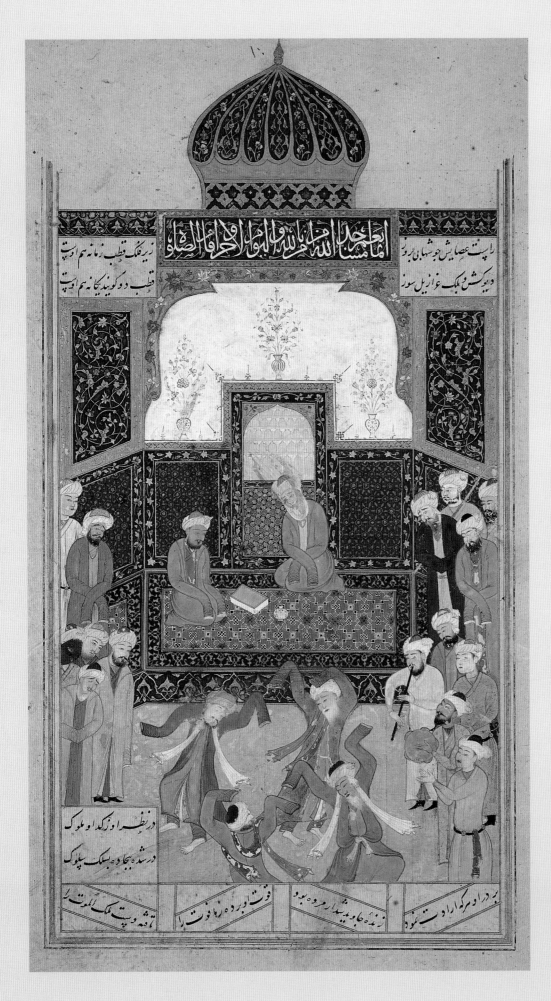

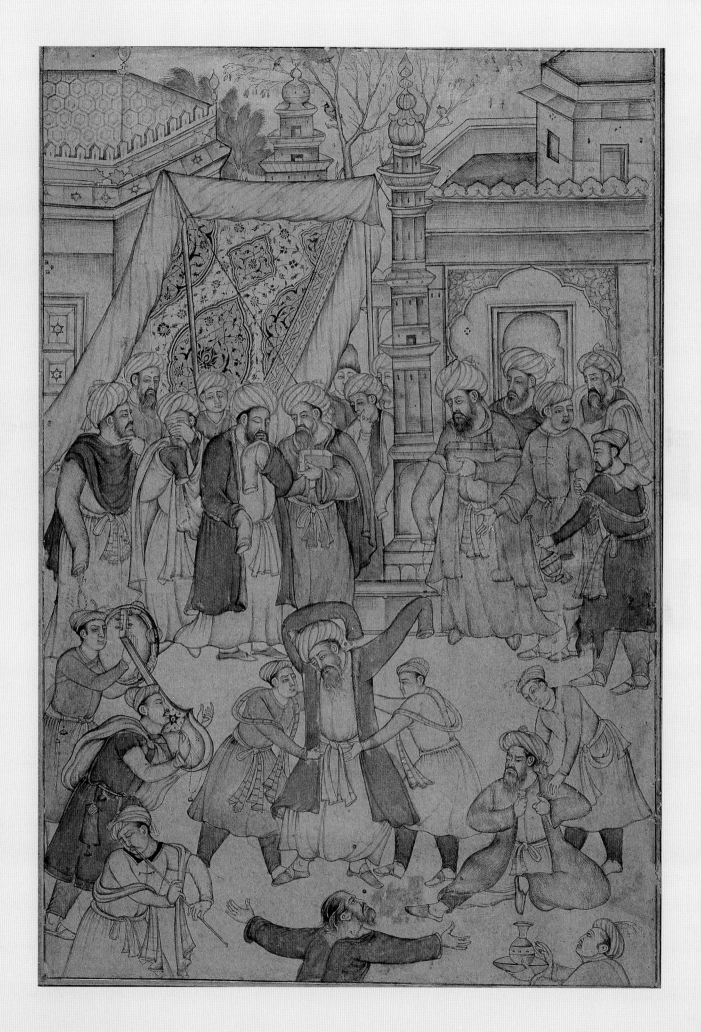

SUFI ORDERS: THE CHISHTIYYA

Chisht is the name of a small village near Herat in Afghanistan where the Syrian mystic Abu Ishaq (d. 940) established himself, and Chishtiyya is the name of the mystical order based on his teachings. The order is, however, more generally associated with one of his followers, Mu'in al-Din Hasan Chishti (c. 1142–1236), who established the order in India (fig. 175 and see also fig. 61). Mu'in al-Din lived in Ajmer in the state of Rajasthan, though the order quickly spread throughout much of India, where it is still today one of the most popular and highly regarded Sufi orders. The order's practices include *dhikr*, the reciting of the names of God both aloud and silently, and forty-day periods of secluded prayer and contemplation. Musical ceremonies, or *sama*, also play a prominent role in Chishtiyya life.

The Mughal rulers of India held the Chishtiyya in high esteem and when the wives of the emperor Akbar (r. 1556–1605) failed to produce a son that lived beyond infancy, the concerned emperor consulted Shaykh Salim Chishti, who lived as a recluse near the small town of Sikri, to the west of Agra, the Mughal capital. The shaykh predicted that the emperor would be blessed with three sons and when soon after, in 1569, one of Akbar's wives became pregnant she was sent to Sikri to be near the shaykh in the hope that her close proximity to him would help ensure the birth of a healthy child. She indeed gave birth to a son, who was given the shaykh's name, Salim (though he would later rule as Jahangir). When a second wife became pregnant, she too was sent off to live near the shaykh, also giving birth to a son, Murad, in 1570. To celebrate and give thanks for the birth of his sons, Akbar walked barefoot from Agra to the Chishti shrine at Ajmer (a distance of just under 400km/249 miles), making annual pilgrimages for several years thereafter. Moreover, in 1571, he began construction at Sikri of what would become his grand new capital city of Fatehpur Sikri (City of Victory), further honouring and

giving thanks to Shaykh Salim and the Chishtiyya. (The third son, Daniyal, was born in 1572.)

The importance and popularity of the Chishtiyya in India has not diminished over the centuries and today Mu'in al-Din's tomb continues to be venerated by Hindus and Muslims alike: each day, but in particular on the anniversary of the saint's death, a vibrant yet serene atmosphere fills the shrine as crowds of pilgrims of all ages circumambulate the tomb or sit gathered together on the marble pavements surrounding it, praying and listening to musicians; stalls selling wicker trays of red roses to place on the tomb line the entrance to the shrine, while the streets outside are filled with even more stalls selling special sweets and other pilgrims' souvenirs, such as small metal bowls inscribed with the name of Allah and verses of the Qur'an and used to ward off evil.

SUFI ORDERS: JALAL AL-DIN RUMI AND THE MEVLEVIYYA

Jalal al-Din Muhammad Rumi has been described as the greatest Sufi poet in the Persian language. He was born in 1207, in Balkh, in what was then northwestern Iran (now in Afghanistan), where his father, Baha al-Din Walad, was a leading theologian and mystic, and so he was from birth steeped in an atmosphere of spirituality. At an uncertain date (but probably about 1216), his family emigrated west, possibly because of a dispute with the rulers of Balkh or in order to avoid the destruction and devastation of the advancing Mongol army. They travelled through Iran to Baghdad, made the pilgrimage to Mecca, and then travelled to Anatolia, or Rum (hence the *nisba* Rumi meaning 'of Rum'), eventually settling in Konya in 1228. Although Konya would remain Rumi's home until his death in 1273 and it was there that he was first initiated into the mysteries of Sufism, he also spent time in Aleppo and Damascus where he studied the Islamic sciences, eventually becoming a master of both the exoteric

Fig. 175
Mu'in al-Din Hasan Chishti, from the Shuja al-Dawla Album

c.1770, Faizabad, India
27.4 x 19.8cm, CBL In 34.12

Mu'in al-Din Hasan Chishti (c.1142–1236) established the Chishtiyya Sufi order in India, and the order and Mu'in al-Din himself are still today highly revered there, with his tomb in Ajmer being a major, year-round pilgrimage site.

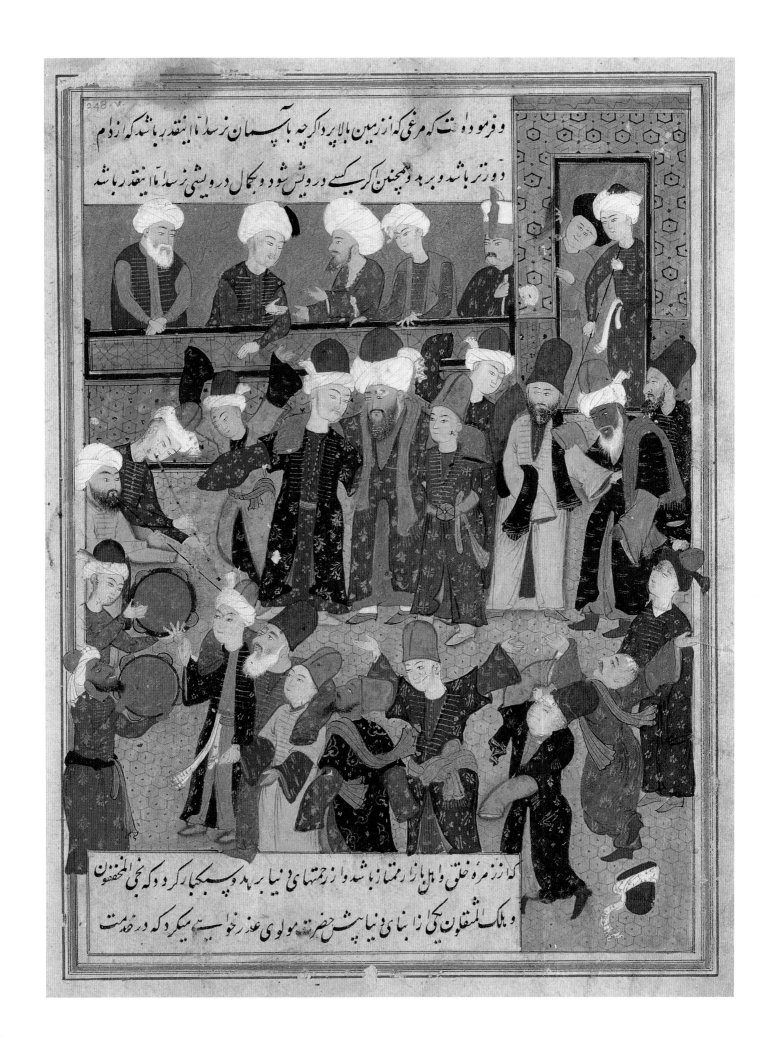

and esoteric dimensions of Islam.

Probably the most important event in Rumi's life was his meeting in his late thirties with Shams al-Din Tabrizi, a wandering mystic. The close companionship that developed between them was to have a profound and lasting effect on Rumi: it was their intense friendship that first led Rumi to compose poetry, transforming him, as one scholar has described it, from a sober teacher of the formal religious sciences into an ecstatic poet. However, their constant companionship, to the exclusion of almost all others, invoked the jealously of Rumi's disciples, and, just less than three years after he first came to Konya, Shams al-Din disappeared, apparently murdered at the hands of Rumi's disciples and with the complicity of his son Ala al-Din (though unbeknownst to Rumi). Devastated by the loss, Rumi spent the remainder of his life immersed in the writing of poetry, listening to music and poetry, dancing, teaching Sufism and training disciples.

After Rumi's death his followers became known as the Mawlawiyya or, in Turkish, the Mevleviyya. As is usual with Sufi orders, the name derived from the order's founder, who was also known as *mawlana* (or *mevlana*), meaning 'our master'. In line with Rumi's teachings, the order is based on the principles of love, charity, humility and tolerance, but perhaps the main feature distinguishing the Mevlevis from most other Sufi orders, at least to the eye of the uninitiated, is their emphasis on music and dance. Indeed, the order is popularly known in the West as the Whirling Dervishes because of the musical ceremony, or *sama*, involving a whirling dance that plays a major role in Mevlevi ritual. In Rumi's lifetime, the dance seems to have been an impromptu event, embarked upon at a moment of ecstasy, but later it came to be performed at set times and was used more to invoke a state of ecstasy. The dance is said to represent the circling of the spiritual around the material world: while whirling, the *sama-zan* (as a dervish performing the dance is known) holds his right hand pointing upwards and his left pointing downwards, symbolising the passing of the knowledge of one world to the other, or, in other words, the passing to mankind of what is gleaned from God (fig. 176).

Rumi's mystical poem *al-Mathnawi al-ma'nawi* (or in Persian, *Masnavi-ye ma'navi*) is esteemed as one of the greatest works of Persian literature. *Mathnawi* is, in fact, merely the name given to a rhymed couplet or a poem comprised of rhymed couplets, and so the title translates simply as the 'Poem of Poems' or the 'Poem in Rhyming Couplets'. This lengthy poem of more than 25,000 couplets was described by Rumi himself as containing 'the roots of the roots of religion'. It consists of six *daftar*s, or books, of Persian poetry, each with a prelude in either Persian or Arabic. Drawing on a wide range of sources, including lives of saints, parables, and earlier mystical and theological works, the *Mathnawi* considers almost every aspect of Sufi thought, while dealing with the hazards encountered during the soul's perilous journey from its obsession with the material world of exterior form to the attainment of the world of inner meaning and union with the Divine (figs. 177–179).

Fig. 177
CBL Per 290,
ff. 57b–58a

Figs. 177–179
al-Mathnawi al-ma'nawi
(The Poem of Poems) of
Jalal al-Din Rumi

Persian text in *shikasteh* script

1866 (AH 1283), Iran
23.9 x 15.4cm, CBL Per 290

This lavishly illuminated copy of
Rumi's famous poem was produced
for Tahmasp Mirza, a prince of the
Qajar dynasty, which ruled Iran
from 1785 to 1925. The somewhat
flamboyant, flowing script in which the
text is copied is known as *shikasteh*.
The three double pages of illumination
reproduced here highlight the division
between the first and second books of
Rumi's poem: one to mark the end of
the first book (fig. 177) and two to mark

the start of the second book (figs.
178–179). As in most manuscripts
reproduced here, the gold has been
densely punched, or pricked, with a
needle or some other sharp, pointed
tool. Although often invisible to the
naked eye, and rarely visible in
reproduction, the tiny indentations
in the surface of the gold that result,
catch the light, causing the gold to
shimmer and shine even more than if
the surface were completely smooth.

Fig. 178
CBL Per 290,
ff. 58b–59a

Fig. 179
CBL Per 290,
ff. 59b–60a

Persian Mystical Poets: Attar and Jami

Mystical poetry played a major role in the development of Islamic literature, and many of the greatest Persian poets were Sufis. In their poems, temporal love (typically focusing on beardless young boys) and intoxication (through the drinking of wine) are consistently used as analogies for divine love (*ishq*).

One of the most renowned Persian mystical poets is Farid al-Din Attar, who was born during the first half of the twelfth century and is thought to have died in 1221, during the Mongol attack on his home town of Nishapur in north-eastern Iran, where he appears to have spent much of his life. His name, Attar, translates as 'perfume' or 'scent' and indeed he was by profession a pharmacologist and perfumer, though it is his mystical poetry not his perfumes that have kept his name alive throughout the centuries. His most celebrated work, *Mantiq al-Tayr* (The Language of the Birds), is an allegory for the quest of the human soul for union with the Divine. This great poem tells the story of the pilgrimage made by the birds of the earth in order to find the King of the Birds, the mythical *simurgh*; few birds actually survive the perilous journey (which symbolises the arduous journey of the Sufi along the Path), but the final reward of those that do is union with the *simurgh* (figs. 180–181).

Another of Attar's well-known works is the poem *Ilahi-nama* (The Book of God, or Book of the Divine), another mystical poem that tells the story of a king who requests that his six sons describe their deepest desires (fig. 182). Each longs for something seemingly very different, but whether it be to wed the daughter of the King of the Fairies, to find the Water of Life, or to have the power to turn base metal into gold, each desires something material and transient. Thus, the king gives the same advice to each son in turn, namely that true happiness is achieved only through an inner search for the spiritual and eternal.

Of perhaps even greater renown than Attar and revered as one of the greatest of all Persian mystical poets is Abd al-Rahman ibn Ahmad Jami (d. 1492). He was highly acclaimed even in his own lifetime and the sultans and princes of the ruling dynasties of Iran vied with one another to bring him to their courts (fig. 183). Jami belonged to the Naqshbandi Sufi order, based on the teaching of Baha al-Din Naqshband of Bukhara (d. 1389) and distinguished from many other Sufi orders by its particular emphasis on silent *dhikr* (recitation of the names of God). Amongst the numerous works of mystical poetry that Jami produced is his *Haft awrang* (Seven Thrones), a collection of seven individual didactic and moralising works, but which as a whole can be interpreted as dealing with a single basic theme, namely the mystical search for union with the Divine (fig. 184). One of the seven poems is *Tuhfat al-ahrar* (The Gift of the Free), which treats a series of individual themes illustrated by anecdotes inserted into the text. One such anecdote – on the virtue of silence – tells the amusing story of a tortoise who befriends two ducks. Wishing to fly away with them, a plan is devised whereby the tortoise bites hold of a stick, either end of which is held in the beak of one of the ducks, who warn their friend to keep his mouth firmly shut. However, when they fly over a group of astonished people, the tortoise cannot resist calling out to them and so falls to his death, thus illustrating the folly of idle talk (fig. 185).

Jami also produced a number of prose works, including his *Nafahat al-uns* (The Breaths of Fellowship), a compilation of the biographies of almost six hundred Muslim saints and Sufis. One of the individuals he discusses is the tenth-century Persian mystic al-Husayn ibn Mansur al-Hallaj, who is most well known for supposedly equating himself with God by proclaiming 'I am the Truth'. According to the record of the trial that led to his execution in Baghdad in 922, the main accusation against him was that his preaching included the assertion that

Figs. 180–181
An Anthology of Poems by Farid al-Din Attar and Jalal al-Din Rumi
Persian text in *nasta'liq* script

1476 (AH 881), Iran
21.3 x 13.2cm, CBL Per 153

Mystical poems by both Attar and Rumi are included in this very pretty manuscript. The frontispiece (fig. 180) functions as a table of contents, listing the names of the various poems included in the manuscript. The layout of all text pages (fig. 181), with columns of horizontal lines of text surrounded by marginal columns containing oblique lines of text, is a format associated mainly with manuscripts produced in the city of Shiraz in south-western Iran. Attar's poems, including *Mantiq al-Tayr*, are mainly written in the centre columns, with the six books of Rumi's *Mathnawi* filling the marginal columns, and the marginal heading on the right-hand page of the opening reproduced here marks the beginning of the second book of Rumi's poem. However, for the last hundred folios or so of this 556-folio manuscript, Attar's works fill both the centre and marginal columns. The layout of the text results in triangular 'thumbpieces' mid-point along the outer side of each folio and 'corner-pieces' in the upper and lower gutter sides, providing the illuminator with further areas in which to practise his art: these small spaces are all filled with tiny sprays of blossoms and arabesque elements, painted in coloured pigments and gold, and, as a result, every opening in the manuscript, even those on which there is no heading, is a delight to behold.

Fig. 180
CBL Per 153,
ff. 1b–2a

Fig. 181
CBL Per 153,
ff. 68b–69a

Fig. 182
An Illuminated Heading for *Ilahi-nama* (Book of God), from a Collection of Poems by Farid al-Din Attar
Persian text in *nasta'liq* script

1416–18 (AH 819–21), Shiraz, Iran
16.6 x 11.5cm, CBL Per 117, f. 1b

The specific style of illumination used in this manuscript is one that was used over a long period of time, from early in the second half of the fourteenth century until the early sixteenth century. Although it originated in, and was always closely associated with, the city of Shiraz, it travelled far and wide and was also used in manuscripts produced in Egypt, Turkey, India and even the Yemen (see figs. 19–20).

Fig. 183
The *Divan* of Jami
Persian text in *nasta'liq* script

1496 (AH 902), Iran
20.5 x 11.3cm, CBL Per 173, f. 37b

Scrolls populated with human and/or animal heads, as in this heading, appear only rarely in manuscript decoration (but also see fig. 186), though they are used more frequently in the decoration of carpets. They are part of the long tradition of grotesque art in both East and West, but they are often, incorrectly, associated with the *waqwaq*, the talking tree that Alexander the Great encountered on his travels and which predicted his death. Alexander's tree, however, is said to have had two trunks, one male and one female, which could speak, and the tree is often portrayed as having branches that terminate in human and animal heads, although accounts of the Alexander story make no mention of this feature. In this thoroughly delightful heading, the arabesque vine is populated with male and female as well as rabbit and lion heads. The white *thulth* script of the heading states that this is the *divan* (a collection of poems) of *mawlana* (our master) Jami.

one could perform the pilgrimage to Mecca without ever actually leaving home. One of the few illustrated copies of the *Nafahat al-uns* ever produced is an early seventeenth-century manuscript made for Akbar, the Mughal Emperor of India (*r.* 1556–1605), which includes a depiction of al-Hallaj's dismembered body being burnt in a fire. Although the artist has depicted a gibbet in the background, al-Hallaj was crucified, not hanged, before being burned (fig. 186).

Fig. 184
Subhat al-abrar (The Rosary of the Righteous) of Jami
Persian text in *nasta'liq* script

Late 16th century, Iran
26.2 x 15.8cm, CBL Per 177,
f. 30b–31a

This poem is one of the seven 'thrones' that comprise Jami's *Haft awrang*. The paper used for the margins of this particular manuscript is in a wide range of colours – blue, grey, peach, cream and dark brown – and is decorated with an equally rich variety of landscapes and lush floral arabesques painted in gold. A note in the manuscript states that the paper is 'Chinese', and, indeed, gold-painted paper of this type was based ultimately on paper imported from China in the fifteenth century. Beautifully decorated manuscripts such as this can be taken as an indication of the high regard in which a poet's works were held.

Fig. 185
The Flight of the Tortoise, from a copy of Tuhfat al-ahrar (The Gift of the Free) of Jami
Persian text in *nasta'liq* script

*c.*1548, prob. Bukhara, Uzbekistan
28.2 x 18.2cm, CBL Per 215, f. 18a

This poem, too (like *Subhat al-abrar*, a copy of which is illustrated in fig. 184), is one of the seven 'thrones' that comprise Jami's *Haft awrang*. One of the anecdotes that make up the poem is the story of the flight of a tortoise, and in this illustration the tortoise is depicted still firmly biting on the stick by which the ducks are transporting him. However, excited by the sight of the astonished people looking up in amazement at him, he will soon foolishly and fatally open his mouth to call out to them.

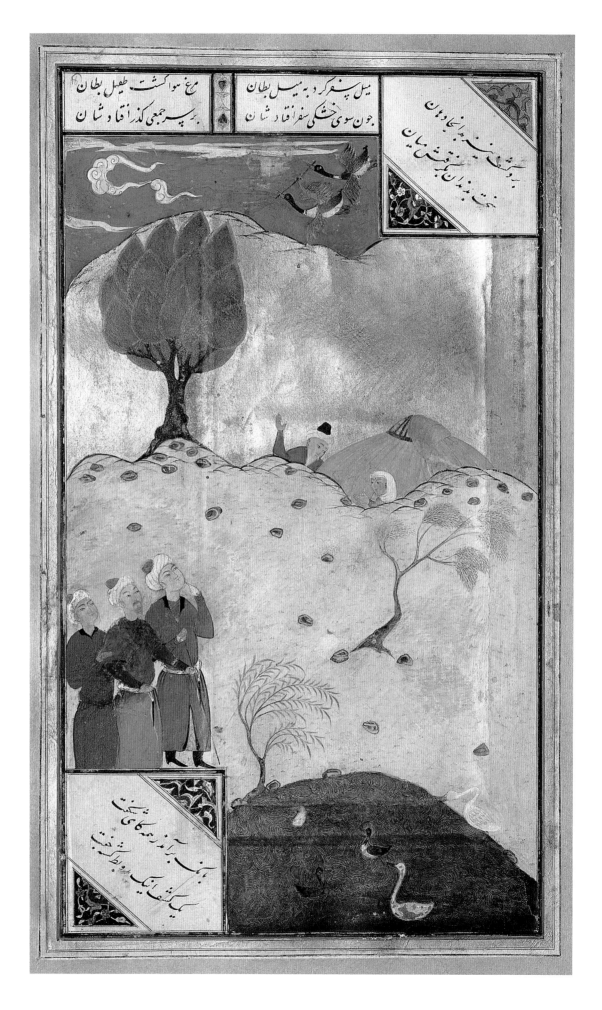

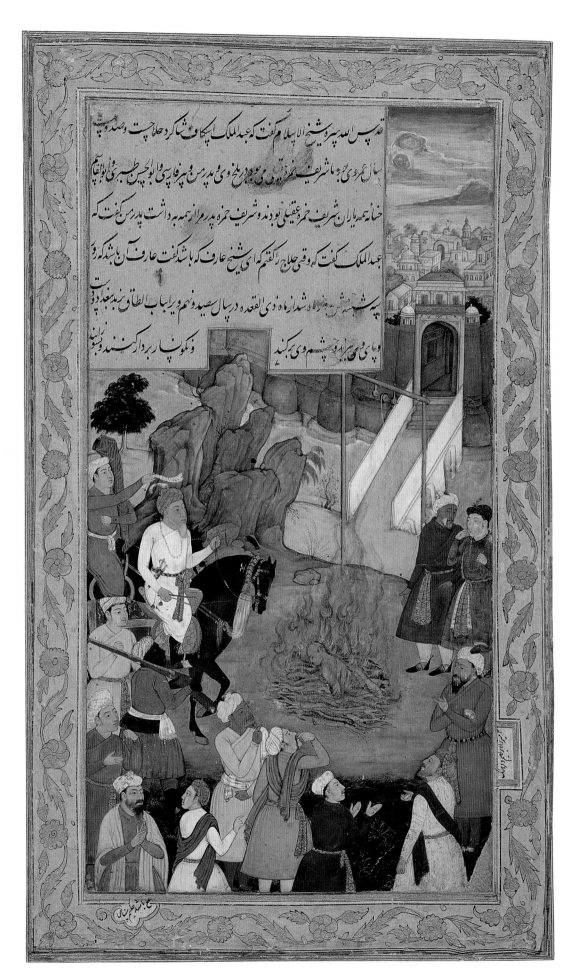

Fig. 186
The Martyrdom of al-Hallaj, from a *Nafahat al-uns* (The Breaths of Fellowship) of Jami
Persian text in *nasta'liq* script

1604–05, India, 34.5 x 22.3cm, CBL In 61.2

In this gruesome scene, the dismembered body of the Persian mystic al-Hallaj is shown being burnt in a fire. While most of the onlookers seem rather unperturbed by the event, two hold their fingers to their mouths, in a gesture of surprise and shock.

Safinas

Anthologies provided a person easy access to a selection of his favourite poems by a number of different poets. In fifteenth-century Iran, the *safina* was an especially popular format for anthologies. This particular example (figs. 187–188) includes the work of Attar, Rumi and several other mystical Persian poets. These small, long and narrow, 'boat-shaped' manuscripts (*safina* means 'boat' in Persian) are thought to have been designed to fit in the pocket. (They often have soft, highly flexible covers that would also seem to suggest

such a use.) In the *safina* reproduced here, a wide variety of geometric and figural patterns decorate the wide borders surrounding the text. Stencils were used to transfer the pattern to each page, with the various elements of the pattern left in reserve against a coloured ground. Each element was then outlined in gold with numerous other details, such as the scales of fish and the feathers of birds, also added in gold. On some folios, fully coloured elements were also added, such as the elegant angels on one of the two pages reproduced here.

Figs. 187–188
An Anthology of Persian Poetry

Persian text in *nasta'liq* script

Mid 15th century, Iran
20.3 x 7.2cm, CBL Per 159

Fig. 187
CBL Per 159, f. 7b

Fig. 188
CBL Per 159, f. 22b

APPENDIX 1

CONCORDANCE OF ILLUSTRATIONS
ARRANGED BY CHESTER BEATTY LIBRARY NUMBER

CBL NUMBER	FIGURE NUMBER
Ar 4168	21
Ar 4180	136
Ar 4181	138
Ar 4188	64
Ar 4204	19–20
Ar 4223	120–123
Ar 4237	108–109
Ar 4936	14
Ar 5193	137
In 01.1	31
In 07A.7a	62
In 07A.12	168
In 07B.25a	172
In 18	152–158
In 34.3	174
In 34.12	175
In 34.14	163
In 61.2	186
In 61.9	61
In 69.1	26
In 69.18	33
Is 1405	67
Is 1411	65–66
Is 1416	52
Is 1417	45–46
Is 1431	87–95

CBL NUMBER	FIGURE NUMBER
Is 1434	68
Is 1438	72
Is 1439	1
Is 1444	81
Is 1448	73–74
Is 1452	71
Is 1461	70
Is 1463	47–51
Is 1466	42–43
Is 1472	59
Is 1473	127
Is 1485	151
Is 1492	54
Is 1493	75
Is 1494	44
Is 1498	76
Is 1499	2
Is 1500	27–28
Is 1519	124
Is 1521	39–41
Is 1522	80
Is 1534	105
Is 1544	38
Is 1545	3
Is 1558	96–104
Is 1560	79
Is 1570	77–78

APPENDIX 2

Concordance of Illustrations Arranged by Date

(Undated manuscripts are listed by AD century only)

CBL number	Figure number
9TH–10TH CENTURY	
Is 1411	65–66
Is 1416	52
Is 1417	45–46
MID 10TH CENTURY	
Is 1405	67
972 (AH 361)	
Is 1434	68
11TH CENTURY	
Is 1607	69
1000–01 (AH 391)	
Is 1431	87–95
1186 (AH 582)	
Is 1438	72
12TH–13TH CENTURY	
Is 1439	1
Is 1448	73–74
EARLY 13TH CENTURY	
Is 1444	81
13TH CENTURY	
Is 1452 (calligraphy)	71
1278 (AH 677)	
Is 1466	42–43
1283 (AH 682)	
Ar 4237	108–109
14TH CENTURY	
Ar 4180	136
Ar 4181	138
Is 1461	70
Is 1463	47–51

Is 1472	59
Is 1485	151
Is 1493	75
1323 (AH 723)	
Is 1473	127
c.1335	
Is 1498	76
EARLY 15TH CENTURY	
Is 1494	44
15TH CENTURY	
Ar 4168	21
Is 1499	2
Is 1519	124
1416–18 (AH 819–21)	
Per 117	182
c.1430	
Is 1500	27–28
Is 1521	39–41
1442 (AH 846)	
Per 125	55
1444 (AH 848)	
Ar 4188	64
1449 (AH 853)	
Ar 5193	137
MID 15TH CENTURY	
Per 159	187–188
MID–LATE 15TH CENTURY	
Is 1492	54
1463 (AH 868)	
Per 137	25

1470 (AH 874)	
Per 144	159
1474 (AH 879)	
Per 148	140–141
1476 (AH 881)	
Per 153	180–181
1485 (AH 890)	
Per 163	173
1496 (AH 902)	
Per 173	183
LATE 15TH–EARLY 16TH CENTURY	
Ar 4204	19–20
16TH CENTURY	
T 429	56–58
T 447 (calligraphy)	24
1529 (AH 936)	
Per 195	162
1540 (AH 947)	
Per 251	144
c.1548	
Per 215	185
MID 16TH CENTURY	
Is 1545	3
Is 1558	96–104
1550–60	
Per 395	8 and 165
c.1558–73	
In 01	31

1567 (AH 974)	
Per 235	7, 34 and 135

1567–68 (AH 975)	
Is 1544	38

1570–80	
Per 231	143, 145, 147–148, 150, 160 and 166

1574–75 (AH 982)	
Is 1534	105

1579 (AH 987)	
T 413	60, 106

1594 (AH 1002)	
T 418	17

1594–95 (AH 1003)	
T 419	5–6, 10, 12–13, 29–30, 32, 35 and 107

1595 (AH 1003)	
Per 245	129–134
Per 254	4, 9 and 16
T 474	128 and 176

1598 (AH 1006)	
T 423	11

LATE 16TH CENTURY	
Is 1452 (illumination)	71
Is 1560	79
Per 177	184
T 414	139, 142, 146, 149, 161 and 167

16TH–17TH CENTURY	
Is 1522	80

c.1600	
In 34.3	174

c.1603–05	
In 61.9	61

c.1604–05	
In 61.2	186

c.1610–20	
In 07A.12	168

1617–18 (AH 1027)	
Per 368	15

c.1635	
In 07A.7a	62

1638–39 (AH 1048)	
Ar 4223	120–123

c.1640–50	
In 07B.25a	172

1649 (AH 1059)	
Per 274	171

c.1650	
Per 270	164

c.1680	
In 69.1	26

1683 (AH 1094)	
Per 278	36–37

1691 (AH 1103)	
T 559.4	23

17TH–18TH CENTURY	
Is 1602	85

18TH CENTURY	
Is 1588	86
Is 1622	63
T 447 (illumination)	24
T 490	53

1729 (AH 1141)	
T 442	126

c.1740–50	
In 18	152–158

1749 (AH 1162)	
T 449	22, 110 and 112

1753 (AH 1166)	
Ar 4936	14

c.1770	
In 34.12	175
In 34.14	163

1782 (AH 1196)	
T 459	18

1798 (AH 1212–13)	
T 463	113–119
T 464	111

c.1800	
In 69.18	33

19TH CENTURY	
Is 1570	77–78
Is 1598	83–84
Is 1601	82

1838 (AH 1254)	
Per 389	169–170

1866 (AH 1283)	
Per 290	177–179

1903 (AH 1321)	
T 493	125

GLOSSARY

Titles (including those of chapters of the Qur'an), the names of God and Muhammad, and the names of scripts are not included.

abjad the Arabic system in which each letter of the alphabet is assigned a corresponding numerical value; the name is derived from the first four letters in the sequence to which values 1, 2, 3 and 4 were assigned, that is, the letters, *alif* (a), *ba* (b), *jim* (j) and *dal* (d)

abu in names is read as 'father of'

adhan the call to prayer

ahl al-bayt people of the house, meaning the family of the Prophet, specifically Ali and his descendants

Allah the Arabic word for God

am al-huzn the year of grief

ansar the Helpers; the name used to designate the Muslims from Medina who provided refuge and protection to the Prophet and his followers when they were driven from Mecca

arkan pillars (of Islam)

ashara ten

ashura the tenth day of the Islamic month of Muharram

ashur-khana Ashura house; the building in which a *ta'ziya* (a replica of the tomb of Husayn) is kept

al-asma al-husna the (99) most beautiful names (of God)

al-asma al-sharifa the noble names (of the Prophet Muhammad)

aya verse; in particular a verse of the Qur'an

banat daughters; here the so-called daughters God (i.e. al-Lat, al-Uzza and Manat)

baqa survival or abiding; the final state along a Sufi's mystical journey to knowledge of God, the point at which the Sufi is considered to survive or exist within God

baraka blessing

basmala the common Islamic invocation that states, 'In the name of God, the Merciful, the Compassionate'

batin interior or inward; referring to spiritual or inner meaning (as opposed to *zahir*, exterior or outward form)

burda cloak or mantle

chahar bagh four garden; referring to the typical form of a Persian garden, divided and subdivided into sections of four

daftar book

da'if weak; a categorisation of *hadith*

dar al-salam the city of peace; usually used in reference to Baghdad

dar al-sultani the abode of the sultan

darwish literally, poor; generally used to refer to any Sufi or mystic but more correctly refers to one not associated with any order or with any other institutional ties

dhikr remembrance or recollection; refers to the audible or silent repeated recitation of the name of God or of a short formulae including the names of God

dhu'l-faqar the name of Ali's sword

divan a collection of poems

du'a voluntary and private prayer that may be said in any language at any time

falnama book of divination

fana extinction, cessation, annihilation or passing away; refers to the penultimate state of the Sufi Path wherein the Sufi's links to the material world are extinguished

faqir poor; a term generally used to refer to any mystic but more correctly to one not associated with any order or with any other institutional ties

fiqh understanding or knowledge; meaning the discipline of Islamic law and its study

firdaws garden, in Persian; *al-firdaws*, meaning Paradise

ghusl the major ablution, or purification, before prayer, which involves the washing of the whole body

guristan cemetery

hadith a tradition or saying of the Prophet

hafiz term used to refer to one who has memorised the complete Qur'an

hajj pilgrimage

hajja a woman who has successfully completed the *hajj*

hajji a man who has successfully completed the *hajj*

hal state, along the Sufi Path

hammam bath

hanif used to refer to a true believer, one of a small number of pre-Islamic Arabs who claimed to have returned to the pure religion of Abraham and to the worship of one god

hasan fair or good; a categorisation of *hadith*

hijra migration; the migration of the Prophet from Mecca to Medina in AD 622; this occasion marks the beginning of the Muslim era and year one of the Islamic calendar

hilya external form, quality, or bearing of a person, but also decoration, embellishment or ornament; a term used to refer to a written description of the physical traits of the Prophet Muhammad

hizb party or group; one-sixtieth of the Qur'an

husayniya a specially constructed building (usually with a circular stage) for the performance of a *ta'ziya*

huzn sorrow or grief; one of the many stations through which the Sufi must pass on his journey along the spiritual Path

ibn in names is read as 'son of'

id al-adha the Festival of the Sacrifice; the four-day-long feast that takes place at the end of the pilgrimage to Mecca

id al-fitr the Festival of Breaking the Fast; the three-day-long feast that takes place at the end of the month of Ramadan

ihram the temporary state of consecration that the pilgrim must enter before undertaking the pilgrimage

ijaza certificate (presented to a novice by his Sufi master upon completion of his instruction of him)

ijma one of two secondary sources of Islamic law, the consensus of opinion – with respect to the interpretation of the Qur'an

and the *Sunna* in regard to legal matters – of the community of religious scholars, jurists and other learned individuals

ijtihad interpretation (of the Qur'an)

al-ilah the god; the god accepted by pagan Arabs as supreme over all others

imam leader, guide or model; used by Sunnis to refer to the prayer leader in the mosque but also for certain outstanding religious scholars; used by Shi'as to indicate the successors to the Prophet

inaba conversion; meaning the decision to turn away from the material world and devote oneself to God, and the name of one of the many stations through which the Sufi must pass on his journey along the spiritual Path

ishq (divine) love

isnad chain; in terms of *hadith* transmission, the chain of authorities that traces the *hadith* back to Muhammad or other source

isra Muhammad's Night Journey, guided by Gabriel, from Mecca to Jerusalem

Ithna asharis Twelver Shi'as, distinguished by their belief in a chain of twelve Imams

jabal al-rahma The Mount of Mercy

jamra pillar; the name applied to the three large pillars at Mina symbolising the devil

janna garden; *al-janna* refers to Paradise

al-jum'a Friday; the day when the community of Muslims gather at the mosque for communal prayer

juz part or section (of the Qur'an)

khalifa caliph, one who succeeds; specifically the individuals who succeeded the Prophet Muhammad as head of the Muslim community after his death

khamsa five

khanagah a Sufi lodge for communal living

khandaq ditch or trench (Persian)

khatam al-nabiyyin the Seal of the Prophets

khirqa patched cloak; received by a Sufi upon completion of his instruction as a symbol of poverty, a symbol of brotherhood (see *muraqqa*)

khutba the sermon delivered by the *imam* from the *minbar*

kiswa apparel, attire, dress or covering; the cloth covering of the Ka'ba

laylat al-qadr the Night of Power; the night between the 26th and 27th of Ramadan during which Muhammad recited the first revelation

liwa al-hamd (the Prophet's) banner of praise

madhhab used to refer to a school of law

madrasa theological school

maghazi Muhammad's military campaigns

maghrib west

mahdi the Rightly Guided One who will return on the Last Day to eliminate evil and establish a world of just rule

ma'na inner meaning, as opposed to *surat* (external form)

manzil used with regard to the Qur'an to refer to one-seventh of the holy text

maqam station (along the Sufi Path)

maqam Ibrahim the place or stage of Abraham; a small domed structure built around a stone on which are two footprints, said to have been made by Abraham as he stood there directing the building of the Ka'ba

mashq a technique in calligraphy whereby a single letter is extended

matn used to refer to the body or main text of *hadith*, as opposed to the *isnad*

mawlana (or *mevlana*) our master; a term of respect usually bestowed upon a respected Sufi teacher, in particular Jalal al-Din Rumi

mihrab a niche in the wall of a mosque indicating the direction of Mecca

minbar a pulpit-like structure from which the *imam* delivers the *khutba* (sermon)

mi'raj Muhammad's ascension to heaven

miswak tooth-stick or toothbrush

mizan scales

mu'adhdhin the individual who makes the call to prayer

mudhnib sinner

muezzin Persian transliteration of *mu'adhdhin*; the individual who makes the call to prayer

muhajirun Emigrants; the early Muslims who, along with Muhammad, emigrated from Mecca to Medina

muharram the Islamic month of mourning

muhr al-nubuwa seal of prophethood; the mark which Muhammad is said to have borne between his shoulders

mulla jurists and other religious scholars

muraqqa cloak or patched frock; presented to a Sufi by his teacher upon completion of his instruction, as a symbol of poverty, a symbol of brotherhood

nim qalam half pen; used to refer to lightly coloured drawings

nisba a modifier added to one's name, usually to indicate place of origin (as in *al-shirazi*, meaning from Shiraz) or position (as in *al-sultani*, indicating being in the employ of the ruler)

pir spiritual leader, Sufi master

qalam a reed pen

qalandar a member of the Qalandariyya Sufi order, the members of which must wander continually and live strictly off the charity of others

qasida an ode, a mono-rhyming verse form

qibla the direction of prayer

qiyas analogical reasoning or deduction; one of two secondary sources of Islamic law

qubba dome or cupola; often used to refer to a shrine or tomb, as such structures are typically topped by a dome

rak'a literally, bowing; a prayer unit, several of which constitute a single prayer

rashidun used to refer to the four Rightly Guided Ones; the first four caliphs who succeeded Muhammad, namely Abu Bakr, Umar, Uthman and Ali

ribat a Sufi lodge for communal living

ridda apostasy from Islam

sadaqa voluntary alms giving

safina boat (Persian); used to refer to manuscripts in a long, narrow format

sahaba the Companions of the Prophet; those individuals who were closest to the Prophet, but also sometimes used to refer more broadly to those who made up the original community of Muslims in Medina, or even all those who saw him during his lifetime

sahih sound; a category of *hadith*

sajda prostration

salam peace

salat ritual prayer that must be performed five times a day in Arabic from memory

sama literally, hearing or listening; a musical ceremony involving music and dance

sama-zan a participant in a *sama*

saqim sick or infirm; a category of *hadith*

sawm the ritual fast

sa'y the ritual walking or running seven times between the hills of Safa and Marwa, one of the rites of the *hajj*

sayyid a descendant of the Prophet

shahada witnessing or testifying; the Muslim profession of the faith

shams sun

shamsa an illuminated sun-like device used to introduce manuscripts

shari'a the Holy Law of Islam

shaykh a title of Islamic religious leaders, a Sufi teacher or spiritual master

shekar bayram sweet festival (Turkish); another name for *id al-adha* or Festival of the Sacrifice that takes place at the end of the pilgrimage to Mecca

Shi'a literally, party; the followers of Ali and his descendants

shirk polytheism or idolatry; the worship of any thing or being in addition to God

shuhada (sing. **shahid**) martyrs

silsila chain

silsila-nama a genealogical text

sira biography; used in particular to refer to a biography of the Prophet

sub used to refer to one-seventh of the Qur'an

subha rosary

suf wool; thought to be the origin of the word Sufi, in reference to the wool garments once worn by Sufis as a sign of their humility and rejection of the material world

sunna (pl. **sunan**) customary practice (of the Prophet); one of the primary sources of Islamic law

sura a chapter of the Qur'an

surat external form; as opposed to *ma'na* (inner meaning)

tafsir explanation, interpretation or commentary; most frequently used to refer to a commentary on the Qur'an

tariqa spiritual or mystical Path or Way; also a Sufi order

tasawwuf the wearing of wool, often used as a synonym for Sufism, or to refer to the mystical journey upon which the Sufi must embark

tawaf the seven-times circumambulation of the Ka'ba, one of the rites of the *hajj*

tawakkul confidence or trust; one of the many stations through which the Sufi must pass on his journey along the spiritual Path

al-tawakkul ala Allah trust in God

tawba repentance; the name of one of the many stations through which the Sufi must pass on his journey along the spiritual Path

tawhid realisation of the Divine Unity

ta'ziya mourning or consoling; a passion play re-enacting the death of Husayn and performed during Muharram, but also, in India, a model of the tomb of Husayn or, less commonly, of Hasan

tuba blessing or goodness

turba tomb

ulama the community of religious scholars, jurists and other learned individuals

umm in names read as 'mother of'

umma the community of Muslims

umra the lesser pilgrimage, which consists of visiting the Ka'ba only, at any time of the year

waqf a pious endowment

wazir minister

wudu the lesser ablution, consisting of the washing of the face and head, the hands and arms up to the elbows and the feet to the ankles

wuquf solemn standing during which the pilgrims contemplate and pray to God, commemorating the expulsion from Eden and the reunion of Adam and Eve, one of the rites of the *hajj*

zahir exterior or outward form, referring to physical appearance (as opposed to *batin*, interior)

zakat the obligatory alms tax

zawiya a Sufi lodge for communal living

zuhd asceticism or renunciation of all worldly pleasure; the name of one of the many stations through which the Sufi must pass on his journey along the spiritual Path

BIBLIOGRAPHY

(Footnotes have not been included in the text, but inclusion here should be taken as an acknowledgement of a volume's use and of a debt owed to the authors listed; any particular use made of a volume, such as the inclusion in the text of direct quotes, is indicated in parentheses at the end of the entry.)

al-Busiri, *The Luminous Stars in Praise of the Best of All Creation – Prophet Muhammad, An Adaptation of 'The Mantle' (Al-Kawakib al-Durriya fi Madh Khair al-Bariya), 9th/15th Century, (A Facsimile Edition of MS Ar 4168),* Recite Publications Inc., London, 1993.

'Ali, 'Abdullah Yusuf, *The Meaning of the Holy Qur'an,* Amana Publications, Beltsville, Maryland, 1996.

Arberry, A. J., *The Chester Beatty Library, A Handlist of the Arabic Manuscripts Vols. 1–7,* Hodges Figgis & Co Ltd, Dublin, 1955–64.

Arberry, A. J., *Classical Persian Literature,* Curzon Press, London, 1958/1994.

Arberry, A. J., *The Koran Illuminated, A Handlist of the Korans in the Chester Beatty Library,* Hodges Figgis & Co Ltd, Dublin, 1967 (pp. xiii–xiv for the quotes from the treatise of Ibn al-Bawwab presented in the section 'The Role and Art of the Calligrapher' in Chapter 4).

Arberry, A. J., *Sufism, An Account of the Mystics of Islam,* Mandala Unwin Paperbacks, London, 1979.

Arberry, A. J., E. Blochet and M. Minovi, *The Chester Beatty Library, A Catalogue of the Persian Manuscripts and Miniatures, Vols. 1–3,* Hodges Figgis & Co Ltd, Dublin, 1959–62.

Armstrong, Karen, *Muhammad, A Biography of the Prophet,* Phoenix Press, London, 2001.

Baldick, Julian, *Mystical Islam, An Introduction to Sufism,* I. B. Tauris and Co. Ltd., London, 1989.

Blair, Sheila, *Islamic Calligraphy,* Edinburgh University Press, Edinburgh, 2006.

Blair, Sheila, *Islamic Inscriptions,* Edinburgh University Press, Edinburgh, 1998.

Burton, John, *An Introduction to the Hadith,* Edinburgh University Press, Edinburgh, 1994.

Derman, M. Uğur, *Letters in Gold, Ottoman Calligraphy from the Sabanci Collection, Istanbul,* The Metropolitan Museum of Art, New York, 1998 (in particular, for the *hilya* translation presented in the section '*Hilya al-nabi*' in Chapter 2).

Déroche, Francois, *The Abbasid Tradition, Qur'ans of the 8th to the 10th Centuries,* The Nour Foundation and Azimuth Editions, London, and Oxford University Press, Oxford, 1992.

Doi, 'Abdur Rahman I., *Shari'ah, The Islamic Law,* Ta Ha Publishers, London, 1984.

Dutton, Yasin, 'Red Dots, Green Dots, Yellow Dots and Blue: Some Reflections on the Vocalisation of Early Qur'anic Manuscripts, Part I, *Journal of Qur'anic Studies,* Vol. 1, No. 1, pp. 115–40.

Dutton, Yasin, 'Red Dots, Green Dots, Yellow Dots and Blue: Some Reflections on the Vocalisation of Early Qur'anic Manuscripts, Part II, *Journal of Qur'anic Studies,* Vol. 1, No. 2, pp. 1–24.

Encyclopaedia of Islam, New Edition, E. J. Brill, Leiden, and Luzac and Co., London, 1960–2002.
Vol. I: 'Adam', pp. 176–78; "A'isha bint Abi Bakr', pp. 307–08; 'al-Baidawi', pp. 590–91; 'Banat Su'ad', p. 1011; 'Burda', pp. 1314–15.
Vol. II: 'Cishti, Khwadja Mu'in al-Din Hasan', pp. 49–50; 'Cishtiyya', pp. 50–56; 'Dhu'l-Fakar', p. 233; 'Djalal al-Din Rumi', pp. 393–97; 'Fatima', pp. 841–50.

Vol. III: 'Hadith', pp. 23–28; 'Hadjdj', pp. 31–38; 'Hawwa', p. 295.
Vol. IV: 'Iskandarnama', pp. 127–29; 'Khadir', pp. 902–05; 'Khalifa', pp. 937–53.
Vol. V: 'Kira'a', pp. 27–28; 'Kisas al-Anbiya', pp. 180–81; 'al-Kuran', pp. 400–32; 'Lut', pp. 832–33.
Vol. VI: 'Mawlawiyya', pp. 883–88.
Vol. VII: 'Miradj', pp. 97–105; 'Miswak', p. 187; 'Muhammad', pp. 360–87.
Vol. IX: 'Salat', pp. 96–105; 'Sulayman b. David', pp. 822–24.
Vol. X: 'Tafir', pp. 83–88; 'Tasawwuf', pp. 313–38.
Vol. XI: 'Yunus', pp. 347–48; 'Yusuf', pp. 352–54.

Encyclopaedia of the Qur'an, E. J. Brill, Leiden, 2001–2003.
Vol. 1: 'A'isha bint Abi Bakr', pp. 55–60; 'Alexander', pp. 61–62; 'Ascension', pp. 176–80; 'Basmala', pp. 207–10; 'Burial', pp. 263–65; 'Cain and Abel', pp. 270–72; 'Codices of the Qur'an', pp. 347–61; 'Devil', pp. 524–27.
Vol. 2: 'Exegesis of the Qur'an', pp. 99–121; 'Fasting', pp. 180–84; 'Fatima', pp. 188–93; 'Festivals', pp. 203–08; 'Form and Structure of the Qur'an', pp. 245–65; 'Garden', pp. 282–87; 'Gazali', pp. 358–77; 'Hafsa', pp. 397–98; 'Hamza b. 'Abd al-Mutallib', pp. 400–01; 'Idris', pp. 484–86; 'Imam', p. 502–04.
Vol. 3: 'Khadija', pp. 80–81; 'Khadir', pp. 81–84; 'Last Day', pp. 135–46; 'Lut', pp. 231–32; 'Moses', pp. 419–26; 'Muhammad', pp. 440–57; 'Names of the Prophet', pp. 501–05.

Guillaume, A., *The Life of Muhammad, A Translation of Ibn Ishaq's Sirat Rasul Allah,* Oxford University Press, London, 1955.

Hallaq, Wael B., *The Origins and Evolution of Islamic Law,* Cambridge University Press, Cambridge, 2005 (pp. 156 and 163 and

more generally pp. 150–77, but in particular for the quotes included in the section on 'The Four Schools of Islamic (Sunni) Jurisprudence' in Chapter 5).

James, David, *After Timur, Qur'ans of the 15th and 16th Centuries,* The Nour Foundation and Azimuth Editions, London, and Oxford University Press, Oxford, 1992.

James, David, *Qur'ans and Bindings from the Chester Beatty Library, A Facsimile Exhibition,* World of Islam Festival Trust, London, 1980 (in particular for identification of the scripts used in many of the Qur'ans and for the identification of the Qur'anic verses used in the beginning illumination of the Ruzbihan Qur'an, CBL Is 1558).

Kennedy, Hugh, *The Prophet and the Age of the Caliphates, The Islamic Near East from the Sixth to the Eleventh Century,* Longman, London, 1986.

Leach, Linda York, *Mughal and Other Indian Paintings from the Chester Beatty Library, Vols. 1–2,* Scorpion Cavendish, London, 1995.

Lings, Martin, *Muhammad, His Life Based on the Earliest Sources,* The Islamic Texts Society, Cambridge, 1991.

Lyons, Ursula, *The Chester Beatty Library, A Handlist of the Arabic Manuscripts, Volume VIII, Indexes,* Hodges Figgis & Co Ltd, Dublin, 1966.

Maddison, Francis and Emily Savage-Smith, *Science, Tools and Magic, Part One: Body and Spirit, Mapping the Universe,* The Nour Foundation and Azimuth Editions, London, and Oxford University Press, Oxford, 1997.

Malekpour, Jamshid, *The Islamic Drama,* Frank Cass Publishers, London, 2004.

Milstein, Rachel, Karin Rührdaz and Barbara Schmitz, *Stories of the Prophets, Illustrated Manuscripts of 'Qisas al-Anbiya',* Mazda Publishers, Costa Mesa, 1999.

Minorsky, V., *The Chester Beatty Library, A Catalogue of the Turkish Manuscripts and Miniatures,* Hodges Figgis & Co Ltd, Dublin, 1958.

Morgan, David, *Medieval Persia 1040–1797,* Longman, London, 1988 (p. 108 for the quote presented in the section 'Shi'a Iran' in Chapter 2).

Nasr, Seyyed Hossein, *Islamic Art and Spirituality,* State University of New York Press, New York, 1987.

Nasr, Seyyed Hossein, *Sufi Essays,* George Allen and Unwin Ltd, London, 1972.

Netton, Ian Richard, *A Popular Dictionary of Islam,* Curzon Press, London, 1992.

Qadi Ahmad, *Calligraphers and Painters, a Treatise by Qadi Ahmad, Son of Mir Munshi (circa A.H. 1015/1606),* translated by V. Minorsky, The Freer Gallery of Art, Washington, 1959 (in particular, p.122 for the quotes from the treatise of Sultan Ali presented in the section 'The Role and Art of the Calligrapher' in Chapter 4).

Renard, John, *Historical Dictionary of Sufism,* The Scarecrow Press, Inc., Oxford, 2005.

Rice, D. S., *The Unique Ibn al-Bawwab Manuscript in the Chester Beatty Library,* Emery Walker (Ireland) Ltd, Dublin, 1955.

Robinson, Neal, *Discovering the Qur'an, A Contemporary Approach to a Veiled Text,* SCM Press, London, 1996/2003 (for the discussion of abrogation, in particular, but also for the general approach taken to the subject as presented in the section 'The Qur'an: Content and Style' in Chapter 3).

Rogers, J. M., *Empire of the Sultans, Ottoman Art from the Collection of Nasser D. Khalili,* The Nour Foundation, London, 1995.

Safwat, Nabil, *Golden Pages, Qur'ans and Other Manuscripts from the Collection of Ghassan I. Shaker,* Azimuth Editions, London, and Oxford University Press, Oxford, 2000.

Sells, Michael A., '*Banat Su'ad,* Translation and Introduction', *Journal of Arabic Literature,* XXI, 1991, pp. 140–54.

Seyller, John, *The Adventures of Hamza, Painting and Storytelling in Mughal India,* The Freer Gallery of Art and The Arthur M. Sackler Gallery, Washington, D.C., and Azimuth Editions, London, 2002.

Sherif, Faruq, *A Guide to the Contents of the Qur'an,* Garnet Publishing, Reading, 1995 (p. 9 for the 'victim in Mecca, avenger in Medina' quote presented in the section 'The Qur'an: Content and Style' in Chapter 3).

Tabbaa, Yasser, 'The Transformation of Arabic Writing: Part I, Qur'anic Calligraphy', *Ars Orientalis,* XXI, 1991, pp. 119–48.

Tabba, Yasser, *The Transformation of Islamic Art During the Sunni Revival,* University of Washington Press, Seattle and London, 2001.

Thackston, Wheeler M., 'Treatise on Calligraphic Arts: A Disquisition on Paper, Colors, Inks, and Pens by Simi of Nishapur,' *Intellectual Studies on Islam, Essays Written in Honor of Martin B. Dickson,* edited by Michel M. Mazzaoui and Vera B. Moreen, University of Utah Press, Salt Lake City, 1990, pp. 219–28.

Trimingham, J. Spencer, *The Sufi Orders in Islam,* Oxford University Press, Oxford, 1971/1998.

Vikor, Knut, *Between God and the Sultan, A History of Islamic Law,* Hurst and Company, London, 2005.

Von Denffer, Ahmad, *'Ulum al-Qur'an, An Introduction to the Sciences of the Qur'an,* The Islamic Foundation, Markfield, Leicestershire, 1983/2000.

von Folsach, Keld *et al., Sultan, Shah, and Great Mughal, The History and Culture of the Islamic World,* The National Museum, Copenhagen, 1996.

Watt, W., Montgomery and Richard Bell, *Introduction to the Qur'an,* Edinburgh University Press, Edinburgh, 1970/1997.

Wood, Barry, 'The *Tarikh-i Jahanara* in the Chester Beatty Library: An Illustrated Manuscript of the "Anonymous Histories of Shah Isma'il"', *Iranian Studies,* Vol. 13, No. 1, March 2004, pp. 89–107 (for the quote and information in the caption to figs. 36–37).

INDEX